GERED MANKOWITZ
50 YEARS OF ROCK AND ROLL **PHOTOGRAPHY**

CARLTON
BOOKS

CONTENTS

GERED MANKOWITZ **INTRODUCTION**

The music business has been very good to me since 1963, but that hasn't stopped me trying to give it up on several occasions.

From Chad & Jeremy in 1963, my career rock and rolled via the delicious Marianne Faithfull through the exciting and dangerous Rolling Stones to the sublime Jimi Hendrix in 1967. Then everything got darker as we all became aware of another harder, crueller world that slid from the innocence of Swinging London to drug-infused confusion.

By 1969 I had to give up my first studio in Mason's Yard because we couldn't afford the rent and Andrew Loog Oldham's creatively inspiring Immediate Records went down the tubes – two events which convinced me that I had to change career and move away from music.

I had the chance to go to Israel to work on a film with Richard Harris and to pursue the idea of working as a

photographer in the film business. It was an interesting trip but a disastrous film and only confirmed for me what I had already experienced a couple of years previously working on a film called *Boom* with Richard Burton and Elizabeth Taylor. The film business was madder, badder and sicker than even the music business – and for me far less exciting, creative and artistic.

I returned to London and the great Chas Chandler asked me to continue my work with his band Slade, who I had first photographed in 1969. I was back in the music business, where I obviously belonged. Together with old colleagues from Mason's Yard, I helped establish a studio in Great Windmill Street in Soho and would stay there enduring three-day weeks and the heady, glittery, glamorous 70s working with the pioneering, unzipped Suzi Quatro, the terrifying Sweet and the infamous Leader of the Gang Gary Glitter amongst many others. Then, a few years down the line, punk reared its grotesque head.

I went to see the Damned and the Adverts play the Roundhouse in North London in early 1977 to try and understand what this punk explosion was all about. In spite of admiring the energy and the instinct, not to mention Gaye Advert herself, I realised that this probably marked the end of my music career and that now was the time to search for another avenue of photographic income. It also coincided with another studio move – this time from the delights of seedy Soho to the friendlier environment of The Old Chapel in leafy Hampstead.

I had always dabbled in other areas of commercial photography though music had always been the genre that I felt most at home in, but now I realised that it was time to try my hand at advertising. I put together what I thought was a terrific portfolio of my record sleeves and associated "ground-breaking" images and began to go around the advertising agencies. Everybody seemed to like the work but nobody wanted to employ me, so it was back to the Old Chapel to think again.

Editorial portraiture was an interesting area and I began to shoot on a regular basis for the magazines of several

newspapers, including the *Observer* and the *Sunday Express*. However, within a few months the initial punk energy was sucked out by the corporate music business. Before I knew it, I was in demand again, working with post-punk acts like the Jam and Generation X, who felt the need for the experience and technical skills I could bring to their table.

The latter part of the 70s turned out to be an exciting time for me with a growing reputation in the editorial world and a continuing career in music, working with artists of the calibre and beauty of Kate Bush and Annie Lennox.

When the 80s arrived, I was determined to combine my music photography with commercial advertising. This time, with a completely new portfolio, I began to get some great work in that strange but rewarding world and was lucky enough to continue to be sought out by several wonderful musicians and their record companies, including the extraordinarily talented Elton John, the new-wave darlings Duran Duran, the endlessly creative Eurythmics and the greatly missed George Harrison. It was a productive and rather exciting decade and I managed to juggle both careers for quite a long period.

By the beginning of the 90s, we were experiencing a dramatic and uncomfortable recession. Advertising was becoming less creative and definitely not as enjoyable as it had been in the previous decade, but the music continued to play for me and I managed to keep it all going, juggling madly and finding different ways of making it fun working with some great Brit Pop talent, including Catatonia, Suede, Ride and even Oasis!

Digital technology was beginning to make its impact on photography and I felt that it was an important development and one which I needed to embrace and make part of my future. However, in 1992 I had an important one-man exhibition in a gallery in Soho, which had become less seedy in the preceding few years and was now the centre of London's advertising business – or perhaps it was just a better dressed and styled seediness. This exhibition signalled the start of a growing interest in my archive, which until that point had been virtually unseen. It triggered an amazing change for me: while my career in advertising began to wind down and my career as a photographer in the music business remained steady, a completely new growth area was emerging which involved my archive and the evolving technical changes.

Interest in my archive, combined with my new digital post-production skills, allowed me to pursue music again as my primary photographic activity. This has continued to the present day with the archive slowly dominating as I finally reach a point where the current music business has sort of given up on me; but I have reached a time in my life where it really doesn't matter anymore and I can say in all honesty: the music business has been very good to me since 1963!

Gered Mankowitz
Cornwall, 2013

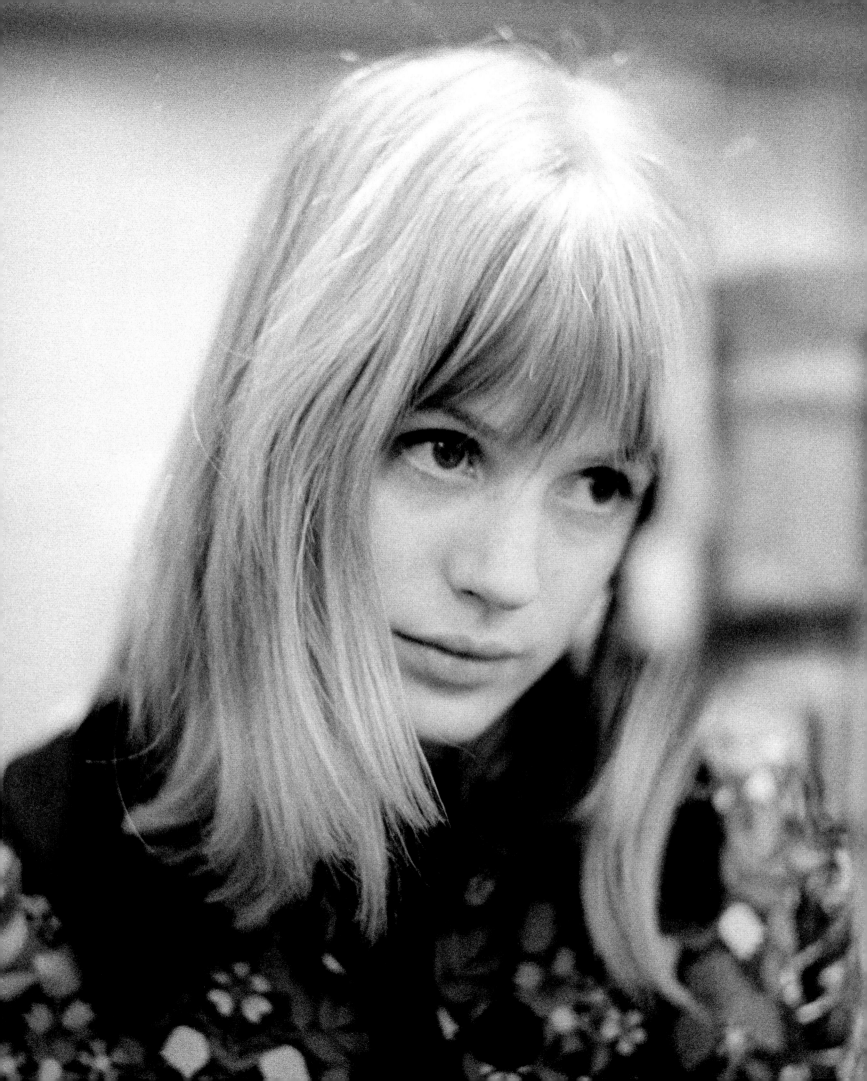

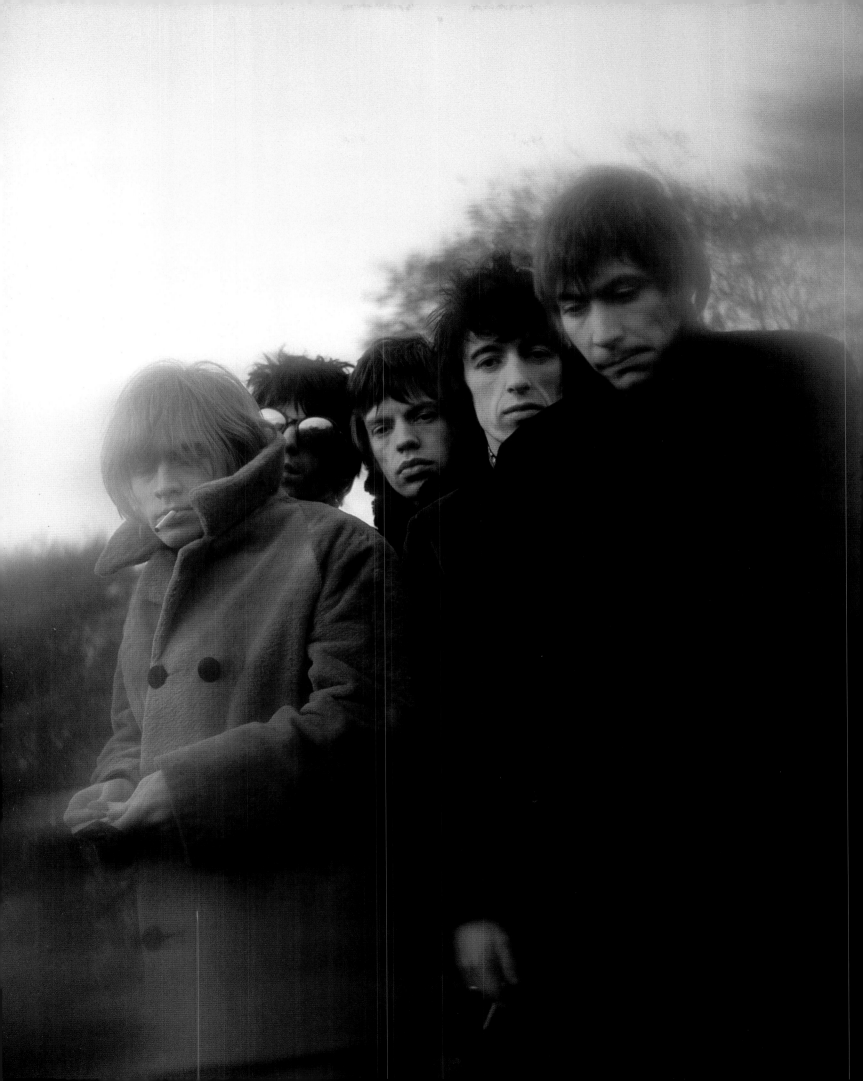

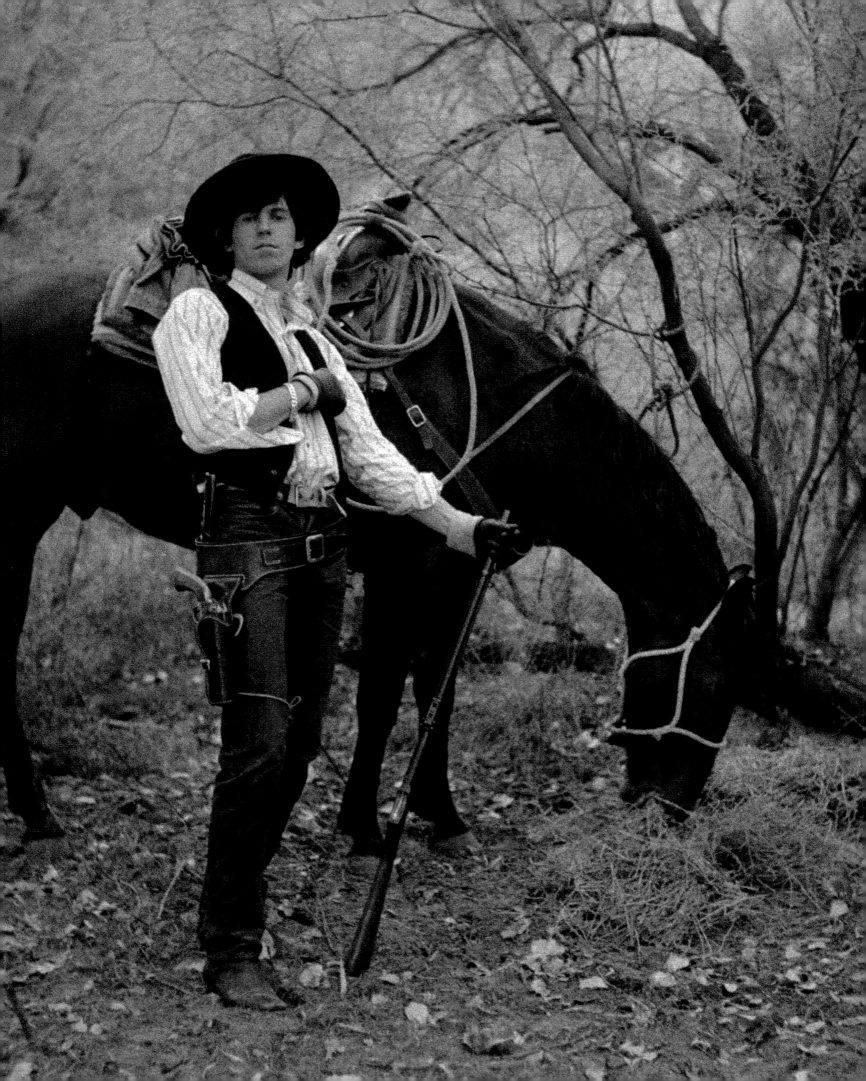

KEITH RICHARDS FOREWORD

Gered: In front of me I have a black & white photo of myself kitted out in true Western garb down to a Colt 45 revolver and a Winchester repeating rifle. (When you're deep in the back country of Arizona you are dead without one.) I'm standing in front of a beautiful chestnut quarter horse, who became my friend and my tutor for about a week.

I look ludicrously young but very much at home. The other person there (not shown in the shot) was Gered, and we were surely two of the most unlikely people to meet in the Arizona desert.

He's not visible because Gered took the photo. I should have taken one of him because he looked the perfect greenhorn: cherubic, bespectacled, always with a camera ready for the fast draw. Those nights beside the fire sleeping on our saddles and trying to keep the beans pacified has been indelibly stamped in my mind. (Also the look on Gered's face as our old Indian guide blasted away at a mountain lion that got too close for comfort.)

He once took me to meet his father on a drive in the English countryside. Wolf must have wondered what his son had dragged in, although it was a very pleasant afternoon.

We've met briefly over the last (mere) 40 years, yet I always feel a warm glow when I think of the photographer on the range and I wonder, does he still carry a camera wherever he goes…

Keith Richards

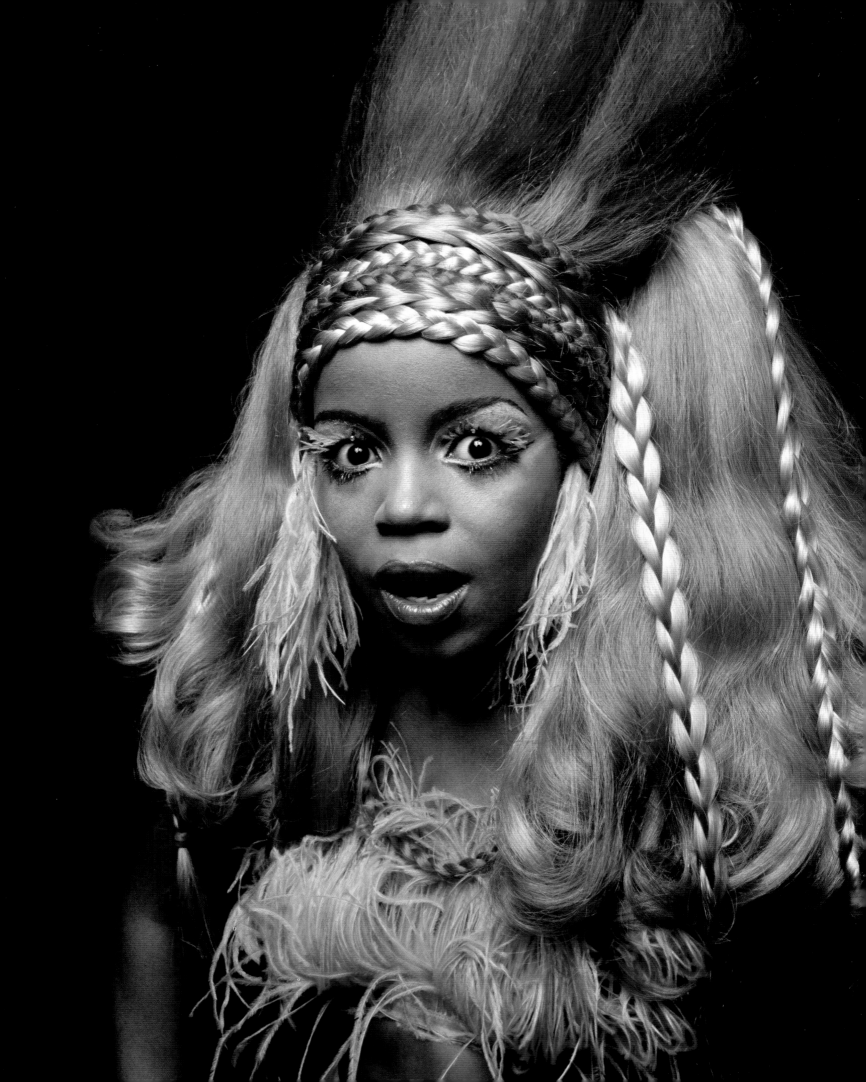

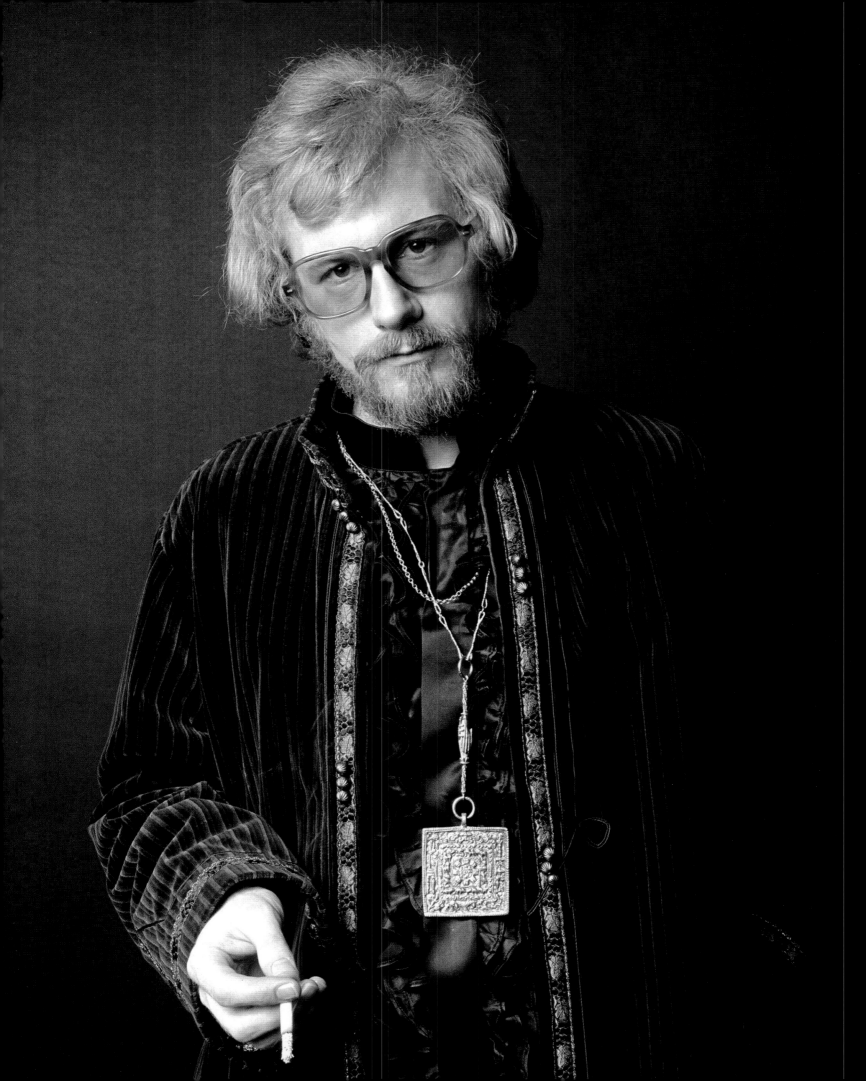

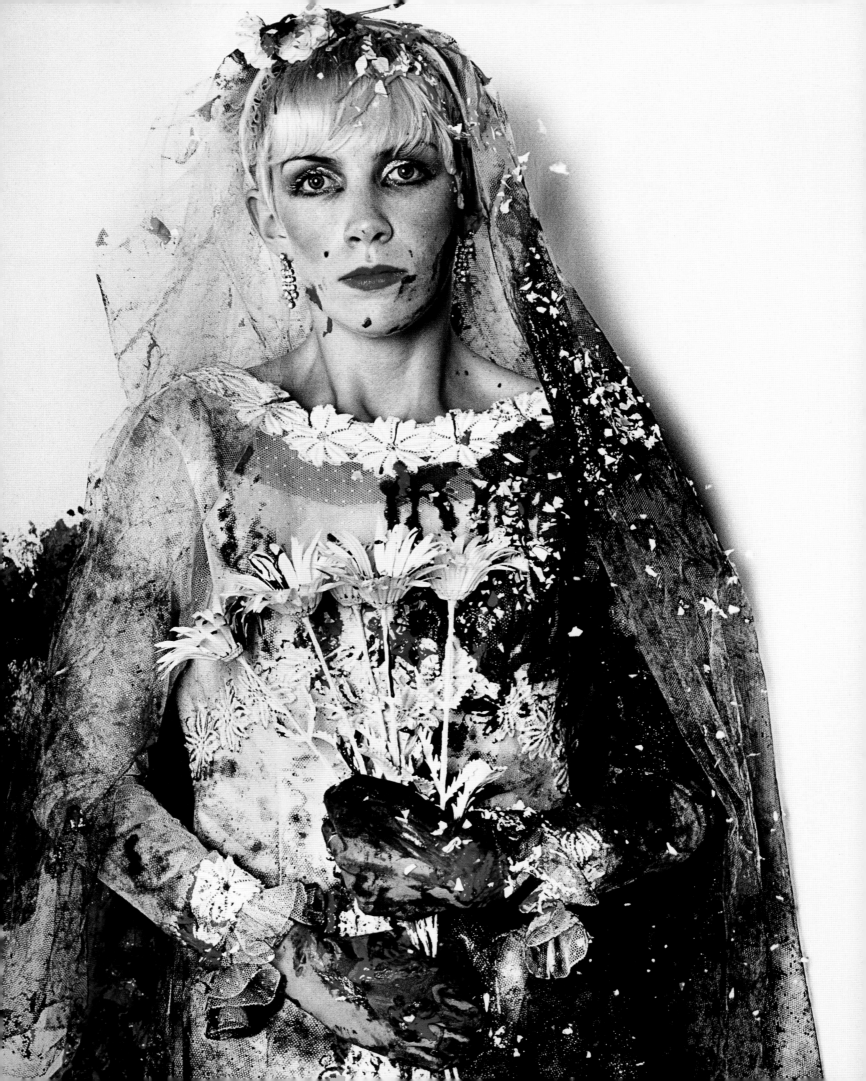

ANNIE LENNOX FOREWORD

Many moons ago in 1979… a somewhat motley bunch of Tourists found themselves in a converted church hall, which was, in fact, Gered Mankowitz's photographic studio in Hampstead, North London.

We had assembled there to have a photograph taken for our second album cover. There was a game plan. We had all discussed it beforehand, right down to the last detail.

A set would be built to resemble a living room, with a table and five chairs positioned in the centre. Everything would be painted white, so that it would be like a completely blank canvas, and we would start to gradually introduce small splashes of primary colours, in the form of liquid gouache paint.

While we were all getting dressed (in white outfits) a little bit of alcohol found its way into Peet Coombe's vicinity. At first there was a kind of celebratory atmosphere… a bit like a small party. Everyone was a bit excited by the event, and looking forward to the intended visual results. As discussed, we'd start off completely white… take a few reels of film, and then *gradually* introduce the initial splashes of colour to the pristine palette. Gered handed out tubes of paint: yellow, blue, green, red. Peet was given the blue tube.

The cover of the aforesaid *Reality Effect* is predominantly blue. He was so inebriated by the time we got to the "gradual colour" bit that he just… well… thing's got very blue very quickly, you might say.

We had quite a few quirky little sessions with Gered after that. I'm surprised he even let us back in the studio… but then Eurythmics were slightly better behaved.

Annie Lennox

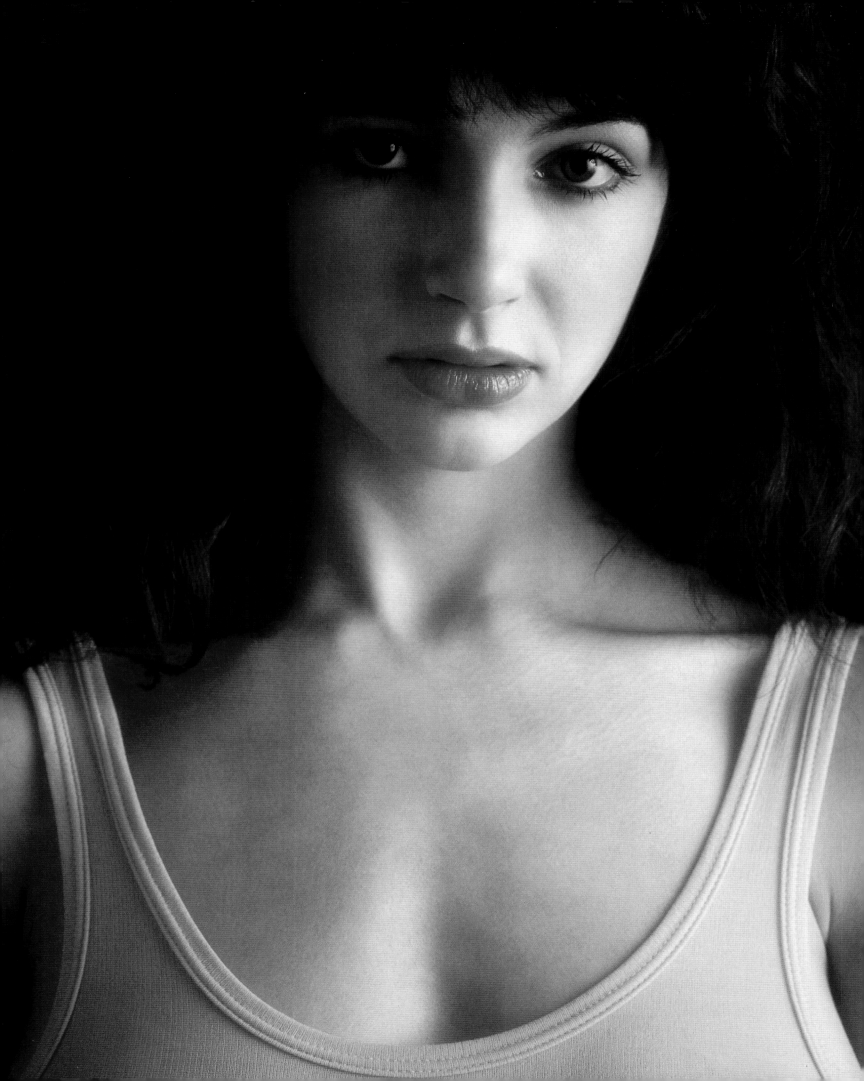

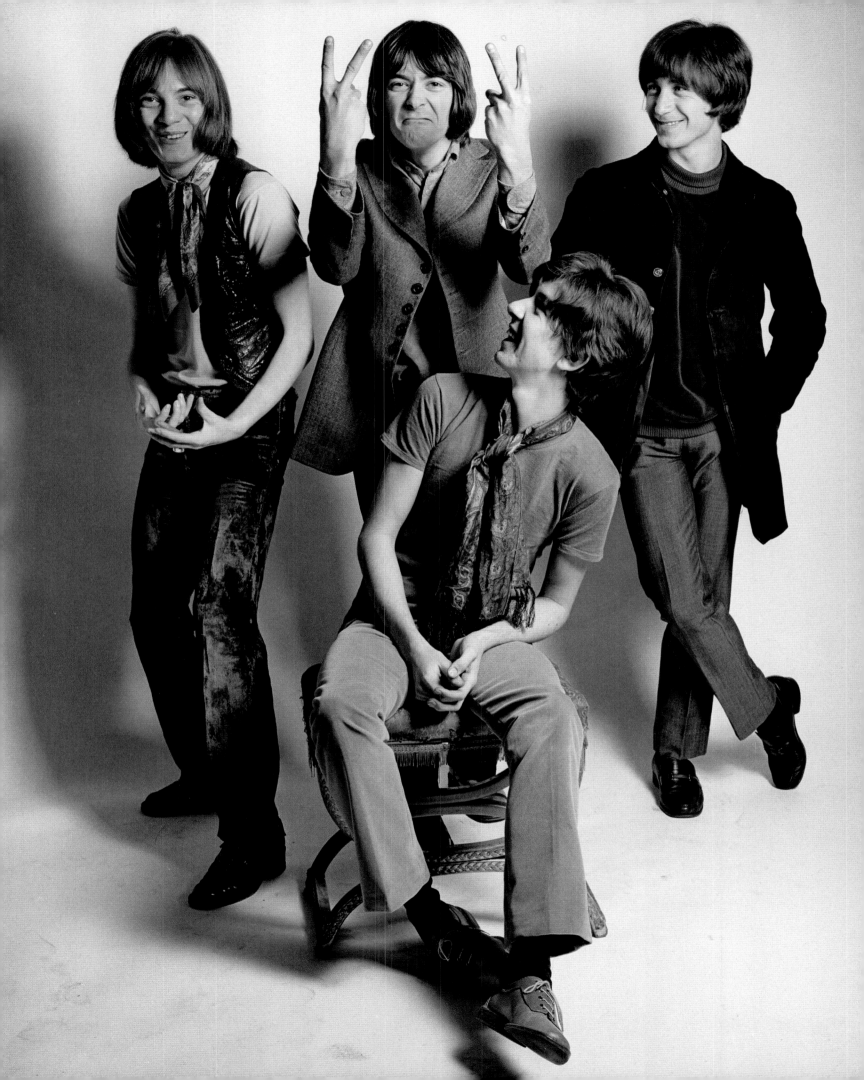

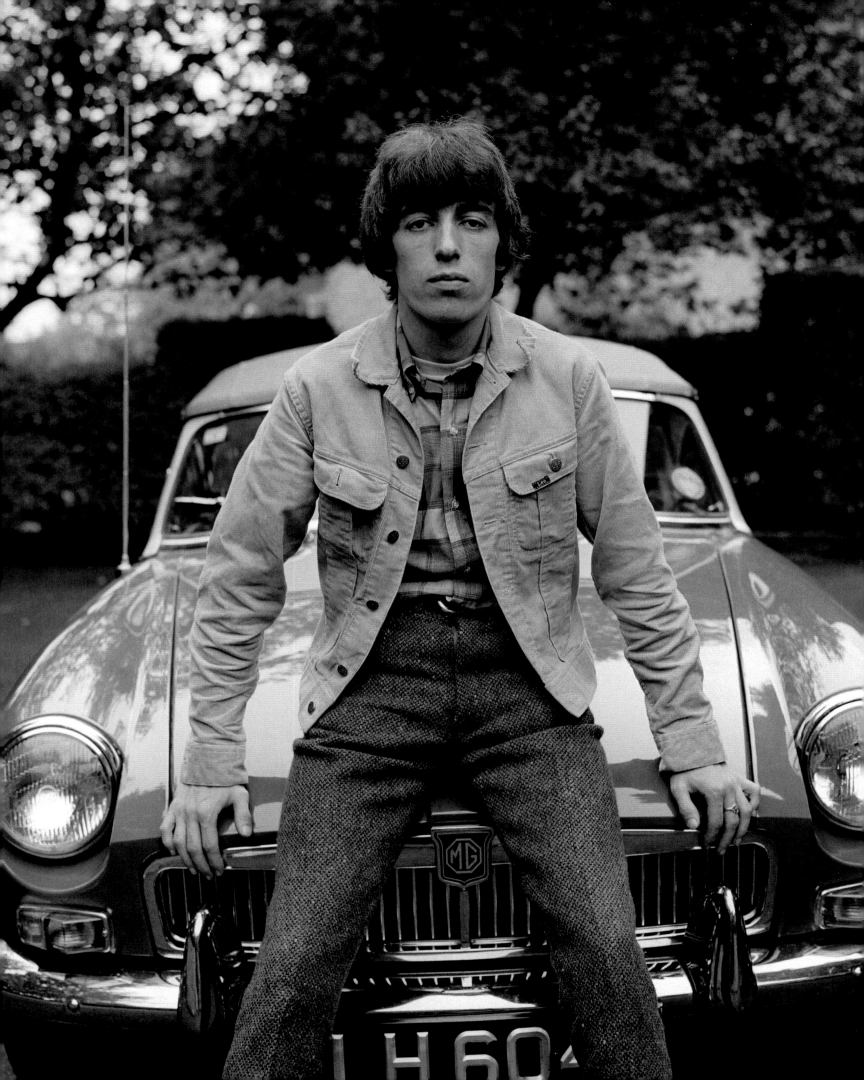

BILL WYMAN FOREWORD

Throughout my years in the Rolling Stones we had our pictures taken by countless photographers – maybe thousands – so it's none too surprising I don't know many of them by name. There are some I know by name and there are a handful of photographers who I know well and count as friends – one of them is Gered Mankowitz.

The first time the Stones met Gered was 7 April 1965. We went to his studio in Mason's Yard, London, and did lots of shots there, and also did more at a building site just up the road. Amongst other things these photos were used for the cover of the *Out Of Our Heads* album, the sheet music of 'Get Off My Cloud', and another was used as the cover shot for our fourth tour of America in the autumn of 1965.

We later did another photo session with Gered and because he knew Andrew Loog Oldham he was invited to come with us on our US tour as a kind of unofficial photographer – not bad for a nineteen-year-old! We left London Airport on 27 October and when we arrived at our New York hotel it took us 15 minutes to fight our way in; this was Gered's first taste of touring – Stones style. After playing in Montreal, Toronto and Syracuse, with Gered shooting photos at every show, we headed back to New York for about a week of gigs around the east coast. One afternoon Gered and I managed to sneak off for a visit to the Museum of Photography.

On 9 November we had spent a quiet day together, as it was the second of two days off, before we were due to fly south to Raleigh in North Carolina to start our criss-crossing of America. Around 5 p.m. we were back at the hotel and all the power went out. This was the start of a 12-hour blackout, which affected the whole of New York City and parts of nine other states. Gered was in my room with three or four girls, and we lit candles that the hotel supplied. We started messing around with the girls, and somebody knocked a candle onto a bed, which caught fire. However, it was soon put out, and we spent the rest of the evening thinking of what might have been.

The following day we checked out of the City Squire Hotel. During our stay here, over-enthusiastic fans had done $50,000 worth of damage; the Loews Hotel Group banned all pop artists from its New York Hotels after this! Our tour lasted until 5 December and during all the chaos and madness Gered managed to take brilliant photographs of us, both onstage and off. When I did my own book, *Rolling With The Stones*, which came out in 2002, I asked Gered to take the front cover photograph. It's over 40 years since we first met and he's still taking brilliant pictures. When I had the first European exhibition of my own photographs in Rotterdam, Holland, Gered came to the opening to support me.

To be honoured by your peers is what everyone appreciates most and it was a lovely gesture by one of Britain's best photographers.

Bill Wyman

PETER YORK FOREWORD

Gered Mankowitz, then 13, met Cliff Richard in 1958 on the set of *Expresso Bongo*, the film version of his father Wolf's play. Our Cliff, then very new, played Bongo Herbert, the teenage pop-star marvel. Laurence Harvey played his manager, sharp-faced, sharp suited, thin-tied, snap-hatted. Another North London boy, Andrew Loog Oldham, just a little older, saw the film the following year and based his life and look on the manager character from then on. By 1964 Oldham had the Rolling Stones and his Immediate Records stable to practise managing. And in 1965 he asked the 18-year-old Mankowitz to become the Stones' unofficial photographer.

In a famously youthful period Gered Mankowitz started absurdly young, at 16, in the completely new trade of pop-star photography. You had to make it up as you went along, because the conventions of Hollywood portraiture, let alone Karsh-of-Ottawa type visions of the great and good, were no guide. Pop stars really were young then, increasingly reflected their audiences, and moved around a lot. They had new poses – rebel, provincial lad, British Left Bank – which had to be interpreted in new ways. It really mattered that Mankowitz was so young – younger than his subjects – and understood the new aesthetic instinctively and at the same time had been raised so up to his neck in full-on, transatlantic showbiz that he was never remotely intimidated by his subjects, never the hopeless fan.

By the mid-60s, still in his teens, he was clearly part of *it*, the tiny world that *Time* described in 1966 as "Swinging London". It was made up of a few hundred people, tops, in pop (still the crucial word before things got pretentious), fashion, design and contemporary art (first wave Britpop). And photography. Antonioni's *Blow-Up* (1966) gave Euro-arty endorsement to the idea that young English fashion photographers lived the sexiest, most exciting life possible anywhere.

It wasn't so easy to place pop photographers. They barely existed as a specialist group. Their subjects seemed much less malleable than models and the whole thing looked more like … reporting. The exceptions were the photographers who actively created the key imagery for the two British groups who mattered to everyone everywhere, the Beatles and the Rolling Stones. At that level you had parity with your first division fashion peers.

Gered Mankowitz's relationship with the Rolling Stones from 1965 to 1967 was short but crucial. It was hugely productive in record covers and tour pictures, and it's endlessly documented. It's valuable history – an important archive that keeps on selling across the world. He was there in his studio in Mason's Yard, St. James's between the Scotch of St. James, one of just three important mid-60s clubs and the Indica Gallery – where John met Yoko in 1966 – run by John Dunbar, Marianne Faithfull's first husband. With his velvet suits and his table at the Ivy beside Marianne Faithfull, and his friendships with the other middle-class media-savvy London boys, you might have expected Gered to slide off later into one or other of the late 60s soft options – haring after feature-film directing, say – or flaking out altogether instead.

But staying with Oldham and his Immediate Records stable when the Stones left in 1967 meant in effect that Mankowitz had committed to pop – and 40 more years of it. And that's the glory of this book, the extraordinarily demotic mix of legendary major stars, second-division artists who hacked it for a decade, one-hit wonders and people I honestly can't remember at all but who still look the period part because he's made something of them. It's got distinct parallels with the *Top of the Pops* approach (1964 to 2006 – and the BBC are clearly thinking they acted too soon in canning it) rather than the self-consciously deep *Old Grey Whistle Test* one.

Mankowitz never went the snobby route of working only with people who saw themselves as "artists" in the massive Student Music bourgeois takeover of the late 60s and early 70s. He'd developed an approach that was professional and pragmatic – he'd build a "story" round a group or do iconography for individuals, whatever seemed to work for them. And he'd pitch the brow level where it belonged. He didn't impose a Mankowitz style that made-over his subjects in a predictable way. His commentaries on the subjects and the shoots are unfailingly polite and positive – even now you usually have to read between the lines to know who he thought was hopeless or hideous.

It's the pop ethic and the pop aesthetic we've got here. The pop idea was desperately important and endlessly discussed in cultural studies circles from the 70s on. But there was none of that in the 60s, of course; pop, if it meant anything at all, meant new and genuinely popular. When the NME had its Poll Winners concerts at the Albert Hall, it was a very broad church. The choice was simple for Mankowitz, to go on doing what he liked doing, working in a job where he'd grown-up very fast and where people in the business increasingly sent their little charges along knowing he could do something with them. Later, of course, self-starting artists like Billy Idol with a sense of pop's history would come to him saying, "We saw what you did for the Stones…"

A lawyer friend of mine, who manages the contract side of things for big music groups, once told me his clients found his sensibly formal clothes and RP voice tremendously reassuring. They'd come from a rackety world and they wanted their money looked after in a calm and orderly one. Gered must have had some of that reassurance – his youthful grown-upness, his tactful, reassuring, can-do quality. It was what you needed when you'd just gone from being, say, a gas fitter in Sheffield and an inch tall in life's great parade to being a pop star and a man a mile high. While they were adapting, learning fast, being groomed (there was much less of that then), they needed some fixed points and somebody who'd listen to what it was like to be them, how they saw their music and the rest of it.

A lot of that first pop generation came in collectives – groups – and it needed immense tact to manage the question of billings and all the other tensions. By the time Gered first photographed the Stones in 1965, Brian Jones was semi-detached with drink and drugs and self-regard, losing out to Mick Jagger's remorseless rise. But in that crucial Primrose Hill dawn shoot in 1966 for the cover of Between The Buttons, the one that sold the idea of the Rolling Stones' moody world, you can see how he's used Jones' oddness and alienation to advantage, to show that these absolutely aren't loveable mop-tops.

This book starts with Billy Fury, legendarily tormented and exploited – the real thing – and near the end features Ray Russell the guitarist, originally from The John Barry Seven. It's Beauty and the Beast. Fury was painfully thin, bravely made-up orange to match the ratty dressing room walls, and leathered and flying collared in the earlier tradition he came from – Larry Parnes' late 50s teen boychick idols – and, as we now know, dying. He was dead four months later. Here's all the defiance and pathos, the vulnerable arrogance of somebody who should've been looked after better. Russell on the other hand is a cheerful man-mountain cleverly tailored into mohair suiting, his big feet winkle-pickered, his sausage fingers round a plectrum, his powerful guitar ready to go, like a South London version of an American black backing musician. Did he do little play-and-move routines like the Shadows? He knows he's never going to be Front Pretty Boy, but he knows his rock solid skills will keep him

chugging away for ever. So it made sense to re-create this early 60s look for his 2006 album.

Marianne Faithfull – the girl with the Look, part Nouvelle Vague, part David Bailey *Vogue*, Liberated Upper – appears here twice. Initially during Mankowitz's first 1964 session for Decca, the one that introduced him to Andrew Oldham and the Stones, he was "enraptured" by her "wonderful innocent sexuality" and presented her as the dream Romantic Pop posh totty she was then, all blonde hair and big lips. Forty years later he photographed her as someone who'd been through her 60s nightmare and come out the other side toughened up, with the corncrake voice and the new cabaret career, looking like a Euro-Duchess who's knocked around a bit.

And here's Andy – Andrew Loog Oldham, the Wannabe Laurence Harvey, wonderfully sharp in one portrait with all the props of 60s Pop Manager performance, especially the cars. And then later in early World's End psychedelic, all velvet and satin, the Rich Hippie fraudulent guru look, a million miles from the terrible provincial uniform of prog rock.

And while we're on the Immediate days, here's P.P. Arnold, the lovely runaway Ikette signed to them for the marvellous 'The First Cut Is the Deepest', just when whitebread English youth was developing its long affair with black America. In 1967 Gered photographed her for an album cover got up in a huge blue and orange striped wig affair with a mass of vaguely Red Indian braiding. It's a look that prefigures those big black 70s touring acts and 70s Ultra Disco.

If you know Mankowitz's early work – Marianne, the Stones, Jimi Hendrix – then its impressive how he's continued to come up with several iconic I-didn't-know-he-did-that-one shoots each decade, those tipping point pictures that defined their subject for a first cohort of pre-internet fans.

Here, so achingly early 70s *TOTP*, is Suzi Quatro. She's with her boys in the band as a gentle dominatrix, in tight leathers and chains but looking sweet and fresh-faced while the boys bury their faces in different bits of her.

And, a decade later, here are Duran Duran against bright planes of early 80s colour – hot pink and lime – looking pretty with their flouncy hair and clothes and suede pixie boots. But they're representing another more knowing, hybrid aesthetic, born of glam and punk, and designed to go straight to video and the calculated extravagance of 'Rio' or 'Wild Boys'.

Here posing is brought to a fine art – Nick Rhodes looks as if he's working with Beaton in the late 20s, the handsome brunettes know how to do moody … Andy Taylor looks like a re-worked Paul Cook and Simon Le Bon, is, amazingly, still quite thin. All of this skill was endlessly enthusiastically flexed for talents and hopefuls for a decade after the Stones years. But, ten years later, the great divide presents. For 60s people – even young ones like Mankowitz, just 30 when punk hit London – it looked as if the game was up. The orthodoxy of punk was that the 60s stars and the 60s stylists were the Enemies of the People. They'd never work again.

Bravely he hung out to study the new world order long enough to realise just how much pose there was in punk and to meet the sublimely posey Billy Idol and Generation X. Billy (a middle-class, Home Counties student called Billy Broad) turned out to know exactly what Gered had done for the Stones and, thinking of his future in American stadium rock, wanted some of the same. Confidence restored, Mankowitz went on to photograph another generation of post-punk pop high and low.

The high and low is desperately important here. Among Mankowitz's own friends – another broad church – are Jeremy Clyde of Chad & Jeremy – an upper-middle

duo rather like Peter and Gordon – and Noddy Holder of Slade, those marvellously raucous Midlands proles in Bacofoil and platforms. Gered loved Slade. And he worked with them from 1969 to 1982, from their first incarnation as a skinhead band in boots and braces on into their highpoint in Low Glam and beyond (High Glam was Bowie and Ferry). Because we hear that song every Christmas, because they represent the *Life on Mars* years, Slade and The Sweet – they're always paired for me and they are here too – they haven't had much beyond ironic acknowledgment. They deserve more.

50 Years of Rock and Roll Photography is a huge all-our-yesterdays cross-cut of the decades. The coverage and range are so wide it'd be a valuable record if it'd just been done by an on-set photographer for *TOTP*. But it's a great deal more, a mass of considered images, ranging from the famous Stones, Marianne and Jimi Hendrix set pieces to clever one-liners like Spooky Tooth held aloft in the extended mechanical jaw of an agricultural digger. Baby-boomers have too much personal capital invested in a range of these looks here to dare to criticise the clothes. We've worn the spoofy country gent look that Alan Price takes on so easily, or the Merchant-Ivory Edwardian gamekeeper's three-piece tweed suit that Donovan's wearing here. Some of the clothes and hairstyles look every bit as ineffably naff as you remember and other pictures bring you up short, just reminding you how beautiful they were. Marianne of course, but Kate Bush in tight gym kit too. Poor Paula Y. Sade. Lovely Kim Wilde at her highpoint.

And then Hendrix, in a series of swagger portraits that dominate everything in sight. These are famous pictures, the product of a simple session miraculously free of management, PR, hair and make-up people. One where Mankowitz created that re-assurance that let Hendrix open up for these latter-day Van Dykes.

All of it's intensely resonant for me too. I've known a few of these people over the years. I've spent quite absurd amounts of time debating the value of terrible musicians in defining who we are in Britain and where we've been. And my mother had a friend in the next street in Hampstead, Celia Oldham, who used to tell stories about what her boy Andrew was doing out in the great world.

Peter York

GERED MA

50 YEARS OF ROCK AND

BILLY FURY 1982

Billy Fury was the first major rock star to emerge out of Liverpool when he was discovered by Larry Parnes in 1958. Born Ronald Wycherley – he was re-named by Parnes, who managed a stable of 1950s British rock singers – Fury went on to notch up a total of 24 chart singles in the 1960s, including ten Top 10 hits. A star of TV shows such as *Oh Boy* and *Boy Meets Girl*, Fury topped the bill on the first edition of *Ready Steady Go* in 1963. He died at the age of 42 in January 1983, just a few months after returning to the UK chart following a 16-year absence.

"Billy Fury was a real hero from my youth – a moody rebel, dangerous and sexy! I had to wait outside his dressing room door for ages before he was 'ready' to see me. He gave me about three minutes – I don't think I would have done it for anybody else! He was dead four months later …"

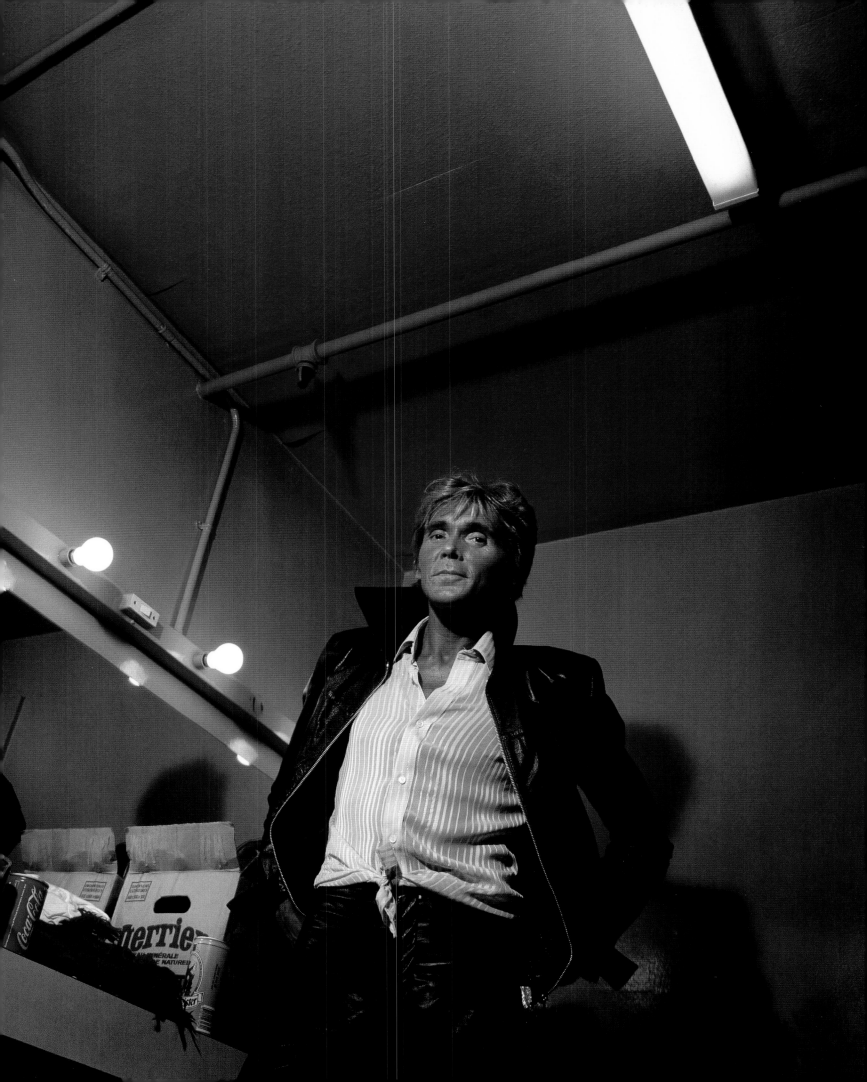

ALAN PRICE 1978

Alan Price was a founding member of the Animals who broke out of Newcastle in 1964 – when they reached Number 1 in both the UK and America with 'House Of The Rising Sun' and racked up three more Top 10 hits – before leaving the group in May 1965. With his group the Alan Price Set, the keyboard player had hits with 'Simon Smith And His Amazing Dancing Bear' and 'The House That Jack Built' before briefly teaming up with Georgie Fame. In addition to writing music for films and the stage, Price had his only solo album success with *Between Today And Yesterday* in 1974 – four years before his *England My England* project.

"This was the cover session for Alan's album called *England My England* – he slipped into the role of an English country gentleman very easily."

BABE RUTH 1974

Babe Ruth emerged out of Hertfordshire in 1970 led by singer Jennie Haan, who was backed by original members Alan Shacklock, Dave Hewitt and Dave Punshon. During the following six years, a collection of musicians came and went as Babe Ruth created a series of rock albums which earned them recognition in North America but no great success in the UK. By 1975 no original members were left in the line-up as the band completed their fifth album for release in 1976. However, the band re-formed in 2005 with Haan, Shacklock, Hewitt and Punshon returning to record an album and complete a reunion tour of Canada in 2010.

"Babe Ruth were a great band who had more success in America than they did in the UK in spite of making several albums in the 70s. Jennie Haan was the singer and had a wonderful, powerful voice. This series of portraits each illustrated a different song on the album."

The familiar line-up for New Romantics band Duran Duran was completed in 1980 when singer Simon Le Bon joined founding members John Taylor and Nick Rhodes alongside the unrelated Roger Taylor and Andy Taylor. During the following 30 years Duran Duran racked up ten successive British Top 10 hits and topped the charts in both the UK and US despite both Roger and Andy Taylor leaving in 1986. The pair then returned in 2000 for a series of concerts and recordings and after Andy Taylor once again departed in 2006, the line-up of Rhodes, John Taylor, Roger Taylor and Le Bon continued to take Duran Duran's record sales past the 100 million mark.

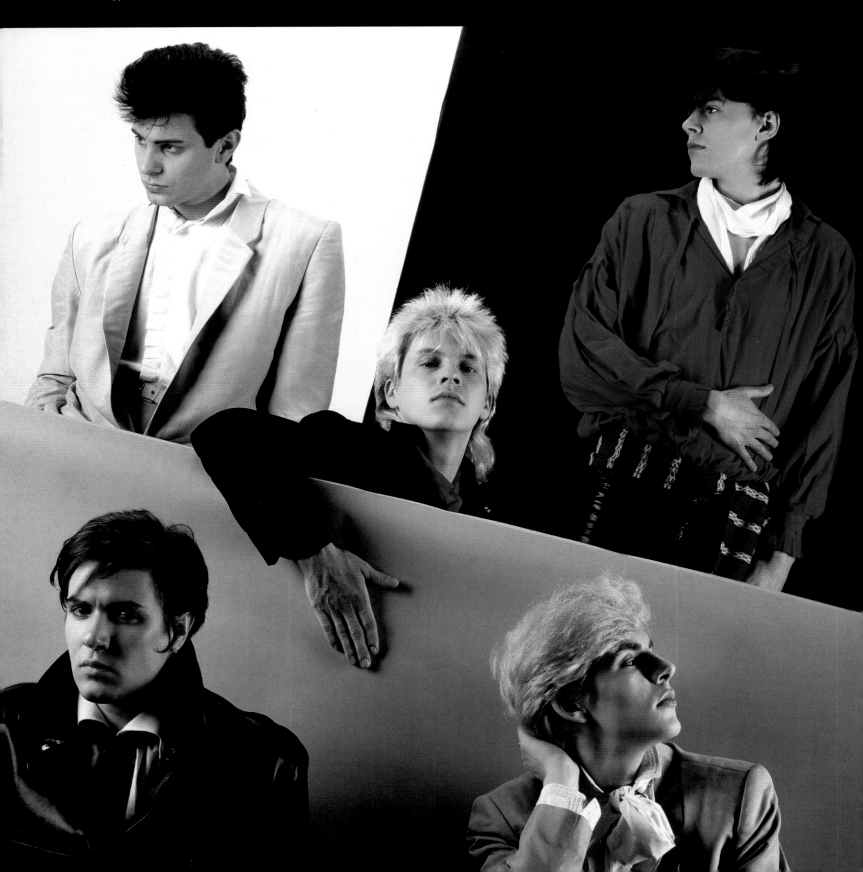

When I had my first exhibition in London I wanted to include a new band as the final image as my 'tip for the top'. I had approached Spandau Ballet but they turned me down, saying that they didn't want to share wall space with the Rolling Stones. After I did a bit of research, Duran Duran was suggested and they agreed to pose for me. The session was a huge success for all of us and I worked with the band several times afterwards. More importantly they were far more photogenic and have lasted far longer than Spandau Ballet!"

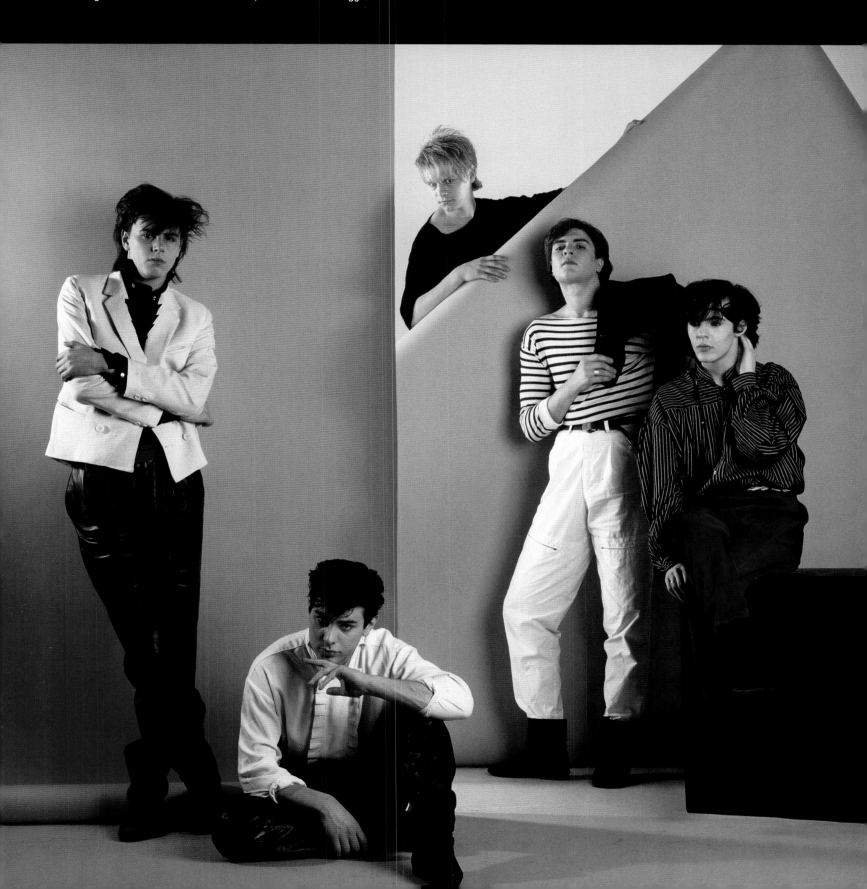

MARIANNE FAITHFULL 1964, 1965 & 1998

Convent-educated Marianne Faithfull was discovered by pop impresario Andrew Loog Oldham in 1964, when her first single 'As Tears Go By' reached the UK Top 10. After more hits in 1965, Faithfull became the regular companion of Rolling Stone Mick Jagger and gave up recording to focus on acting, although she returned to the charts in 1975 with the album *Broken English* and the single 'The Ballad Of Lucy Jordan'. While continuing to write songs and make appearances both as a singer and actor, Faithfull has also made a series of recordings, including collaborations with PJ Harvey, Nick Cave and Damon Albarn and she released her eighteenth album in 2011.

"I was enraptured by Marianne from the moment we first met in 1964. She had the most wonderful, innocent sexuality and was a joy to photograph. I lost touch with her, as she slipped into her 60s nightmare, until 1988. We stayed in touch after that and I photographed her again in Dublin in 1998 – the innocence had been replaced by a remarkable power and the sexuality was intact …"

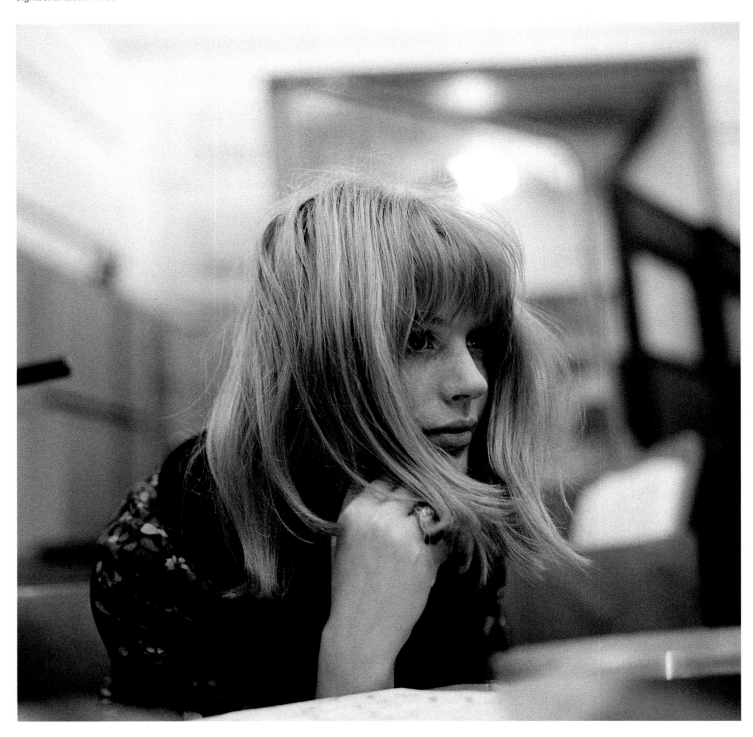

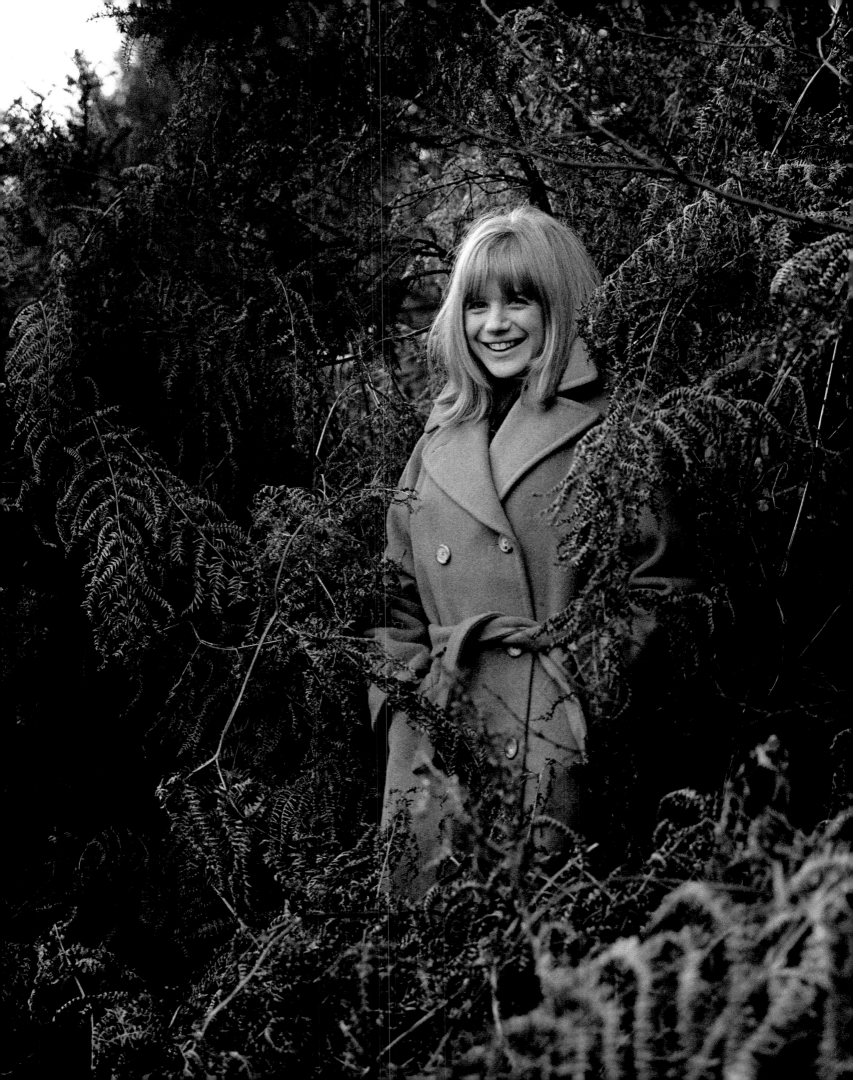

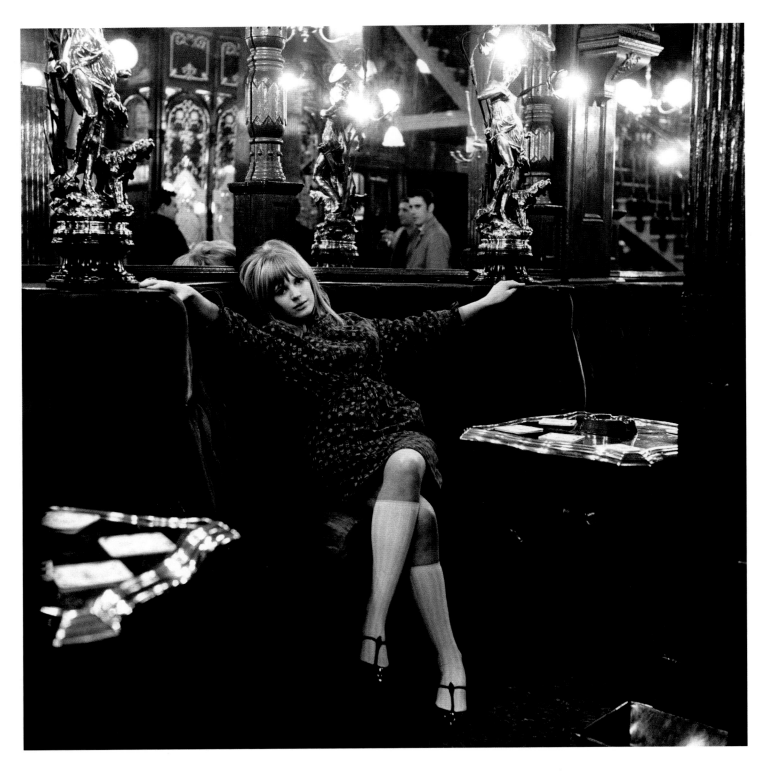

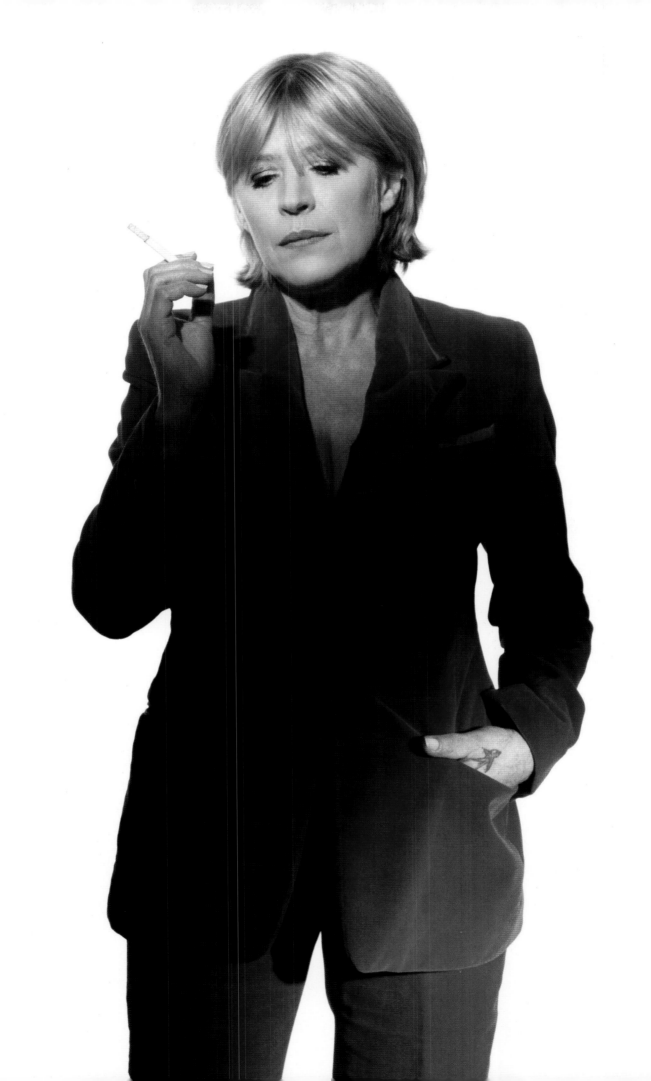

GENTLE GIANT 1978

The progressive rock band Gentle Giant was created by three brothers who were born in Glasgow, Scotland but moved to Portsmouth in England in 1966 where Phil, Derek and Ray Shulman created the soul/pop band Simon Dupree and the Big Sound. By 1970 they had founded Gentle Giant, recruited Gary Green, Kerry Minnear and Martin Smith and released their debut eponymous album. In 1972 Phil Shulman left, but the band continued throughout the 70s with brothers Derek and Ray plus Minnear, Green and drummer John Weathers, releasing seven albums. In 1980, after a total of four American Top 100 albums, Gentle Giant finally broke up.

"This well-established British prog rock band came to my studio in Hampstead and we decided that we would shoot in the nearby Belsize Park Underground station. We had to avoid the staff in the station, as taking photographs was not normally allowed, but being one of the deepest stations in London it had a rather decrepit lift that I thought would make a good location, and would be out of sight!"

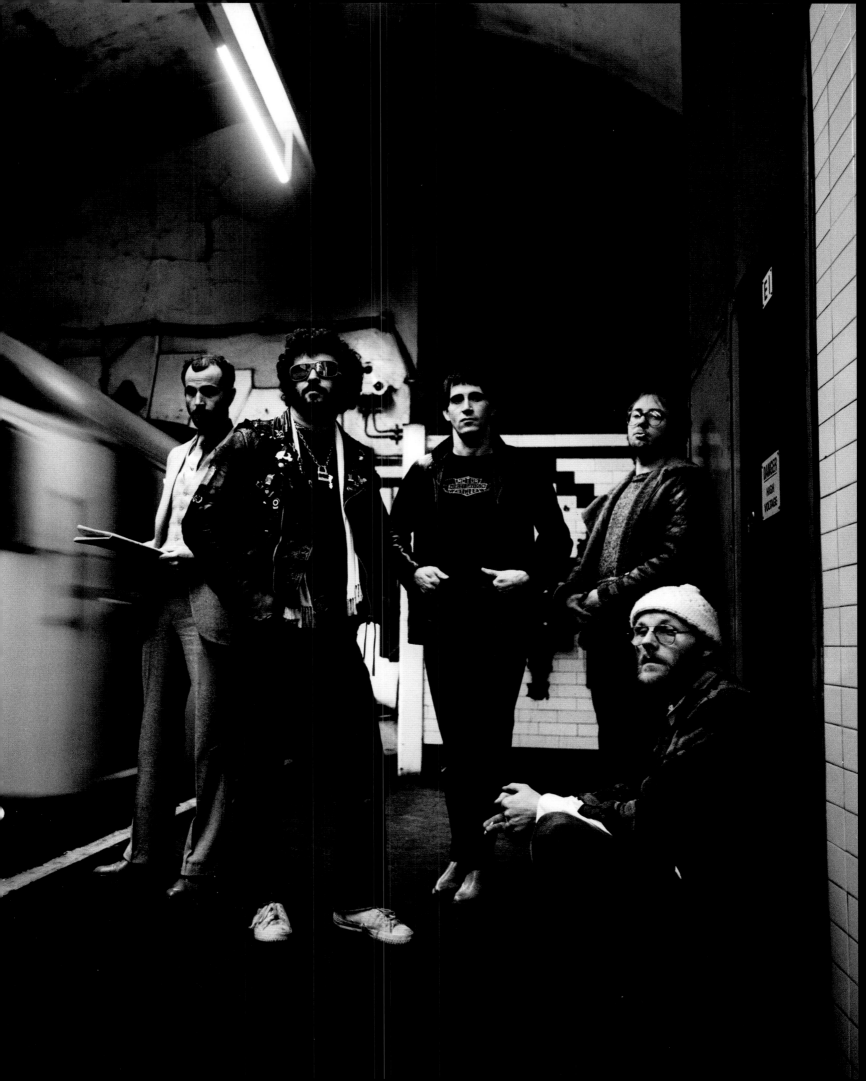

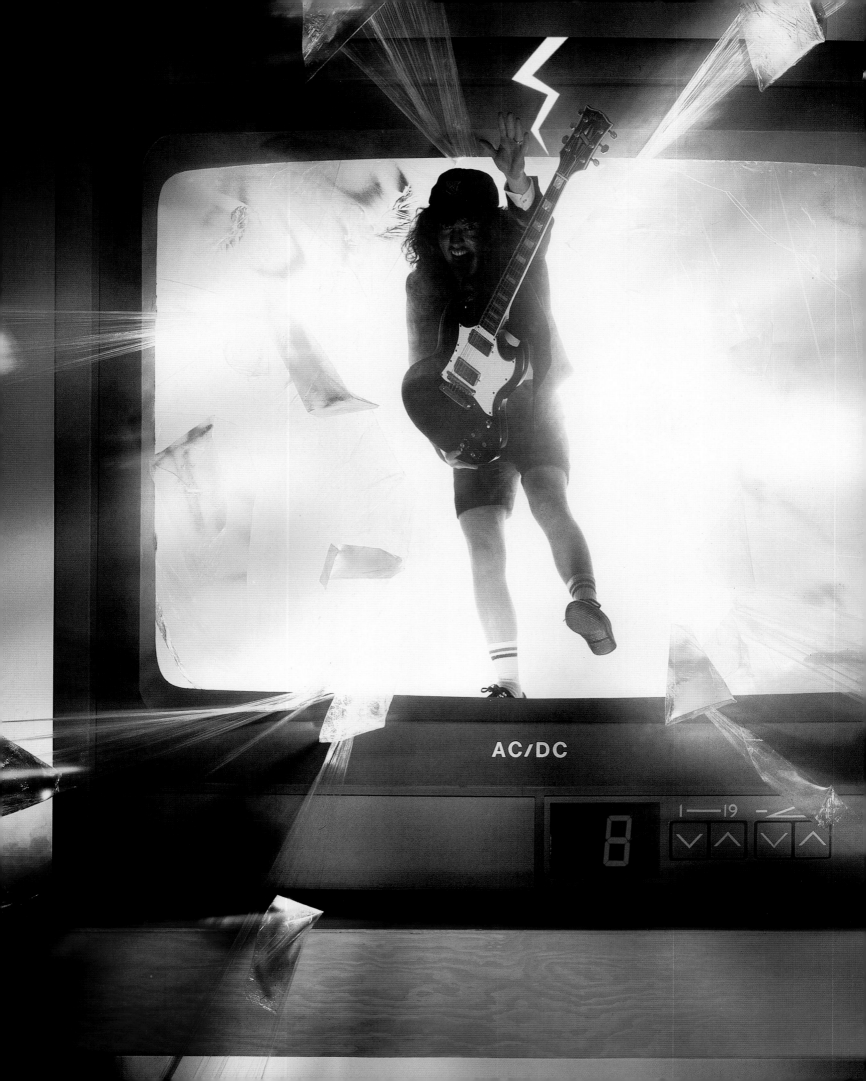

AC/DC 1981

The brainchild of the brothers Angus and Malcolm Young, who emigrated from Scotland to Australia in 1963, heavy rock band AC/DC released their debut album *Let There Be Rock* in 1977 and during the next nearly 40 years followed up with a collection of over a dozen US and UK Top 20 albums, including the 1988 hit 'Blow Up Your Video', which was photographed by Mankowitz. After the death of singer and founding member Bon Scott in 1980, ex-Geordie front man Brian Johnson was recruited to join the Young brothers, Cliff Williams and Phil Rudd (who was replaced by Simon Wright in 1983).

"I love building sets, and before digital technology everything was done in camera, in one shot if possible. This TV was nearly 3m tall and Angus had to leap out of the set dozens of times before I was happy with the result – he did a great job!"

ANDY FAIRWEATHER LOW 1969

Andy Fairweather Low began his career in Wales with the seven-piece band Amen Corner, who first hit the charts in 1967 and had their first Top 10 hit with 'Bend Me Shape Me' a year later. In 1969 the group topped the UK charts with '(If Paradise Is) Half As Nice' but split up the following year after just one more hit. As a solo artist Fairweather Low had Top 10 hits with 'Natural Sinner' and 'Wide Eyed And Legless' before embarking on a successful career as a highly acclaimed guitarist working with the likes of Kate Bush, Eric Clapton, George Harrison, Roger Waters and Bill Wyman.

"I had known Andy since working with his band Amen Corner, who were signed to Immediate Records in the 60s, and with whom I shot several covers and other sessions. In 1975 we did a session for his solo album *La Booga Rooga*, from which this leaping photo comes from!"

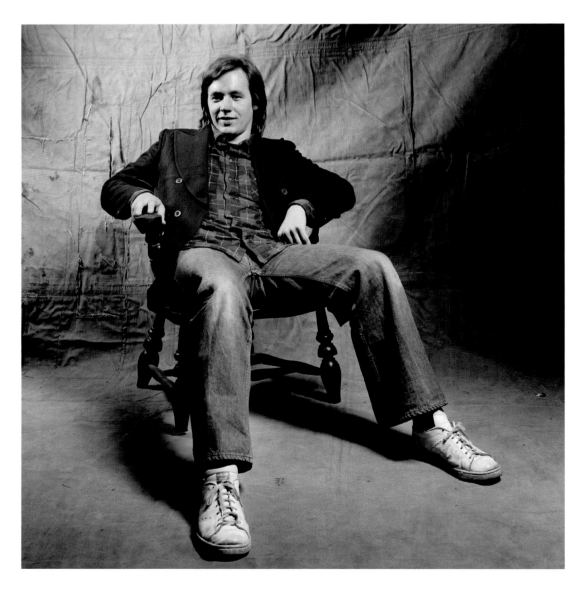

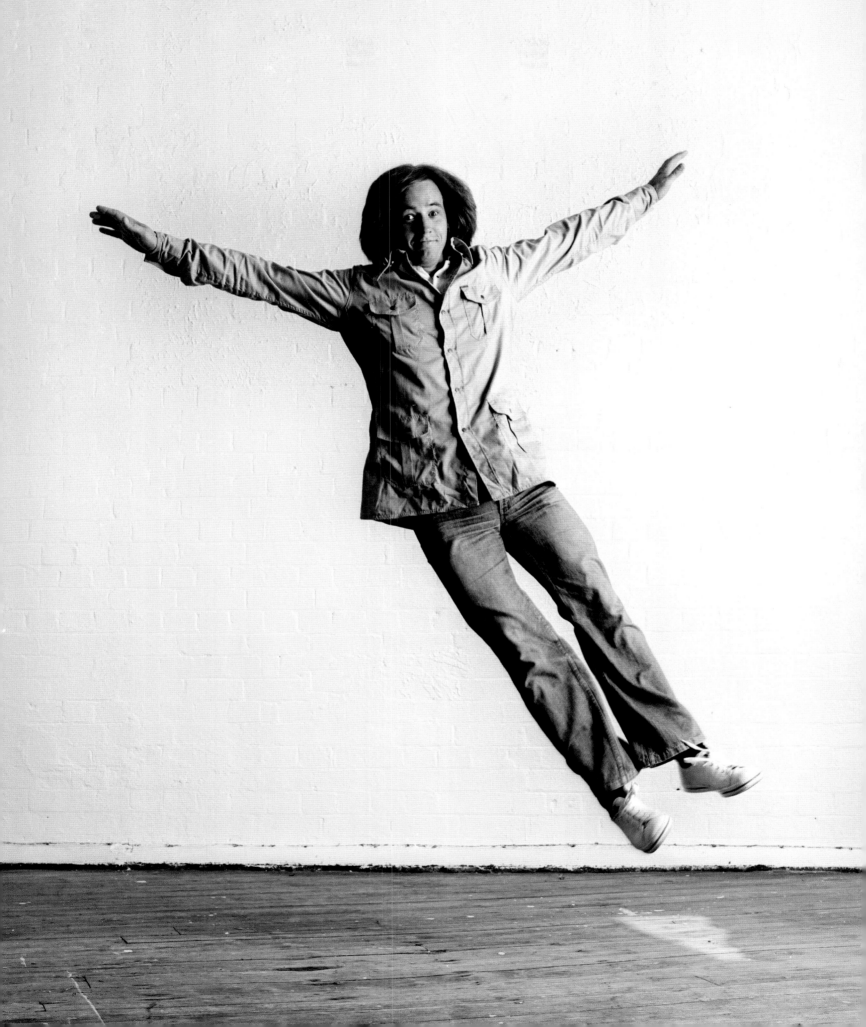

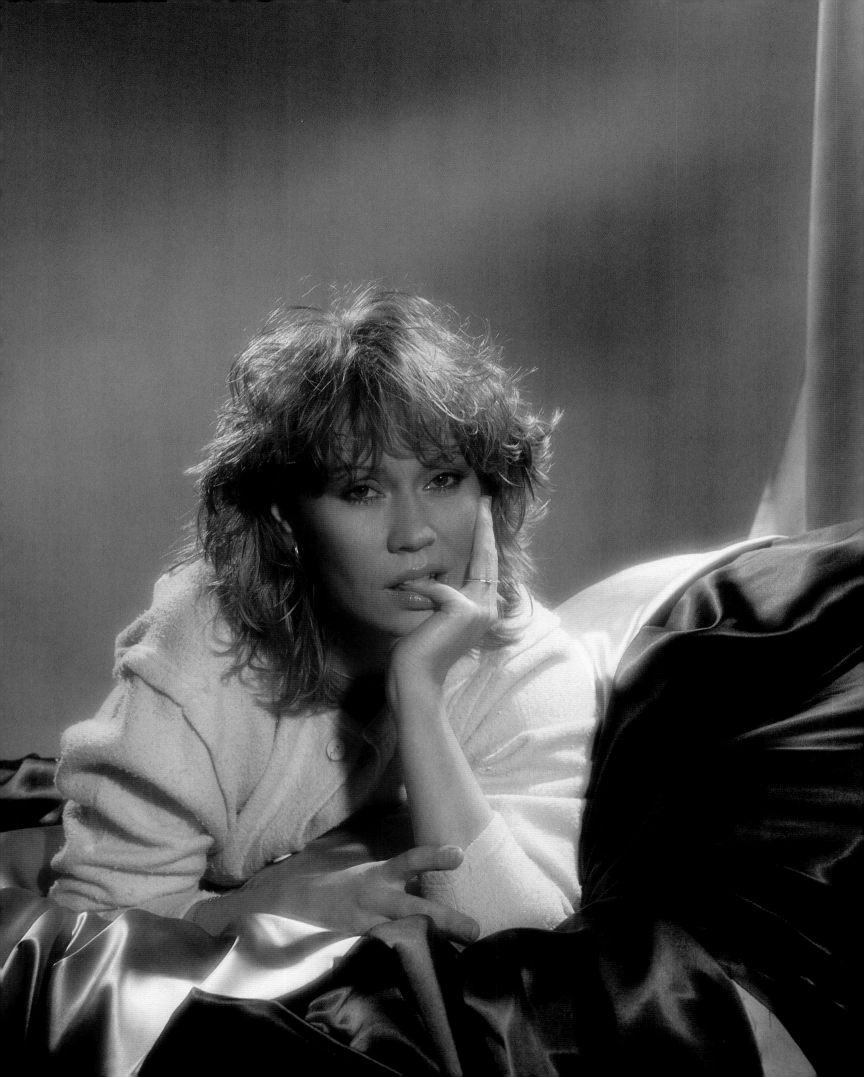

AGNETHA FÄLTSKOG 1983

After spending a decade in partnership with Benny Andersson, Björn Ulvaeus and Frida Lyngstad as the group ABBA – and selling a total of more than 300 million records – Agnetha Fältskog left to pursue a solo career as a singer and actor in 1982. Her second solo album *Wrap Your Arms Around Me* was released in 1983 and reached the UK Top 20 and was followed by two more hit albums before Fältskog retired from public life in 1988. She made a comeback in 2004 – just before the success of the ABBA-inspired stage show *Mamma Mia!* – with the 1960s-inspired hit album *My Colouring Book*, which reached Number 12 in the UK.

"Agnetha was being produced by Mike Chapman, with whom I had worked a great deal in the 70s; and he asked me to come to Sweden to shoot this cover. Agnetha was charming, very sexy and photogenic – we had a lovely session together. When I got home to London, there was a huge bouquet of flowers waiting – a thank-you from her, and a sweet and thoughtful gesture!"

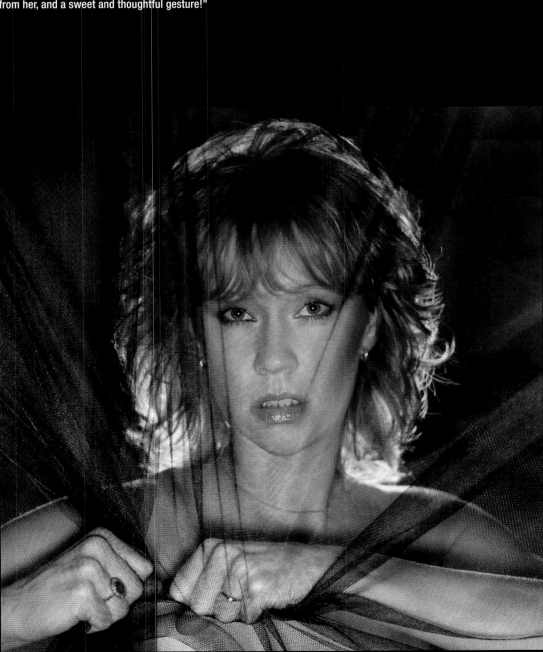

BUDDY MILES 1969

As one of the leading rock and soul drummers, Buddy Miles has played with some of the finest musicians during a career spanning over 50 years. He began drumming in the early 1960s and worked with the Ink Spots and Wilson Pickett before joining Mike Bloomfield and Harvey Brooks in Electric Flag in 1967. A year later Miles formed his own Buddy Miles Express prior to teaming up with Jimi Hendrix in 1968 on the album *Electric Ladyland* and a year later as a member of the Band of Gypsys. After Hendrix's death in 1970, Miles collaborated with Carlos Santana and also made a collection of solo albums.

"Buddy was one of a large group of musicians brought together for an ill-fated television experiment called *Supersession*. As far as I can remember, the idea was to have great artists from different genres of music 'jam' together in the hope that great music would be made. Unfortunately, apart from a couple of 'moments', the result appears to have been just a terrible mess! It was great for me though, as I got to photograph several fabulous musicians as well as Buddy Miles, including Eric Clapton, Buddy Guy, Stephen Stills, Jack Bruce and several others. It should have been fabulous …"

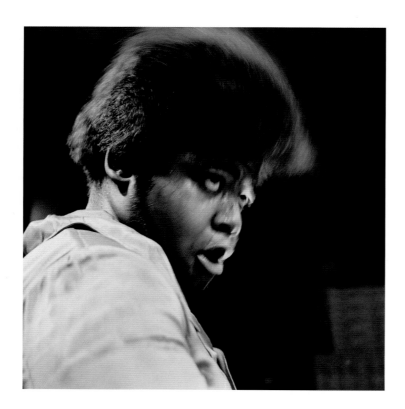

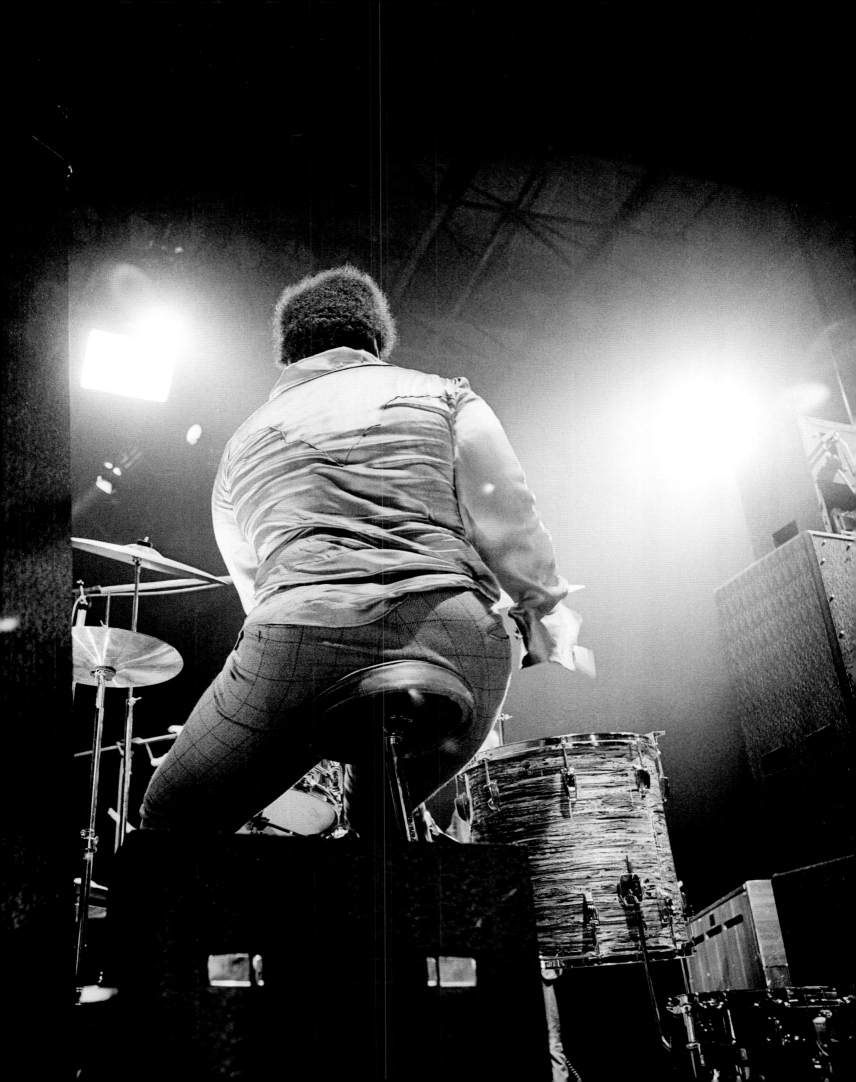

GUY STEVENS 1983

As a successful DJ in London in the 1960s, Guy Stevens had a huge influence on bands such as the Who, the Small Faces and the Rolling Stones, who were fans of his R&B and soul sessions. Born in London, Stevens worked at Island Records and with Pye International – overseeing the UK releases from the Chess label – and produced albums by Mott The Hoople, Free and Spooky Tooth before joining forces with the Clash in 1979 to produce the album *London Calling*. Stevens died in 1981, aged just 38, and as a tribute the Clash wrote and recorded the song 'Midnight To Stevens'.

"I first met Guy when I started taking photographs for Chris Blackwell at Island Records. Guy ran the Sue label for Island and these portraits were done for the cover of *The Sue Story*, for which he also produced the sleeve notes. He was an extraordinary and diverse character whose extensive and passionate knowledge for many different types of music led him to produce many bands including Free, Spooky Tooth and the Clash."

One of Italy's most successful and influential stars of pop and rock, Lucio Battisti released a total of 18 albums during a career that ran from 1966 to his death, aged 55, in 1998. Working as a guitarist, singer and songwriter, Battisti played with a host of Italian bands while his songs were recorded by artists such as The Grass Roots ('Bella Linda'), Amen Corner (('If Paradise Is) Half As Nice') and Tanita Tikaram ('And I Think Of You'). He recorded his English language album *Images* in 1977 and his 1982 album *E già* – photographed by Mankowitz – was one of more than a dozen Italian chart-topping albums.

"This session was for the cover of Lucio's album called *E già*, which was Number 1 in the Italian charts for several weeks in 1982. Lucio was a singer/songwriter and considered to be one of the most important artists in Italian pop/rock music history. He was an extraordinary person and had a dream that gave him the idea for the cover shoot. He had seen a very specific location and asked me to find it! This particular spot on the Welsh coast fitted his vision completely and we had a wonderful, creative and most satisfying day on the beach shooting many different set-ups. I introduced the mirror to try and give the sense of a portal to another world, an idea that appealed to Lucio very much. I was always very proud of the session and was very sad when Lucio died from cancer at only 55 in 1998."

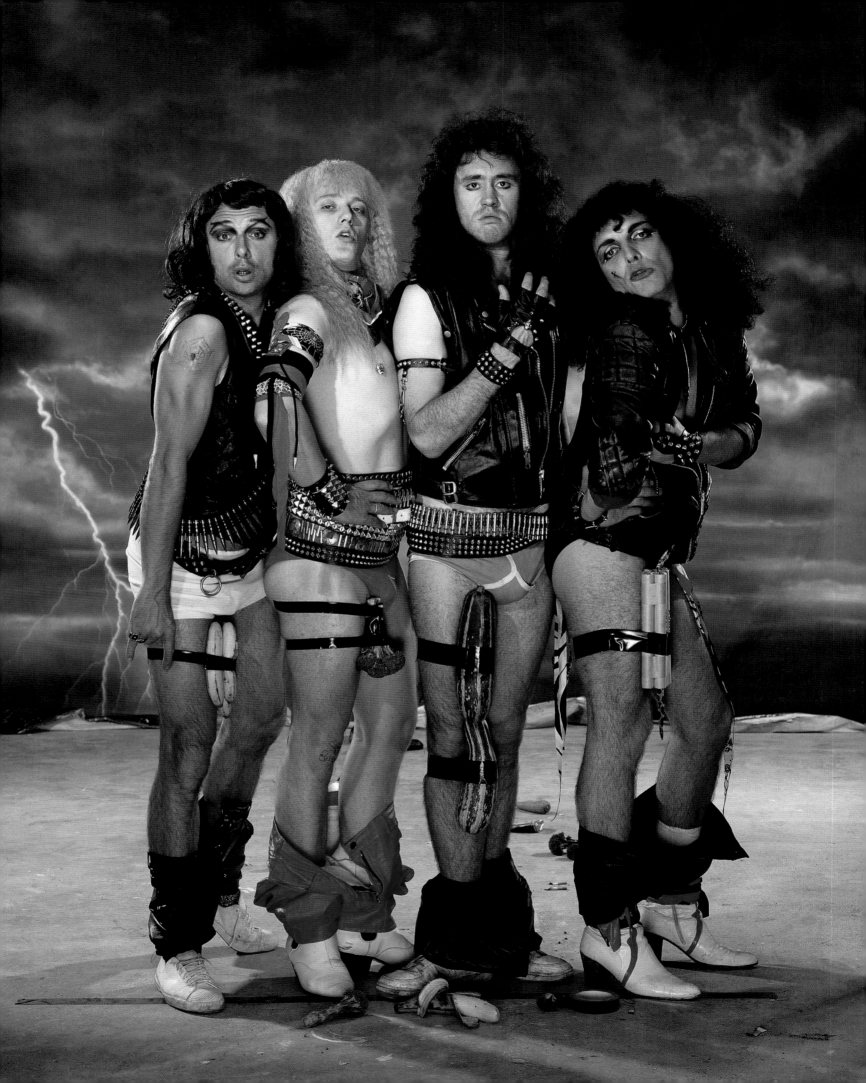

BAD NEWS 1987

The first album from Bad News came out in 1987 and focused attention on the spoof rock band created in 1983 for the Channel 4 TV series *The Comic Strip Presents …* which featured as its members the actors Ade Edmondson (vocalist/ guitarist Vim Fuego), Nigel Planer (rhythm guitarist Den Dennis), Rik Mayall (bass player Colin Grigson) and Peter Richardson (drummer Spider Webb) in an episode titled 'Bad News Tour'. The album was produced by Queen guitarist Brian May and included a version of 'Bohemian Rhapsody', which peaked at Number 44 in the UK chart. Bad News played at the Monsters of Rock festival at Castle Donington as part of a follow-up film *More Bad News*.

"I was asked to shoot the cover for the album and the session was absolutely hysterical. The guys got so involved with their characters that at one point Rick Mayall, who was swigging Jack Daniel's from the bottle in true Rock and Roll style, would respond only if I called him 'Colin'!"

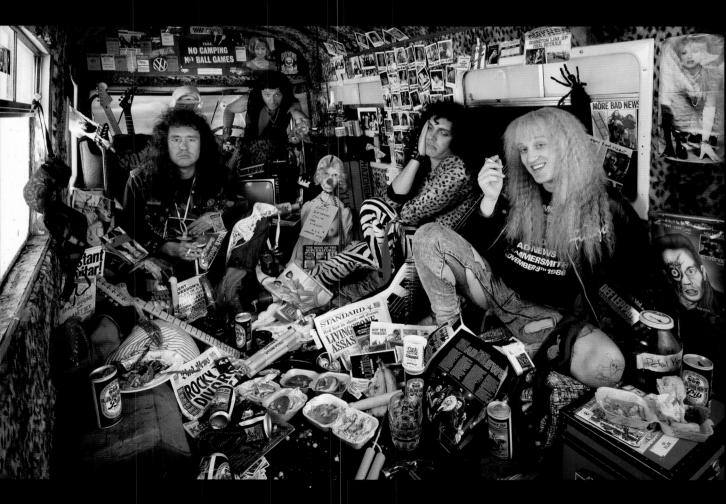

53

BING CROSBY 1977

Bing Crosby made his first record in 1926 as a member of the Rhythm Boys and went to become the 'King of the Crooners' with career sales in excess of 400 million. He went on to appear in films in the 1930s and starred in a series of *Road To …* films with Bob Hope and also in *High Society* and *Holiday Inn,* which featured his biggest ever hit record 'White Christmas'. Released in 1942, it passed the 30 million sales mark and charted for 18 consecutive years. He duetted with David Bowie in September 1977 – when they recorded 'The Little Drummer Boy' – but died a month later although the record became a major hit in 1982.

"Bing Crosby was probably the biggest 'star' I worked with. He had been at the top of his profession for 50 years and was recognized around the globe. Consequently this shoot was shrouded in anxiety and a general nervousness at how to deal with the great man. The idea was to shoot four different portraits representing the different seasons, and we had put together outfits for each one with clothes purchased for the occasion from shops that Bing had personally specified. The tension was very high when he arrived and he appeared sullen and very uncommunicative. I showed him the outfits and asked which one he felt like starting with, to which his response was simply to say 'No'! I was so taken aback that I asked him again, believing that he couldn't have heard what I had said, and he said a definitive 'No' yet again. I then asked what he was saying 'No' to, and he announced that he was in a hurry and he would pose for only a single portrait and he would wear the clothes he came in! I had no choice but to agree and nobody from the record company was prepared to challenge him, so we hurriedly had to select the background 'season' that most suited the outfit he was wearing and proceeded to shoot. I nearly managed to complete a single roll of film before Bing got up and strode out of the room, announcing that if I didn't have it I was never going to get it! He left the studio for the airport to catch a plane to Spain to play his beloved golf, where he died three days later."

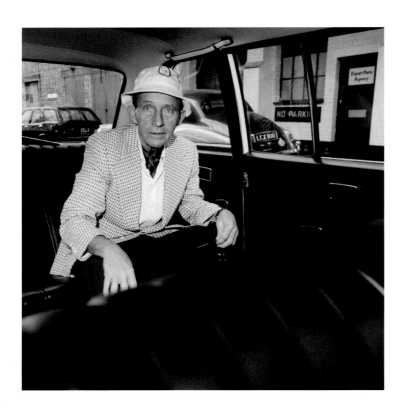

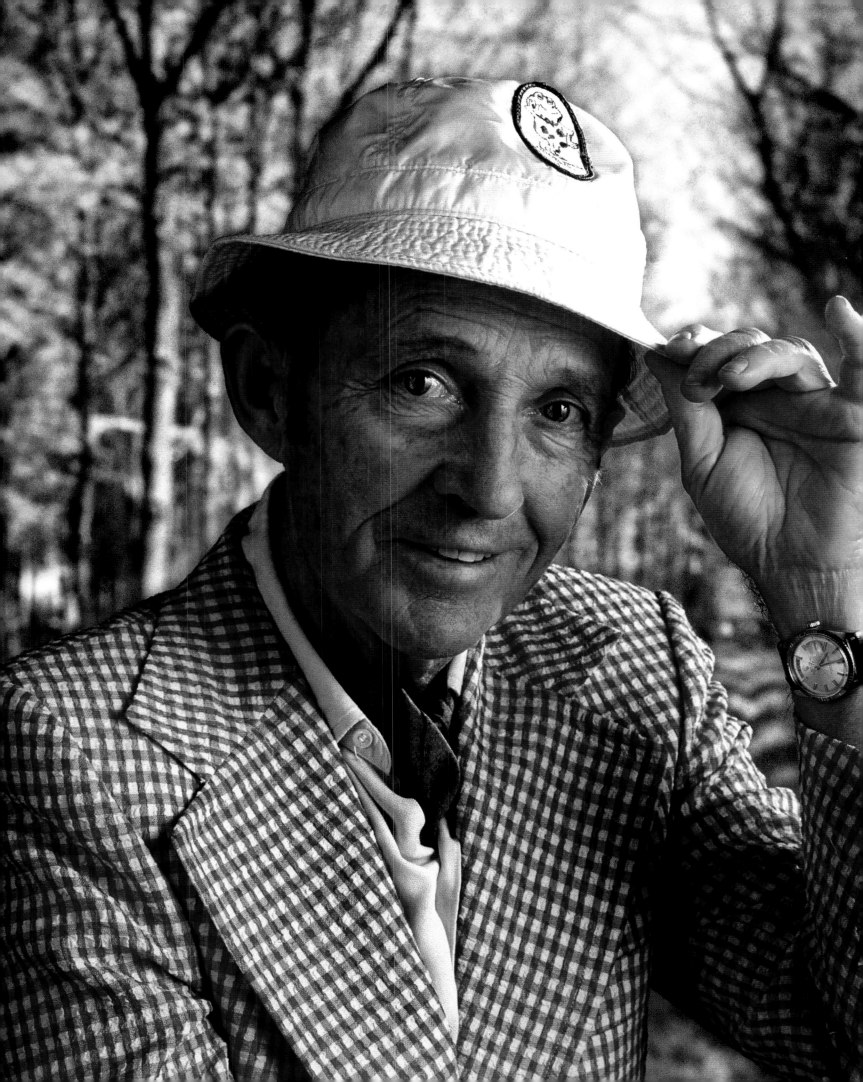

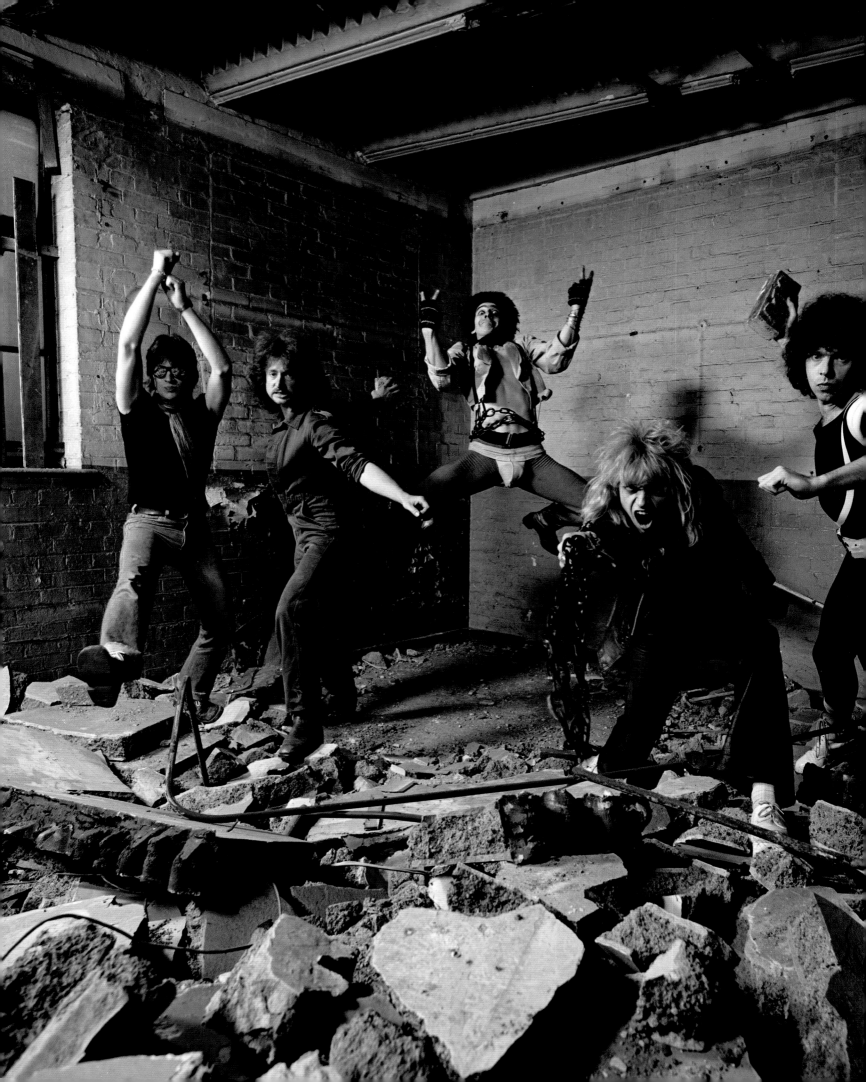

US 1976

d themselves after the gang of street kids
va Express. Featuring singer Gary Holton
Keith Boyce and Cosmo, the glam/heavy
and continued with two more albums –
Mickie Most – before singer Holton, who
sehen, Pet, died in 1985. After a break of
ged in 2002 and, despite various changes

his RAK Records and asked me to come
vent. The band had quite a reputation for
be amusing to shoot them in a completely
or above my studio in Soho was deserted
d took to the idea and made a terrific job
m, with singer Gary Holton in particularly

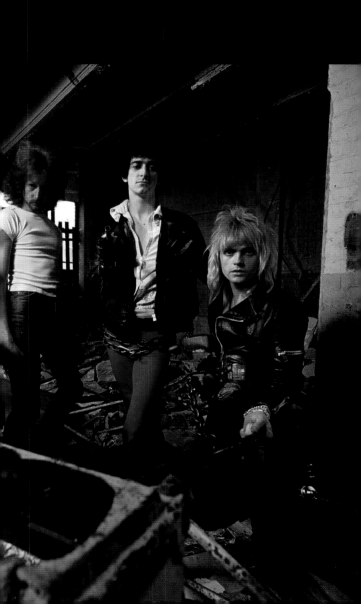

...s-born Françoise Hardy was a leading actress, model, musician, song write
...d multi-lingual vocalist during the Swinging 60s, when she was France's best-
...lling singer. She reached the UK chart with three singles in the early 1960s – with
...l Over the World' reaching the Top 20 – while her releases in French and Italian
...ought her huge hits. She appeared in a number of films produced by Roger Vadim
...d also provided music for a number of other films before collaborating with Blur
... the 1994 single 'To The End (La Comedie)'. Hardy returned to the studio to make
...comeback album in 2000.

...1 1966 I was asked to go to Monte Carlo for a few days to shoot some portraits o
...e stars of the film *Grand Prix*, including the delightful Françoise Hardy. She was
...ther reserved but incredibly pretty and very French!"

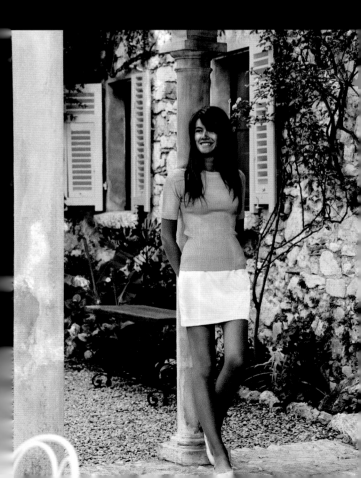

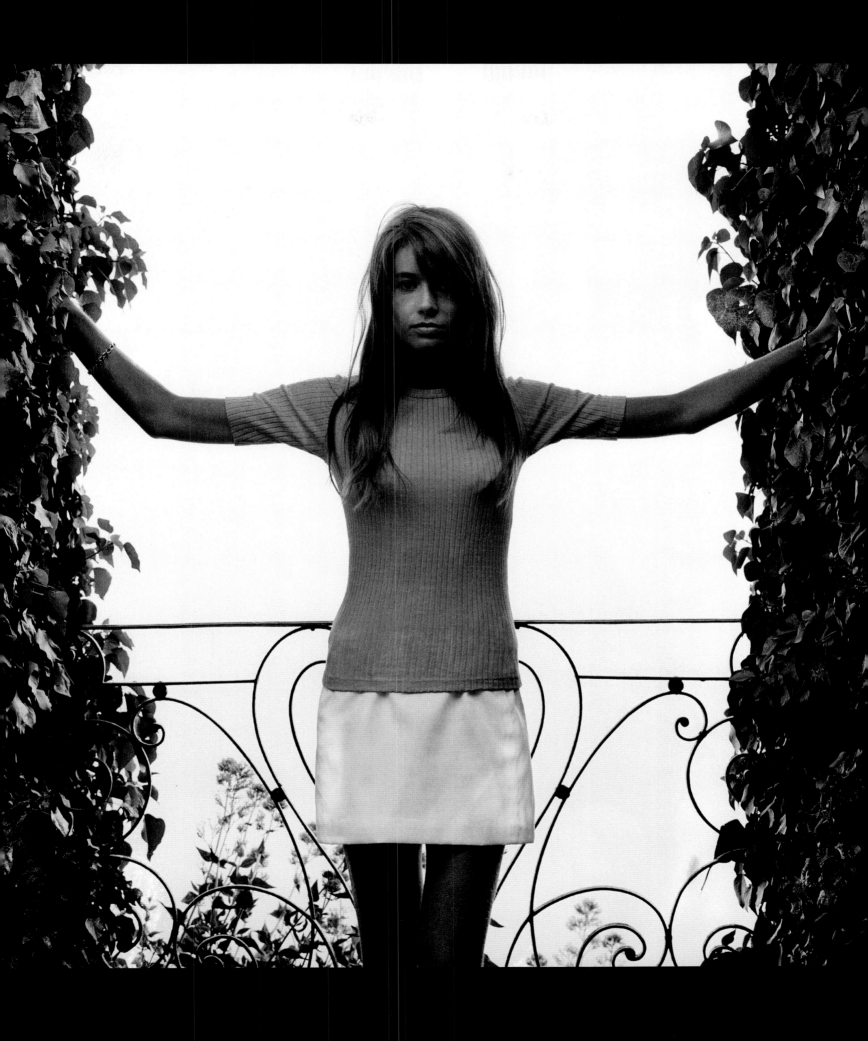

ELKIE BROOKS 1973

After working with big bands led by Eric Delaney and Humphrey Lyttelton during the 60s, Elkie Brooks moved on to join the rock/blues outfit Vinegar Joe in the early 1970s where she shared vocals with Robert Palmer until the band broke up in 1974. Her solo career took off in 1977 with the hit single 'Pearl's a Singer', which was followed by a series of chart singles and albums, including the Top 10 hits *Pearls* and *Pearls II.* Cited as the "bestselling female album artist in UK in the past 30 years", Brooks has continued to tour and in 2010 she released her twentieth album.

"Elkie and Robert were in a band called Vinegar Joe and had a tremendous sexual electricity on stage which I wanted to try and present in my portrait of them. I went on to work with Elkie as a solo artist on several occasions, including the single sleeve for her big hit 'Pearl's a Singer'. I last photographed her in 1999 and she was as magnetic and exciting as ever!"

CHRIS FARLOWE 1965 TO 1967

From his early beginnings as an acclaimed skiffle singer and then leader of beat group the Thunderbirds, Chris Farlowe became one of Britain's leading soul and blues singers. He was signed to the Immediate label by Andrew Loog Oldham in 1965 and reached Number 1 in the UK chart a year later with 'Out Of Time', which was written by Rolling Stones Keith Richards and Mick Jagger, who also produced the single. After four more minor hits, Farlowe moved on to join various bands including Hill, Colosseum and Atomic Rooster before re-uniting with the Thunderbirds in the mid-1980s.

"Chris Farlowe was one of the mainstay artists of Andrew Oldham's Immediate label, and I photographed him on several occasions. He had a marvellous voice but was a challenge to photograph as he wasn't particularly photogenic and Andrew was always asking me to find different ways to portray him, hence the long-distance, grainy and atmospheric location shots that were taken in Islington, north London."

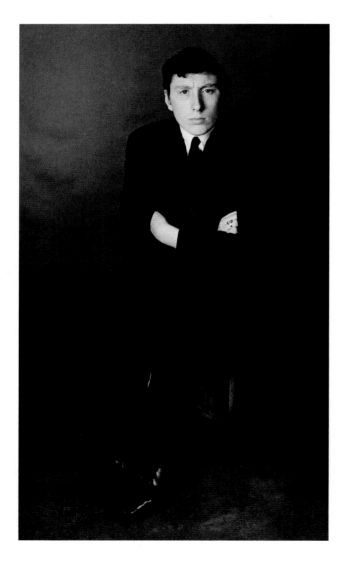

JOOK 1973

Four young men who termed themselves as "rudies" rather than skinheads were brought together in 1972 to form the band Jook, who took their name from the lyrics of Gene Chandler's hit 'Jook (Duke) of Earl'. In their uniform of sports shirts, braces and boots – plus cropped hair – Trevor White, Ian Kimmett, Ian Hampton and Chris Townson released their first single in 1972 and issued four more before the group eventually split in 1974, when White and Hampton joined forces with the Mael brothers in the American group Sparks, who were managed by the man who had created Jook.

"Jook were a great bunch of guys. I really liked their image and they had great attitude – I believe it was the first time anybody had used the 'Rule OK' graffiti in a music image, and they responded to the moody lighting with some great looks. Unfortunately they just couldn't get a hit and their career dissipated after three years or so."

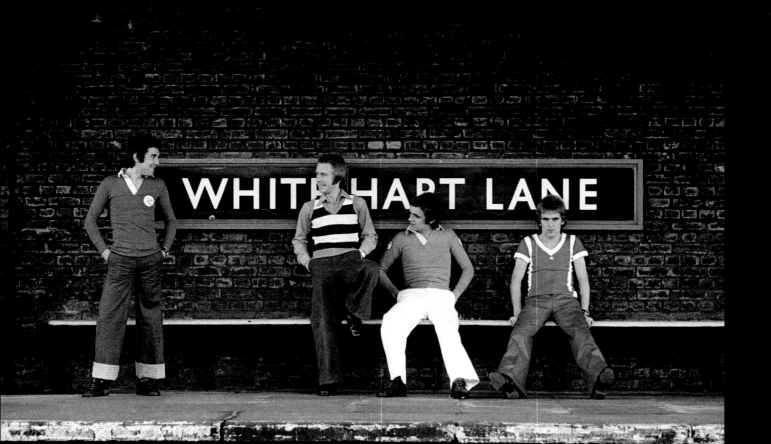

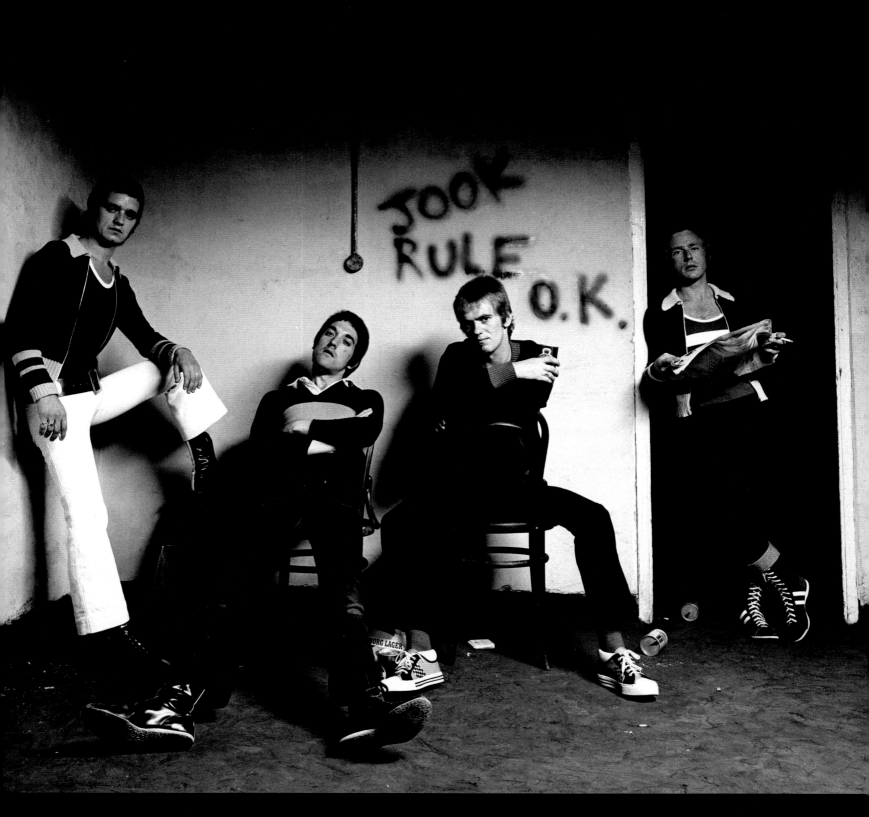

HAZEL O'CONNOR 1980

Hazel O'Connor's performance as Kate in the 1980 film *Breaking Glass* brought her critical acclaim and a Top 5 single with 'Eighth Day' from the film's soundtrack album, which also included her hit 'Will You'. The role earned her a Variety Award as Best Film Actor and a BAFTA nomination. The former teacher and model turned punk singer and songwriter had only minor chart success in the early 1980s. As an actor O'Connor made appearances on TV and stage before returning to the studio in 1997 to make the first of a number of albums, which she promoted with appearances at the Glastonbury Festival and around the UK.

"I had been asked to shoot a calendar for top rock and roll transport company Edwin Shirley Trucking. Typically they wanted girls and I was obligated to include several nudes in the project, but I was also able to include various other shots that related to music and which I hoped would be more interesting! I had met Hazel and was working on her tour book when I came up with the idea of setting up a 'gig' in one of Edwin's trucks and invited her to be the 'performer'. She got into the spirit of the enterprise and we got some great shots …"

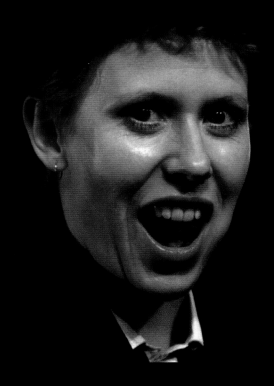

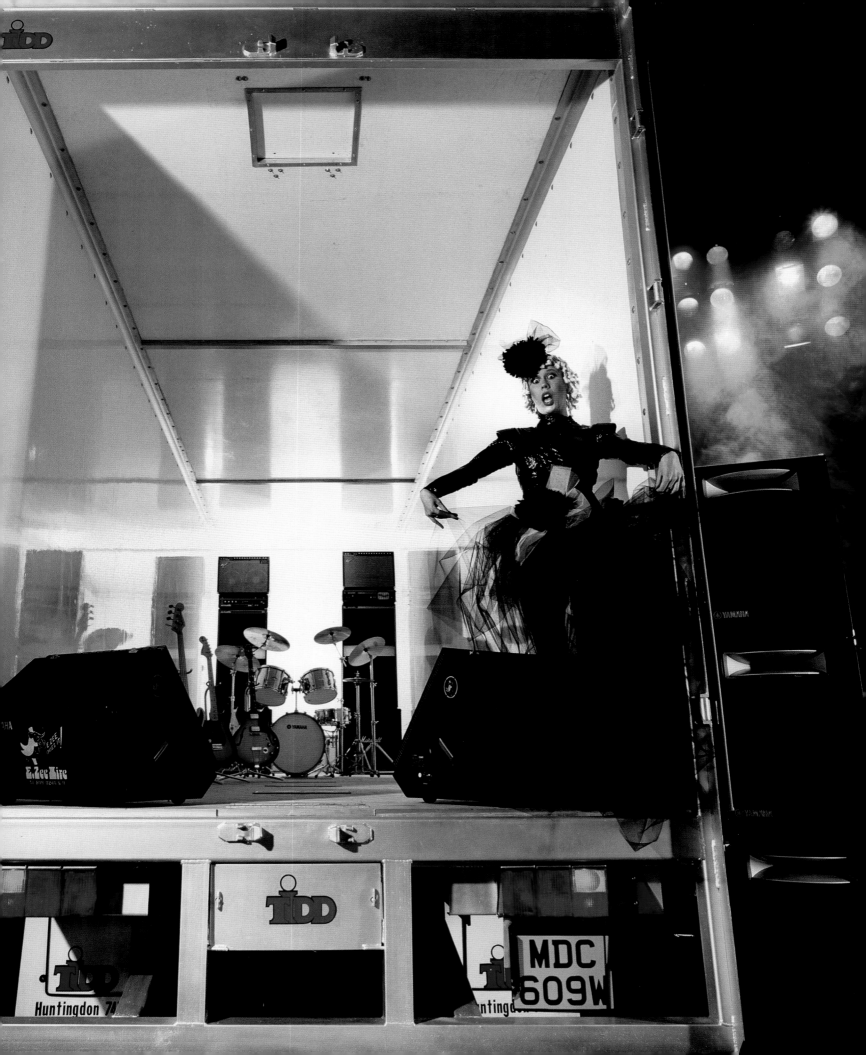

BUDDY GUY 1969

When Mankowitz captured Buddy Guy on camera in London in 1969, the Louisiana-born blues guitarist was firmly established as one of the most influential musicians of his generation. In 1957, at the age of 21, he burst on the Chicago club scene and signed for the Chess label a year later. He teamed up with harmonica player Junior Wells and they worked together throughout the 70s and 80s before a blues revival in the 1990s brought Guy his first UK chart success and saw musicians such as Eric Clapton, Jeff Beck, Mark Knopfler, Bonnie Raitt and Paul Rodgers appearing on his albums.

"These shots were taken during the filming of a television spectacular called *Supersession*. The idea was that various musicians from different genres of modern music would come together and 'jam', creating several 'super groups' in the process. Unfortunately the result was disappointing, and apart from a few highlights was generally accepted as a failure. Of course, watching Buddy Guy was a treat and I was very pleased to have the opportunity of photographing him."

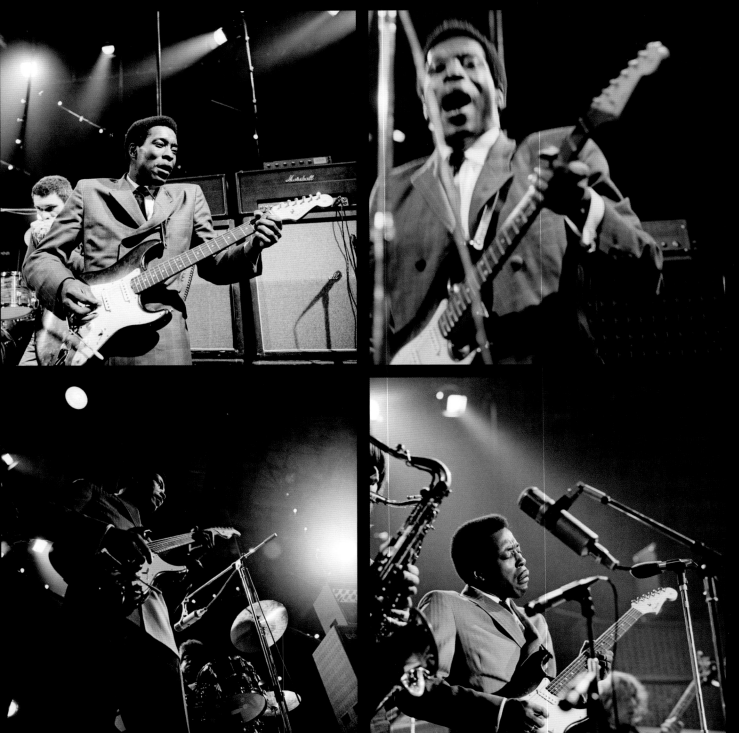

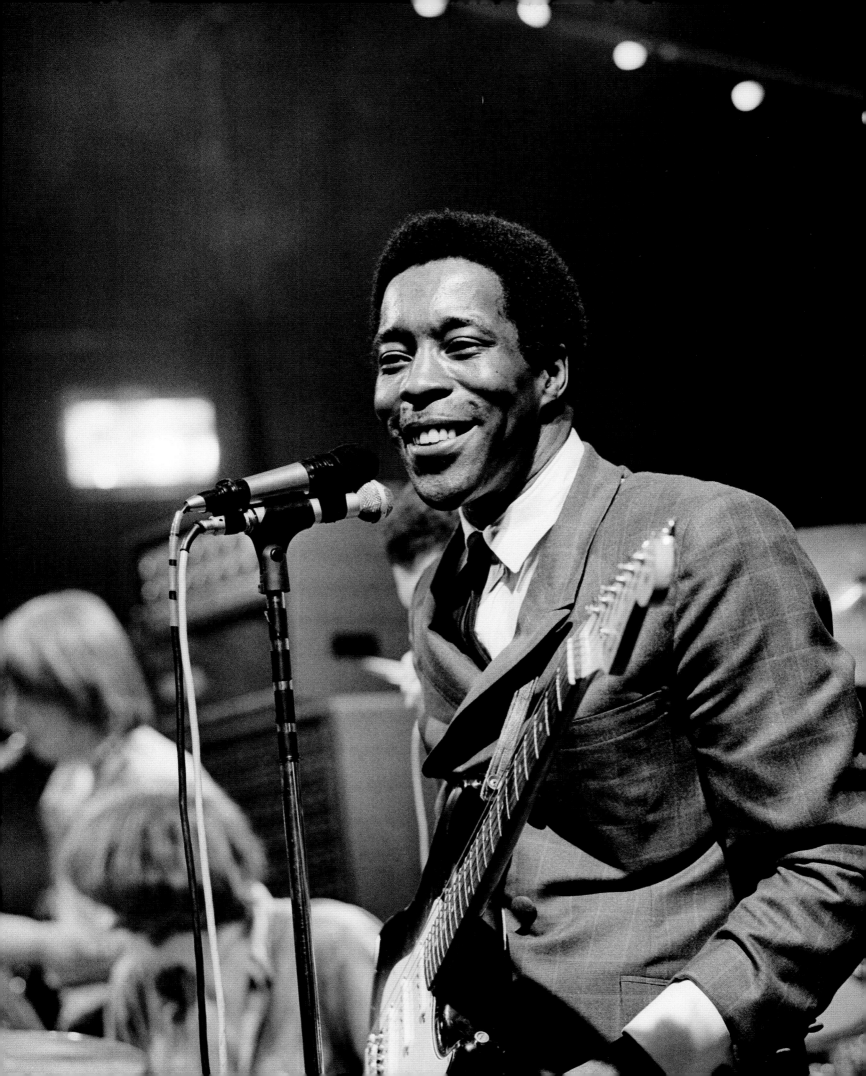

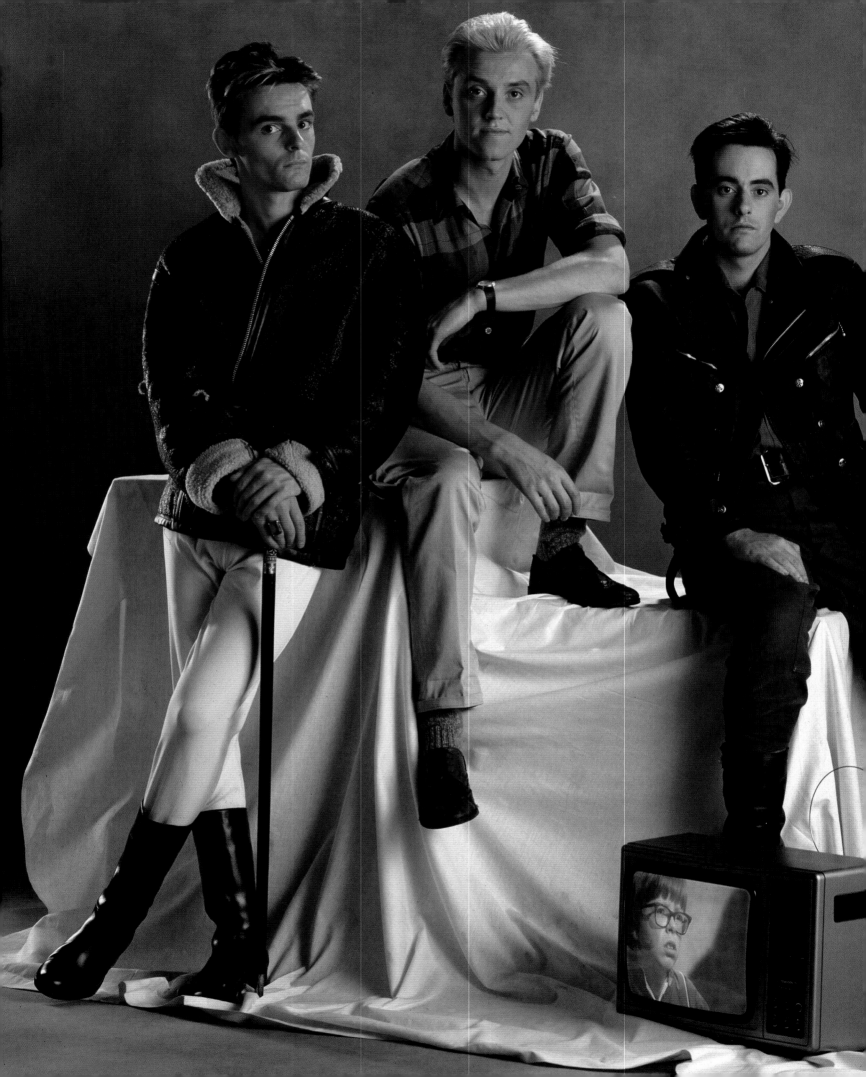

HEAVEN 17 1984

The trio of Glenn Gregory, Ian Craig Marsh and Martyn Ware formed Heaven 17 – named after a band in *A Clockwork Orange* – in 1980 and over the following seven years notched up 11 UK hit singles – including the Top 10 hits 'Temptation' and 'Come Live With Me' – plus three Top 20 albums. The electronic pop trio co-existed with their British Electric Foundation, which was involved in a series of projects involving guest artists such as Sandie Shaw and Tina Turner. By the mid-1980s Marsh and Ware focussed on production work although Heaven 17 returned with a final collection of new material in 1987.

"High camp, low fashion, British New Wave Synthpop – great look with a touch of film noir! I have no idea what the TV is all about but remember that it was important at the time …"

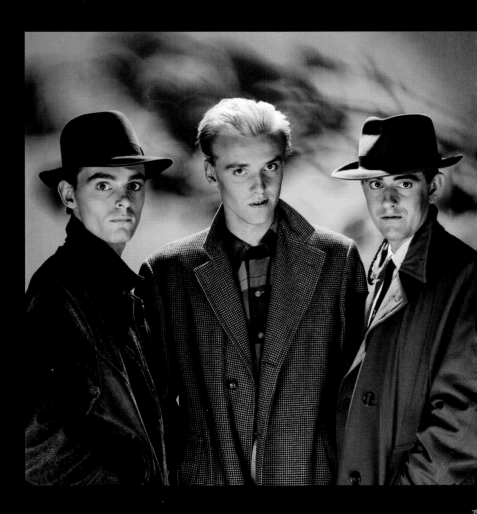

TOURISTS 1979 TO 1980

The duo of Dave Stewart and Peet Coombes eventually launched the Tourists in 1977 after travelling from Sunderland to London, meeting Scottish singer Annie Lennox, forming and recording as the Catch before finally recruiting Eddie Chin and Jim Toomey to create a new five-piece band. Between 1979 and 1980 the Tourists released five hit singles – including the Top 10 hits 'I Only Want To Be With You' and 'So Good To Be Back Home' – and three albums. The group disbanded in 1980 during a tour of Australia and in the midst of poor reviews and internal wranglings.

"The Tourists had just had their biggest UK chart success with the Dusty Springfield song 'I Only Want To Be With You' and Annie Lennox was the talk of the town, with her amazing chameleon looks and extraordinary voice. They were a very creative unit and the session was frenetic and productive. The cover for their second album *Reality Effect* was a little different. The idea was really simple – I built a dining room set where everything was pure white and the band would wear white outfits in individual styles. They would then slowly add colour from bottles of non-toxic kids' paint in a controlled way. Unfortunately Peet and Eddie had taken a tab of acid and forgot my instructions, hurling the paint quite randomly across the set and the other members of the band! All I could do from my perch 12 feet above the set was to try and stop them at various intervals and get my shots. As it happens, the Jackson Pollock madness was far more interesting that the original concept!"

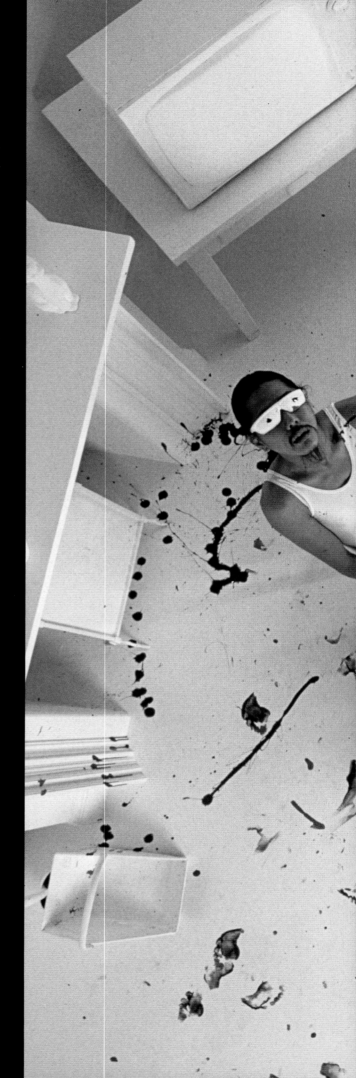

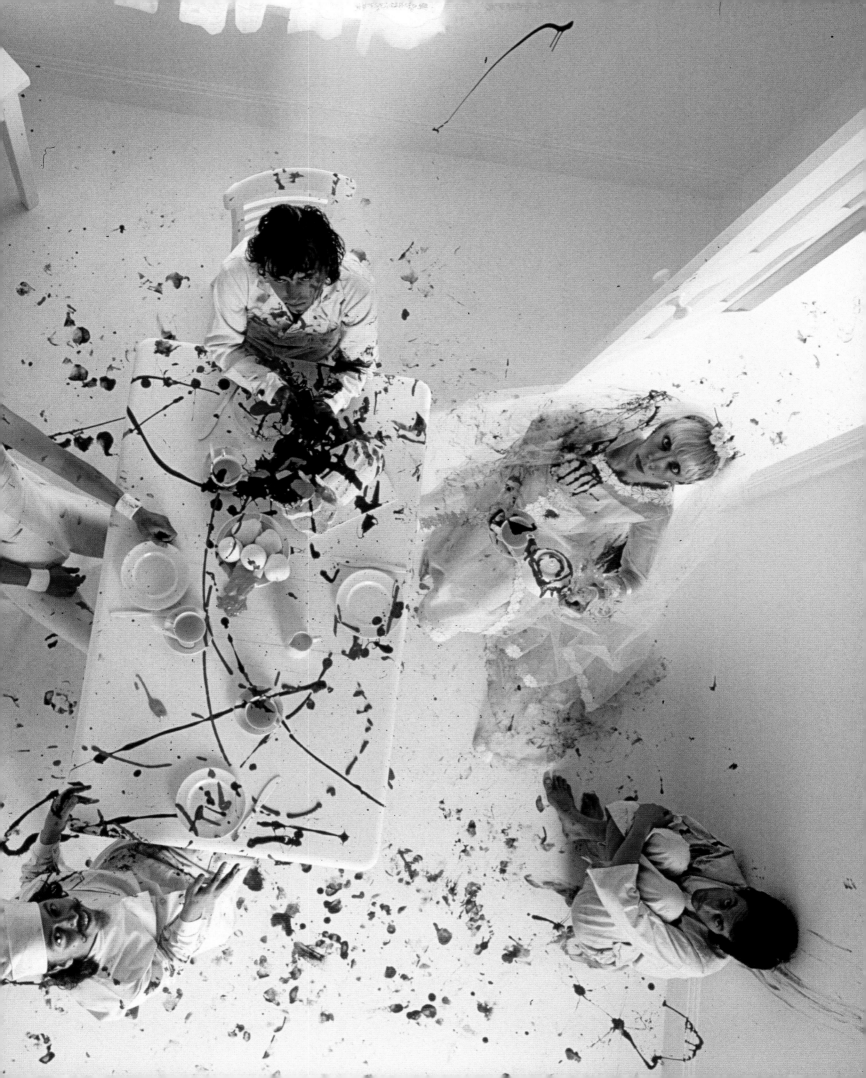

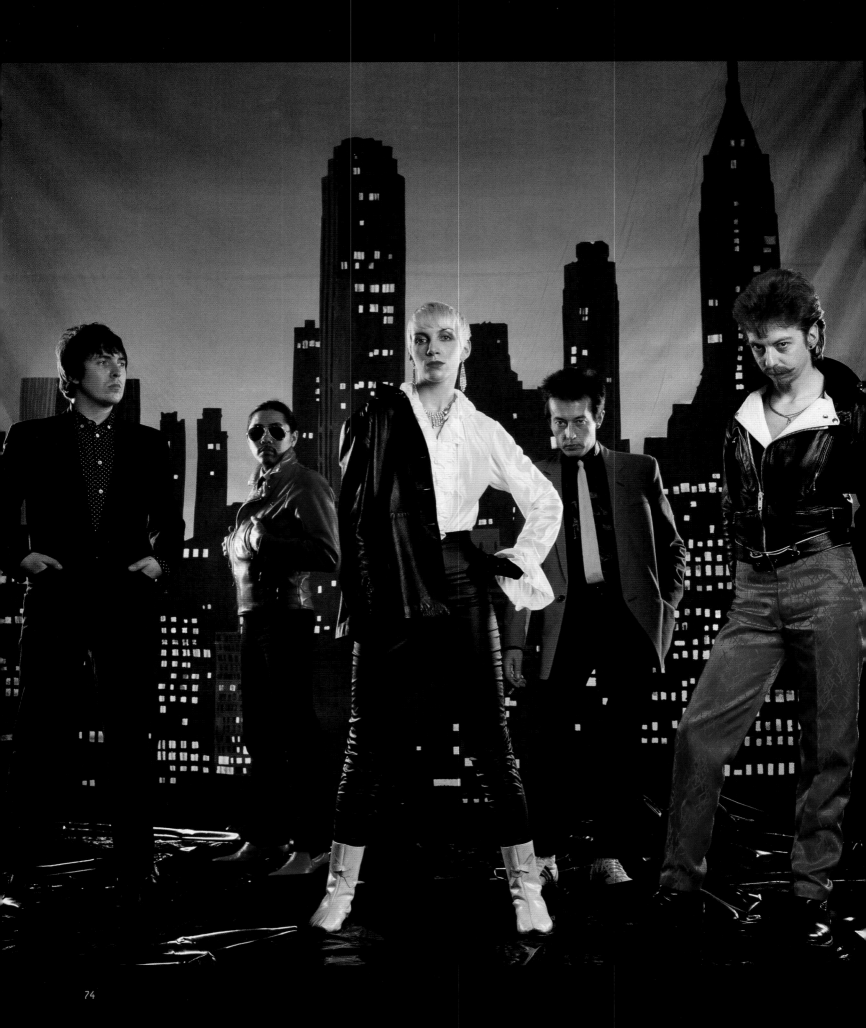

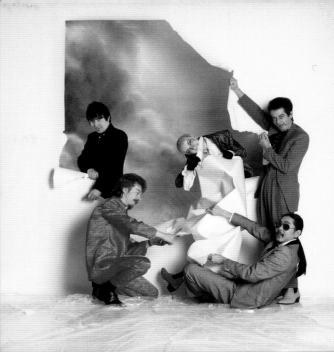
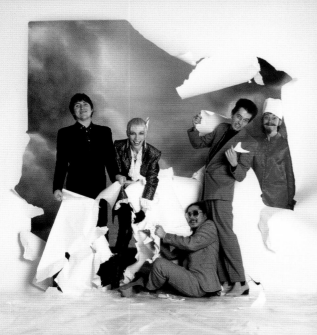
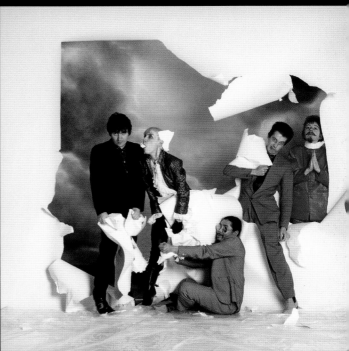
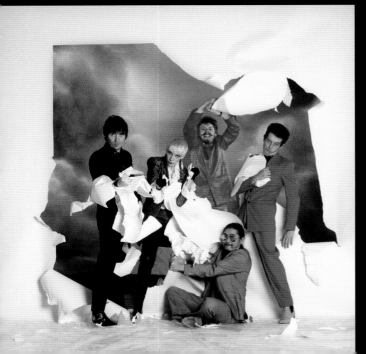
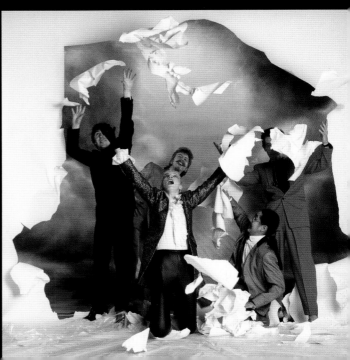

EURYTHMICS 1981 TO 1986

After the demise of the Tourists, the re-named David E. Stewart and Annie Lennox emerged as Eurythmics and took their name from a form of mime and dance dating back to the 1900s. Their debut album *Sweet Dreams Are Made Of This* – and the title track single – were both Top 10 hits in 1983 and during the following seven years Eurythmics released more than 20 hit singles and eight chart albums. From 1990 onwards Stewart involved himself with a host of projects while Lennox, after taking a two-year sabbatical, returned as a highly successful, award-winning, solo artist and notching up a further ten hit singles and two chart-topping albums.

"By the time the Tourists broke up I had become good friends with Annie and Dave and they asked me to shoot with them as Eurythmics. In the first year or so they could only get a record deal for one single at a time and I did the first couple of sessions with them on a speculative basis, hoping that they would get a release. The rest is pop music history! I loved working with them and adored their music – Annie was glorious in front of the camera and Dave was the perfect visual foil. My last session with them was for the *Revenge* cover and was shot in Paris. After I delivered the session Dave told me that they were going to have a painting made of one of the shots for the final cover. I was terribly disappointed and we never worked together again."

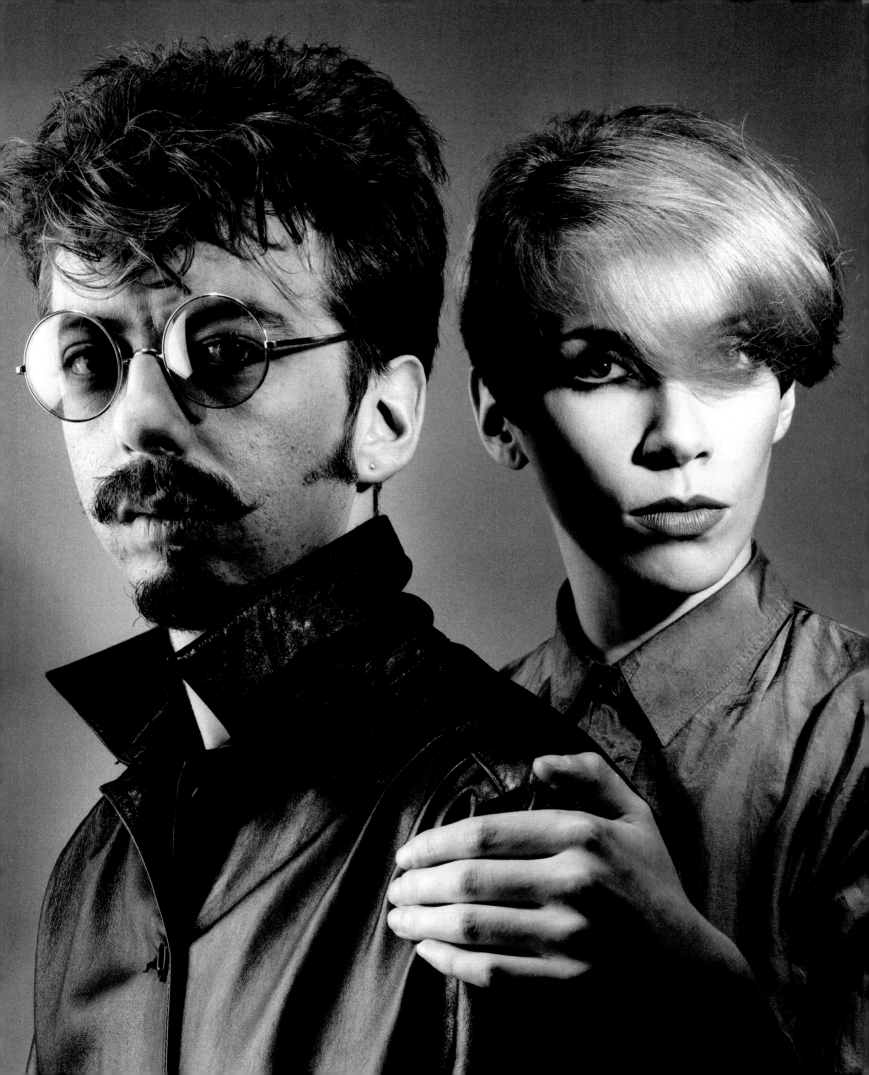

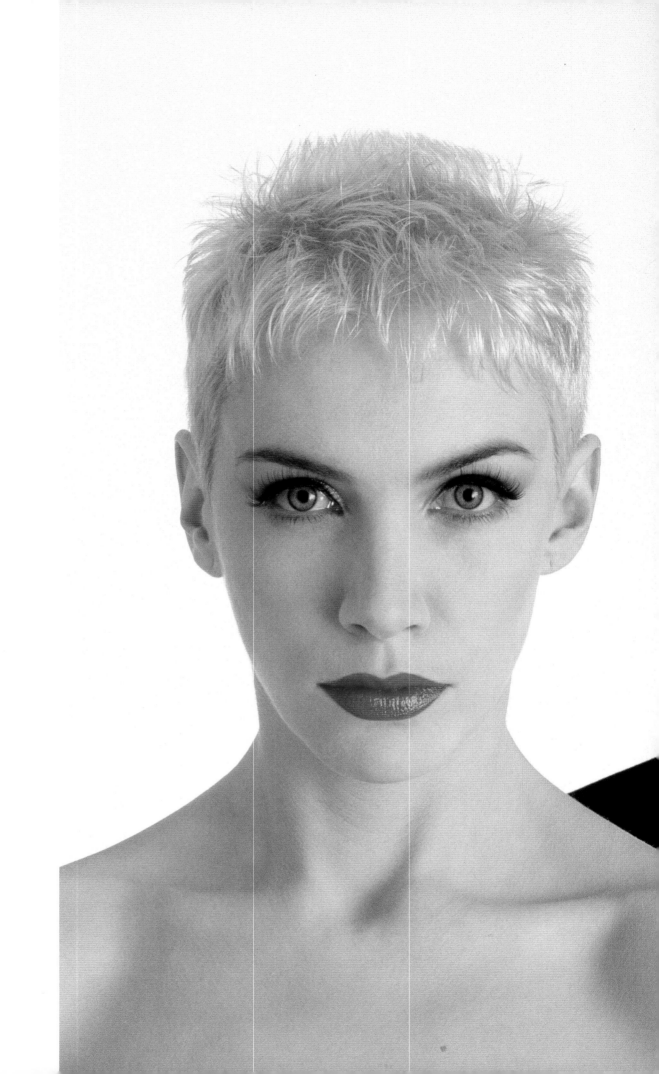

...aphed him for a new album cover – Donovan had
...nings as Britain's version of folk hero Bob Dylan.
...writer broke into the flower power scene of the
...0 singles, including 'Catch The Wind', 'Sunshine
... addition to major tours and appearances at folk
...the Beatles for their live TV broadcast of 'All You
...ndia with them to spend time with the Maharishi

...uential voices of the 60s British scene and I had
...e mid-60s, but didn't get to work with him until
...alled *Donovan File* and saw him working with
...en involved with all the most important records
...d had started his RAK label, which I had worked
...was always charming and had brought one of his
...t her into a few of the shots!"

PAULA YATES 1995

Welsh-born Paula Yates spent time as a journalist, model and singer before emerging as the host of Channel 4's controversial TV music show *The Tube* in 1982, where she teamed up with former Squeeze pianist Jools Holland. Together they appeared on the show until 1987, during which time Holland returned to Squeeze before finally departing in 1990 to focus on a career in television. After *The Tube* Yates moved on to become a presenter on *The Big Breakfast* on Channel 4, marry Boomtown Rats' leader Bob Geldof and finally enter into a relationship with INXS singer Michael Hutchence. In 2000, five years after publishing her autobiography, she was found dead.

"I adored Paula – she was fun, bright, funny and gorgeous! I did a couple of sessions with her and Jools for *The Tube* TV show which they presented and then photographed her for the launch of her autobiography in 1995."

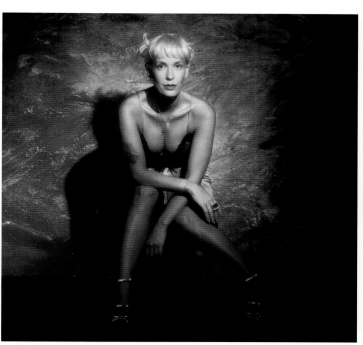

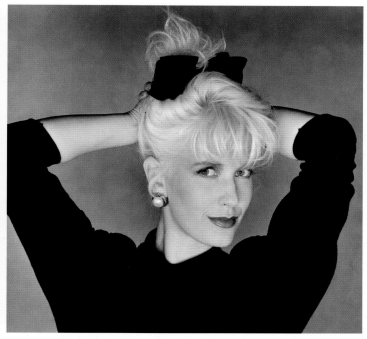

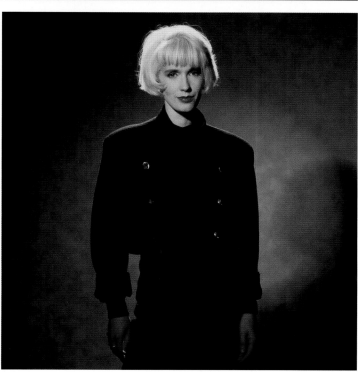

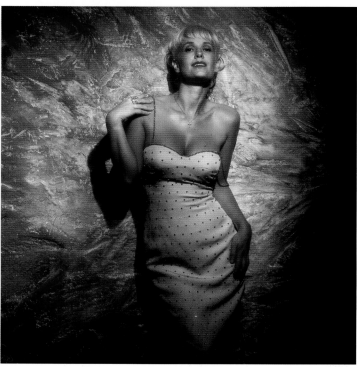

GEORGE HARRISON 1981 TO 1986

George Harrison had been a successful solo star for over 20 years by the time he released *Cloud Nine* – his tenth album without the Beatles – in 1987. Released on his own Dark Horse label, the album hit the Top 10 in both the US and the UK and featured his second American Number 1 single 'Got My Mind Set On You'. Harrison, who died in 2001, was also a member of the Traveling Wilburys alongside Bob Dylan, Jeff Lyne, Roy Orbison and Tom Petty.

"I had met George on several occasions but had never photographed him. Therefore I was delighted when the art director and my dear friend David Costa asked me to shoot the *Cloud Nine* cover. We shot in my studio in Hampstead and had decided that we would use several painted backgrounds of various cloudy skies, as well as a huge textured canvas. George arrived by himself without any entourage and was a wonderful and most patient subject, as I had decided to shoot on the rather slow and laborious large format camera. He regaled us with tremendous, funny and occasionally filthy Liverpool stories over lunch and involved himself with all aspects of the shoot. The heroic, 'man in black' portrait was influenced by one of the cowboy heroes from my childhood called Paladin!"

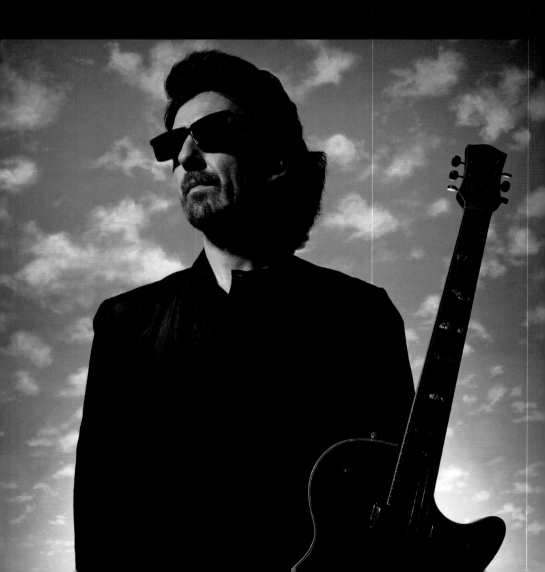

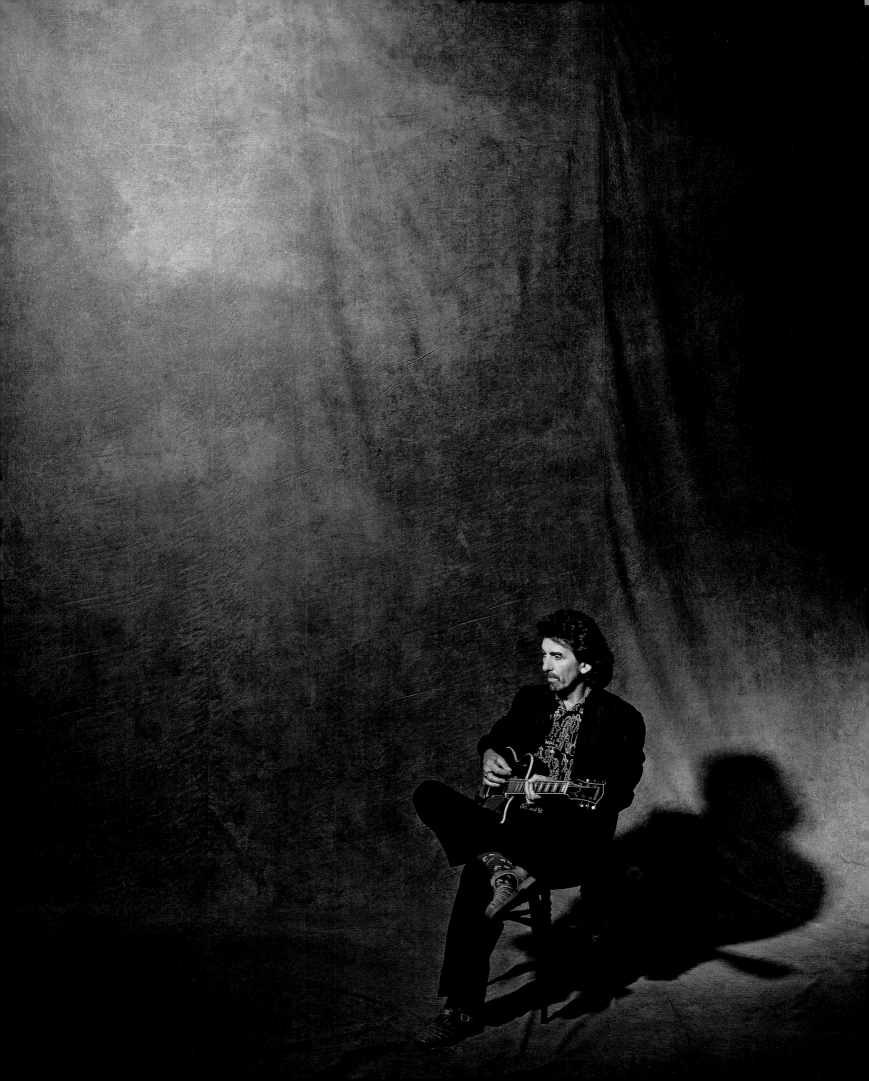

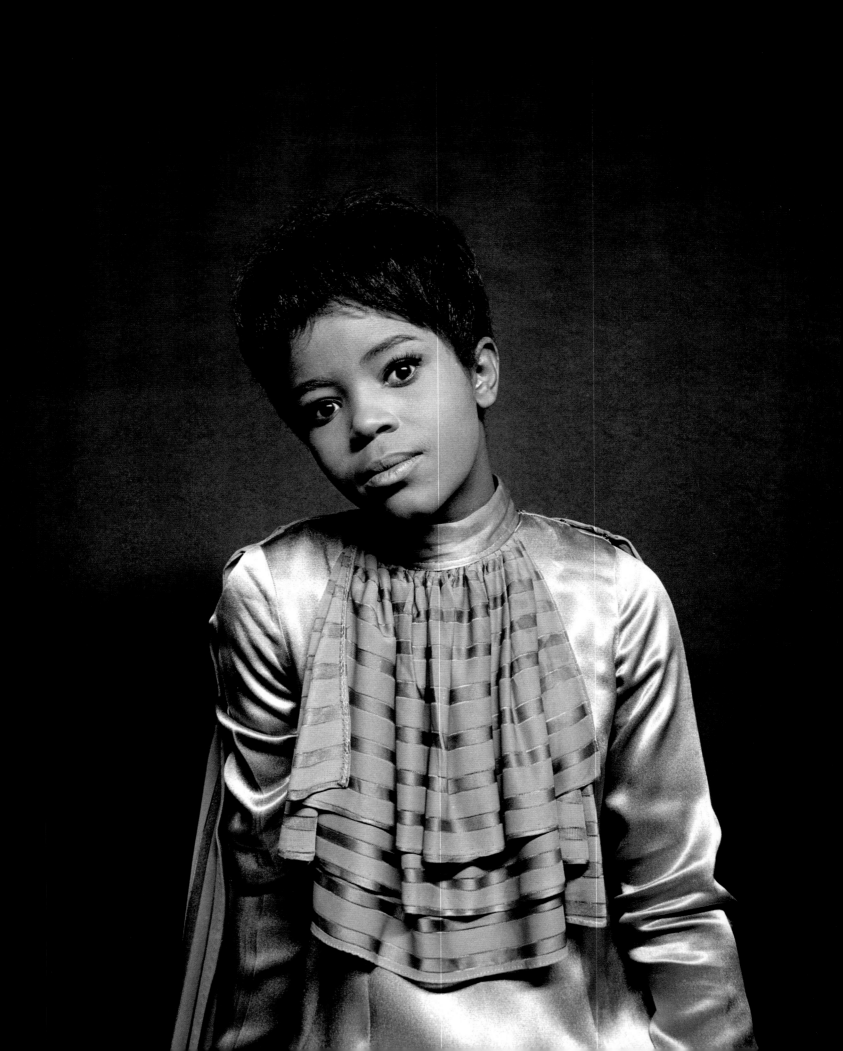

PP ARNOLD 1966 TO 2006

Born in Los Angeles, Patricia Arnold began her career as a member of the Ike & Tina Turner Revue before arriving in London in 1966 and beginning a new career under the name P.P. Arnold. Her first hit was 'The First Cut Is The Deepest' in 1967 and launched her as an in-demand vocalist touring and recording with acts such as the Small Faces, the Nice, the Who, Jimi Hendrix, David Bowie and Eric Clapton. After appearing on stage in the musical *Starlight Express,* she scored a second Top 20 hit in 1988 with 'Burn It Up' and continued to work with the likes of Roger Waters, Ocean Colour Scene and Oasis.

"Patricia Arnold came over to the UK as one of Ike & Tina Turner's Ikettes to tour with the Stones in 1966. Everybody adored her and was knocked out by her tremendous vocal talent, particularly Mick Jagger, who pursuaded her to leave the Ikettes and sign to Immediate Records as a solo artist. One evening in the recording studio the question of a stage name came up and I suggested just using her initials and so Pat became P.P. for ever more! She has been a dear friend since then and I have photographed her throughout her long and eventful career."

THE CHI-LITES 1977

Between 1971 and 1976 American soul vocal group the Chi-Lites released eight UK chart singles, including 'Have You Seen Her' – a Top 3 hit in both Britain and the US – and 'Oh Girl', the group's only US Number 1. Formed in 1960 – and known as the Chanteurs and Marshall and the Hi-Lites before becoming the Chi-Lites – the five harmony singers were at the peak of the 70s sweet soul boom. Despite changes in their line-up, which involved lead vocalist Eugene Record leaving and returning, the group continued to record and tour and had their final UK hit in 1983.

"This session was for the album called *The Fantastic Chi-Lites,* and they really were! I didn't get the opportunity to work with a lot of American artists, but this was one of those rare occasions and I was delighted to work with a band that had such an extraordinary history and one whose music I had always enjoyed. Their energy was fabulous and their look was quite amazing with the oddest disco outfits one could imagine – everything one hoped for in a band of their type!"

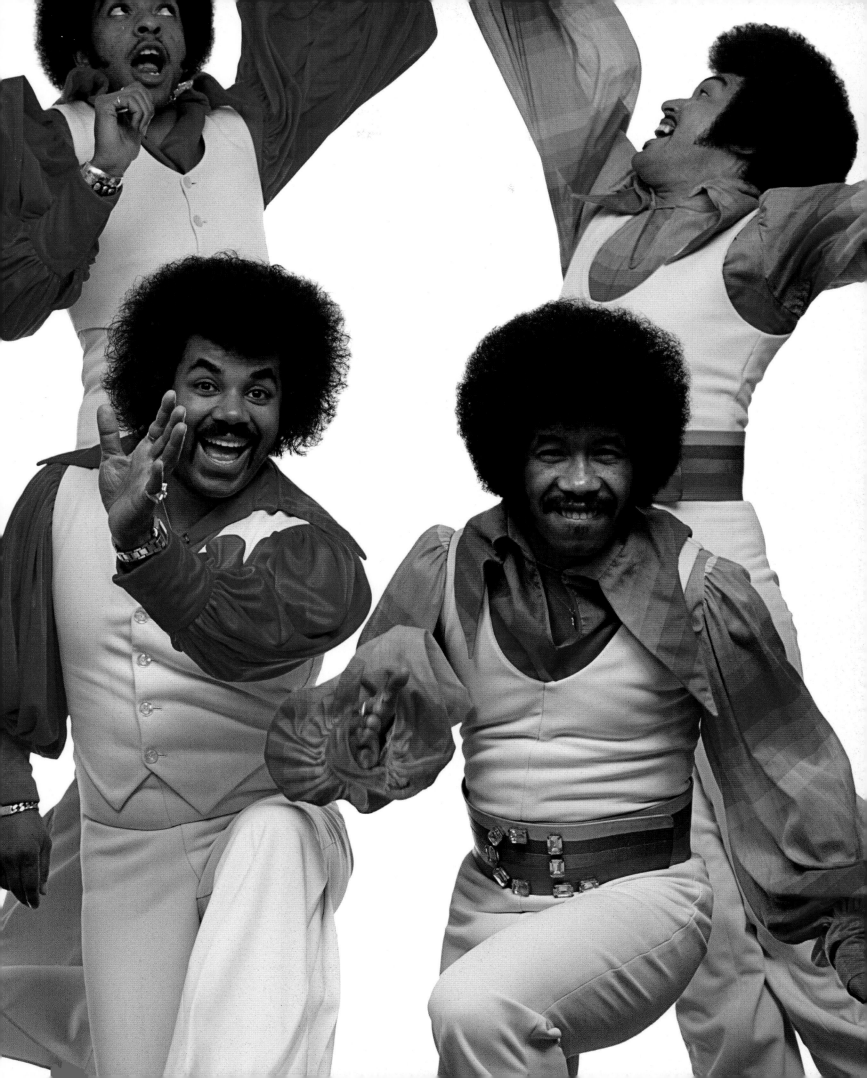

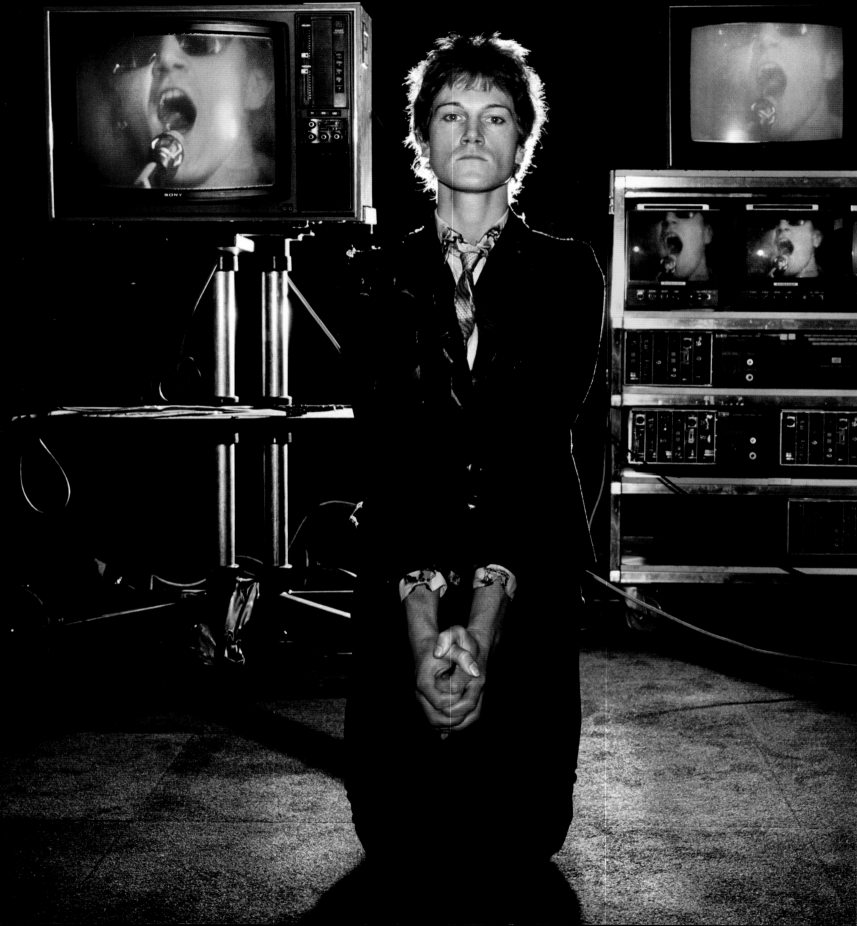

ULTRAVOX 1976

John Foxx founded a band called Tiger Lily with Chris Cross in 1973 before recruiting Warren Cann, Steve Shears and Billy Currie into the line-up which first appeared as Ultravox in 1976, when they were photographed by Mankowitz. With Roxy Music's Brian Eno on board as producer, the band released their debut album in 1977 and issued two more before Foxx finally split from the band in 1979 and was replaced by ex-Rich Kids member Midge Ure, who led the band on their 1980 Number 2 hit 'Vienna' and on six Top 10 albums, including their final release *U-Vox* in 1986.

"I was feeling pretty uncertain of my career as punk took over the world and was delighted when Island Records asked me to work with John Foxx and his band Ultravox! They were great to look at and John Foxx was very creative and worked hard to get his image just right. It was exciting to use some different techniques to try and get the shots that would catch the feel of the band that John had imagined, in spite of the obvious tensions that existed within the group. I had the neon sign made and we did the shots at Island Records' studio, where we were able to utilize the state-of-the-art video equipment for the 'I Want To Be a Machine' portrait."

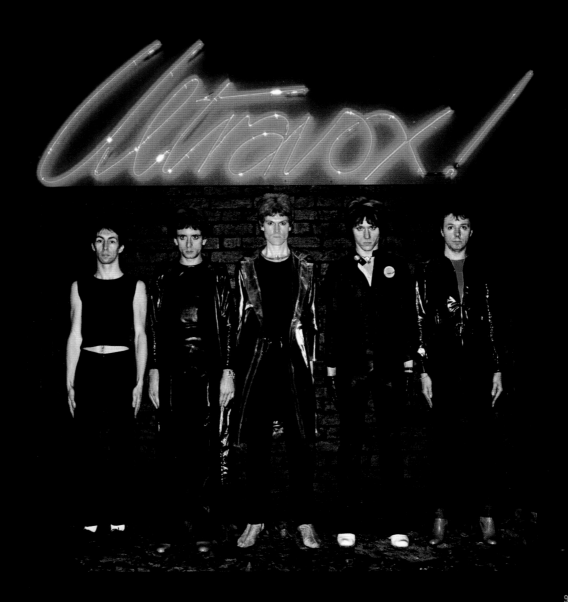

THE BRAVERY 2006

The post-punk and indie rock band the Bravery were formed in New York when Sam Endicott and school mate John Conway, who were partners in Skabba The Hut and Conquistador, recruited Michael Zakarin, Mike Hindert and Anthony Burulcich to the band which debuted in Brooklyn in 2003. In addition to their three studio albums, including the UK Top 5 2005 hit *The Bravery*, the five-piece group also issued three UK hit singles, became renowned as one of the first acts to become involved with profiling on MySpace and also released an early Internet live album.

"This New York band were creating a massive amount of interest in London when I was approached to work with them. They were very involved in their image on an individual basis and we had a long discussion to try and establish an approach that might bring about a more unified look to the band. They worked very hard and we shot late into the night and produced a load of strong images."

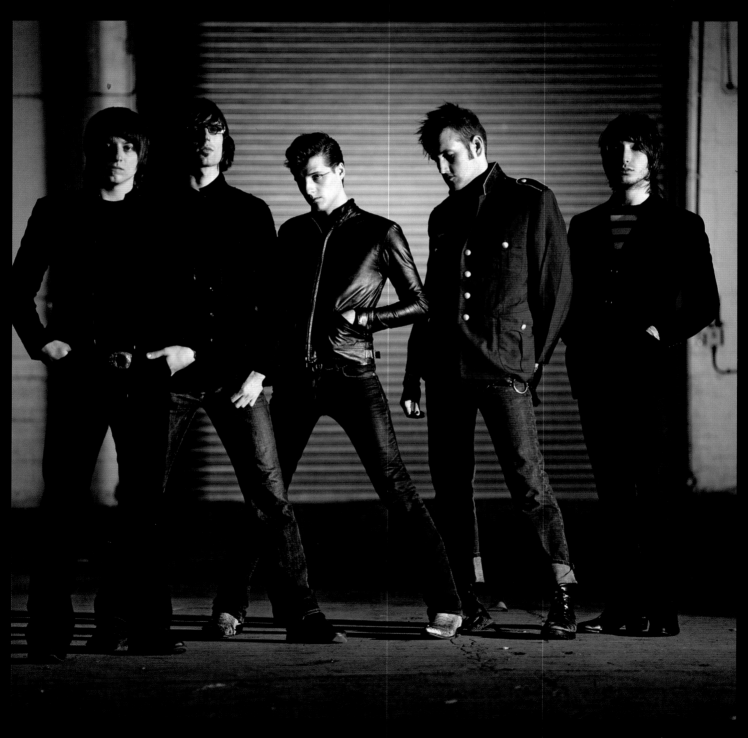

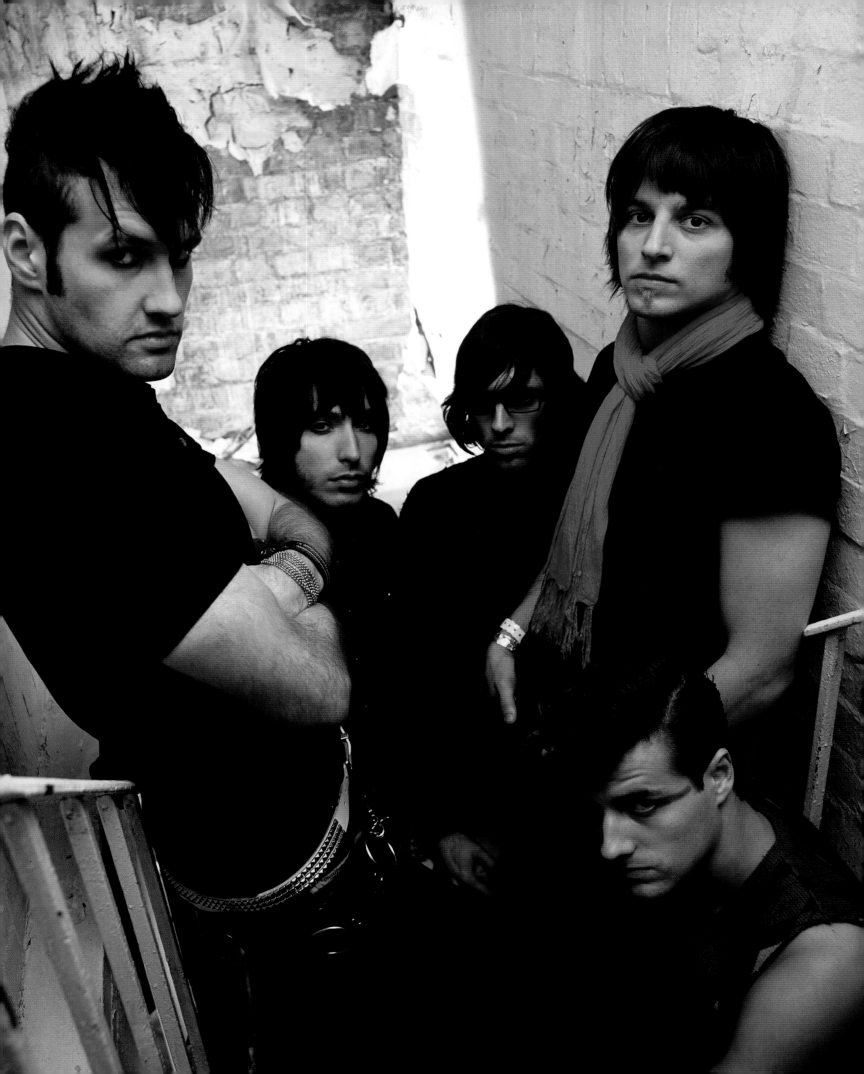

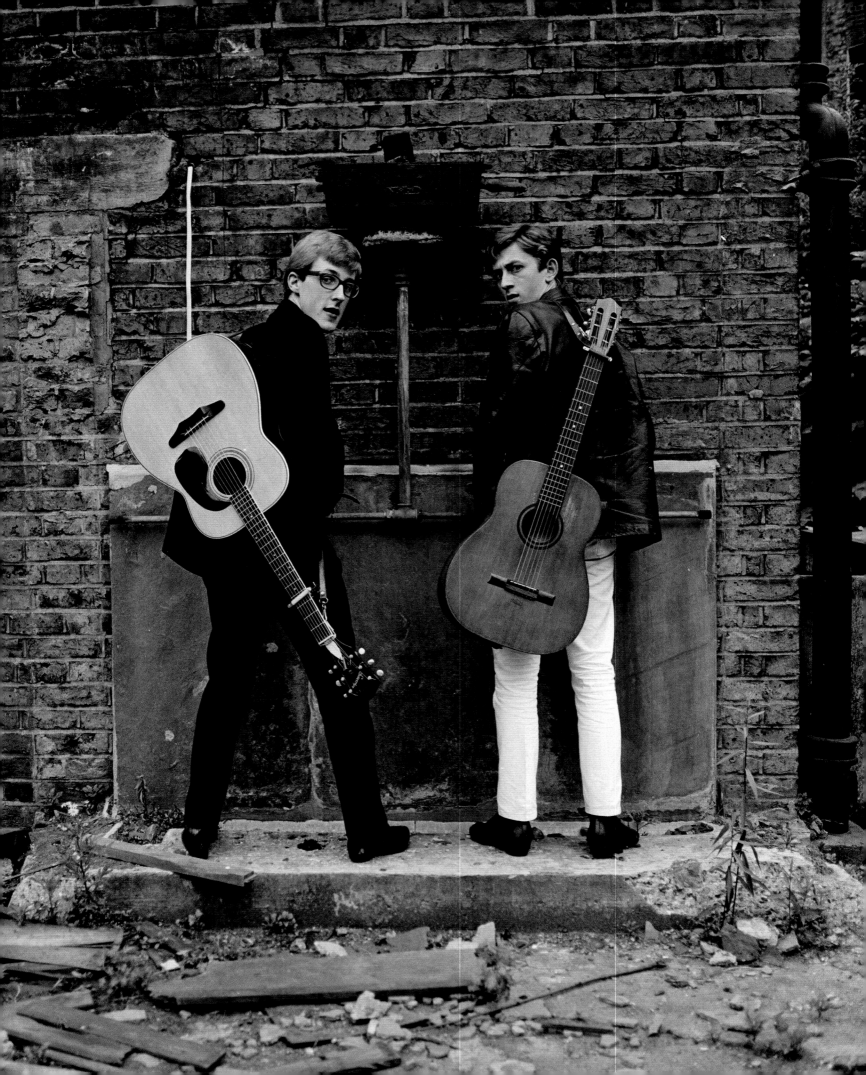

CHAD & JEREMY 1963 TO 2007

Former public school boys Chad Stuart and Jeremy Clyde teamed up in the early 60s after meeting at the London School of Speech and Drama and launching themselves as a folk/pop duo under the name Chad & Jeremy. Their first single 'Yesterday's Gone' was a 1964 hit in both the UK and the US but it was in America where the duo had their greatest success with a Top 20 debut album and ten successful singles. Despite appearances on a variety of US TV shows – including *The Dick Van Dyke Show* and *Batman* – the duo split in 1969 but reunited in 1983 to continue recording and performing.

"I first started photographing Chad Stuart and Jeremy Clyde when they were young actors and struggling musicians playing a tiny coffee shop in Mayfair called Tina's in 1963. It was here that they were discovered by legendary composer John Barry and signed to a tiny independent record company called Ember Records. Jeff Kruger, who owned Ember, liked my photos of the guys and began to give me sessions with the other artists on the label, and John Barry asked me to photograph his band who were called the John Barry Seven. So began my career in music! Although C&J struggled in the UK they went to America as part of the British invasion and had phenomenal success over several years, achieving several hits in both single and album charts as well as guest appearances on many of the top TV shows of that decade. I have continued to work with Chad & Jeremy since that time and am pleased to say that Jeremy remains one of my closest friends."

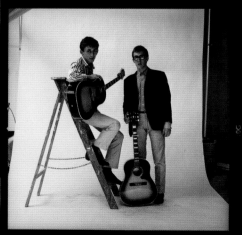

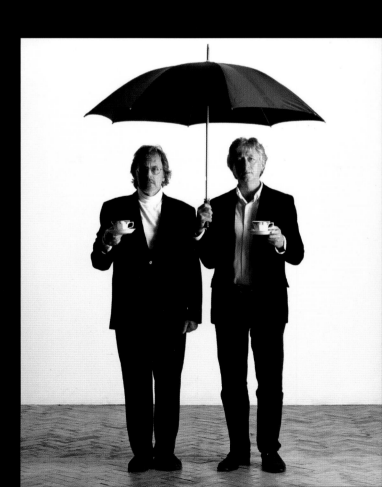

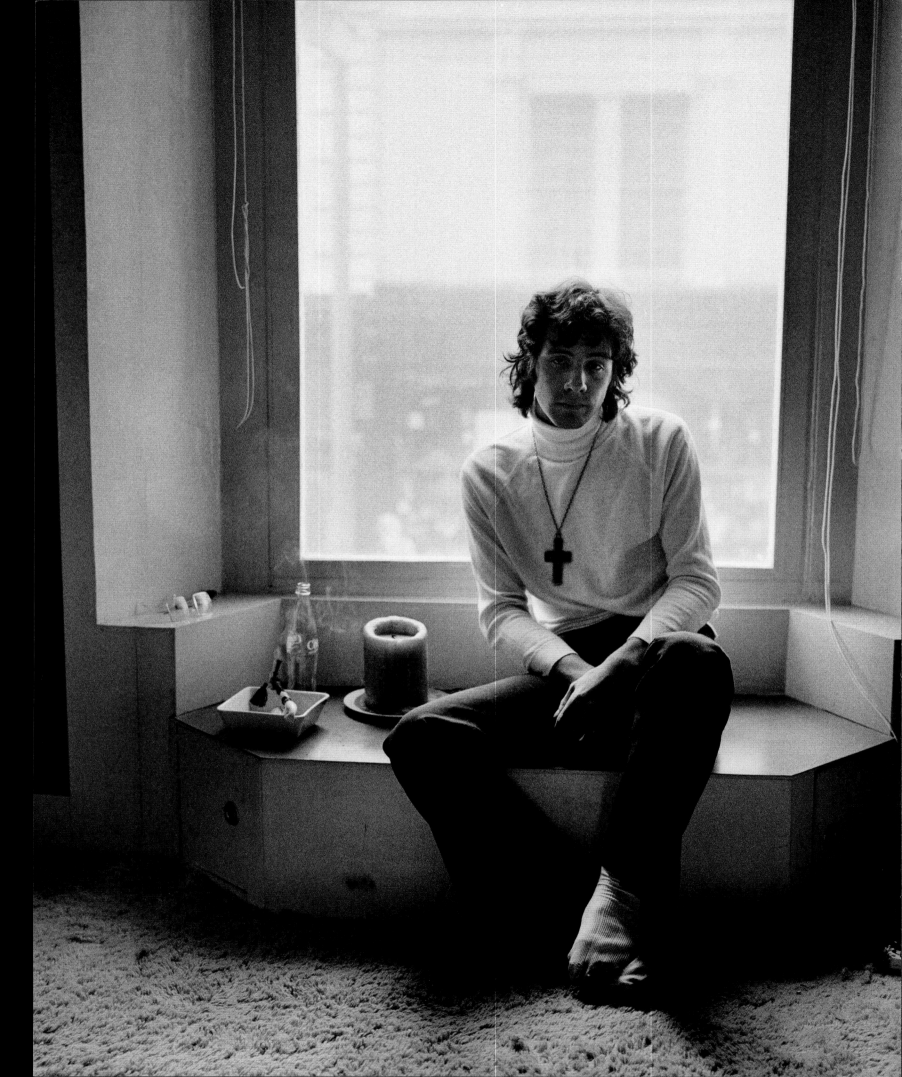

CAT STEVENS 1966

After debuting on the chart in 1966 with his first single 'I Love My Dog', 19-year-old Cat Stevens continued as a successful and influential folk-pop artist and songwriter throughout the 60s and 70s. With six UK Top 10 albums, the half-Greek and half-Swedish London-born singer also released the best selling singles 'Matthew And Son', 'Moonshadow' and 'Morning Has Broken' before formally embracing Islam, changing his name to Yusuf Islam and officially retiring from pop music in 1981. In recent years he has returned to give both live performances and make recordings, including a 2004 hit version of 'Father and Son' with Ronan Keating.

"These portraits were taken early in Cat's career and were shot in his flat above the family café in central London."

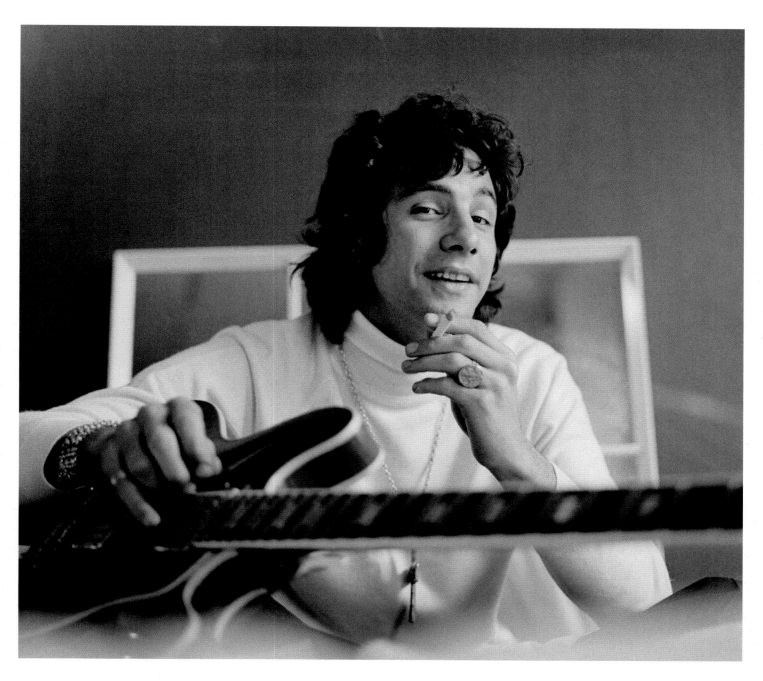

PHIL COLLINS 1969 ONWARDS

Phil Collins was still a member of Genesis when he set about establishing himself as a solo artist with the release of his debut album *Face Value* in 1981 which reached Number 1 in the UK and featured the hit single 'In The Air Tonight.' During the next 15 years – until he officially left Genesis in 1996 – Collins released a further five hit albums including the UK and US chart toppers *No Jacket Required* and *… But Seriously*. He was famously the only artist to appear in both the British and American Live Aid concerts – courtesy of Concorde – but after more solo success and reuniting with Genesis in 2006, Collins was rumoured to have retired from music in 2011.

"I worked with Phil and his first band who were called Flaming Youth in 1969, and produced one of the most ambitious album covers of my career for them. The album was called *Ark 2*, and I created a sort of stained glass window collage, which was printed on clear plastic and inserted into an extra page of the cover so that fans could cut it off and place it against a window achieving the complete stained glass effect!! The cover was terrific but the band didn't make it and Phil joined Genesis. I worked with Genesis on several occasions and it was always thanks to Phil that the photos had any life and energy, as Mike and Tony were two of the most un-photogenic people I had come across and always seemed to hate the experience. I also shot several sessions with Phil as a solo artist, including the cover for the *Into The Light* album."

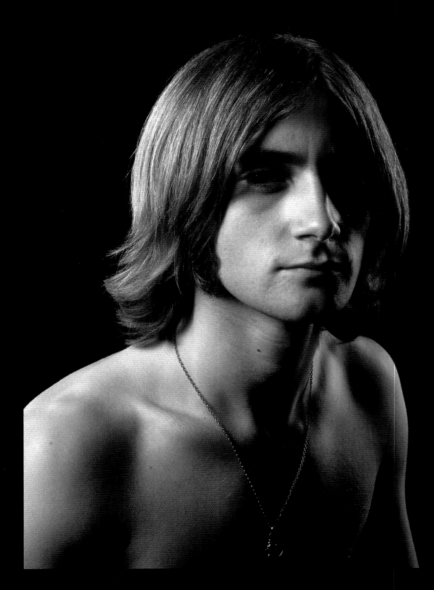

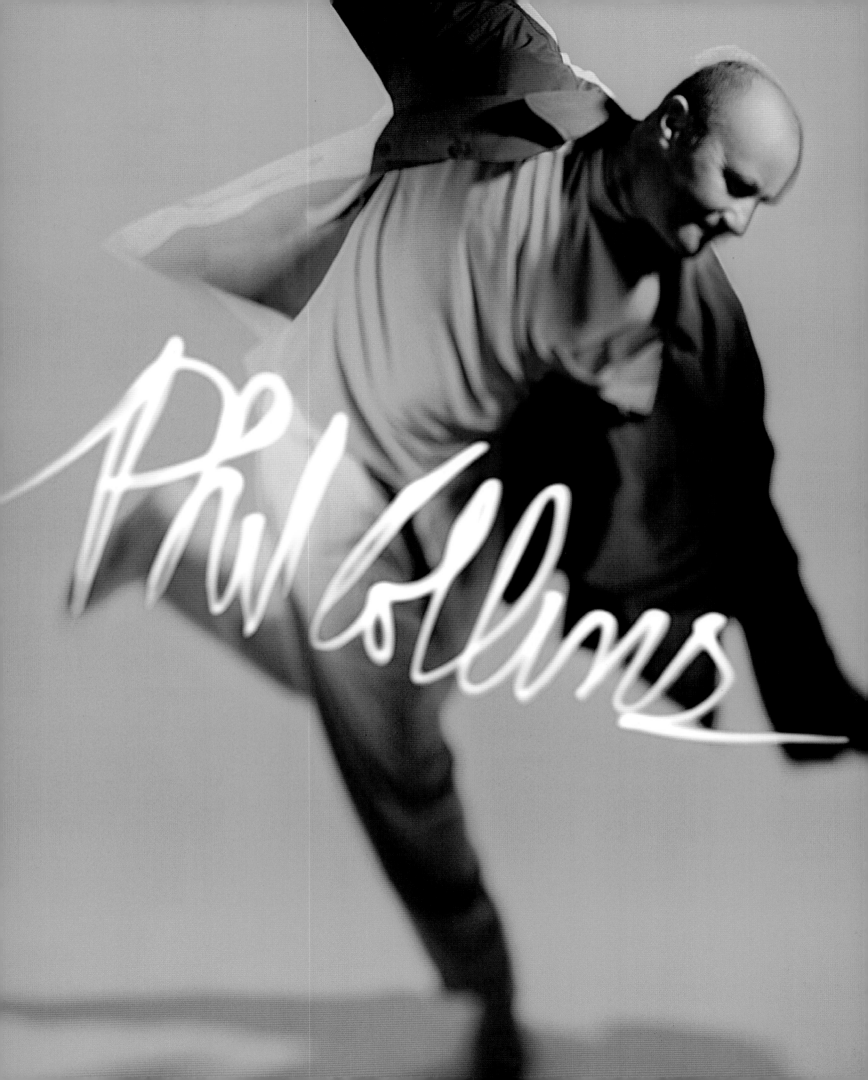

THE HIVES 2004

After originating in Fagersta in Sweden in 1993 – and known in 1997 as Barely Legal – the Hives, by 2000, were at the forefront of a garage punk/rock revival that brought them their first major success in the UK in 2002. Led by singer Howlin' Pelle Almqvist – together with Nicholaus Arson, Vigilante Carlstroem, Dr Matt Destruction and Chris Dangerous – the Hives reached the Top 10 with their albums *Your New Favourite Band* and *Tyrannosaurus Hives*. The band's wild live shows are coupled with their insistence on wearing only black and white stage outfits, which change with each album release or tour.

"I was asked by the *NME* magazine to contribute to a special edition they were publishing and they offered me the opportunity to work with the Hives. I thought the Hives were a perfect band for me because of their strong, theatrical visual identity and I chose a club in Notting Hill Gate as a location. The band responded to my idea perfectly, each one of them working with the others to create a wonderful coordinated look. They were charming and easy to get on with and the whole session was probably over in a couple of hours."

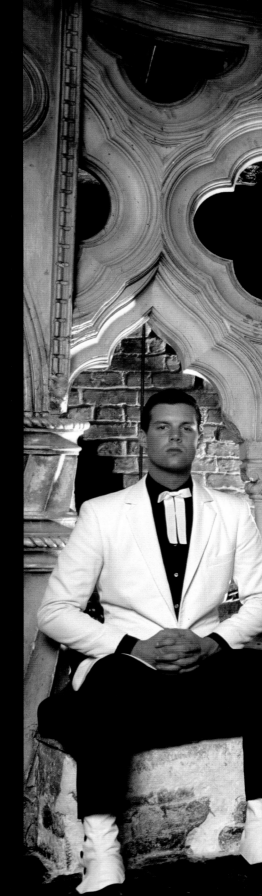

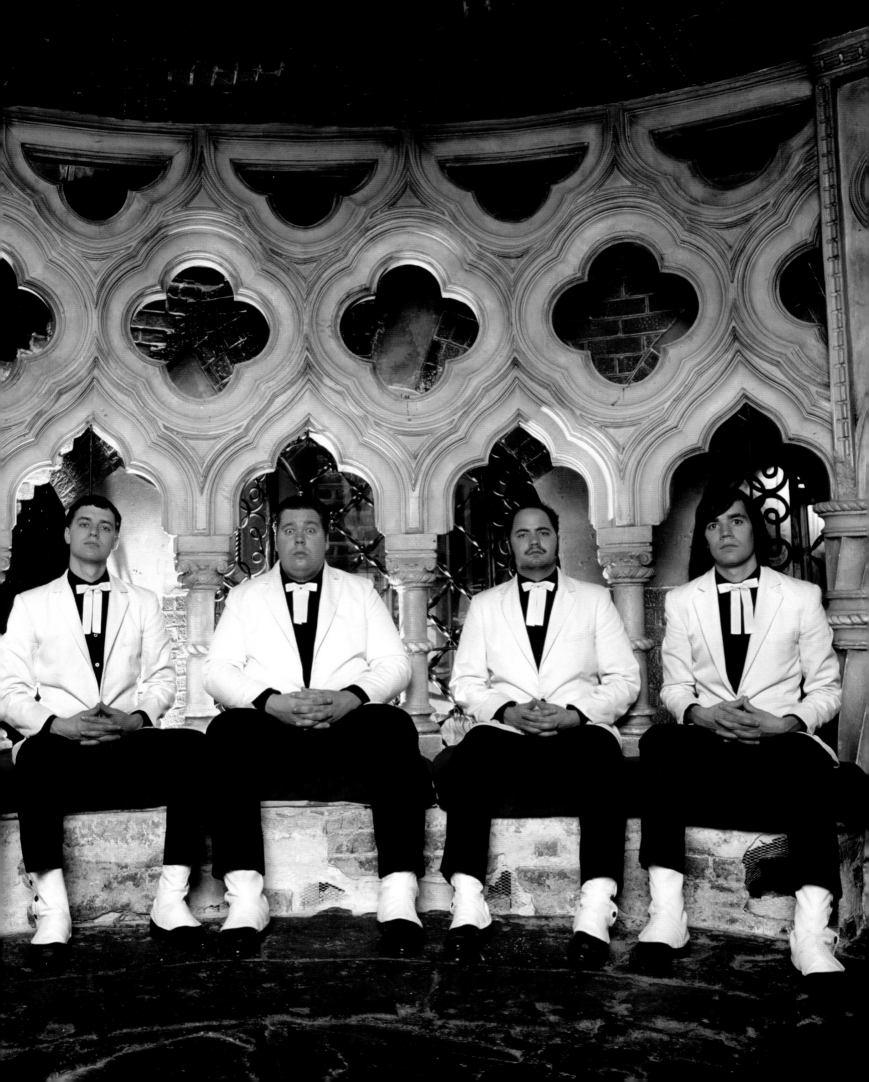

JOE COCKER 1968

A former fitter with the Gas Board in Sheffield and part-time singer in local rock bands, Joe Cocker burst on to the pop scene in 1968 with his chart-topping rendition of the Beatles' song 'With a Little Help from My Friends'. A further 15 hit singles followed plus the successful album *Mad Dogs And Englishmen* – a Number 2 hit in the US – which featured more than 20 musicians, including Rita Coolidge and Leon Russell, on the accompanying tour. A star of both the Woodstock and the Isle of Wight festivals in 1969, Cocker duetted with Jennifer Warnes on the major 1983 hit 'Up Where We Belong'.

"I think this was one of Joe's first London sessions after he had been found by the producer Denny Cordell. He was very funny and made endless 'loony' faces to the camera, quite unlike a lot of musicians of the day who tended to be moody and sought a sullen, sexy look. He had only just given up his job as a gas fitter in his home town of Sheffield and was about to make the record that would take him to Number 1 in the UK charts: 'With a Little Help from My Friends'."

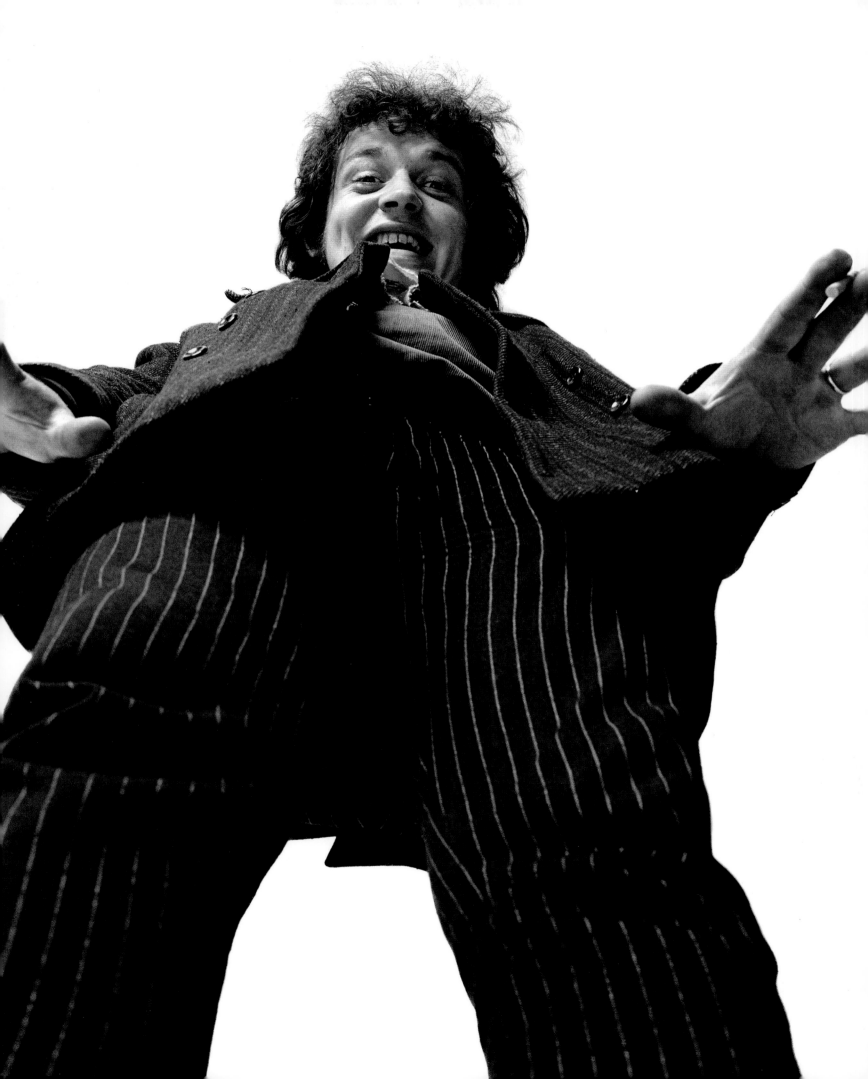

JOAN ARMATRADING 1984

In 1958, at the age of eight Joan Armatrading arrived in the UK from St Kitts in the West Indies and began her professional music career in 1971, releasing her debut album two years later. However, her breakthrough came in 1976 when she first hit the UK charts with her eponymous second album and the single 'Love And Affection'. By the time Mankowitz photographed her in 1984, she had notched up a further six chart albums and six singles in the UK plus two US hit albums. She appeared at the Wembley Stadium concert to celebrate Nelson Mandela's 70th birthday in 1988.

"This was one of a series of adverts that I shot for a company which distributed various different instruments and recording devices. This particular one was for Ovation Guitars and featured Joan. She recorded for A&M Records, who were regular clients of mine, and I had always hoped to work with her, but the opportunity had never come up, so I was very pleased to have this chance. She was very quiet and reserved but responded very well to my direction and brought a tremendous dignity to the portrait. Getting the shaft of light just right proved very tricky and she was patient and supportive while I struggled to get the desired effect. The black & white version won a prize in the ILFORD awards that year!"

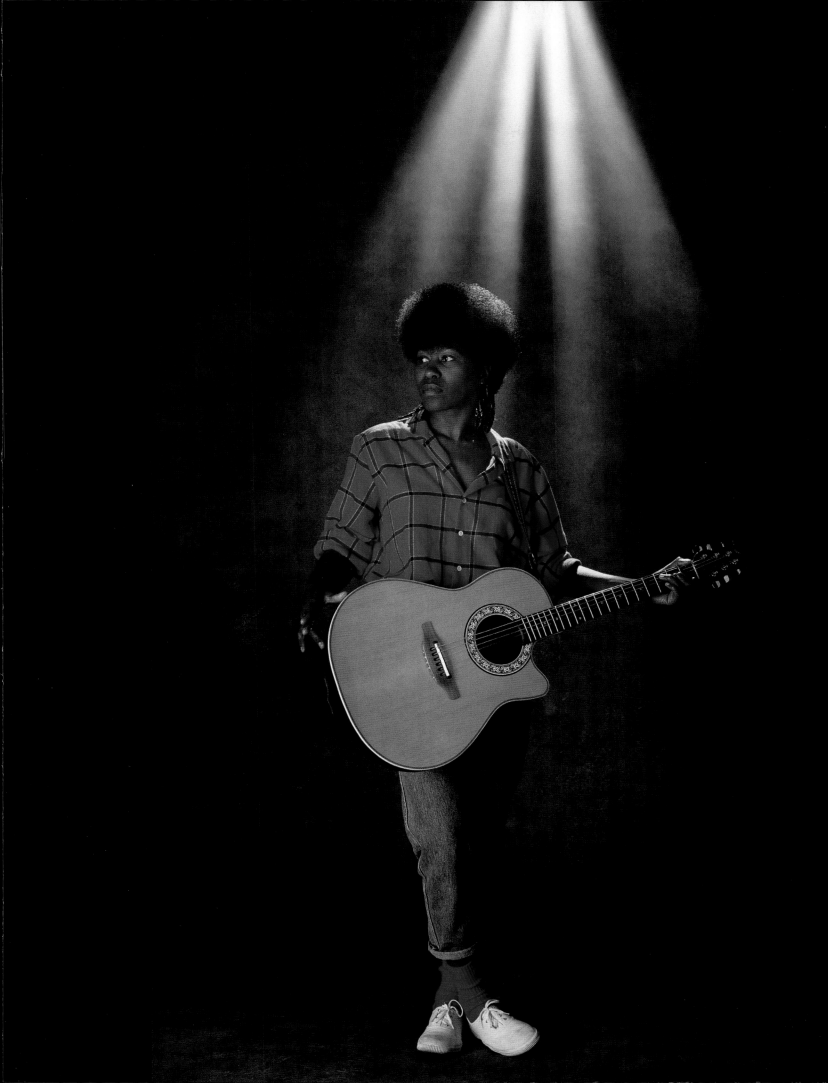

rding in 1968, but
York' – a tribute to
e UK Top 20 a year
nd 'I Could Be So
op 10 hit for actor
t singles, Kenny's
lathis, Jack Jones

was an enormous
l songs, including
Through The Rain'.
hat illustrated the
within the sleeve,
pany got cold feet
old sleeve, which
size. It still looked

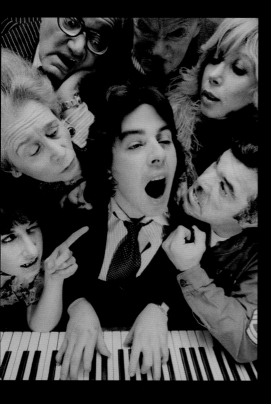

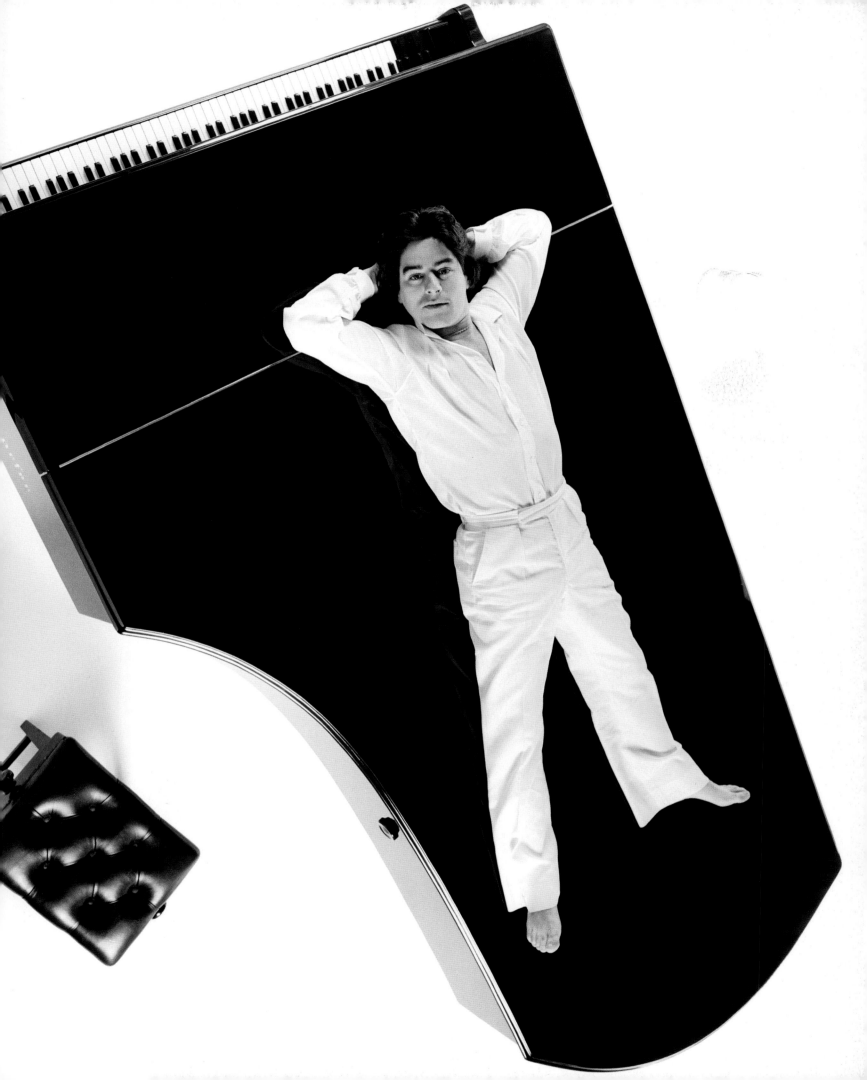

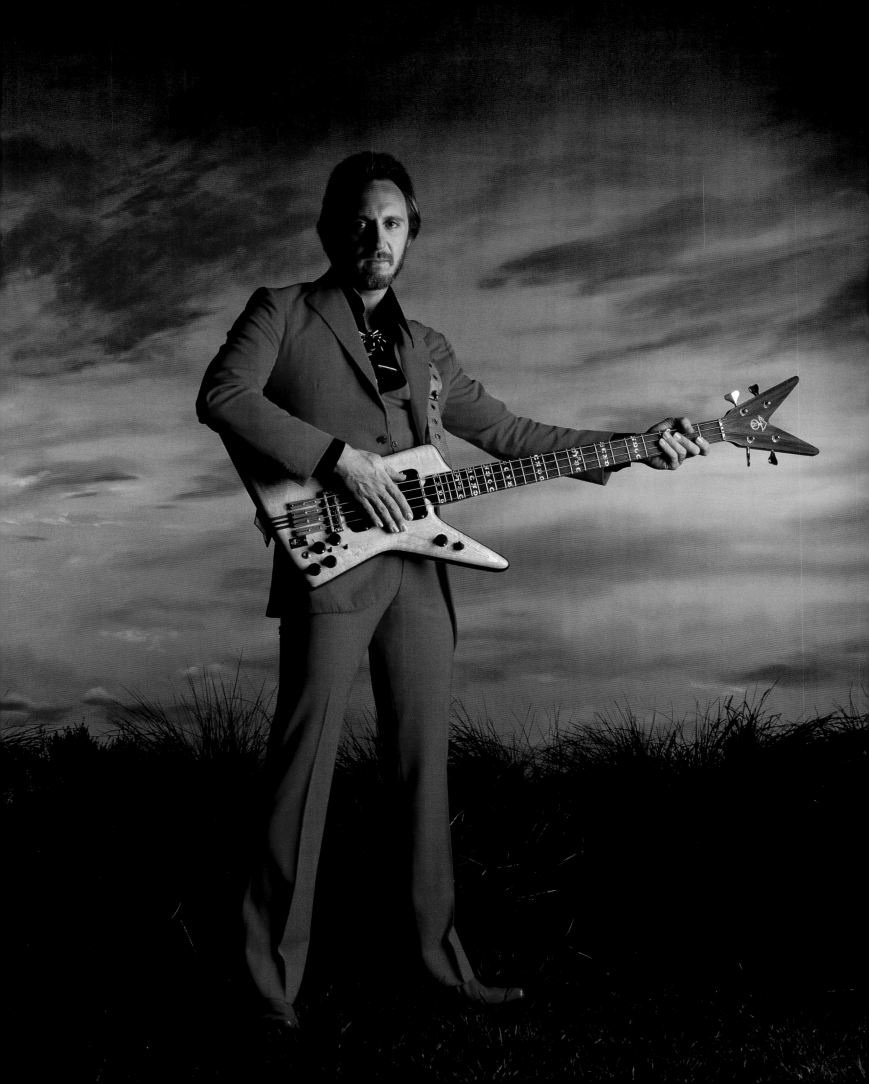

JOHN ENTWISTLE 1981

Seven years after he first joined forces with Pete Townshend, Roger Daltrey and Keith Moon in the High Numbers, John Entwistle became the first member of the renamed band the Who to achieve any solo success when his debut album reached the US Top 200 in 1971. The bass player known as "The Ox" remained with the Who throughout the band's long career – which began with 'I Can't Explain' in 1965 – while also releasing a further seven non-Who albums, including 1981's *Too Late The Hero*, which made the US Top 100. Entwistle died in a Las Vegas hotel room in July 2002, aged 58.

"It is one of my few regrets that I never worked with either the Who or the Kinks back in the 60s, so I was pleased to get the chance to work with John for this solo album sleeve. He wanted to dress up in various different uniforms and seemed very knowledgeable about them and the history surrounding them, but I found the whole session a little weird and he was curiously un-communicative throughout. However I always loved the 'Hero' portrait in the red suit – the survivor on some ancient battlefield!"

10CC 1977

After first recording as Hot Legs in 1970, Eric Stewart, Lol Creme and Kevin Godley recruited Graham Gouldman to the band that would emerge as 10cc in 1972 and top the UK charts with 'Rubber Bullets' a year later. After the success of the single 'I'm Not In Love' in 1975, Godley and Creme left 10cc and Stewart and Gouldman recruited new members Paul Burgess, Rick Fenn, Tony O'Malley and Stuart Tosh to the line-up for the 1977 album *Live And Let Live*. The band split in 1983 and reunited in 1991 although Godley and Creme left again soon after. Stewart and Gouldman made a final album in 1995.

"This shot is an out-take from the *Live and Let Live* album session and was shot at an industrial site in west London. This was the only time I had the opportunity to work with the band and the great sleeve designer Barney Bubbles."

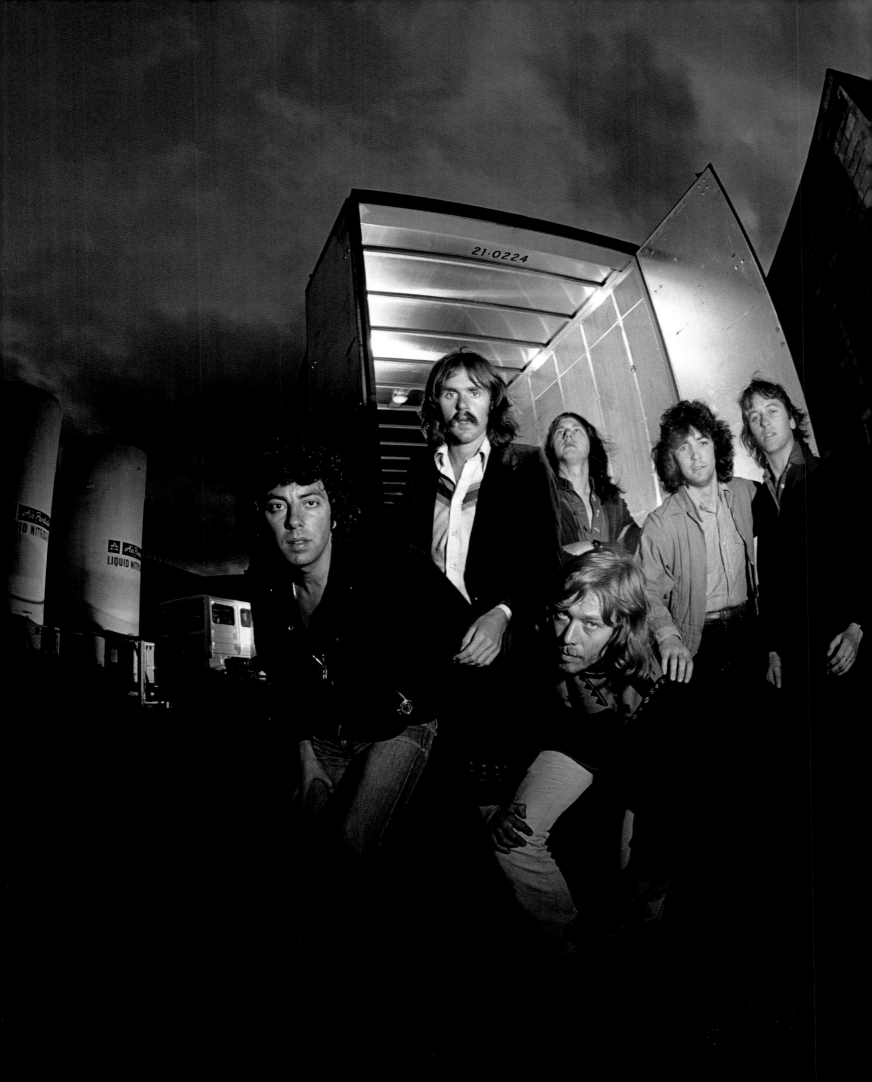

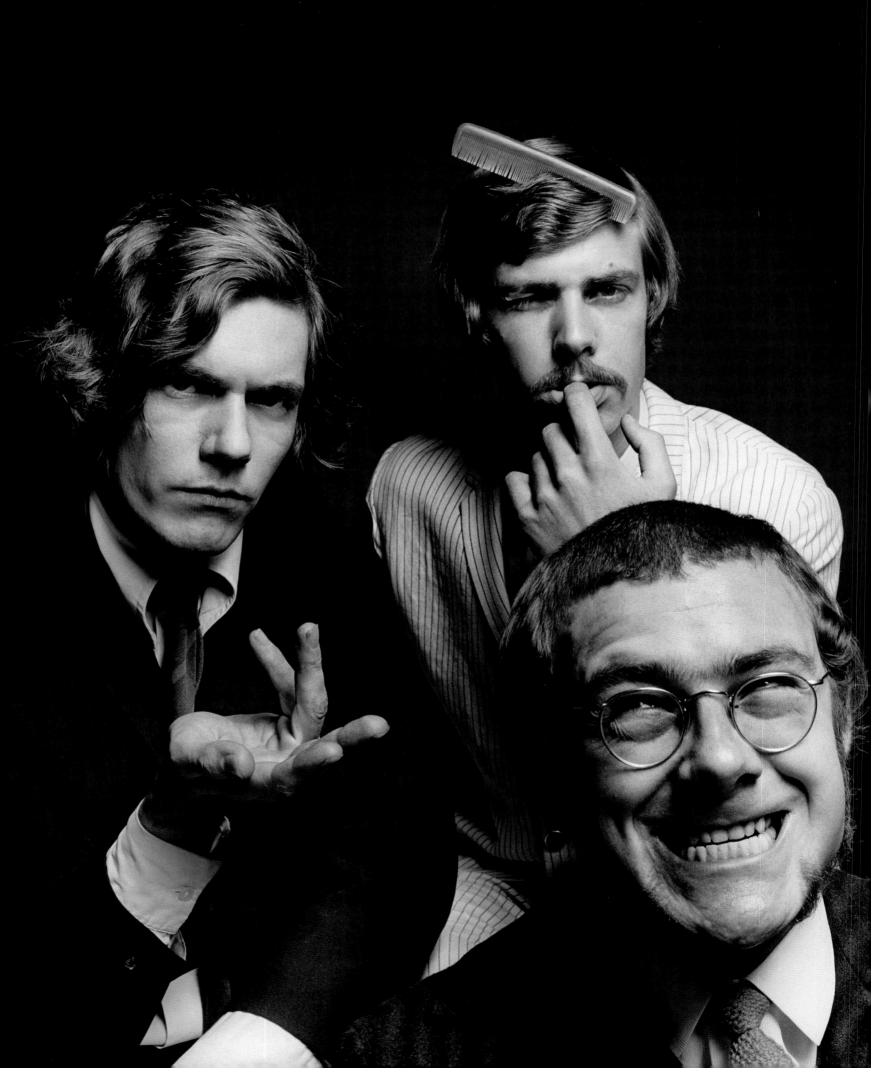

GILES, GILES & FRIPP / KING CRIMSON 1968 TO 1974

The trio of Giles, Giles & Fripp was a short-lived band consisting of brothers Peter and Michael Giles and Robert Fripp, who got together in 1967. They released just one album during the following year before Fripp and Mike Giles together with Ian McDonald, Pete Sinfield and Greg Lake emerged as King Crimson in 1969, hitting the UK Top 10 and US Top 30 with the album *In The Court Of The Crimson King*. After five more successful albums, King Crimson became the trio of Fripp, John Wetton and Bill Bruford, who were photographed by Mankowitz in 1974 for the album *Red*.

"Robert Fripp had teamed up with the Giles brothers in late 1967 and when I worked with them in 1968 I believe they had just signed to the new Deram label, which was part of Decca records. They had a marvellous madness to them and were good fun to have in the studio, creating lovely zany faces and bringing a lightness with them that was a pleasant change to the rather 'heavy' atmosphere that was beginning to pervade the late 60s in London.

"By the time I got to shoot with Fripp again, as part of King Crimson in 1974, everything had changed and they were all taking themselves rather too seriously. However, I chose to shoot them on the large format camera and created a series of rather classical solo portraits that were collaged together for the album cover."

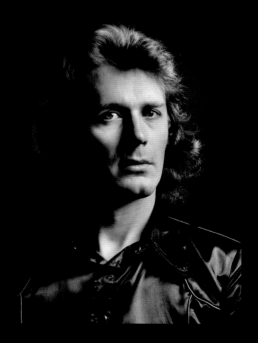

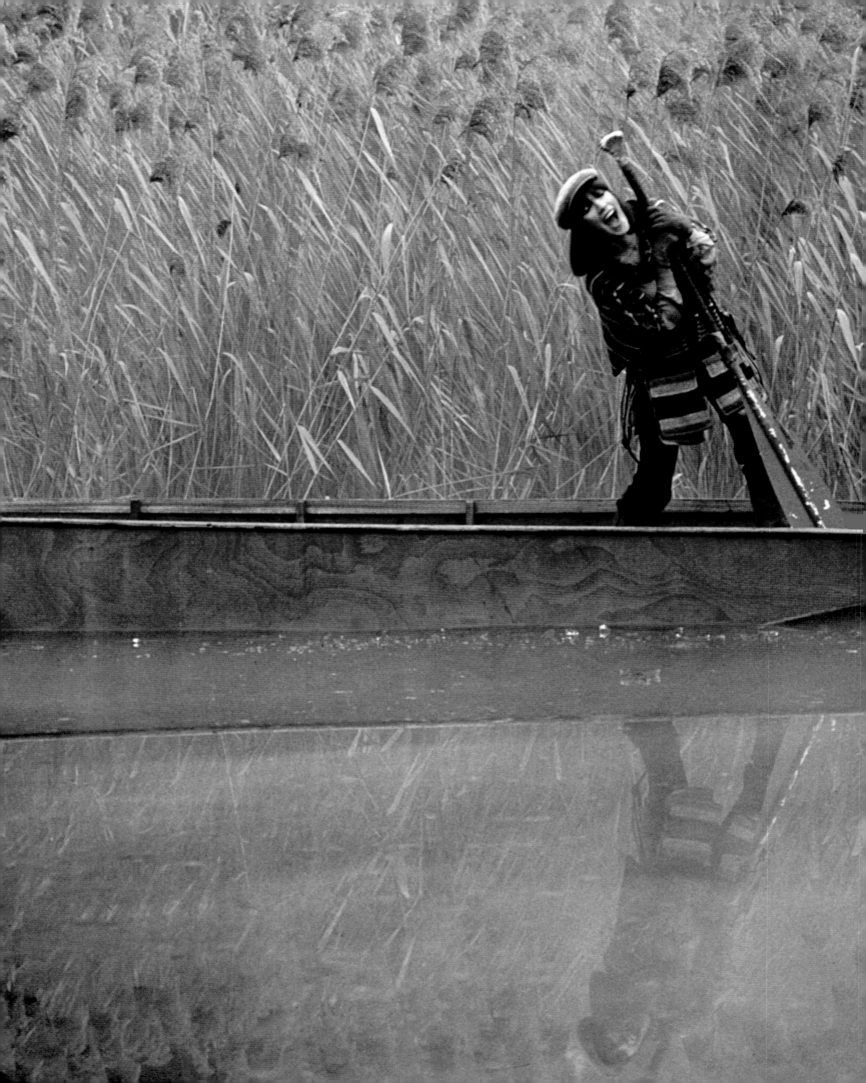

KIKI DEE 1976 & 1977

Kiki Dee began her career as a session singer working with the likes of Dusty Springfield and in 1969 became the first British female artist to sign with Tamla Motown. After switching to Elton John's Rocket label she hit the UK Top 20 with both 'Amoureuse' and 'I've Got The Music In Me', and then joined forces with John in 1976 on 'Don't Go Breaking My Heart', which topped the charts in both the UK and the US. While she had further chart hits and sang on numerous John albums, Dee moved into musical theatre and during the 80s appeared in both *Pump Boys and Dinettes* and *Blood Brothers.*

"I had known Kiki Dee a little bit from the 60s, but didn't get the chance to work with her until she was signed to Elton John's Rocket Records and I was asked to shoot the cover for the *Kiki Dee* album. David Costa was the art director and we arranged to do the shoot at Elton's house in Old Windsor. It was an incredibly cold day and Elton's pond had frozen over, so we managed to break enough ice to push the punt, with Kiki in it, into a position that suited my composition. After taking a few frames we told Kiki that we had got it and made out that we were leaving her stranded on the ice, at which point she collapsed in laughter and we got the best shot!"

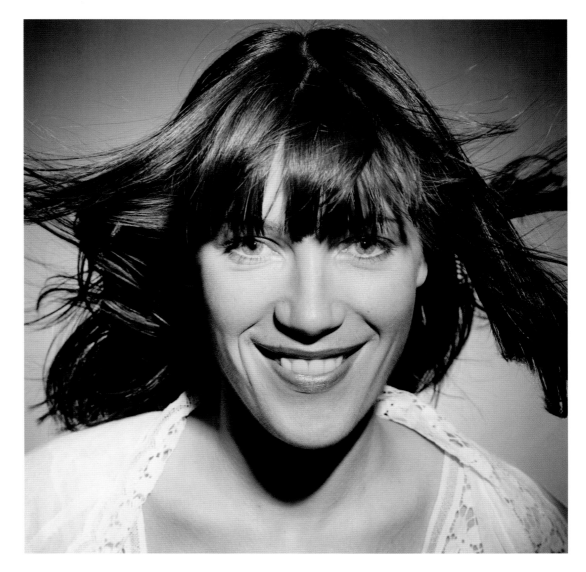

SLADE 1969 TO 1982

Formed as Ambrose Slade in Wolverhampton in 1969, Noddy Holder, Dave Hill, Jimmy Lea and Don Powell first charted as Slade in 1971. Over the next four years (under the direction of manager and producer Chas Chandler) they racked up a total of 13 UK Top 10 hits with six reaching Number 1 – including the million selling 'Merry Xmas Everybody' – and three chart-topping albums. They continued to release hits throughout the 80s, but in 1992 both Holder and Lea left the band. The original members Hill and Powell recruited new musicians to Slade as the band's singles sales figure passed the six million mark.

"I loved Slade! They were always fun to work with and I ended up shooting over 35 sessions with them throughout their long and distinguished career. I shot almost every album cover they did and many other sessions as well. They were hugely talented and made an endless stream of brilliant, raucous pop hits throughout the 70s. I considered them to be good mates and am still in contact with Noddy Holder, and recently had tea with Dave and Don when they played a local gig!"

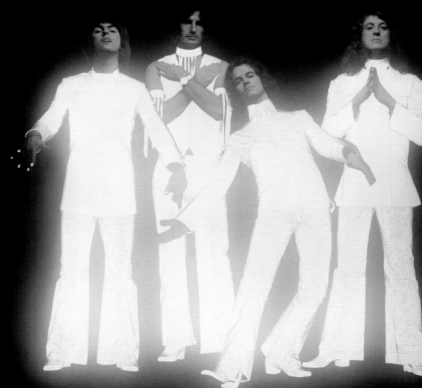

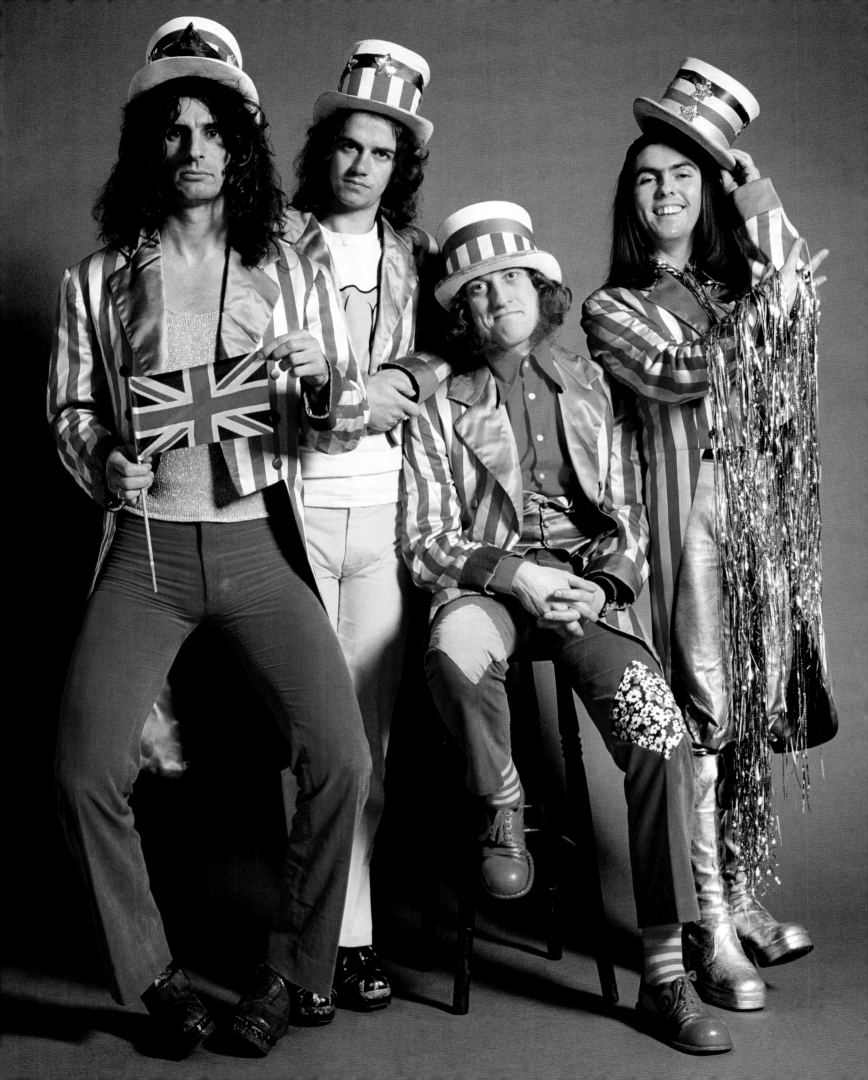

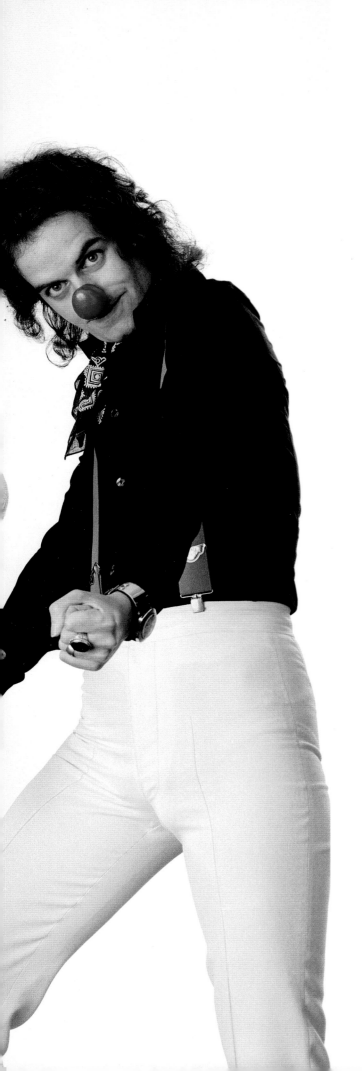

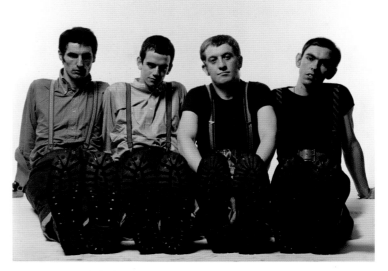

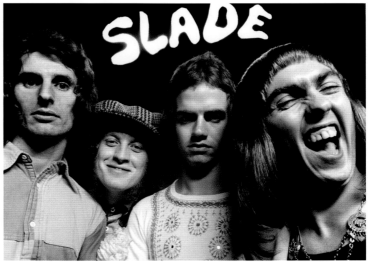

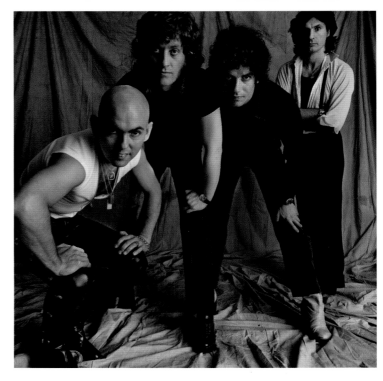

JOAN JETT 1980

Dubbed the Queen of Rock and Roll, Joan Jett was a founding member of the Runaways, who released five albums before she left to embark on a solo career in 1979. This included working with Sex Pistols Paul Cook and Steve Jones, and she then teamed up with producer Kenny Laguna. With her band the Blackhearts, Jett reached Number 1 in the US and the UK Top 10 in 1982 with 'I Love Rock 'n' Roll' and after three successful group albums she released *The Hit List* in 1990 and *Sinner* in 2006 while also continuing to work as a songwriter and producer.

"This session was made when Joan came to Europe to pursue a solo career and had left her band the Runaways. She was working with ex Sex Pistols Paul Cook and Steve Jones, with whom she recorded an early version of 'I Love Rock 'n' Roll', which was to become such a huge hit for her two years later."

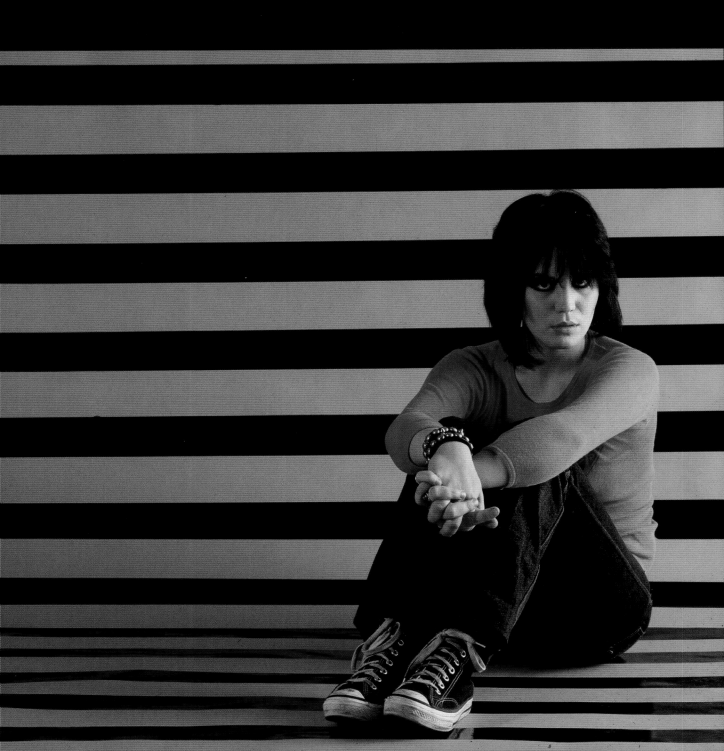

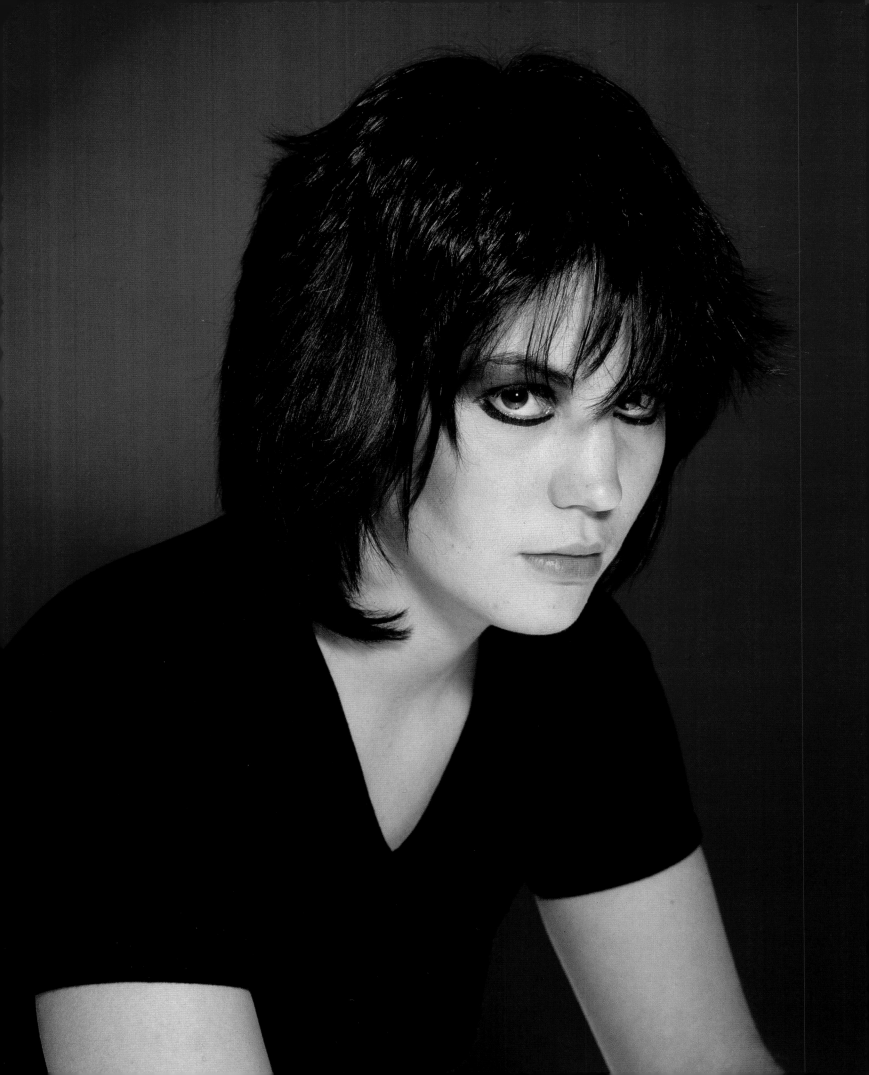

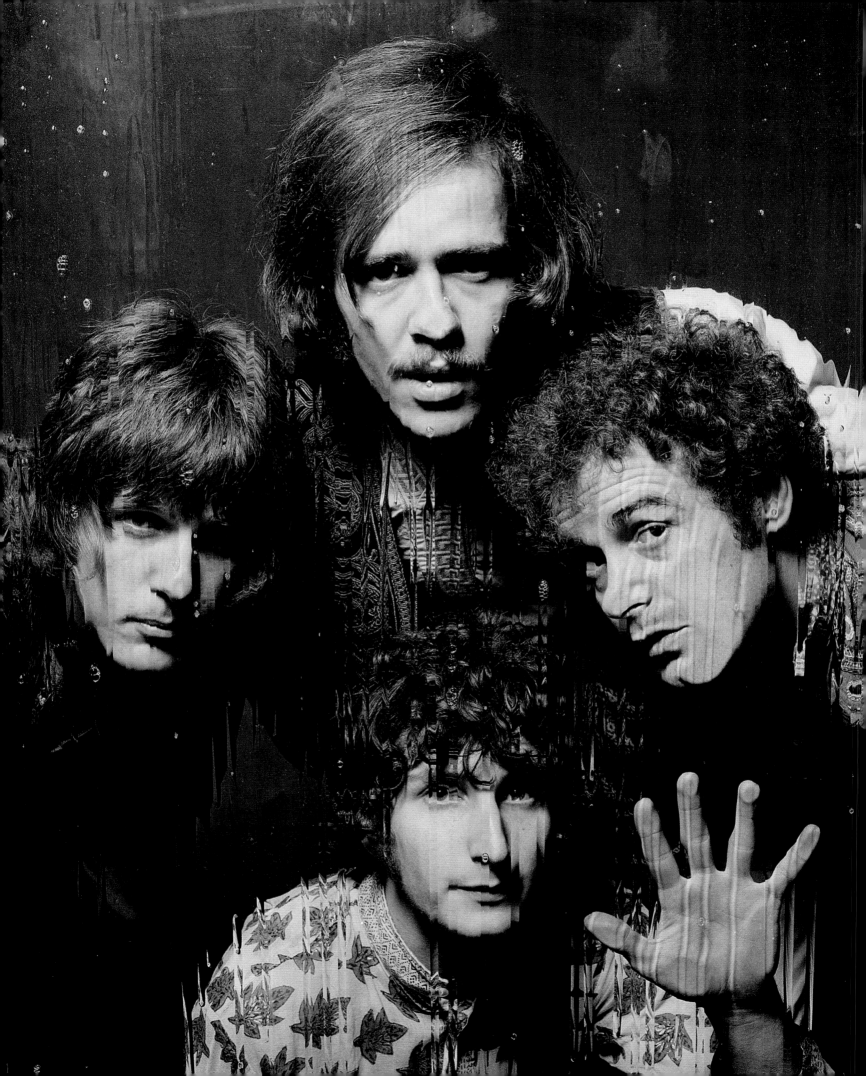

...ey hit the UK charts with a version of the song 'America' from Leonard Bernstein's *West Side Story,* which was banned in the US after the band burned an American ...g onstage at the Royal Albert Hall. Following O'List's departure, Mankowitz ...otographed the cover of the band's unsuccessful 1968 album *Ars Longa Vita* ...*evis,* which was followed by three UK Top 10 albums before the group disbanded ...1970 when Emerson founded Emerson, Lake & Palmer.

...he Nice were formed to back P.P. Arnold, but soon gained their own following ...d started to record their own material for Andrew Oldham's Immediate label. ...eir music was pretty strange, psychedelic and a bit pretentious, but gave me the ...portunity to try some weird ideas of my own. The cover for their second album ...*s Longa Vita Brevis* won me my first award! And my image for their recording of ...merica' caused quite a lot of controversy."

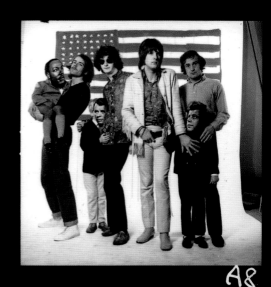

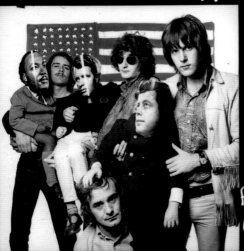

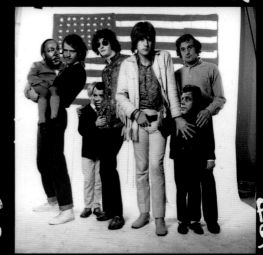

McALMONT & BUTLER 1995

The duo of David McAlmont and Bernard Butler originally got together in 1995 when they produced two UK hit singles and a hit album in the same year before deciding to go their separate ways. McAlmont was a member of the Thieves and had worked with Morrissey ahead of joining forces with ex-Suede guitarist Butler, who had featured on the band's Number 1 album *Suede* before leaving in 1994. McAlmont and Butler reunited in 2001 and issued two more hit singles and a Top 20 album – and made a series of rare public performances – before they once again parted company in 2004.

"I had met Bernard Butler when I photographed his band Suede in 1993, and we had got on rather well, so I was very happy when he approached me to work with McAlmont & Butler. They made an extraordinary couple visually and were delightfully weird to work with. Very creative, inspiring and motivated."

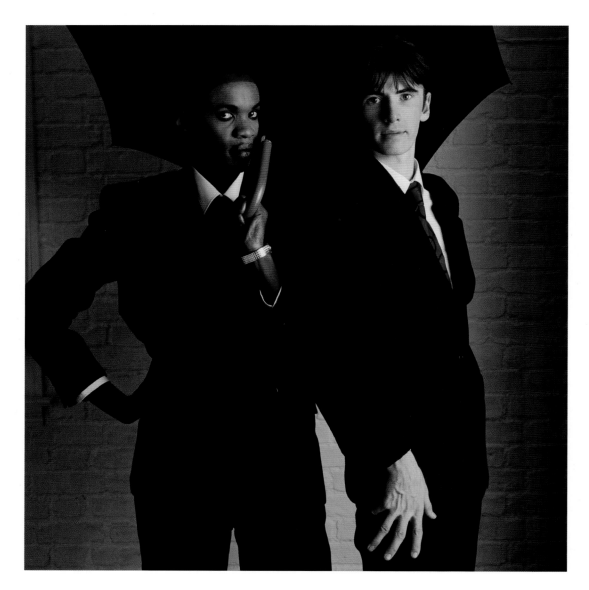

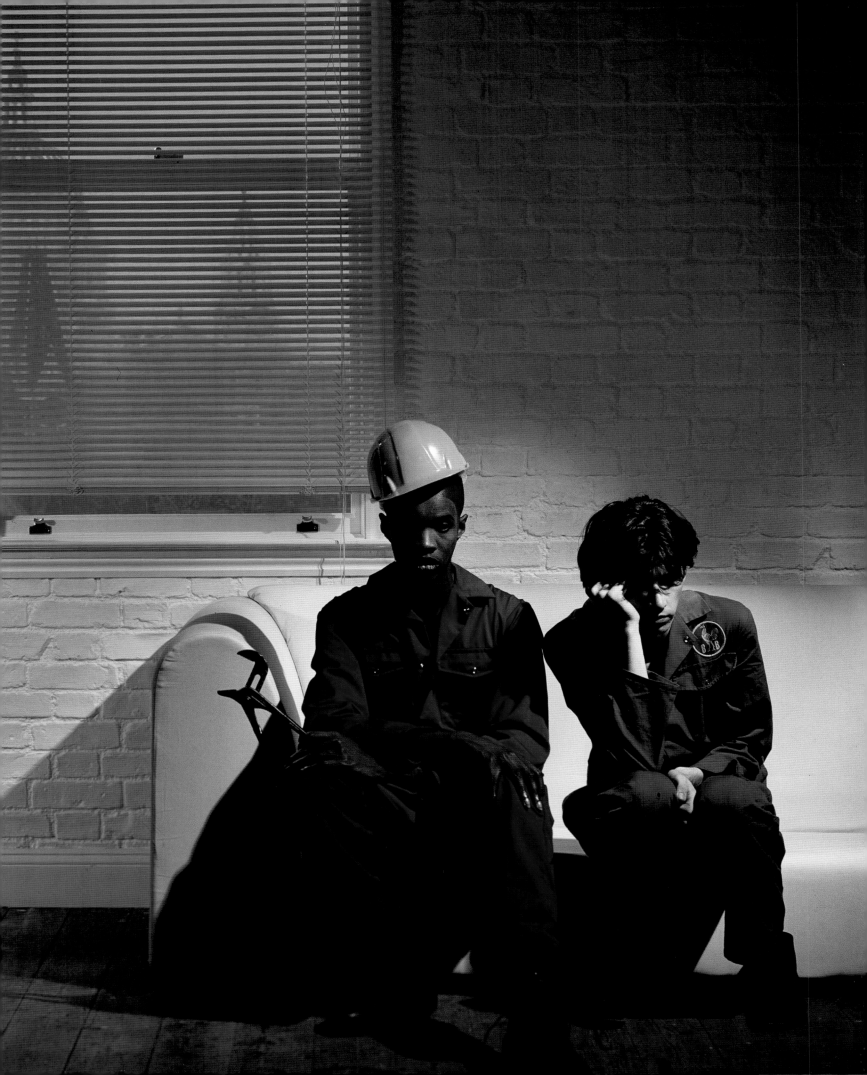

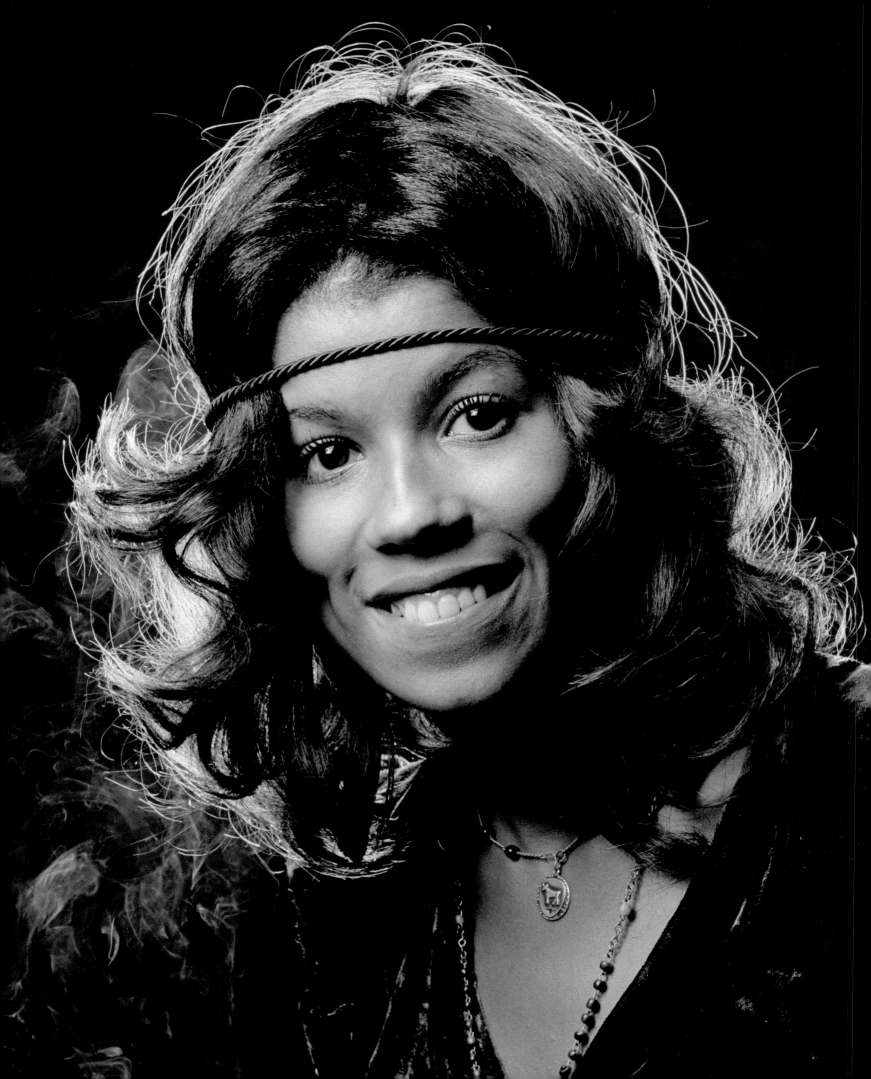

American singer Maureen Gray began her singing career at the age of three and appeared at New York's prestigious Carnegie Hall at the age of five, before being discovered by producer and songwriter John Medora (Madara) who was involved in producing 15 songs for Gray in the early 60s as she became a pioneer of the Philly Sound. After a couple of minor US hits, Gray moved to London, where she released her debut solo album and also recorded with Billy Preston and David Bowie before creating the trio Girl Talk in the 1990s and appearing under the name Girl.

"I can't remember how I met Maureen (now known as Girl!) but she made an incredible impression and I rather fell for her! She came from Philly and had been singing since she could walk, or just about. She was determined to make it and I tried to help by taking some photos of her and introducing her to a few people. I always felt that these portraits caught the magic of 'flower power – Swinging London'. She was infatuated with Steve Winwood and Traffic and I was able to introduce her to Chris Wood from the band, who was a friend of mine through my various sessions with the band. I remember driving her uninvited out to Steve's cottage in the country one day and dropping her at the top of the drive – I don't think I ever saw her again…"

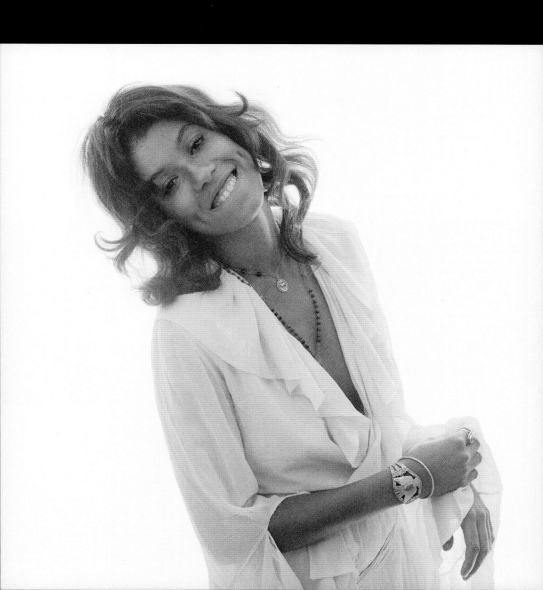

IBRAHIM FERRER 2001

Ibrahim Ferrer was born in Cuba in 1927, began performing at the age of 13 and worked continuously throughout his island home for over 50 years with various groups, including Conjunto Sorpresa and the Afro-Cuban All Stars, before he was enlisted by American singer and guitarist Ry Cooder as a singer with the Buena Vista Social Club. The 1997 release was a critically acclaimed album and led to Ferrer recording his first solo album – with Cooder as producer – in 1999, for which he won a US Grammy award. His second album was issued in 2003, two years before he died in Havana at the age of 78.

"World Circuit Records asked me to photograph the Buena Vista Social Club in Vienna when they were playing at the Opera House. I was thrilled at the prospect, and working with this extraordinary group of musicians was not remotely disappointing. They all looked fabulous and Ibrahim had a wicked twinkle in his eye that I tried hard to capture. After the shoot I watched the performance and they received a standing ovation that lasted for several minutes – a huge success! Afterwards I rushed backstage to try and capture the moment Ibrahim stepped off the stage, and just managed to catch him being congratulated by Nick Gold from the record company."

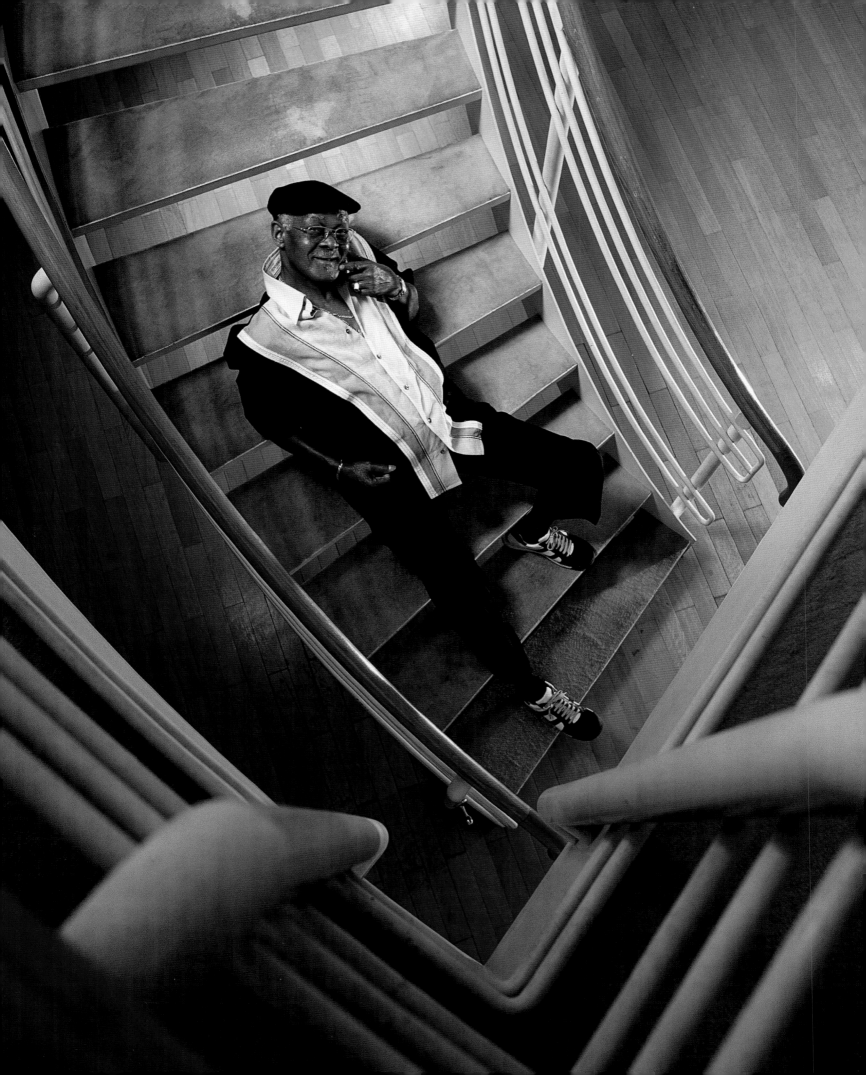

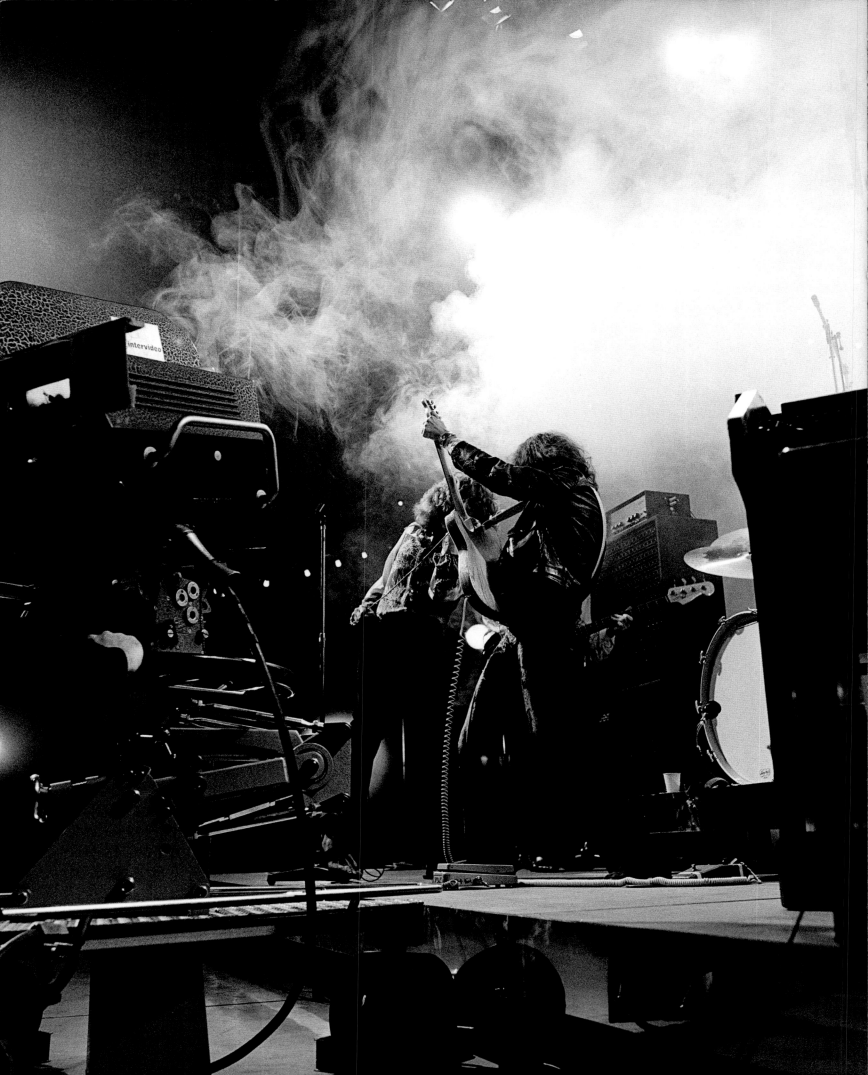

LED ZEPPELIN 1969

The world famous quartet of Robert Plant, Jimmy Page, John Paul Jones and John Bonham got together to appear as the New Yardbirds in 1968 before adopting the name Led Zeppelin a year later when their eponymous debut album peaked at Number 6. After that Led Zeppelin went on a run of eight consecutive UK Number 1 albums alongside six albums which reached the top of the US chart. With more than 200 million albums sold worldwide, Zep's only UK hit single was the 1997 release of 'Whole Lotta Love', which had reached Number 4 in the US in 1969. After Bonham died in 1980, the group announced the end of Led Zeppelin.

"I had known and photographed Jimmy Page since his days as a solo artist and producer with Immediate Records, including his spell with the Yardbirds, but never got the chance to work with Led Zep. My one opportunity came when they performed on a TV show called *Supersession,* for which I was shooting stills. They were very insular and didn't talk to anybody else on the show but gave the most electric performance. I was quite pleased with the shots although they were never properly published until 2007!"

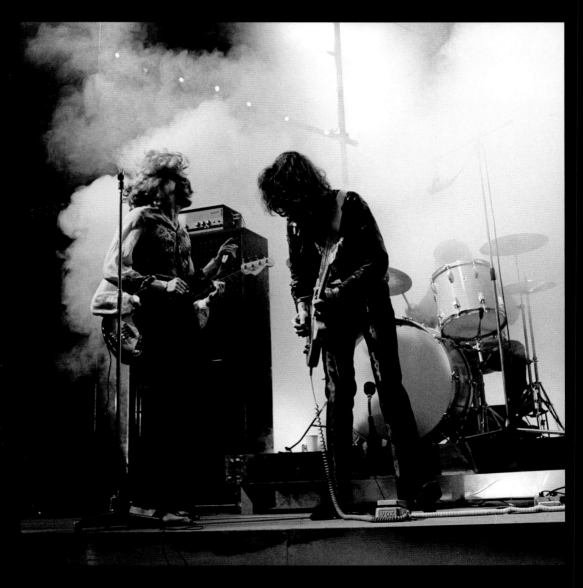

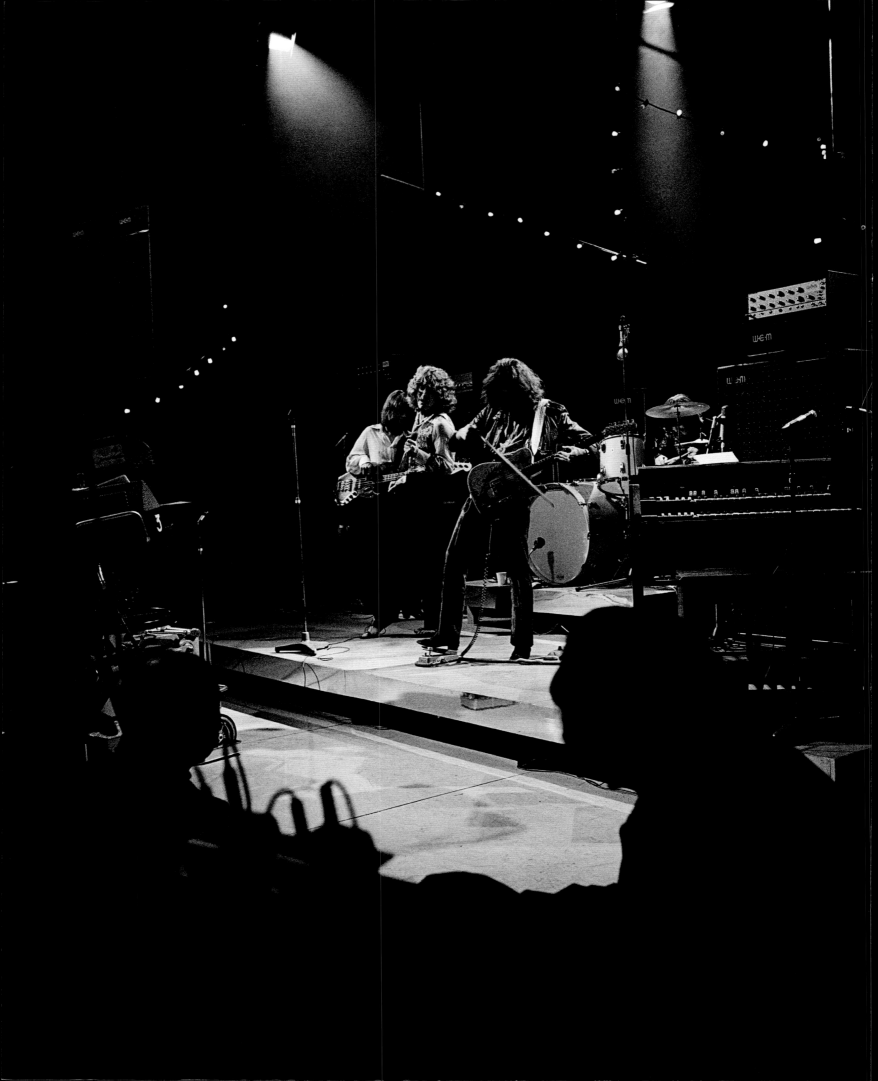

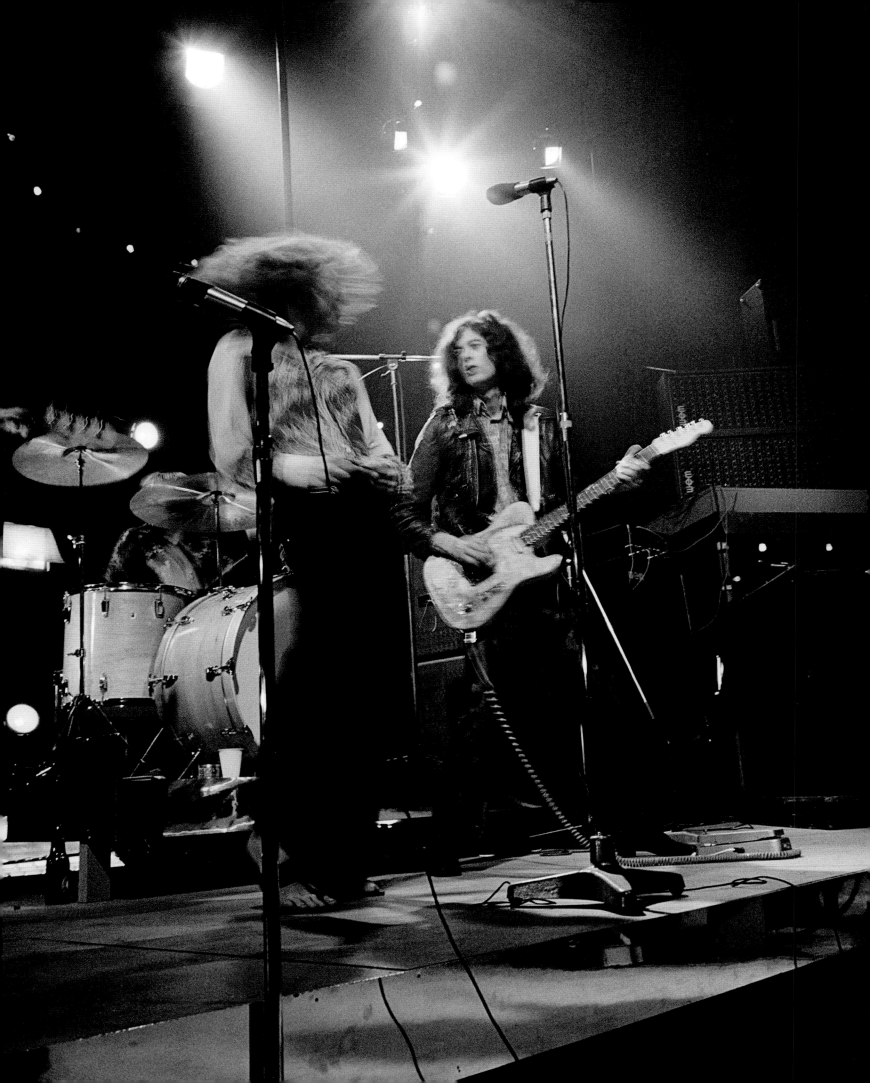

JOBRIATH 1974

Under the name Jobriath Salisbury, Bruce Campbell from Philadelphia relocated to Los Angeles in the mid-60s to appear in the musical *Hair* and, in 1969, he formed the band Pidgeon. Three years later – under the name Jobriath Boone – he released his debut album *Jobriath* and in 1974 issued his follow-up *Creatures of the Street,* which featured Peter Frampton and John Paul Jones plus photography by Mankowitz. Disillusioned by the record business, Jobriath retired in 1975 and became a New York cabaret singer under the name Cole Berlin. In 1983 he died at the age of 37.

"Jobriath Boone was a mysterious American performer who came to me because his manager Jerry Brandt was an old friend of mine from the Stones tour of America back in 1965. He was probably the first openly gay rock 'star' and was an amusing, talented and visually fascinating person to work with. Unfortunately in spite of all the hype, or perhaps because of it, his albums didn't sell and he died in New York in 1983."

MILLIE 1964

Having sung and recorded in Jamaica throughout her childhood, Millie came to London as a 17-year-old in 1963 to record the song 'My Boy Lollipop', which peaked at Number 2 in both the US and the UK during the following year. Although it was released on the Fontana label, it was the first major hit for the newly formed Island Records and went on to sell over seven million copies. Millie Small also joined the Beatles on their *Around The Beatles* TV special in 1964 and followed up her hit with two more UK Top 50 hits before fading from the pop scene, although she began recording again in 2012.

'Millie Small was a delightful bundle of energy who had a massive hit with 'My Boy Lollipop' in the UK and USA. This record was the first hit in the 'bluebeat' style of music and was also the first major hit for Chris Blackwell's Island records."

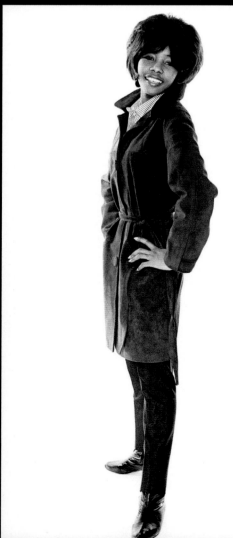

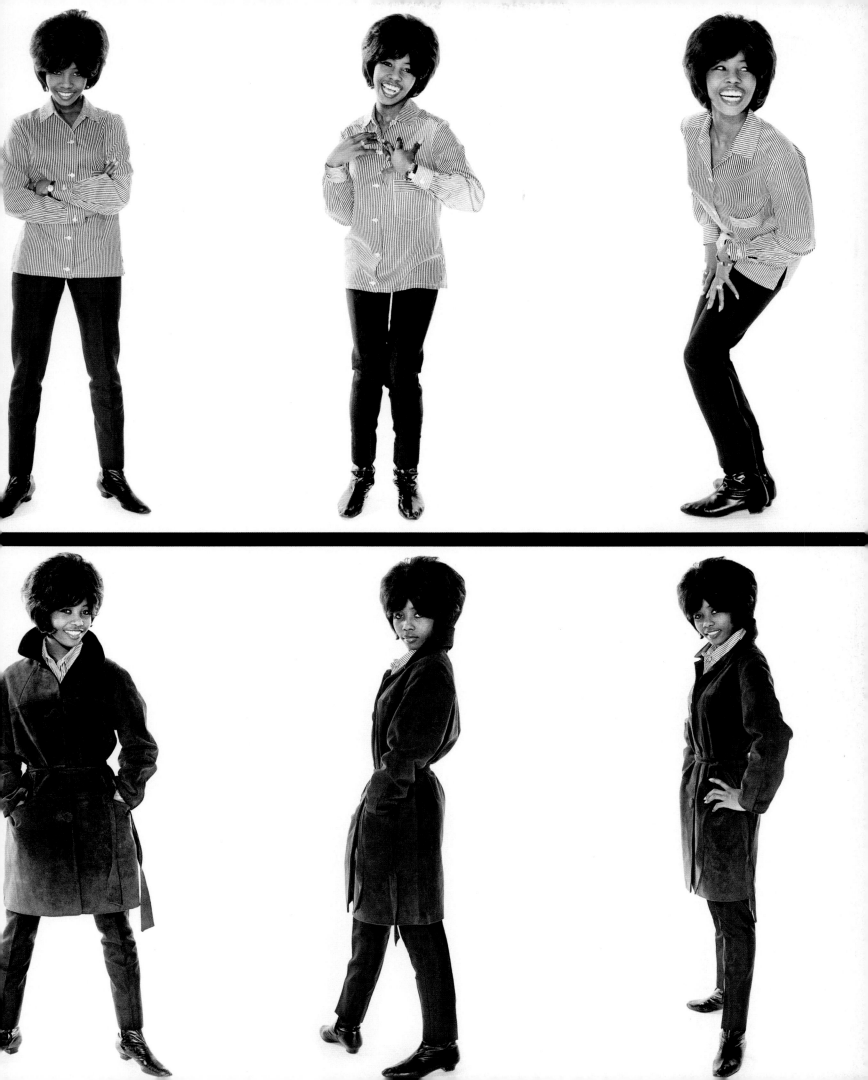

STEPHEN STILLS 1969

In 1968 – one year before Mankowitz photographed him in London – Stephen Stills joined forces with ex-Byrds member David Crosby and Graham Nash, from the British band the Hollies, to create a supergroup called Crosby, Stills & Nash. Having left Buffalo Springfield and rejected a chance to join Blood, Sweat & Tears, Stills joined his new band mates on their 1969 two million-selling debut album before Neil Young joined the band a year later to make the US chart topping album *Déjà Vu*. Over the next four decades the band members recorded as a four-piece, as a trio, and as the duo Crosby & Nash while Stills also made numerous solo recordings.

"Stephen was another artist who appeared in the ill-fated TV show *Supersession*. He got into the spirit of the production and played a couple of great sets."

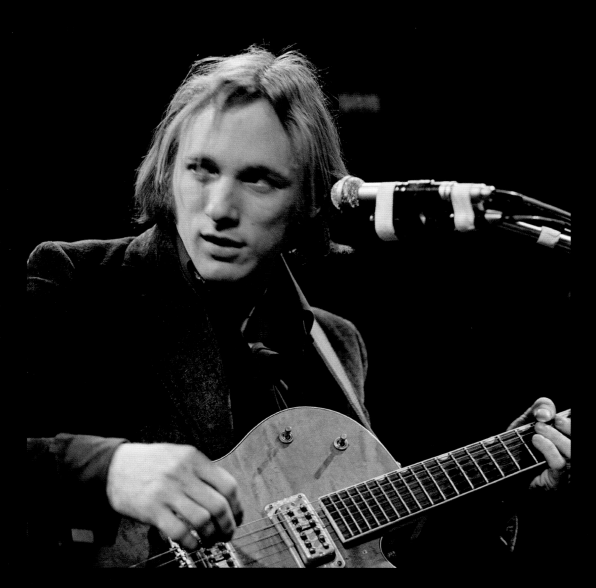

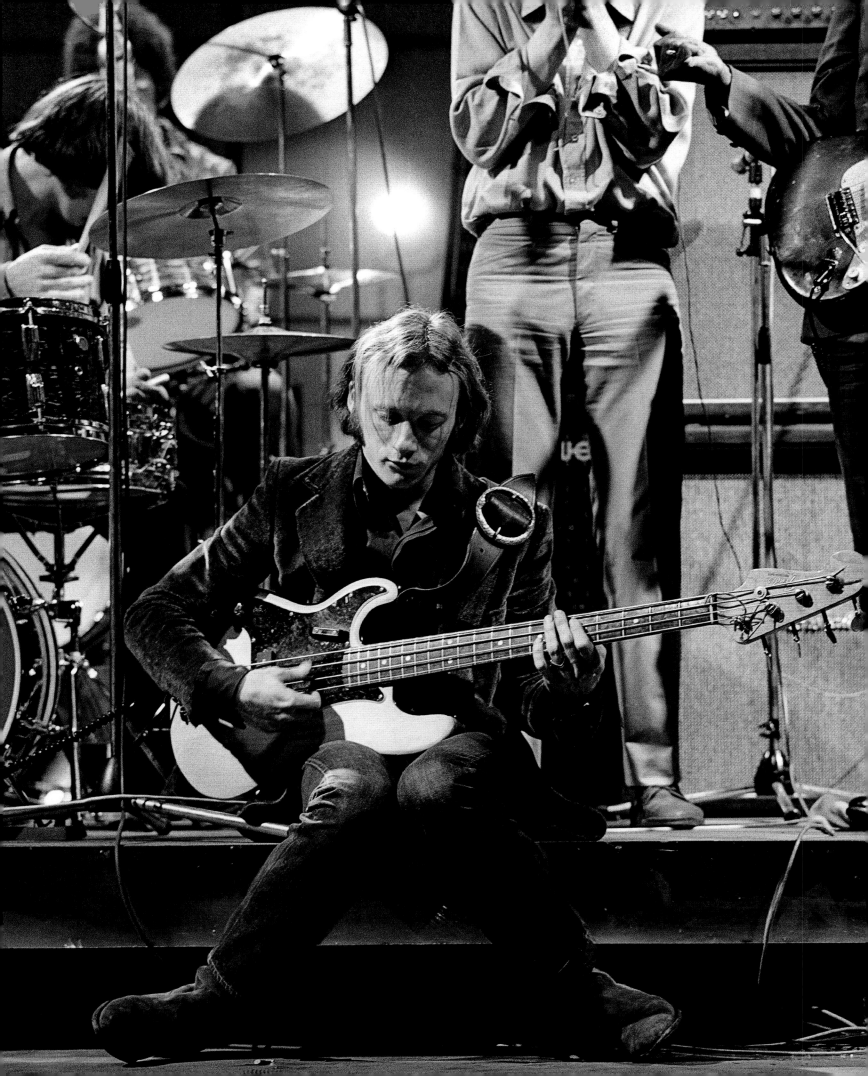

CATATONIA 1995

Welsh indie-pop band Catatonia was formed in Cardiff in 1991 when singer Cerys Matthews joined up with Mark Roberts, Owen Powell, Paul Jones and Aled Richards. Their first chart success came in 1996 but it was in 1998 when they broke through with the Top 3 single 'Mulder And Scully' and the chart-topping album *International Velvet*. Their second UK Number 1 album – *Equally Cursed and Blessed* – in 1999 was followed by a final Top 10 collection in 2001 when the five-piece band decided to part company, Matthews pursuing a solo career as both a singer and a broadcaster.

"This was pretty early in the band's career and before they made it really huge. Cerys was obviously a 'star' and had terrific charisma and was very photogenic. She understood the camera and how to project into it and responded well to my direction. She rather overshadowed the rest of the band and trying to get them to project a suitable mood was a bit tricky!"

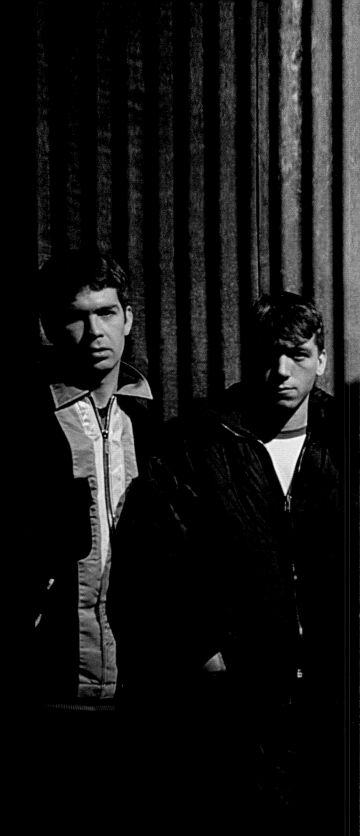

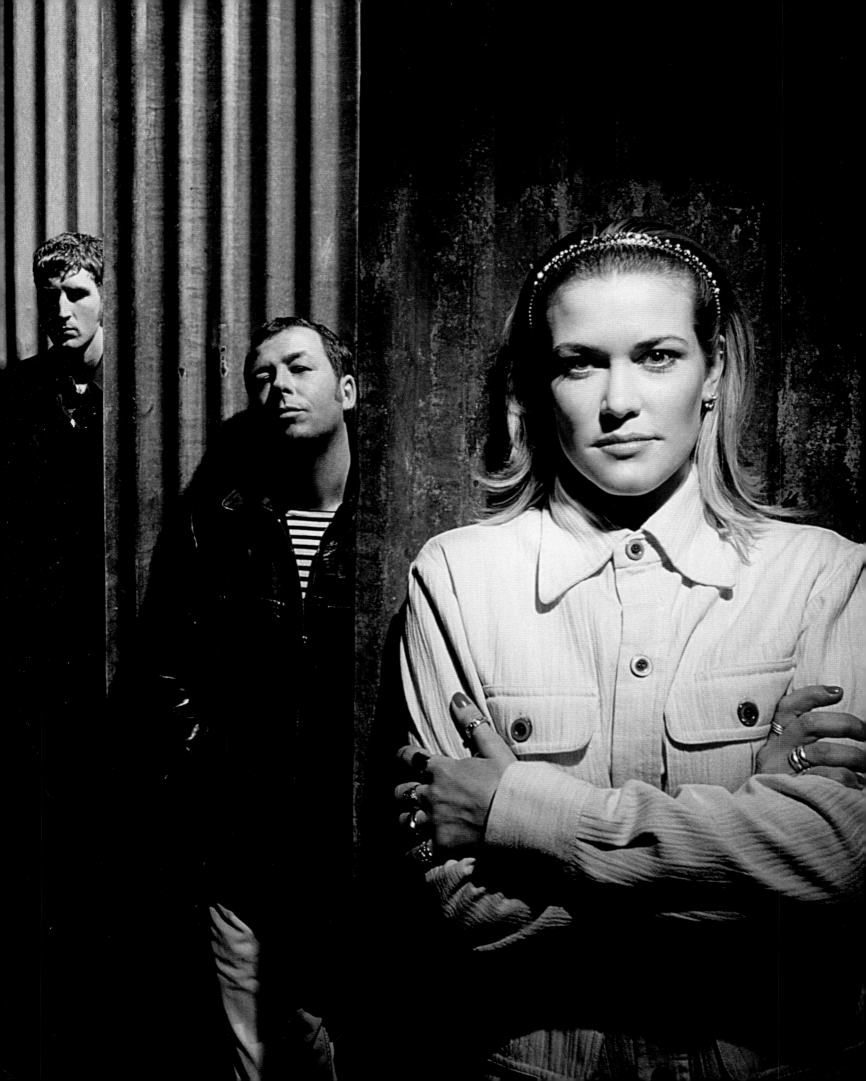

JOHN BARRY SEVEN 1963

Musician, composer and arranger John Barry formed the first John Barry Seven in 1957 and soon after they began appearing on the TV shows *Six-Five Special* and *Oh Boy!* They hit the charts for the first time in 1960 with 'Hit And Miss', the theme tune to the TV show *Juke Box Jury*, but after seven more hit singles – including the Top 20 hit 'Walk Don't Run' – the JB7 briefly disbanded in 1963 although Barry reformed the line-up photographed by Mankowitz later the same year. However, with Barry concentrating on composing and arranging film music – including the 'James Bond Theme' – the John Barry Seven finally folded in 1965.

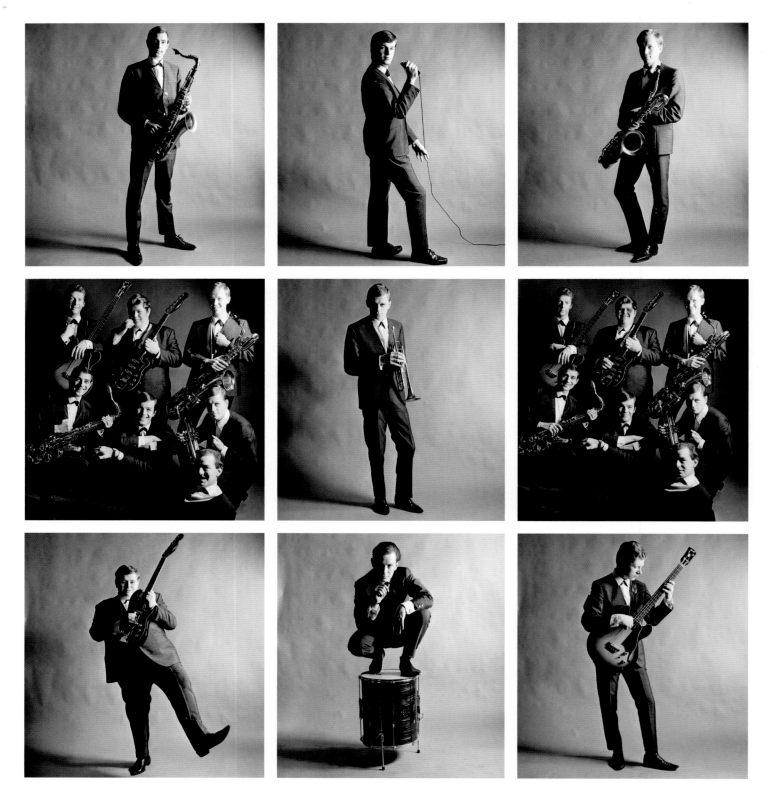

"John Barry is so important to my career – I first met him through Chad & Jeremy and because of him I started to work on a regular basis for Ember Records and consequently became a full-time and fully committed music photographer. The John Barry Seven was formed to promote the John Barry name and the instrumental hits that he was producing at the time. They were a terrific group of guys, all of whom went on to have important careers in varying genres of popular music, and I tried to present them as serious musicians!"

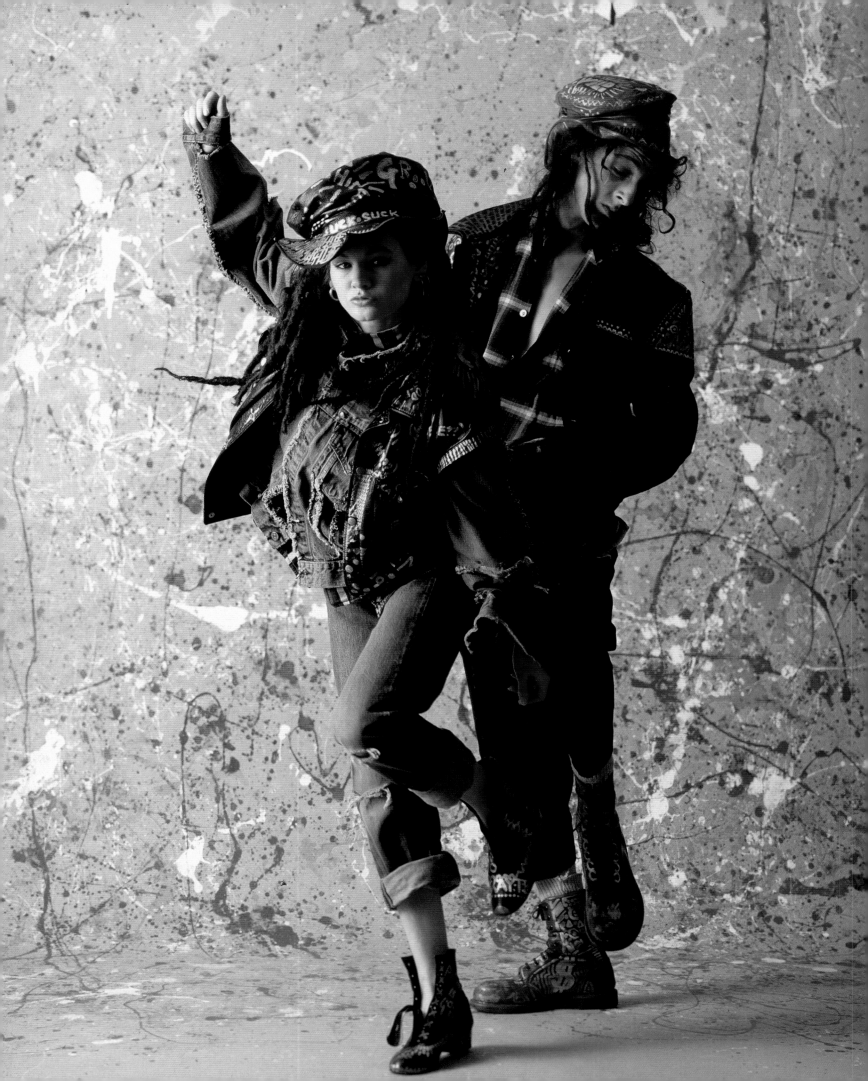

Haysi Fantayzee came together in 1981 when singers Jeremy Healy and Kate Garner teamed up with pianist, writer and producer Paul Caplin to create the act which reached the UK Top 20 in 1982 with the single 'John Wayne Is Big Leggy'. The quirky duo, whose style of dress was described as "charity shop" or a combination of Dickensian meets Huckleberry Finn, released three more hit singles and the album *Battle Hymns For Children Singing* before Haysi Fantayzee finally broke up in 1983.

"Haysi Fantayzee had scored a big hit in 1982 and had built up a considerable fan base as well as generating a lot of media interest. They were famous for their garish and avant-garde fashions and Kate had become a bit of an alternative sex symbol! I had been told before the session that they were going to wear some new clothes which they had decorated themselves, and so I decorated a paper background with Jackson Pollack style splashes that I thought might work with the outfits. When they first arrived they were very odd and completely unable to communicate and might have been totally stoned, although it could have just as easily been some sort of 'pose'! Jeremy appeared to be entirely incapable of anything, but they actually managed to dance rather well in a strange and slightly tribal manner and I thought the shoot was rather successful, making magazine covers all over the world. Kate now lives in Los Angeles and is an excellent photographer."

SNOW PATROL 2004

...ed by Gary Lightbody, Snow Patrol emerged out of Scotland's Dundee University in ...994 under the name The Polars Bears. In 1998, after the group of Lightbody, Mark ...cLelland and John Quinn had opted for a change of name, they released their debut ...lbum and recruited new member Nathan Connolly. In 2004 the group's third album *Final Straw* reached Number 3 in the UK alongside the Top 5 single 'Run'. Operating ...n recent years as a six-piece band, Snow Patrol have released a total of six albums, ...ncluding the Number 1 hit *Eyes Open* plus the Top 3 successes *A Hundred Million Suns,* from 2008, and *Fallen Empires* in 2011.

"Snow Patrol had really broken through by the time I shot this session, but their ...isual image needed some work and the record company asked me to try and come ...p with a really strong, glamorous look for the band."

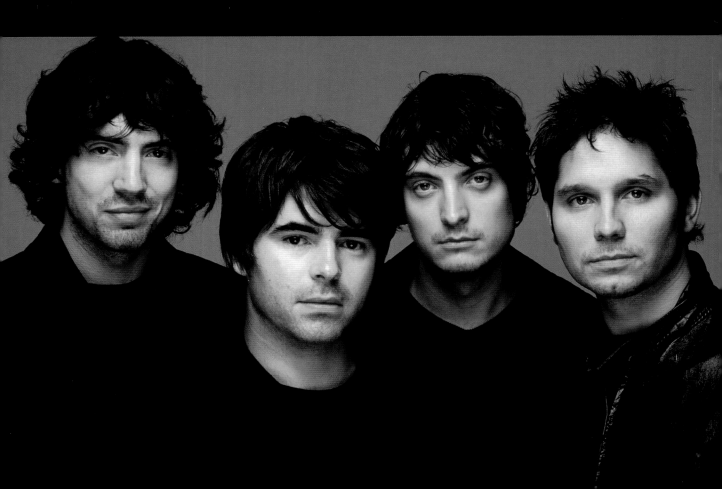

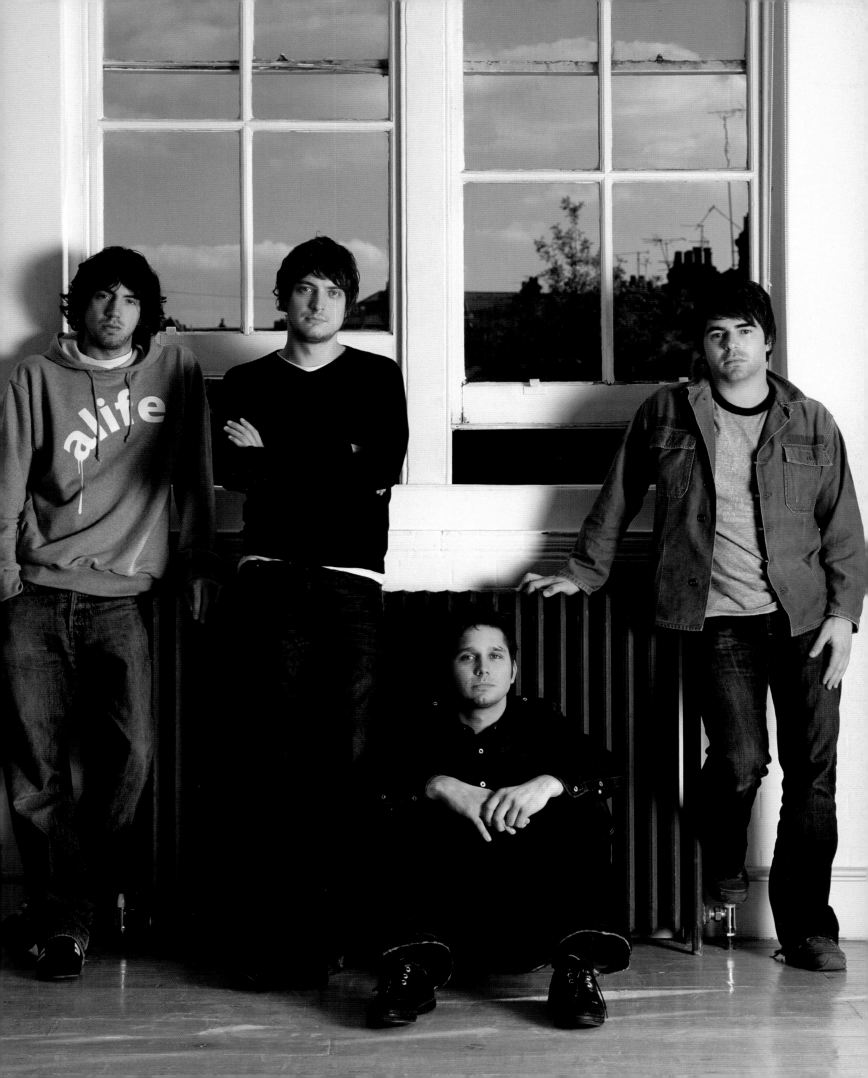

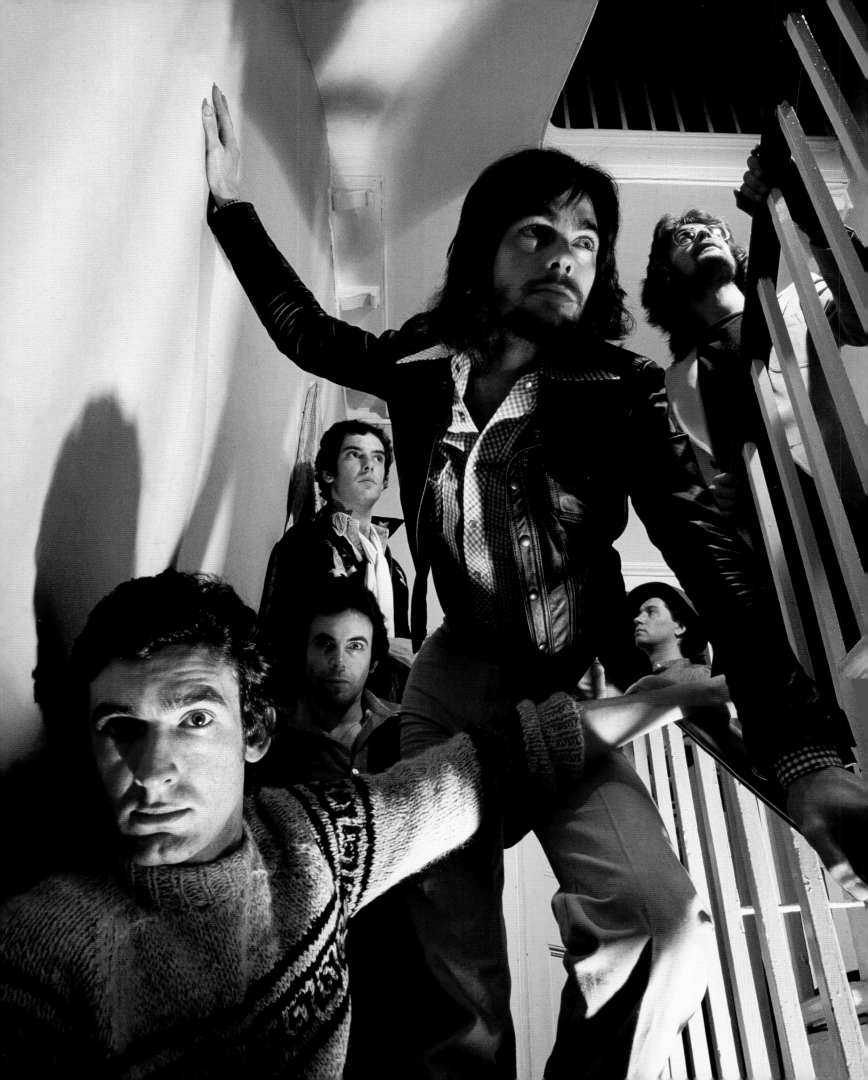

SAD CAFE 1977

Formed in Manchester in 1976, when musicians from the bands Mandala and Gyro got together, Sad Café released their first album *Fanx Tara* – featuring Mankowitz's cover photography – in 1977 and reached the UK Top 60. The six-piece line-up – with Paul Young as vocalist – reached Number 3 in 1979 with the single 'Every Day Hurts' and the Top 20 in 1980 with 'My Oh My'. After initially breaking up in 1990, the band reformed three more times, including getting together for a tribute concert for singer Young, who left to join Mike + The Mechanics in 1985 and died in 2000.

"These two shots were for the back cover of the band's album *Fanx Tara*. I always felt uncomfortable about the actual cover which showed a partly dressed young woman and decided not to include it here! Bands have always loved any opportunity to put a semi-naked woman on their covers and I have managed to resist this throughout most of my career but weakened on this occasion…"

HOWARD DEVOTO / MAGAZINE 1978

After just one album – and a memorable tour in 1976 with the Sex Pistols and the Damned – Howard Devoto left Manchester punk band Buzzcocks to form Magazine with John McGeogh, Barry Adamson, Martin Jackson and Bob Dickinson. Their 1978 debut single 'Shot By Both Sides' reached the UK Top 50 and was followed by an album and five more singles before Magazine split in 1981 and Devoto went solo. With his new five-piece band he released one hit album and then took four years off, returning in 1988 to link up with Noko to form Luxuria.

"Howard Devoto had left Buzzcocks in 1977 to form his new band Magazine. Virgin records asked me to meet him and discuss a photo-shoot and I thought we had got on really well and left the meeting full of ideas for the session. When Howard arrived at the studio he seemed somewhat disoriented and although we managed to get the first setup completed, when I tried to move on to my next idea he began to complain about what I was doing, and after a few heated words chose to leave the shoot. I never understood what his problem had been, but have always loved the one portrait we did get."

KATE BUSH 1978 TO 1979

Kate Bush was just 18 when she signed her first recording contract in 1976 and two years later her debut single 'Wuthering Heights' raced to the top of the UK charts and was followed by her Top 3 debut album. Since then Bush – who was the first British female artist to have a UK Number 1 album – has notched up over 25 hit singles and a further nine chart albums although she has delivered only three in the last two decades. She is a reluctant live performer, and her only major tour of the UK and Europe took place in 1979, although she has appeared on stage with Pink Floyd's Dave Gilmour, the man who discovered her, and Peter Gabriel.

"When I first heard Kate's single 'Wuthering Heights' I knew that her record company needed a really strong portrait to support this strange and enchanting music. Her interest in dance inspired me to suggest that she wear dancers' practice gear and she looked wonderful! She was frenetic and exhausting to work with but endlessly rewarding!"

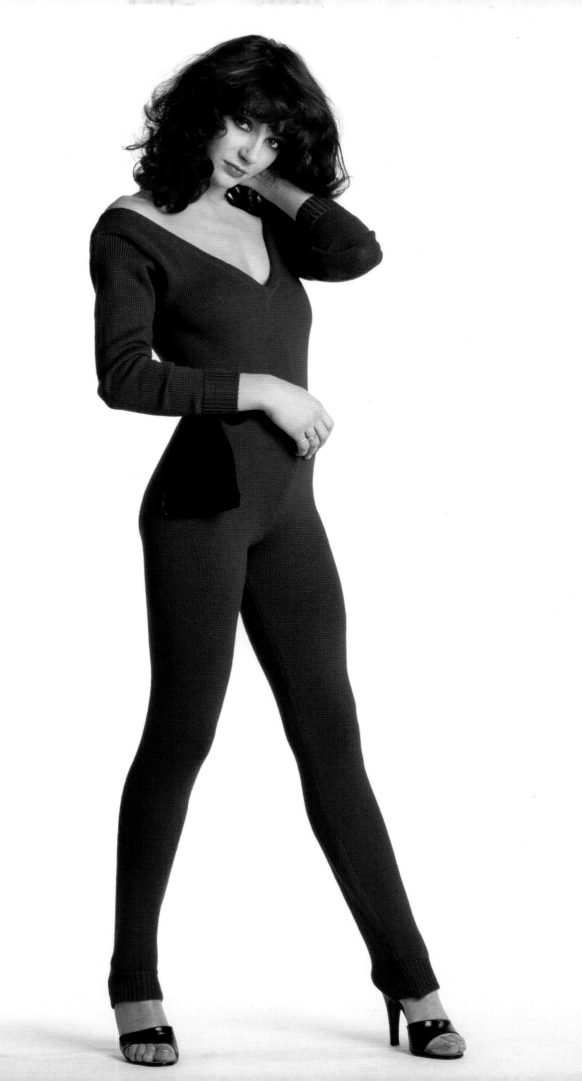

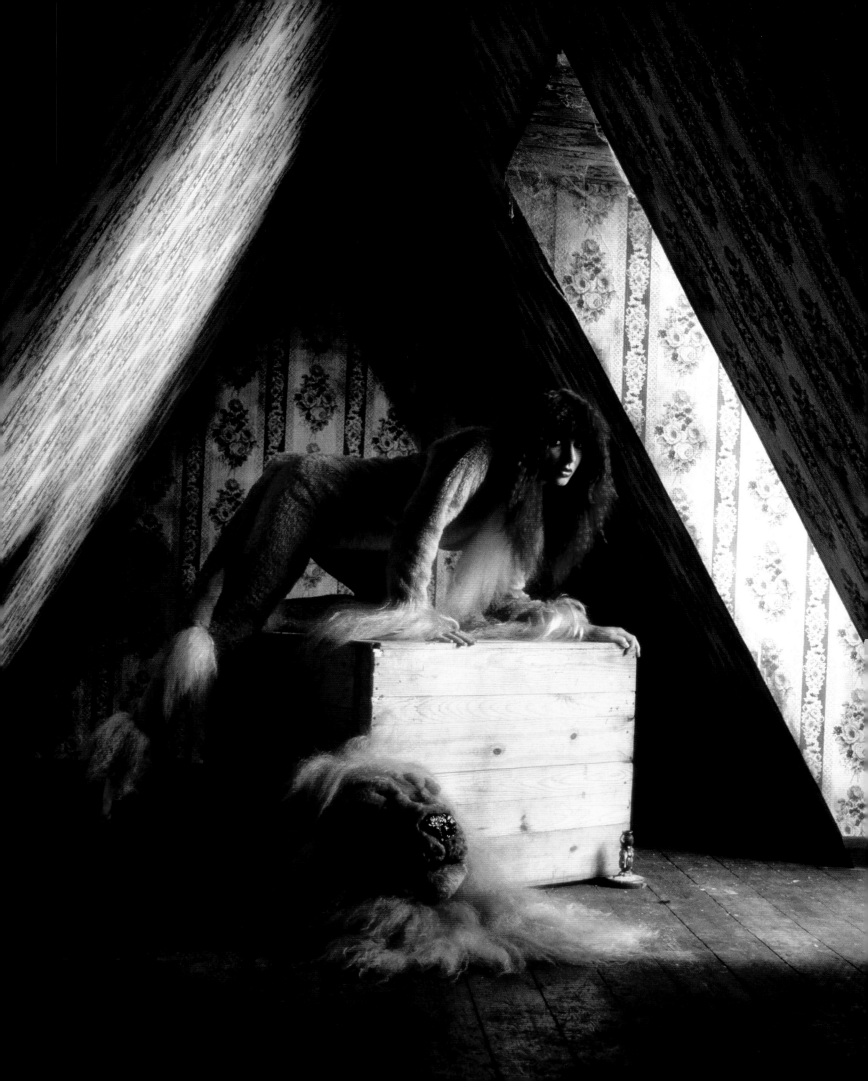

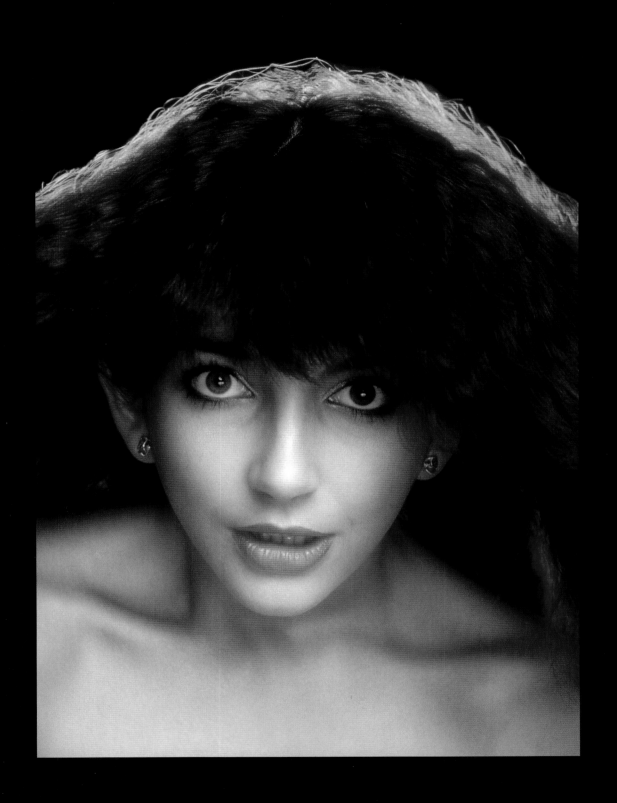

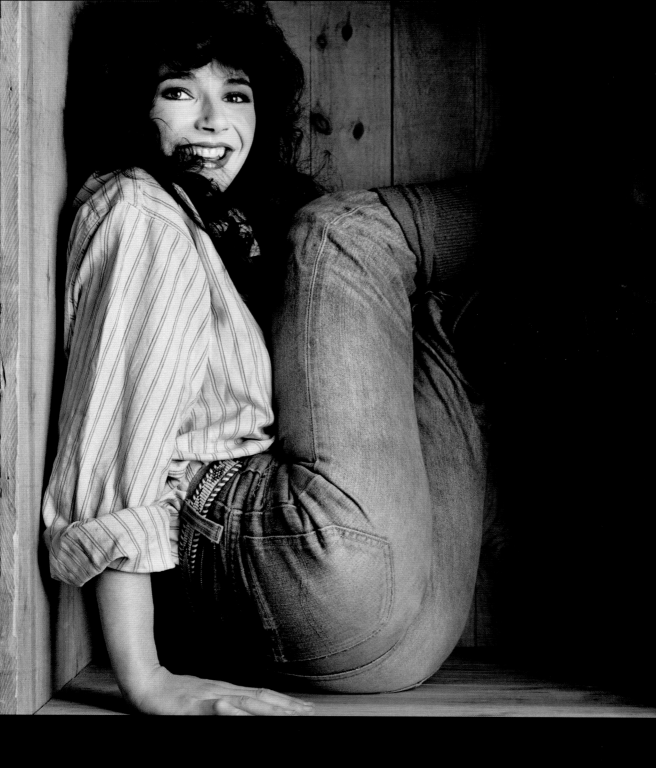

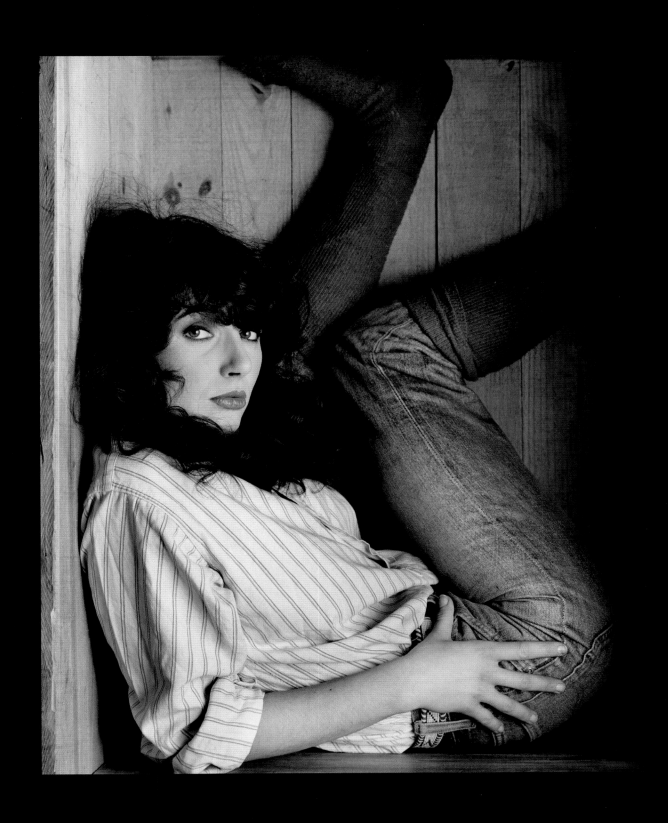

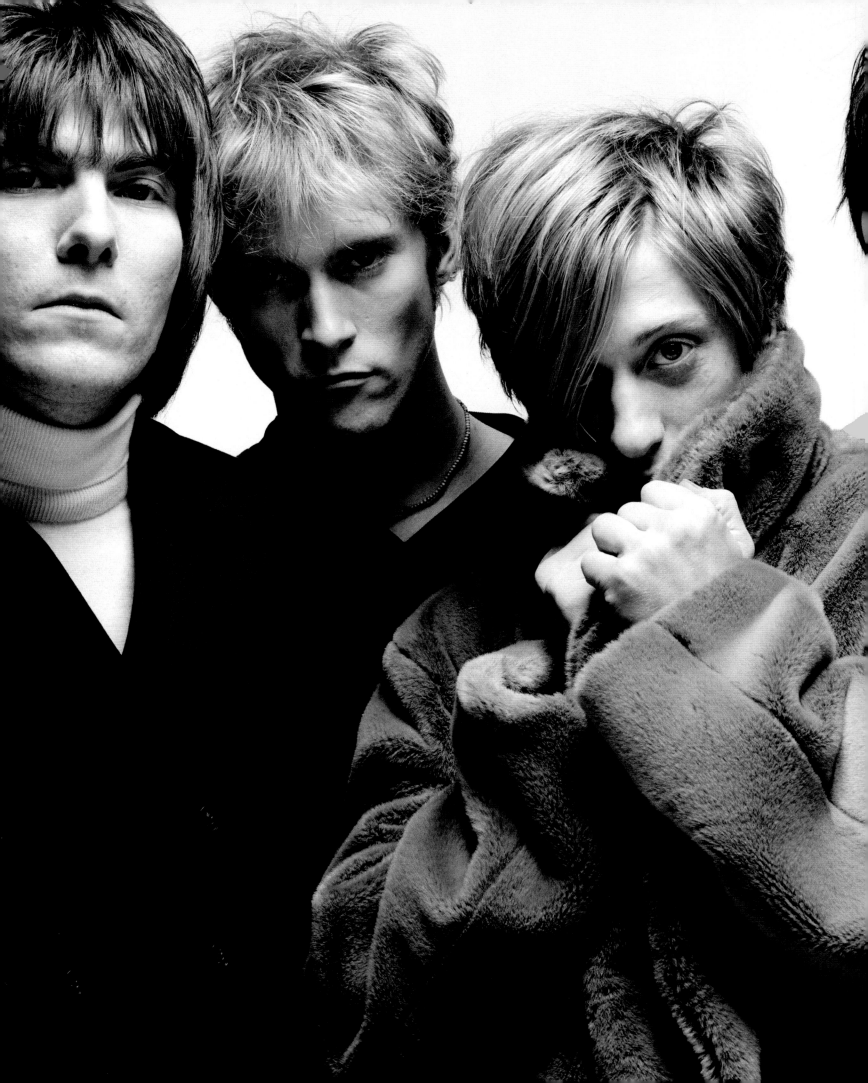

KULA SHAKER 1996

Crispian Mills – the son of actress Hayley Mills and director/writer Roy Boulting – formed two early bands called the Lovely Lads and the Objects with school mate Alonza Bevin before Kula Shaker emerged and jointly won the 1995 In The City contest for new bands. Together with Jay Darlington and Paul Winter-Hart, they went on to release five Top 10 singles between 1996 and 1998 plus the Number 1 album *K*. After the 1999 success of their Top 10 album *Peasants, Pigs & Astronauts*, Kula Shaker disbanded later the same year and Mills went on to form Jeevas.

"I thought that Kula Shaker had tremendous potential and their charismatic singer Crispian Mills really knew how to work in front of the camera. I was pleased to work with them so early in their career and was sorry to see them break up in 1999."

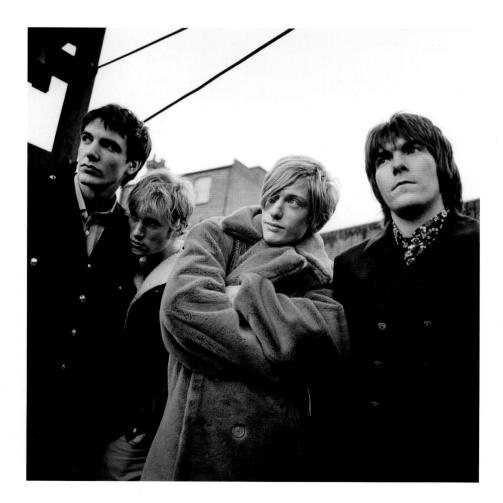

GENERATION X 1978

Singer Billy Idol formed Generation X in 1976 in the midst of Britain's punk boom and recruited Tony James, John Towe and Bob Andrews into the band, who debuted on the charts in 1977. Their first album – which was photographed by Mankowitz – was released in 1978 (with Mark Laff in for the departed Towe) and peaked at Number 29. The following year the single 'King Rocker' made it to Number 11 in the UK, but by 1981 the band had runs its course and after the final album *Kiss Me Deadly*, Idol left to pursue his career as a successful solo singer.

"Apparently Billy Idol wanted to work with me because of my covers for the Stones back in the 60s. I was delighted to work with them, as they were very powerful visually and I felt that they encapsulated the poseur punk post-76 look. I took them very seriously and we developed several completely new techniques to try and give them a really unique package."

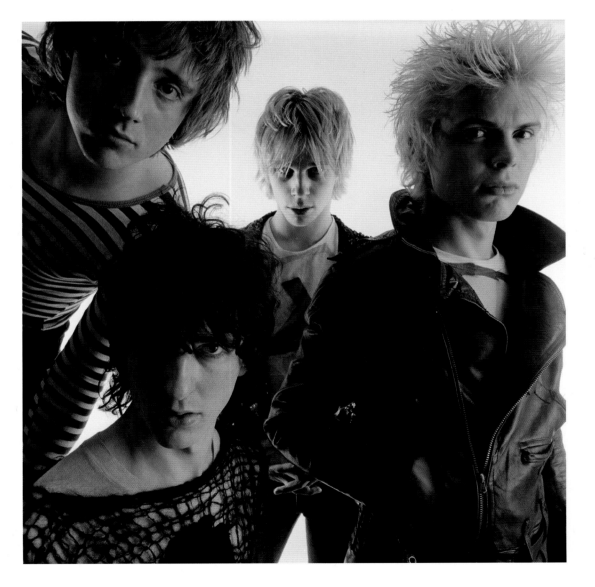

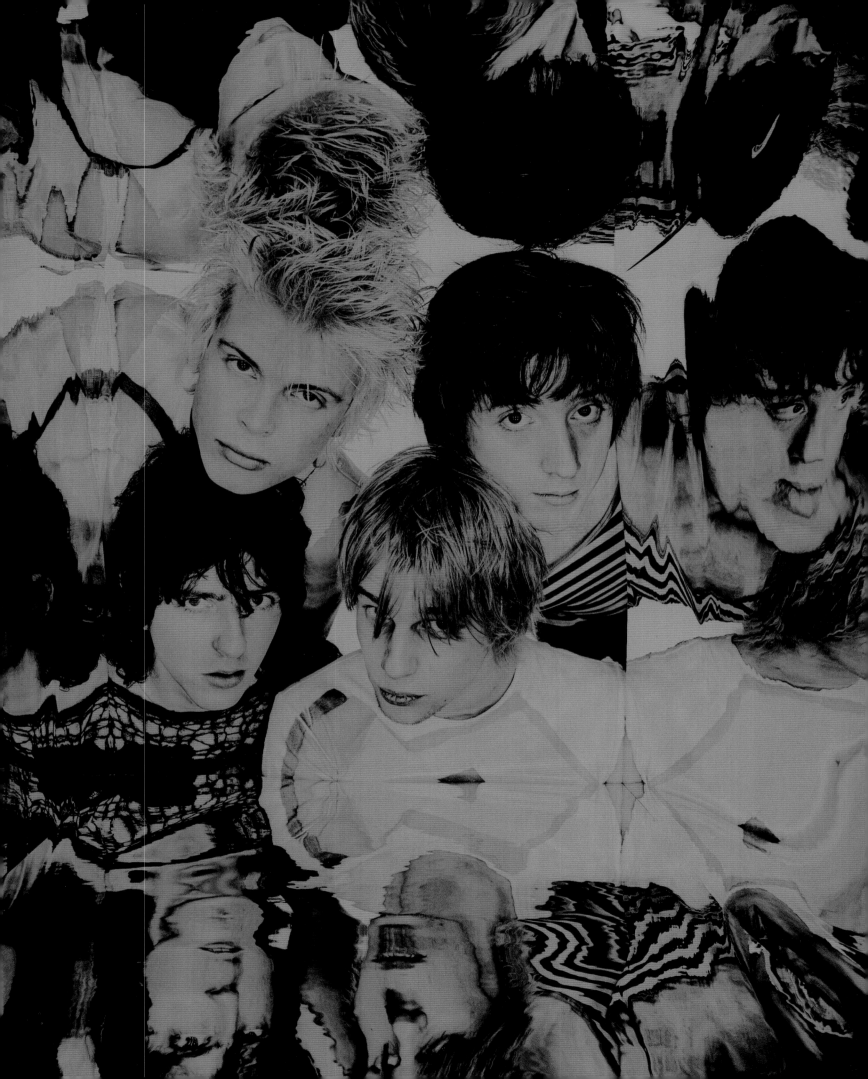

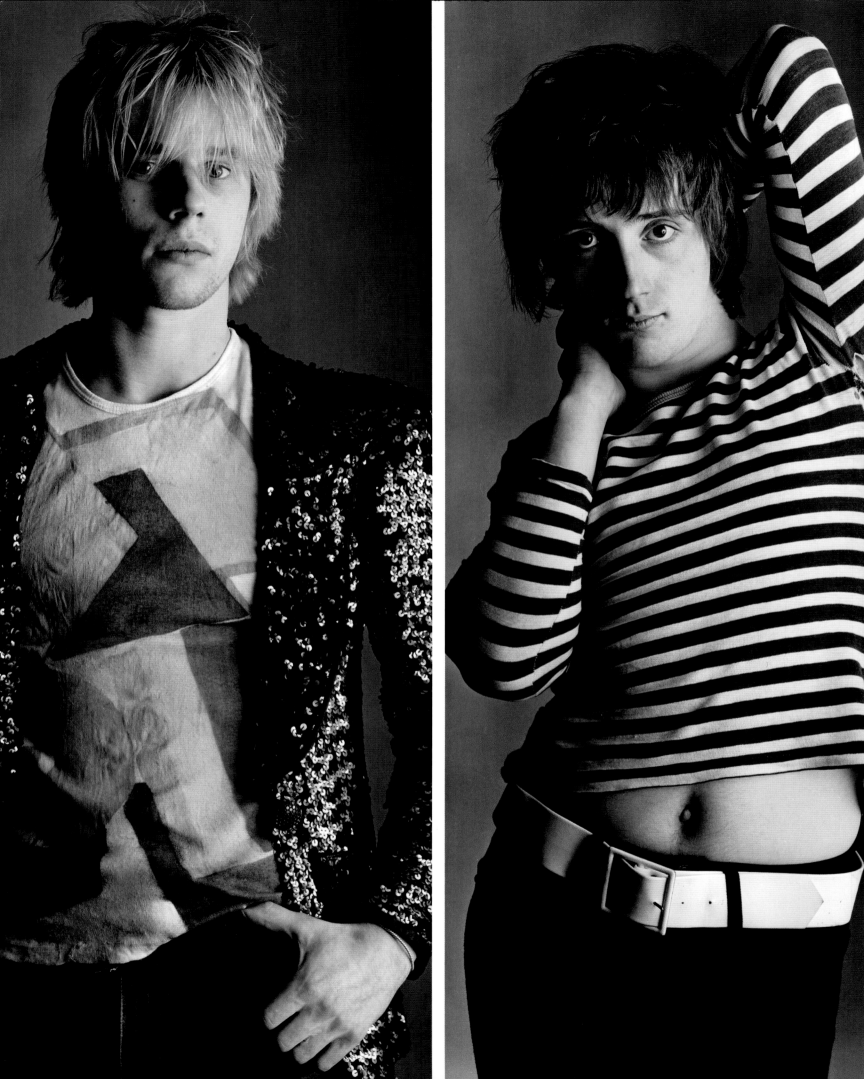

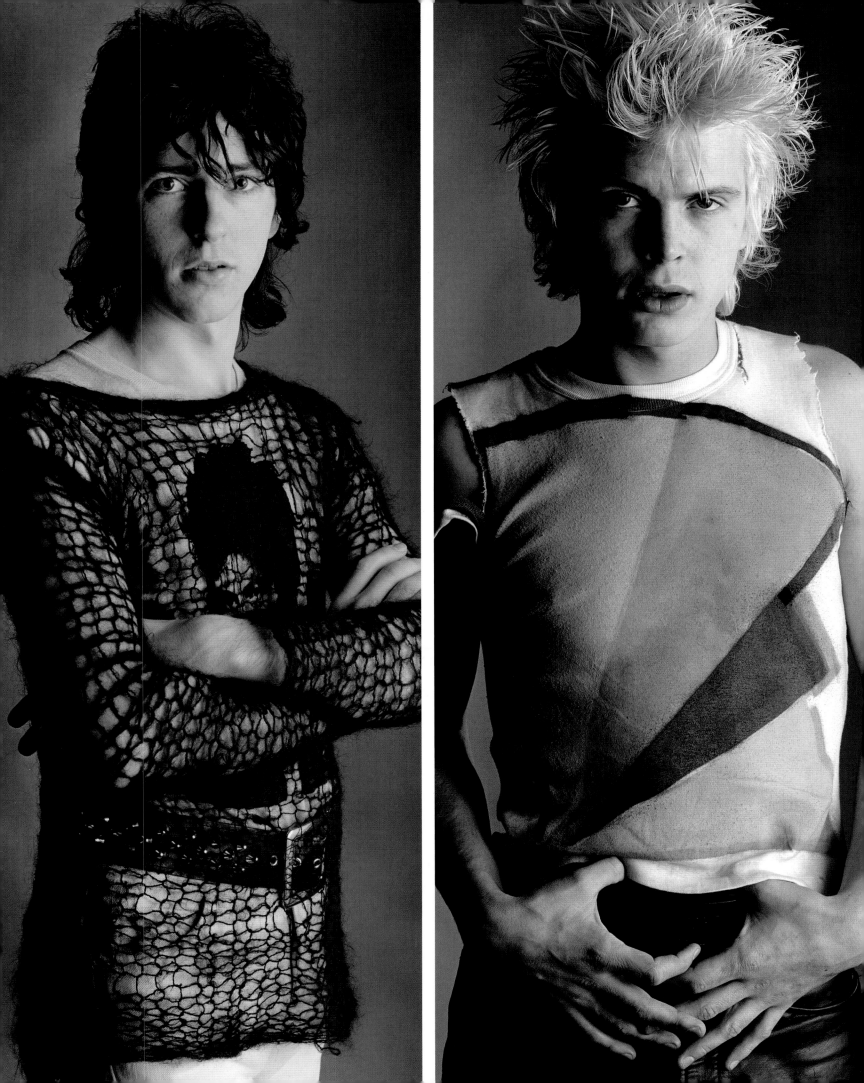

ELTON JOHN 1977, 1986 & 1987

Elton John began performing in 1961, made his first solo recording seven years later and debuted in the UK singles chart in 1971 when 'Your Song' reached the Top 10. Since then he has sold over 150 million albums, including more than 40 chart entries, and racked up in excess 90 chart singles. In 1977 he released his *Greatest Hits Vol II* – featuring Mankowitz's cover shot of John playing cricket – and John's later "bootleg" release *Leather Jacket Demos* included another photograph by Mankowitz. In 1997 at the funeral of Diana, Princess of Wales, John performed his song 'Candle In The Wind' and the subsequent single, released for charity, amassed record worldwide sales of over 33 million.

"I have done four covers for Elton although he has appeared in only two of them! All of them were made with my dear friend and top art director David Costa. *Greatest Hits Volume II* was shot in my studio in 1977 and was the first time I met Elton. *Leather Jacket Demos* was shot in Hilversum, where he was recording the album – and, as you can see, Elton and the band went mad with the costumes! The other photograph was for the 1987 *Live in Australia with the Melbourne Symphony Orchestra* album and took three days to build and set up!"

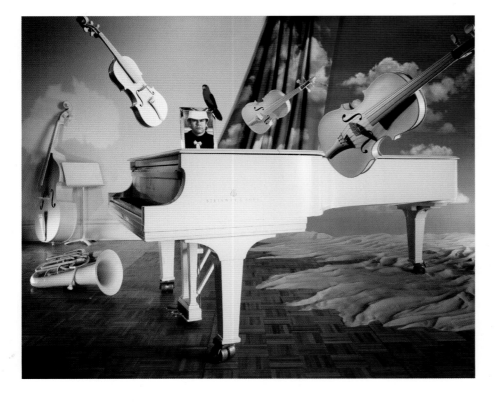

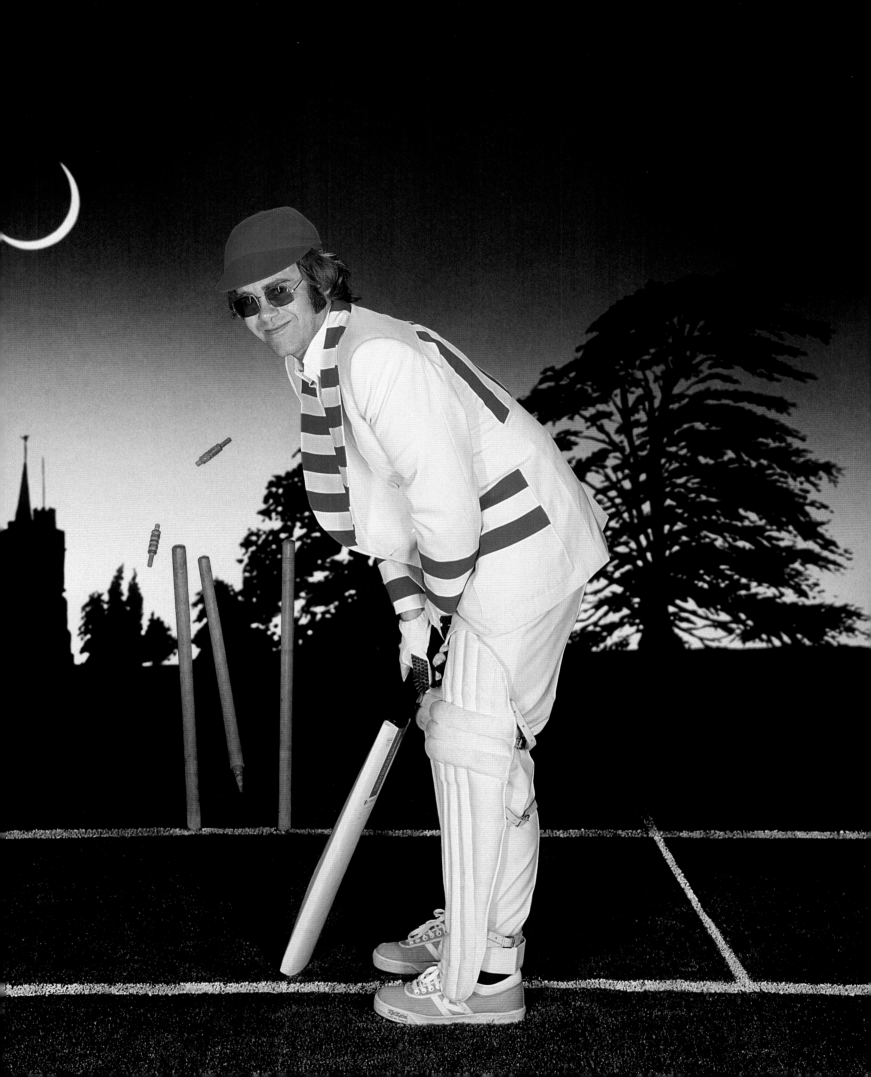

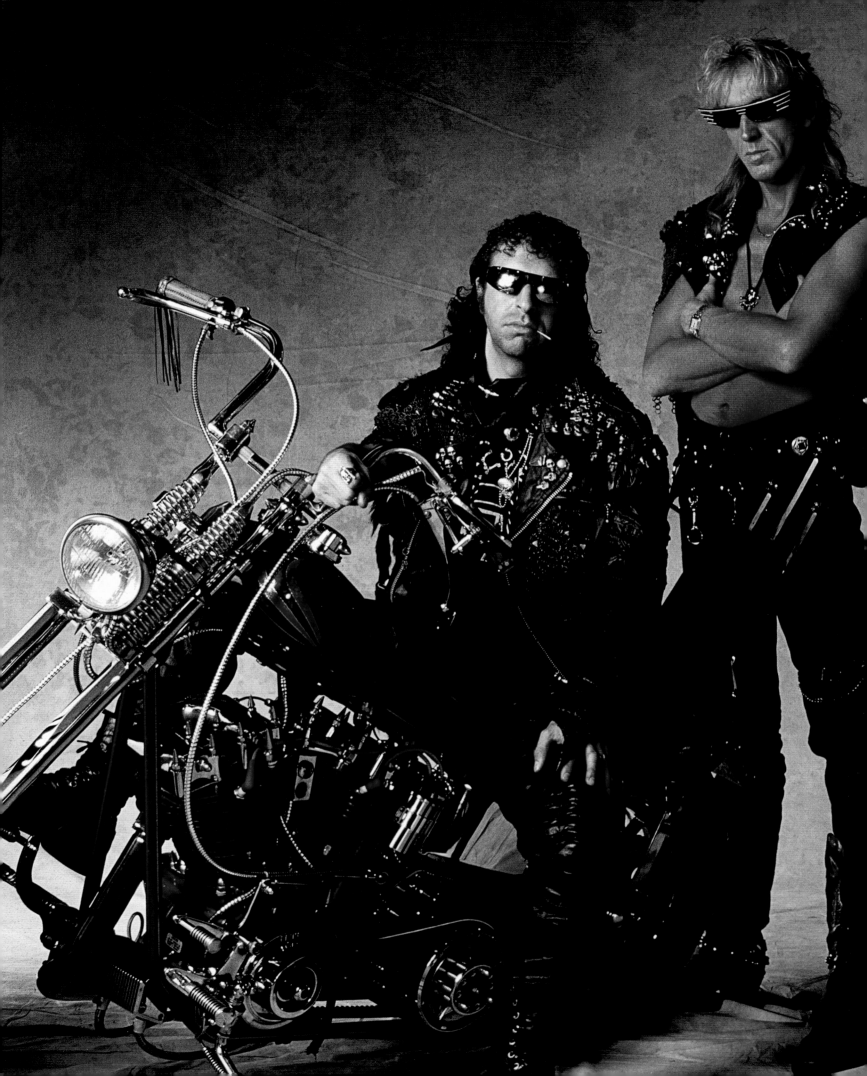

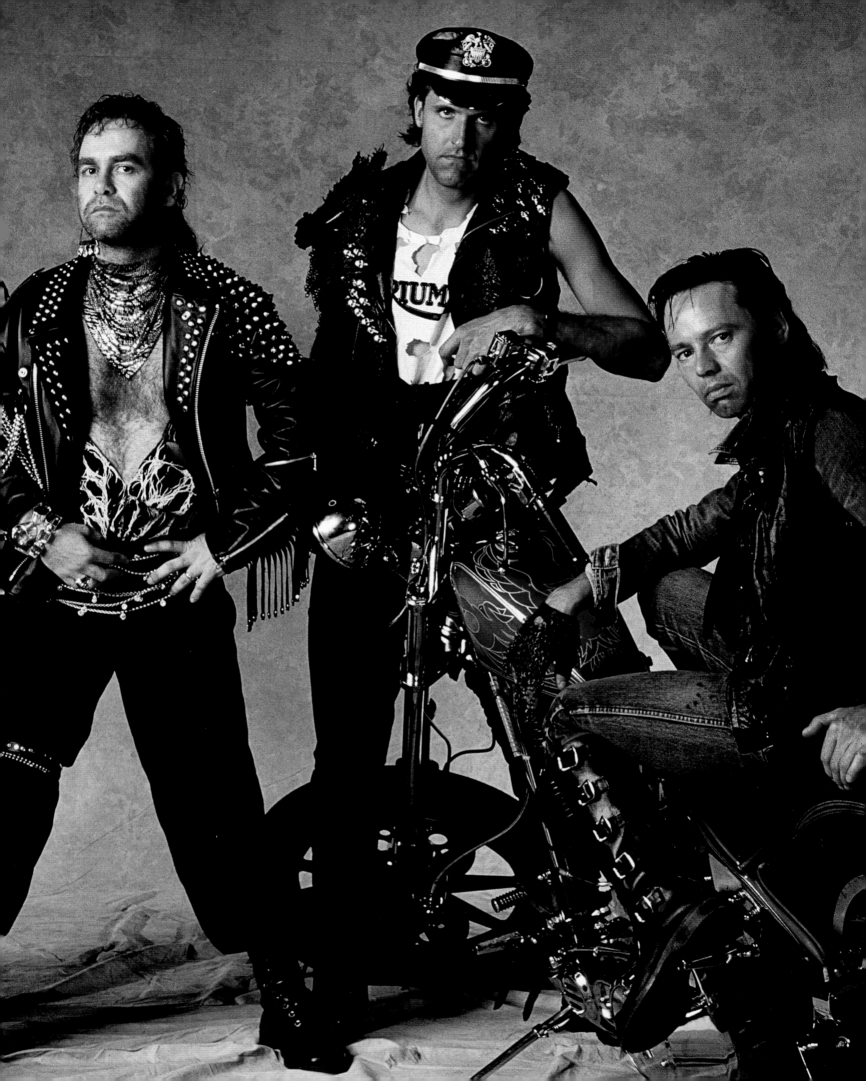

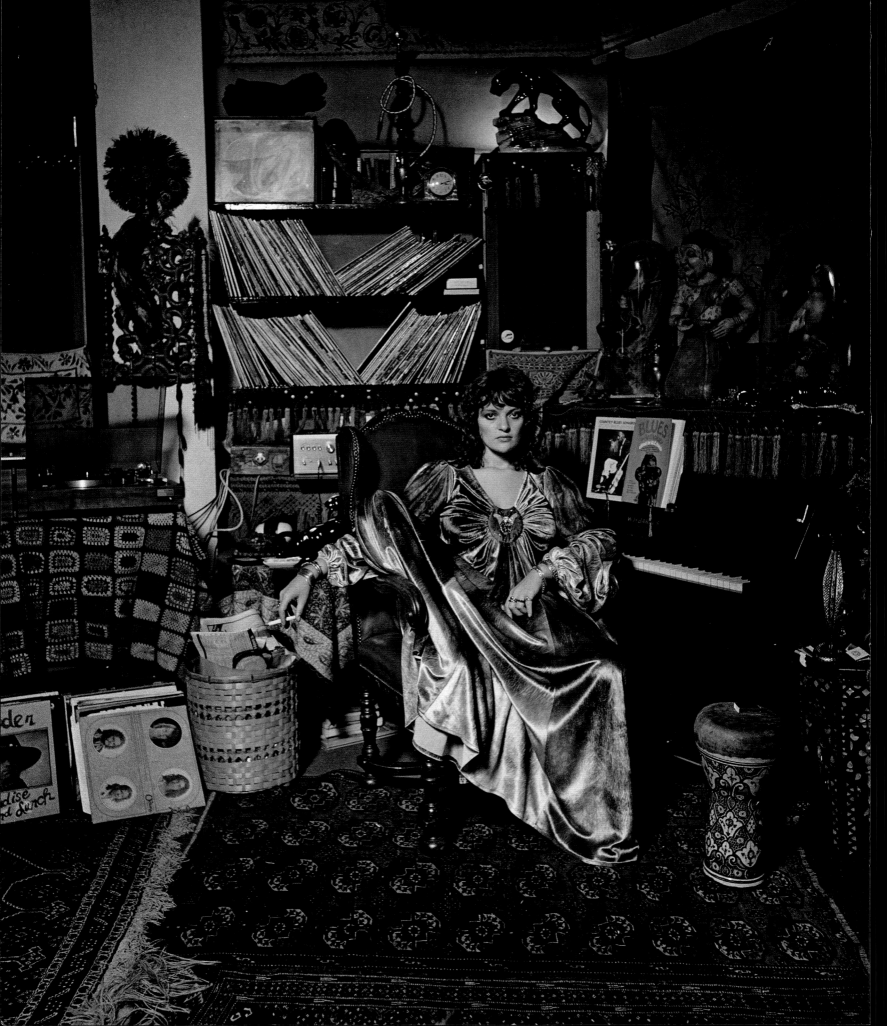

DANA GILLESPIE 1965 ONWARDS

Born in Surrey in 1949, Dana Gillespie began her career as a folk singer before she moved in to pop music in 1966 to record 'Thank You Boy', which was produced by Led Zeppelin's Jimmy Page. She sang on David Bowie's album *Ziggy Stardust*, and her own 1973 album *Weren't Born A Man* was co-produced by Bowie with Mick Ronson. Gillespie, who appeared in the first stage production of *Jesus Christ Superstar*, is credited with being involved in the making of over 45 albums and appearing in ten movies between 1966 and 1990. She has now turned her attention to fronting the London Blues Band.

"I have been fortunate to have known and worked with Dana for over 40 years! Back in the 60s she was one of the sexiest women in music and over the years has evolved into one of the greatest blues singers this country has produced, winning awards for her vocal accomplishments and producing over 40 albums, for many of which I have shot the covers. Over the past few years her love of India has led her to produce several albums of spiritual music under the name Third Man."

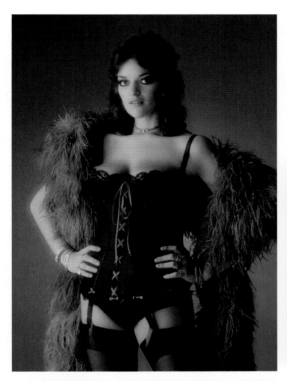

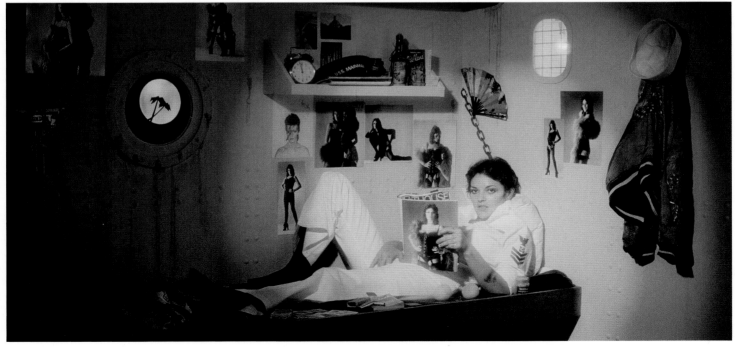

LIGHT OF THE WORLD 1982

Taking their name from the title of a 1974 Kool & The Gang album, British jazz funk group Light Of The World came together in 1978 when Breeze McKrieth, Kenny Wellington, Paul Williams, David Baptiste and Jean Paul Maunick joined forces and recruited three more musicians to complete the band's original eight-piece line-up. Releasing their debut album in 1979, the group notched up six UK hit singles before re-emerging as a trio consisting of Nat Augustin, Ganiyu Bello and William Carson, who made the album *Check Us Out* in 1982, which featured Mankowitz's photography on the cover.

"I wanted to include these shots because I thought the image was so extraordinary and eccentric! The band were an eight-piece when they first formed in the late 70s but had reduced to just three by the time they came to me for the cover of their *Check Us Out* album in 1982."

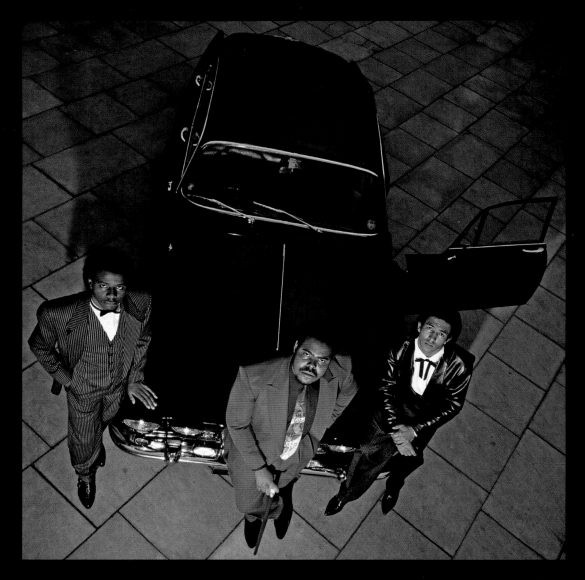

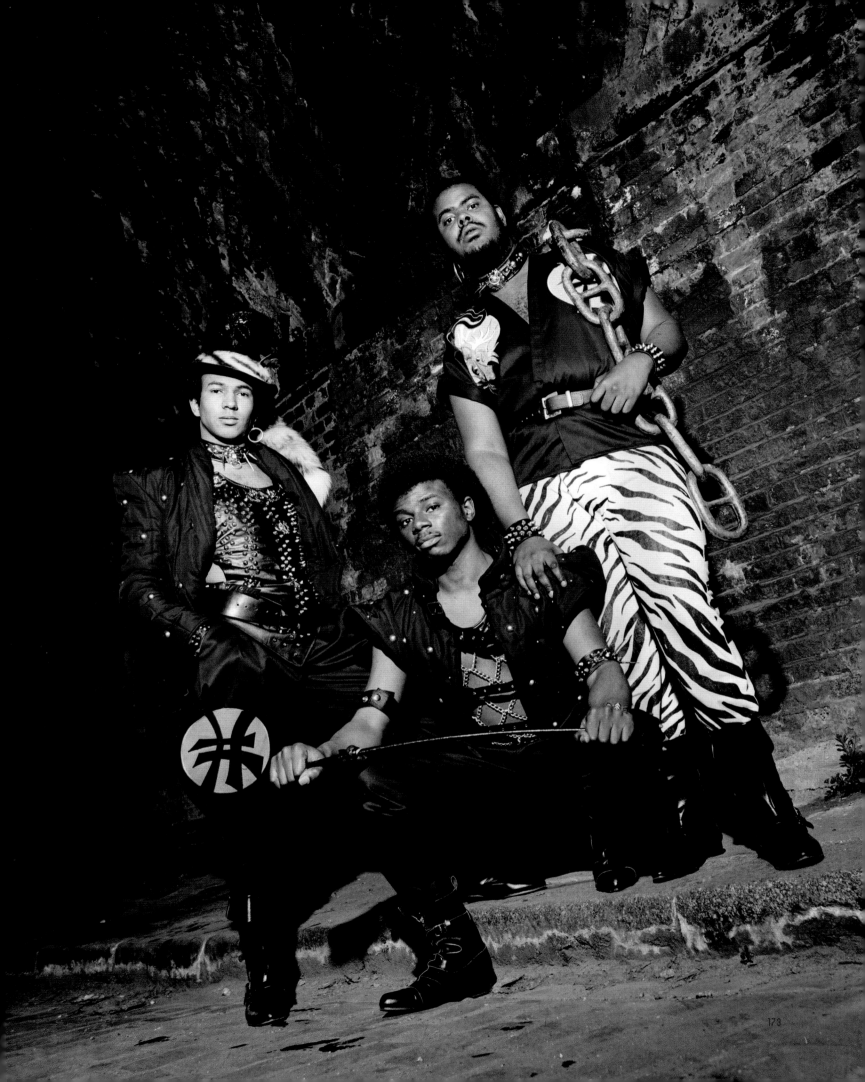

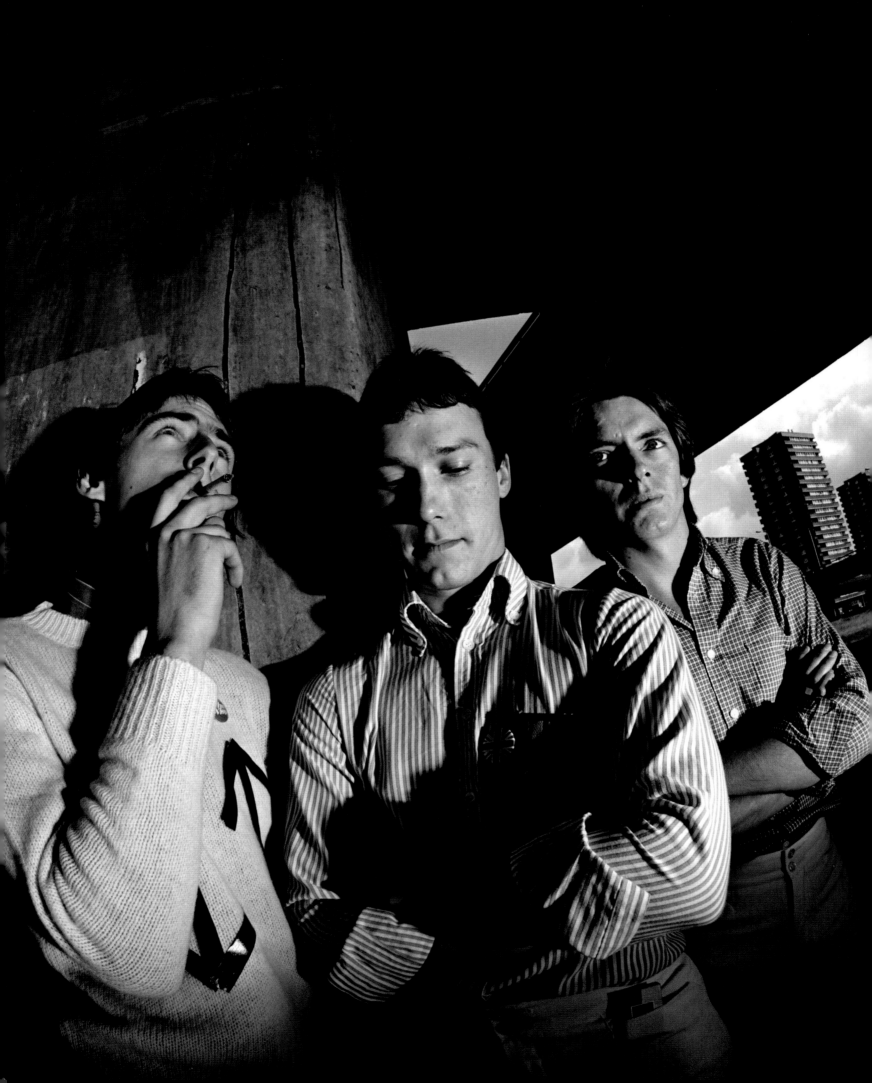

THE JAM / STYLE COUNCIL 1977 & 1984

The trio of Paul Weller, Bruce Foxton and Rick Buckler teamed up to form the punk-based band the Jam in 1976 and during the following year released three hit singles and two chart albums. By the time they split in 1982, the Jam had notched up four Number 1 singles and a chart-topping album. Weller's next move was to form the Style Council with former Merton Parkas keyboard player Mick Talbot and over six years – until they disbanded in 1989 – the duo had 18 hit singles and five chart albums, including the Number 1 *Our Favourite Shop*.

"This was my first shoot with the Jam and it was for the cover of their second album *This Is The Modern World*. I chose the location, which is under a motorway flyover in West London. The band were pretty sullen and not particularly forthcoming, but when I asked Paul Weller if he could do something with his rather bland sweater, he grabbed my gaffer tape and made the pair of arrows on his chest – a spontaneous and brilliant touch! The session with the Style Council was actually an advert for the speaker manufacturer!"

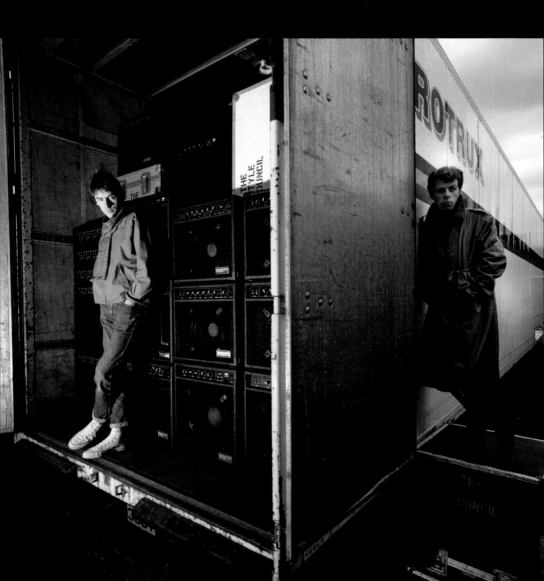

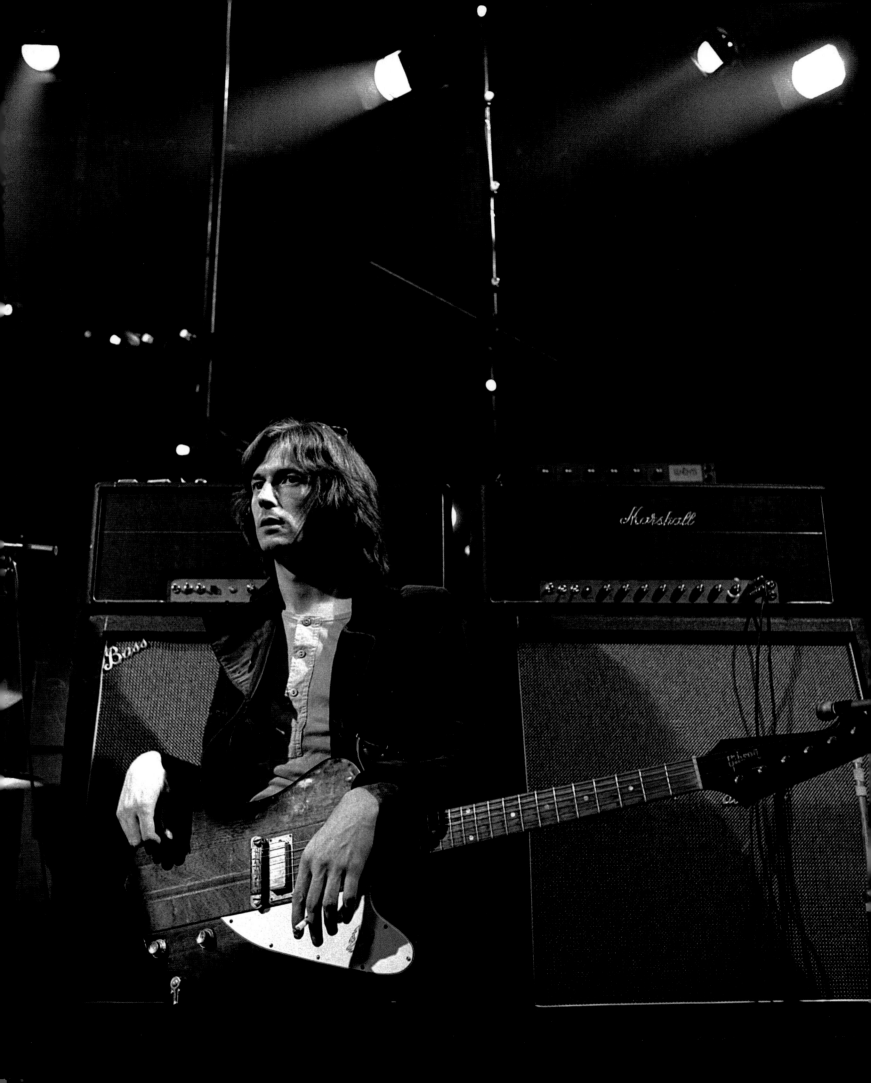

ERIC CLAPTON 1969 & 1982

A former member of the Yardbirds and the Bluesbreakers, Eric Clapton joined up with Jack Bruce and Ginger Baker to form the super group Cream in 1966. After four hugely successful albums, Clapton moved on to briefly join Blind Faith – with Baker, Stevie Winwood and Ric Grech – and then re-emerged in 1970 as Derek and The Dominos, who released the global hit 'Layla'. Since 1974 Clapton has operated as a solo artist with assorted sidemen while also appearing on albums by the likes of George Harrison, Phil Collins, Tina Turner and Sting. During the past six decades the man known as "Slowhand" has released more than 30 chart albums.

"The portrait was taken during the ill-fated TV spectacular called *Supersession* in 1969. In fact it turned out to be the only time I actually photographed Eric in spite of shooting several covers for him. The other shot is an outtake from the 1982 album *Time Pieces: The Best Of Eric Clapton* and I used an old friend to stand in for Eric!"

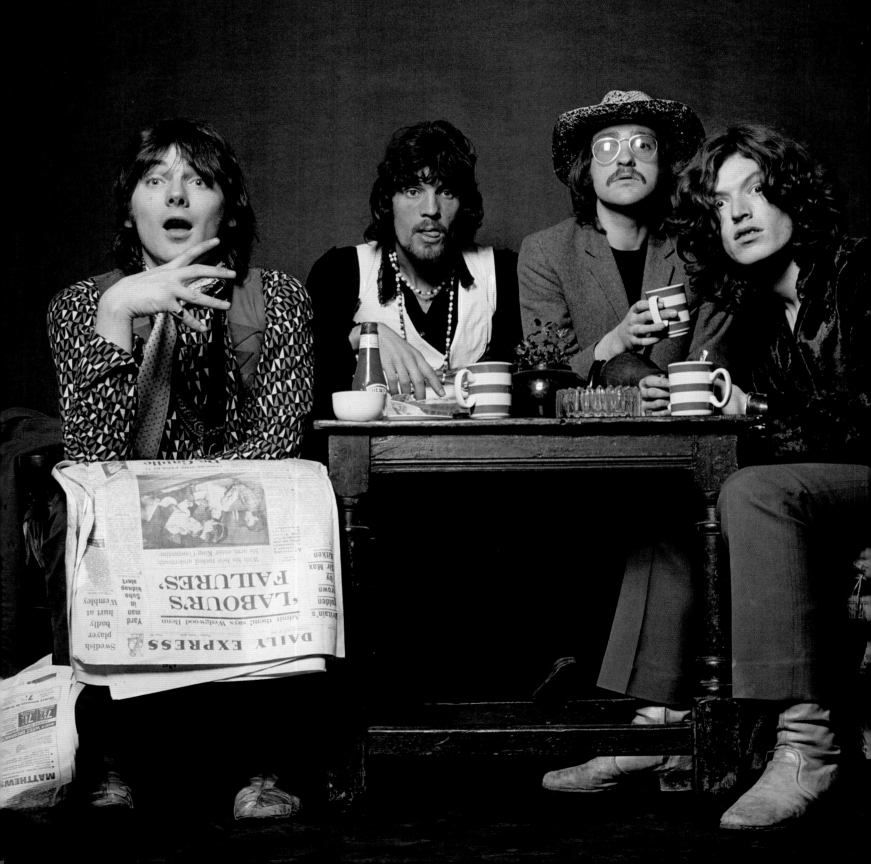

SPENCER DAVIS GROUP / TRAFFIC 1965 & 1967

Starting out in Birmingham in 1963 as an R&B quartet, the Spencer Davis Group had three minor hits before 'Keep On Running' reached Number 1 in the UK in 1965 and was followed to the top by 'Somebody Help Me'. The group of Davis, Steve Winwood, Muff Winwood and Pete York also hit the Top 10 with their debut album *Their First LP* – with a cover photograph taken by Mankowitz – before finally splitting up in 1968. A year earlier Steve Winwood had left to form Traffic with Dave Mason, Chris Wood and Jim Capaldi and during two years together they released four chart singles and two Top 10 albums, including *Traffic.*

"I shot several sessions with Spencer, including their first two album covers. Steve Winwood was only 16 when I first met them and had a remarkable voice and a tremendous song-writing talent. Steve left the band and formed Traffic in 1967 and I shot several sessions with them as well, including their second cover image for the album *Traffic.*"

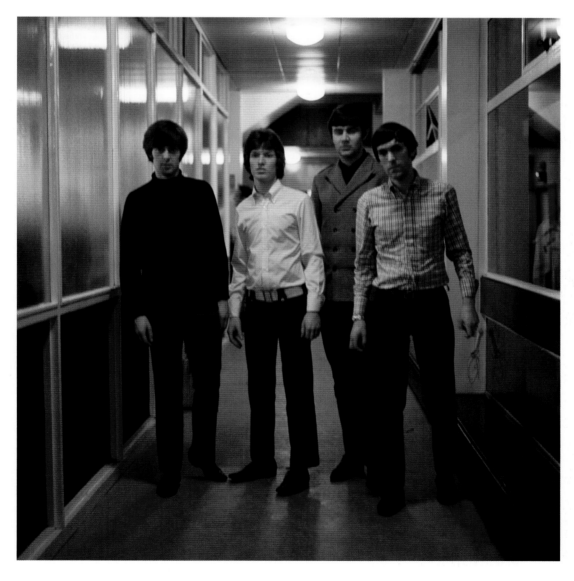

ELECTRIC PRUNES 1967

In 1965 – at the start of America's influential psychedelic movement – The Electric Prunes emerged out of Los Angeles. The band's classic 1966 line-up consisted of James Lowe, Mark Tulin, Ken Williams, Preston Ritter and James Spagnola and in 1967 the Prunes released two US chart singles, with 'I Had Too Much To Dream Last Night' hitting the Top 20. Despite numerous line-up changes, the band still managed to release five albums during the 60s before breaking up in 1970. They reformed in 1999 and, following another split, reunited again in 2001.

"Dave Hassinger (the Stones LA engineer) showed me an album cover Gered had done for the Stones (*Between The Buttons*) and I made up my mind right there if we ever got to England he was gonna be the first person I looked up. I remember he had a Rolls or Bentley or some big fancy car and a beautiful blonde girlfriend in a very short dress and a white fur coat, the perfect image of an English gentleman; he started clicking pictures and it all went weird … There was this great moodiness about his photos and he was so cheap!" James Lowe – Electric Prunes

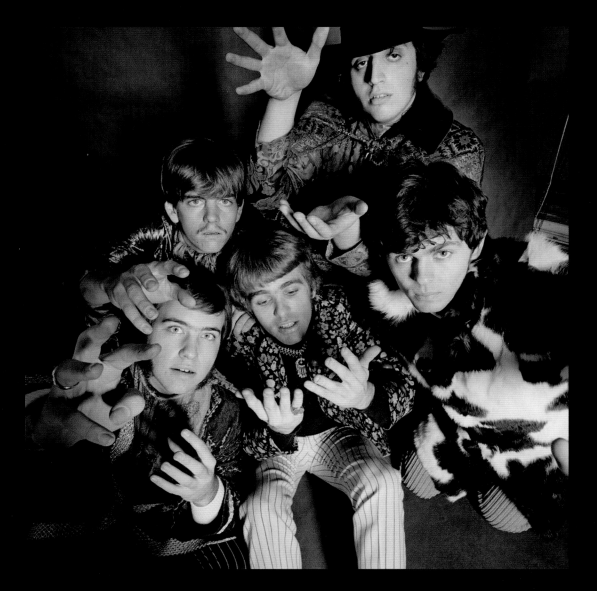

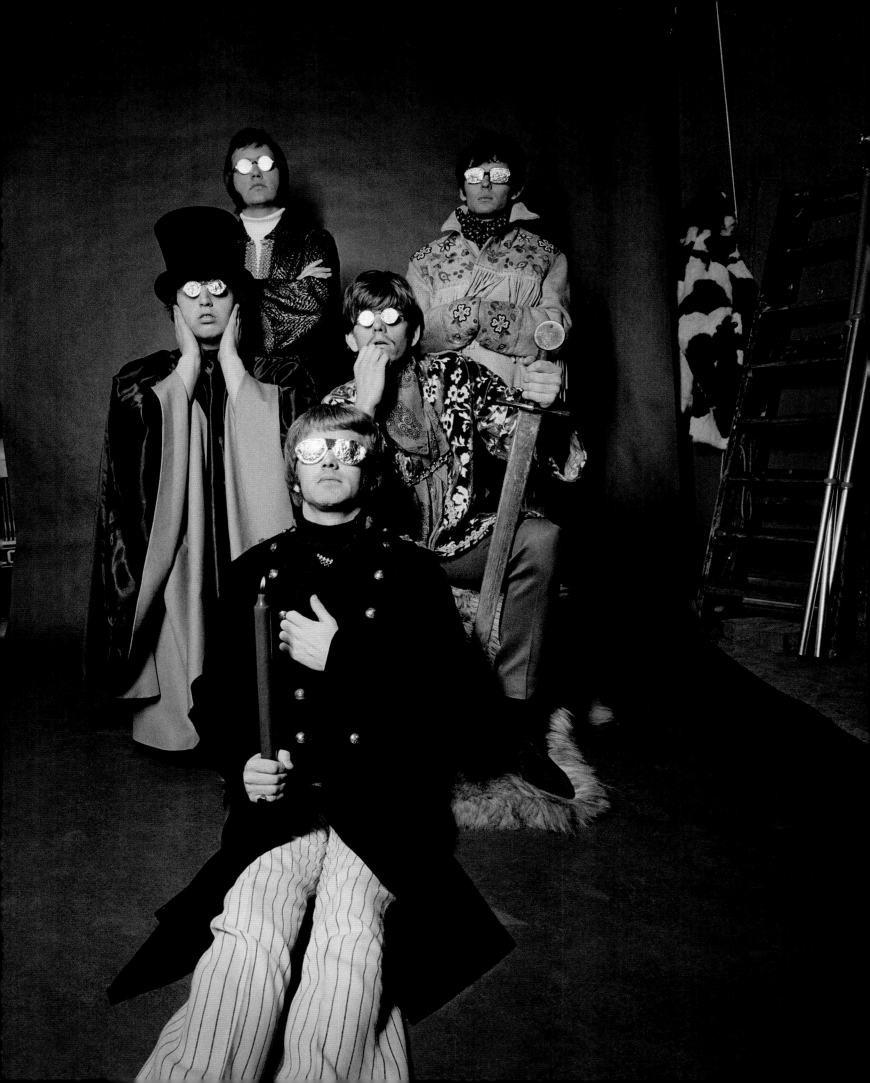

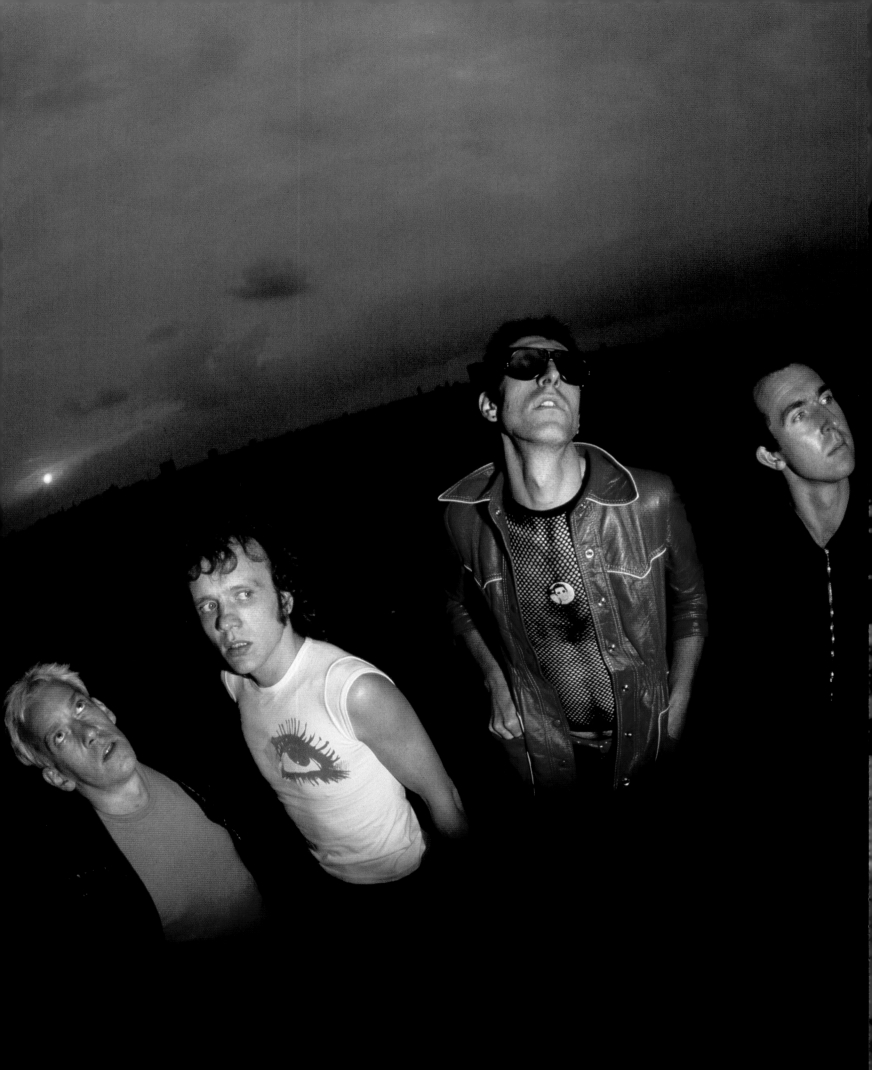

DOCTORS OF MADNESS 1977

The British punk art group Doctors of Madness was formed in Brixton in 1974 under the leadership of Richard "Kid" Strange together with Urban Blitz, Stoner and Peter Dilemma. During their heyday they were supported on tour by the likes of the Sex Pistols, the Jam and Joy Division and released three albums between 1977 and 1975. When Blitz left in 1978, Dave Vanian joined the band briefly after he had split from the Damned, but after he departed, the Doctors continued as a trio until finally disbanding in October 1978.

"There was a moment in 1976 when punk threw up its ugly head and I thought that I should retire from music and move on to other areas of photography. Fortunately there were still enough bands who wanted to work with me and the Doctors were one of them. Richard 'Kid' Strange was a terrific character and a great poser, as were the rest of band, and they all embraced the session with a full-on energy and enthusiasm that resulted in some of my favourite shots from the period. The band didn't really have the success that they deserved but have since been recognized as one of the most influential of early punk bands."

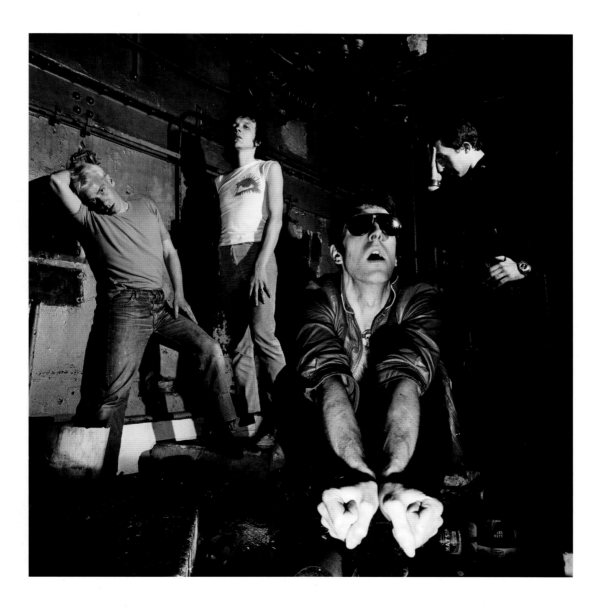

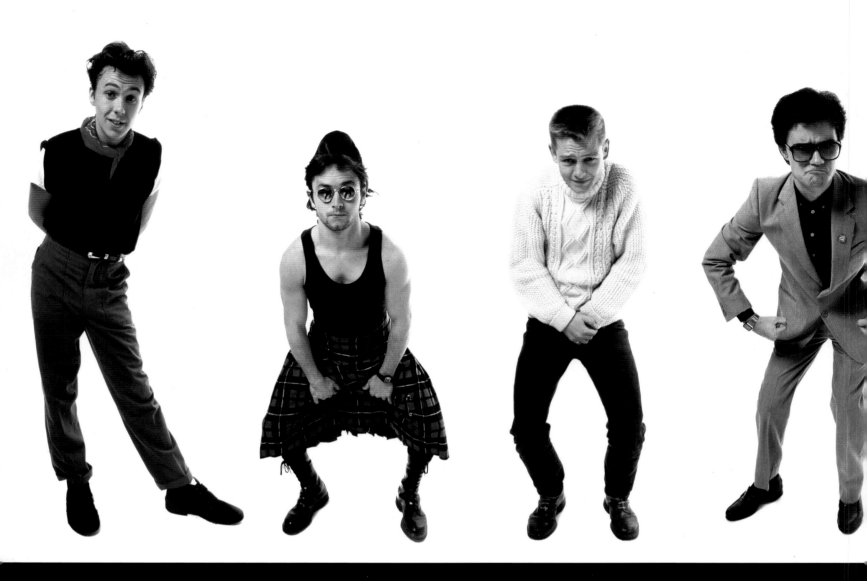

MADNESS 1981

The Camden-based ska band the Invaders eventually became Madness in 1979 when Graham "Suggs" McPherson, Mike Barson, Chris Foreman, Lee Thompson, Mark Bedford, Dan Woodgate and Chas Smash got together and debuted in the charts the same year with the Number 2 album *One Step Beyond*. During a career spanning more than 30 years Madness hit the Number 1 spot in 1982 with the single 'House Of Fun', from the chart-topping album *Complete Madness*. After losing Barson and disbanding twice – in 1986 and 1988 – Madness reformed in 1999 and featured as part of Queen Elizabeth II's 2012 Golden Jubilee concert.

"Madness were a huge band by 1981 and were on the verge of their peak success. I was asked to shoot the band for *Event* magazine, which had been launched by Richard Branson, and I had shot several covers for them already. Madness were famous for their great poses and they didn't disappoint me for this session."

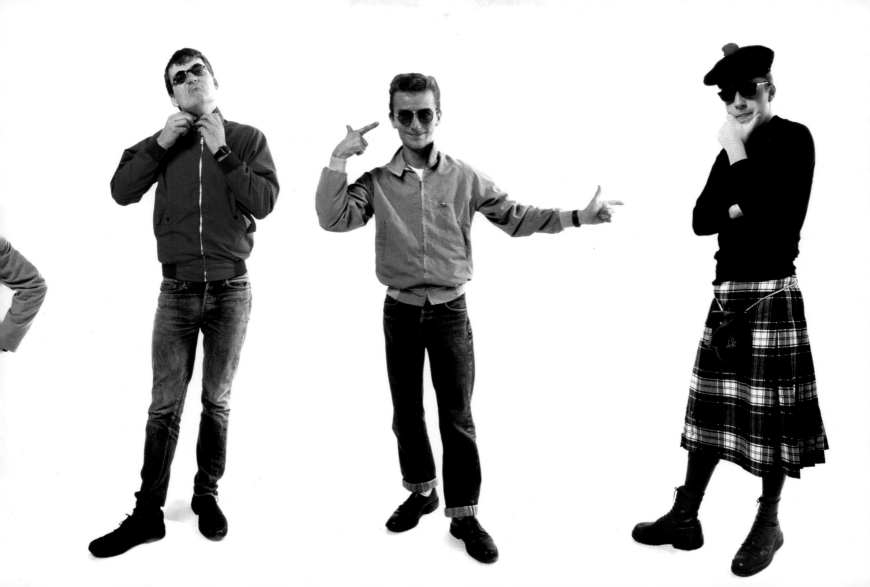

REN HARVIEU 2008

Salford-born Lauren Maria "Ren" Harvieu was first photographed by Mankowitz in 2008 when she was 17 years old and performing under the name Maria. An aspiring songwriter, she was releasing her music online where she was discovered and then brought to London to record her debut single in 2011. Under the name Ren she was nominated for the BBC Sounds Of 2012 poll – previously won by Keane, Adele and Jessie J – while her debut album *Through The Night* reached the UK Top 5.

"Ren was at the very beginning of her career when I was asked to photograph her to assist in her manager's efforts to get her signed to a record company. She had an incredible voice and I attempted to construct the first stages of a look that might work for her as her career began to take off. She did sign to a major company and was nominated as one of the BBC's Sounds of 2012, with her first album making it to a respectable Number 5 in the charts."

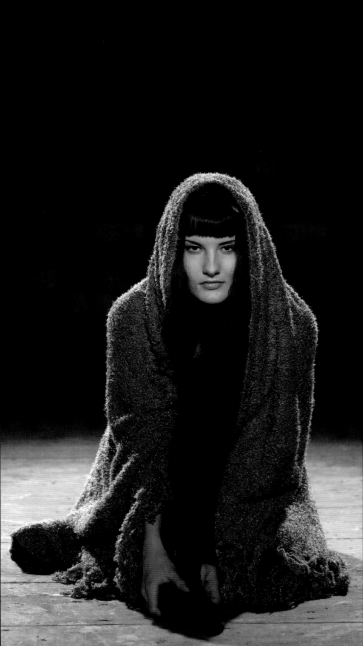

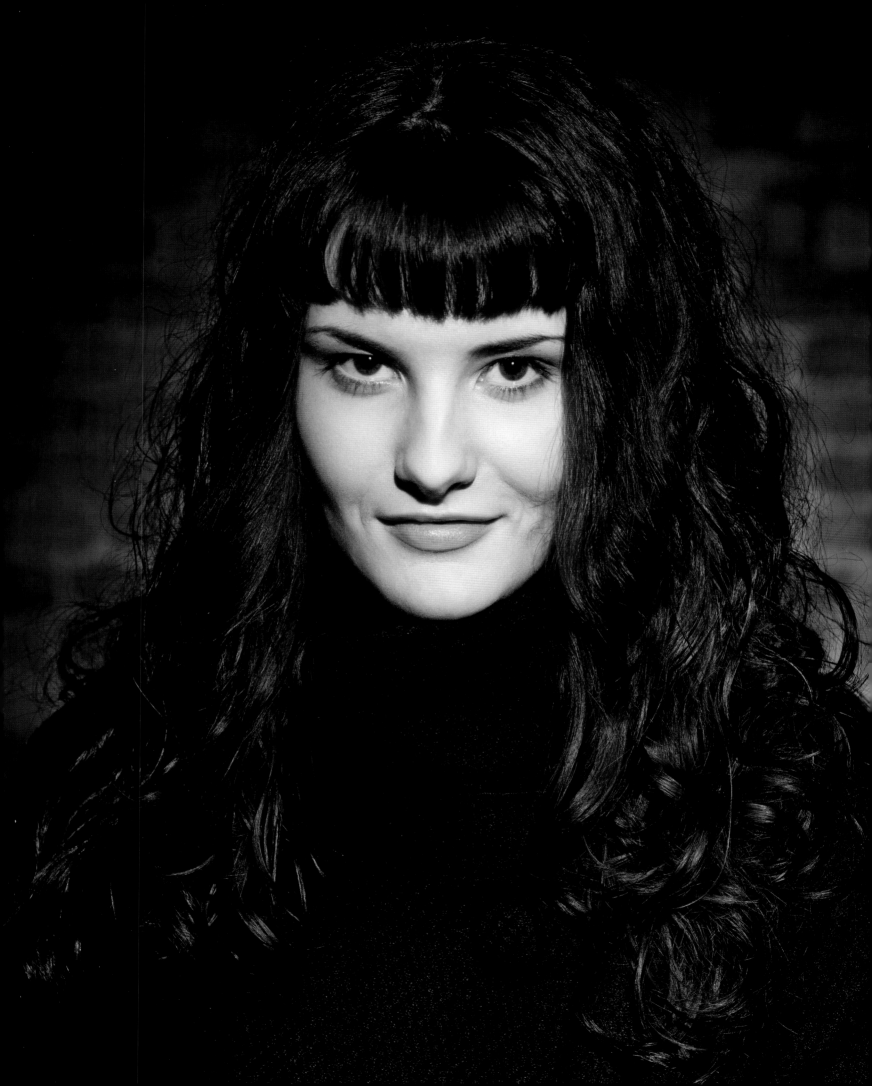

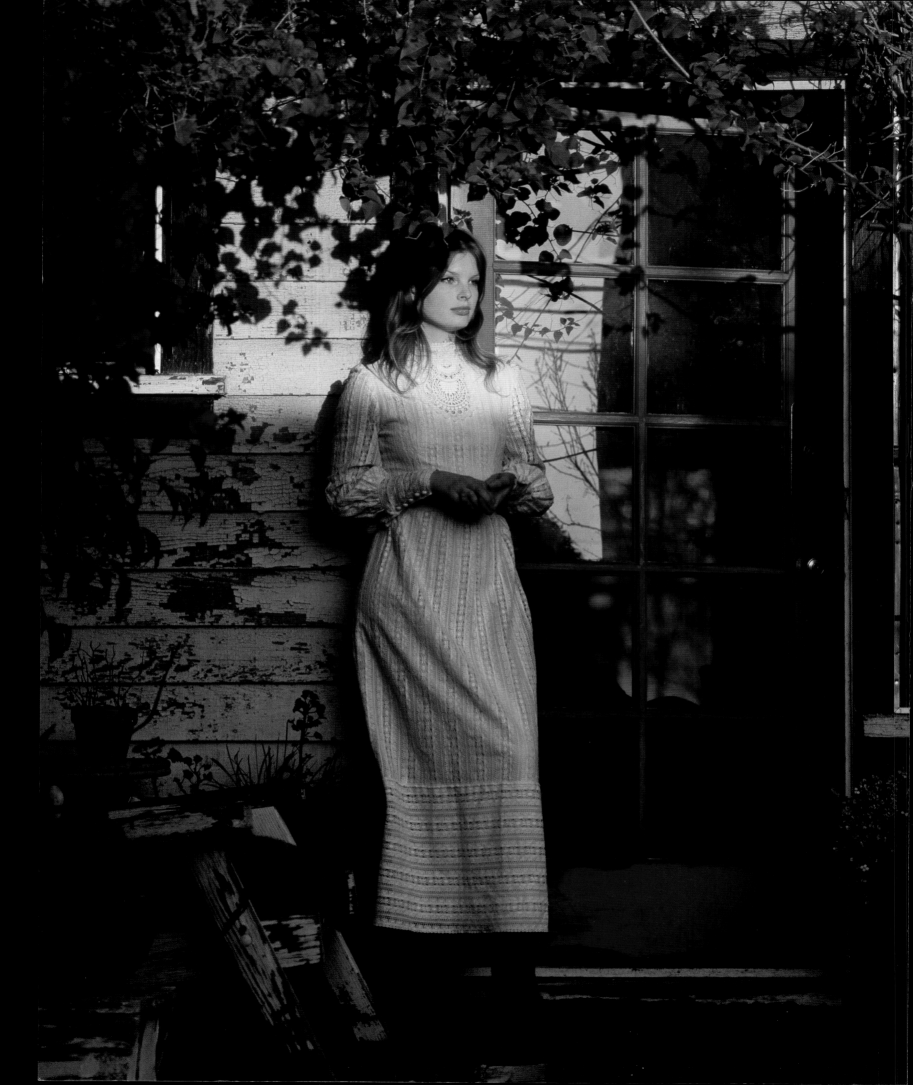

MIRANDA LEE RICHARDS 2001

Miranda Lee Richards grew up in San Francisco during the late 1970s and went to a performing arts school ahead of opting for a career as a model. After a fruitless trip to Paris, she met Metallica guitarist Kirk Hammett and that set her off on a musical path which led to her making her first demo tapes. A move to Los Angeles resulted in the release of her debut album *The Herethereafter* in 2001 which included the Rolling Stones' song 'Dandelion' and 'The Long Goodbye', which reached the Top 5 in Japan's international chart.

"Miranda looked like a cross between the young Marianne Faithfull and Claudia Schiffer and sang like an angel, and I was thrilled that she chose me to shoot her debut album cover. We worked together very easily and her experience as a model meant that she completely understood the process. Everybody was delighted with the results, but the album was delayed and for some reason my images never made it onto the final cover!"

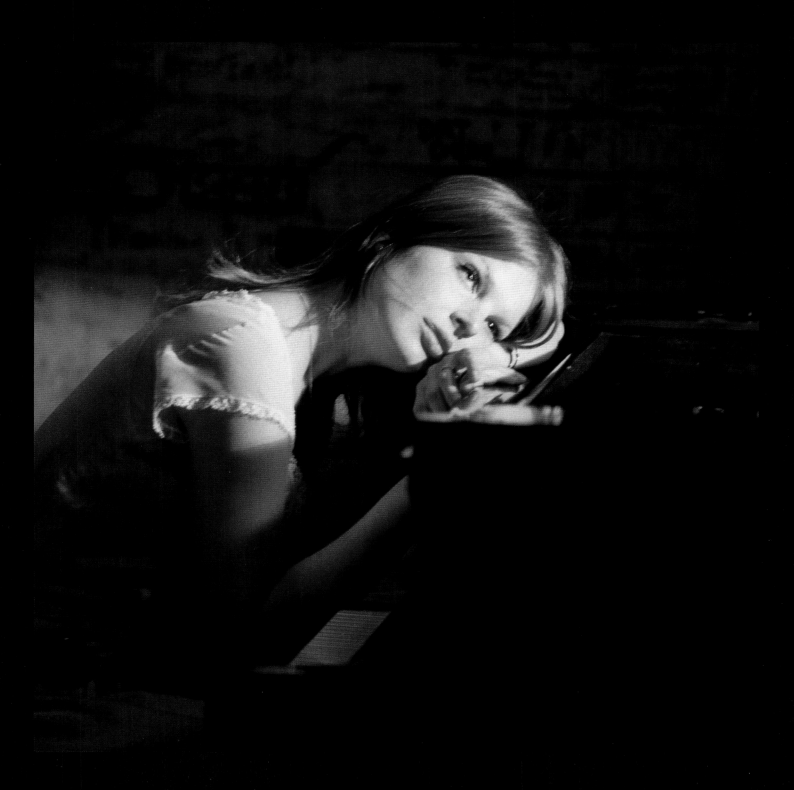

SOFT MACHINE 1968

Having started out in 1967 as a four-piece, Soft Machine had become the trio of Robert Wyatt, Mike Ratledge and Kevin Ayers by the time they released their debut album *The Soft Machine* in 1968. However, before they issued their follow-up album, Hugh Hopper had replaced Ayers and the group went about recruiting various musicians for their Top 20 hit album *Third* and the follow-up chart entry *Fourth*. Although founding member Wyatt left to go solo in 1971, the band continued under the banner Soft Machine – despite numerous personnel changes – until the release of their tenth album in 1981.

"Soft Machine was one of the late-60s most important progressive, psychedelic rock bands, and I first worked with them soon after they had become a trio. My photos were used inside their first album, which was produced by Chas Chandler, who also produced and managed Jimi Hendrix, with whom they toured. I also worked with them during a brief interlude in 1968 when Andy Summers, later of the Police, joined them."

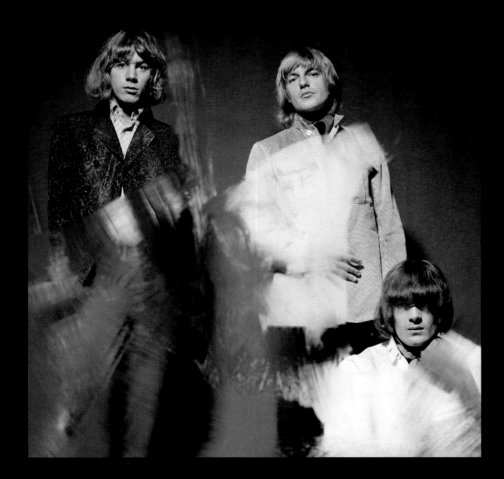

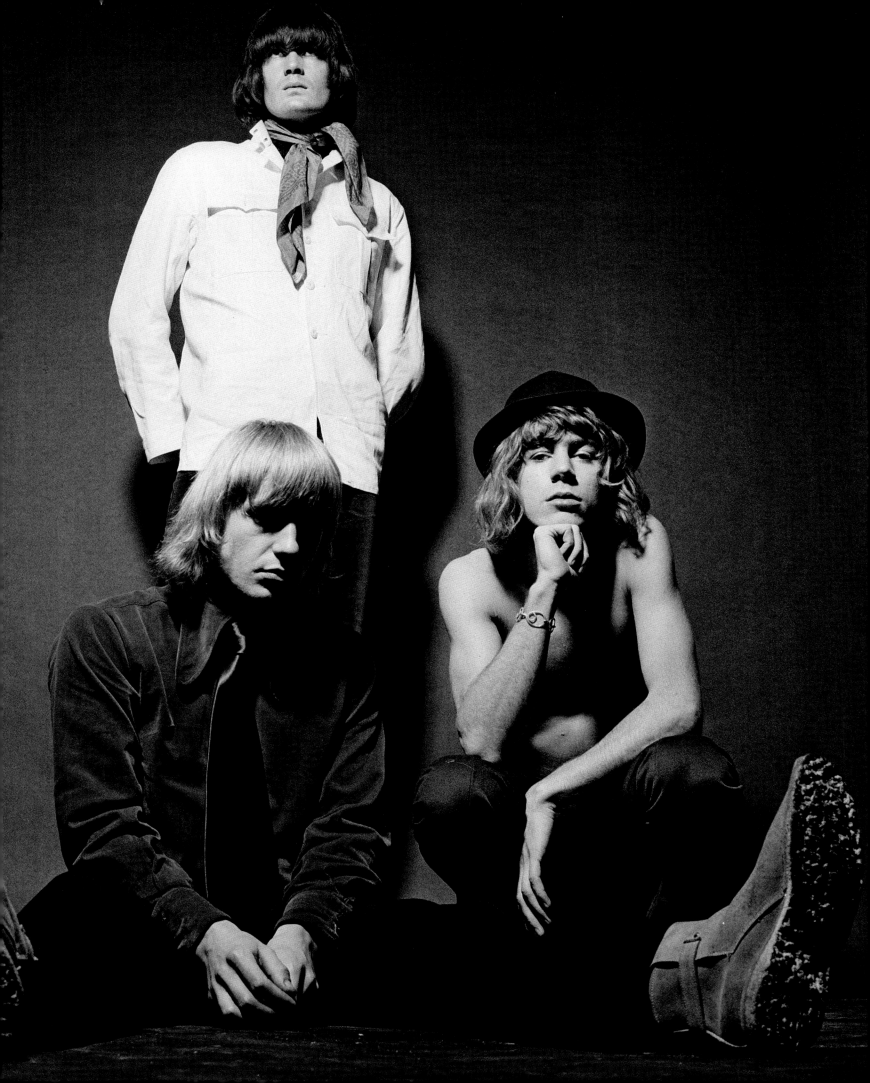

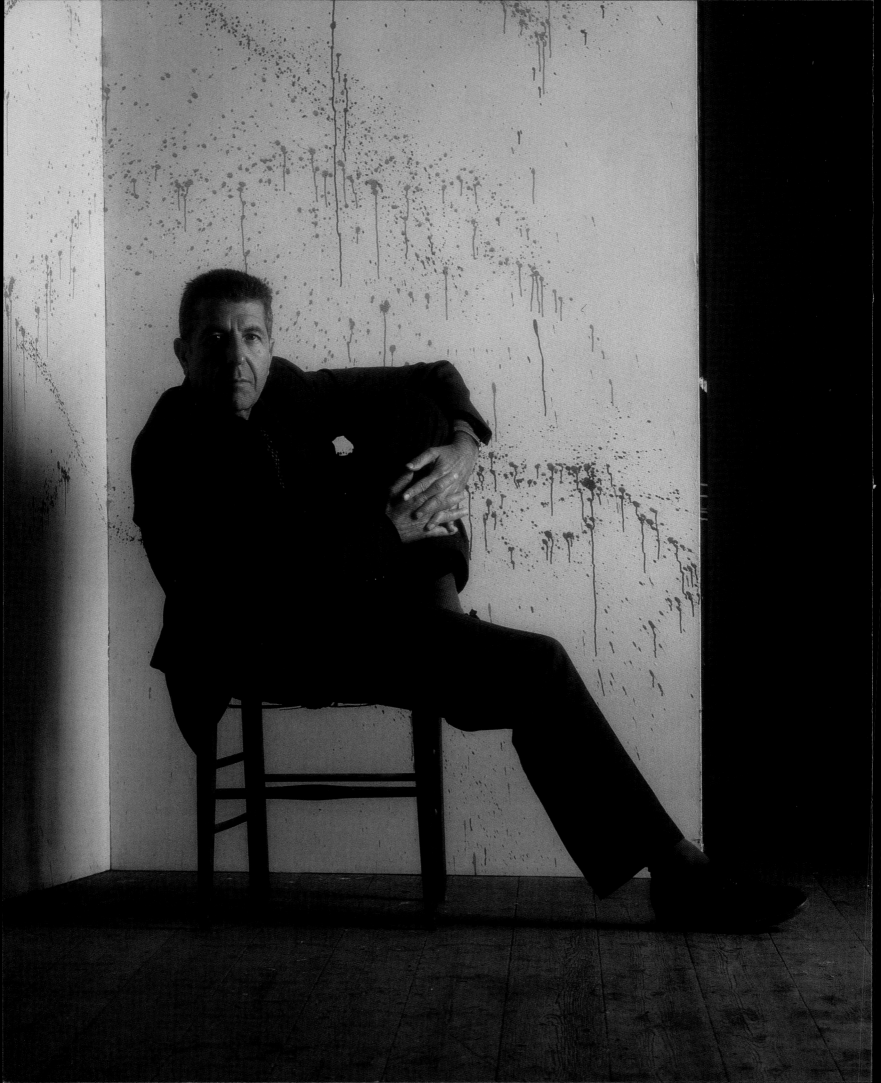

LEONARD COHEN 1994

Leonard Cohen was 60 years of age in 1994 and he had been creating poetry, literature and music for nearly 40 years since publishing his first book of verse in 1956. After drifting from his native Montreal to New York, Cohen was signed to CBS in 1966 and he has remained with the label ever since despite producing only a dozen studio albums. His most successful collections *Songs From A Room* and *Songs Of Love And Hate* were both UK Top 10 hits while his anthemic composition 'Hallelujah' has been covered by over 200 artists, including John Cale and Jeff Buckley.

"This session was for *MOJO* magazine and I was thrilled when they asked me to photograph Leonard. He was utterly charming and appeared to enjoy the experience very much, throwing shapes and posing like crazy! He also told us some of the funniest and filthiest jokes I have ever heard!"

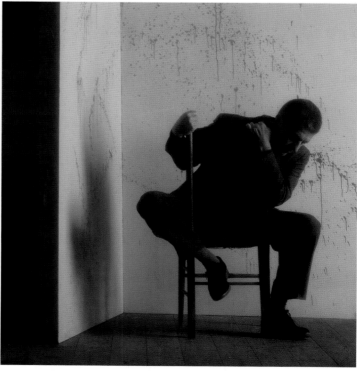

SPARKS 1975 TO 1979

Brothers Ron and Russell Mael formed their first band Halfnelson in Los Angeles in 1968 and issued their debut album four years later when the two brothers also opted to re-name their band Sparks. After the UK Number 2 success of their debut single 'This Town Ain't Big Enough For The Both Of Us' and the Top 5 album *Kimono My House* in 1974, Sparks notched up a string of hit singles and albums during the 70s until, despite Mankowitz's cover photography, the failure of their 1980 album *Terminal Jive*. They returned to the charts in the 1990s and in 1997 issued a new version of their first hit under the billing Sparks vs Faith No More.

"I loved Sparks! They were a great band who made some terrific music and had a wonderfully weird image. Brothers Ron and Russell Mael worked brilliantly off each other and understood the dynamic of a photo shoot, making them superb subjects. I shot several sessions with them and we became good friends for a while. The black & white shots for the *Terminal Jive* album were from one of the strangest and funniest shoots I have ever done!"

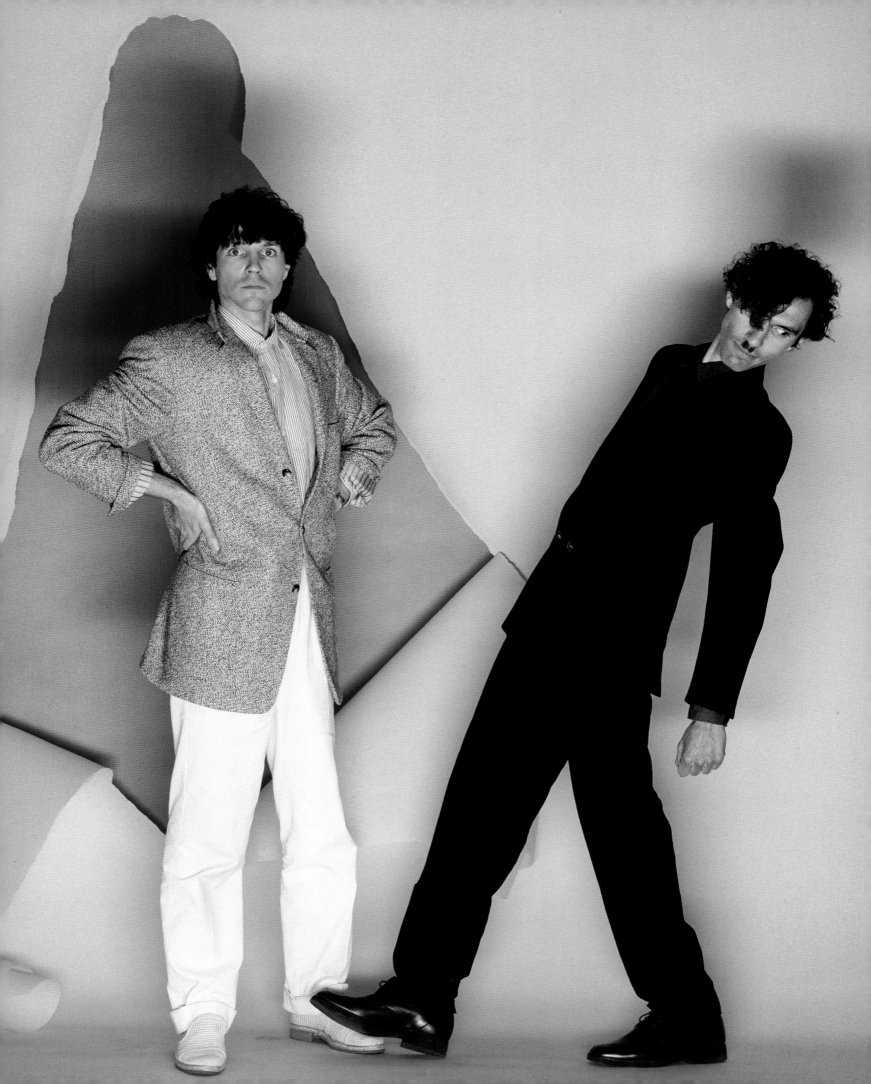

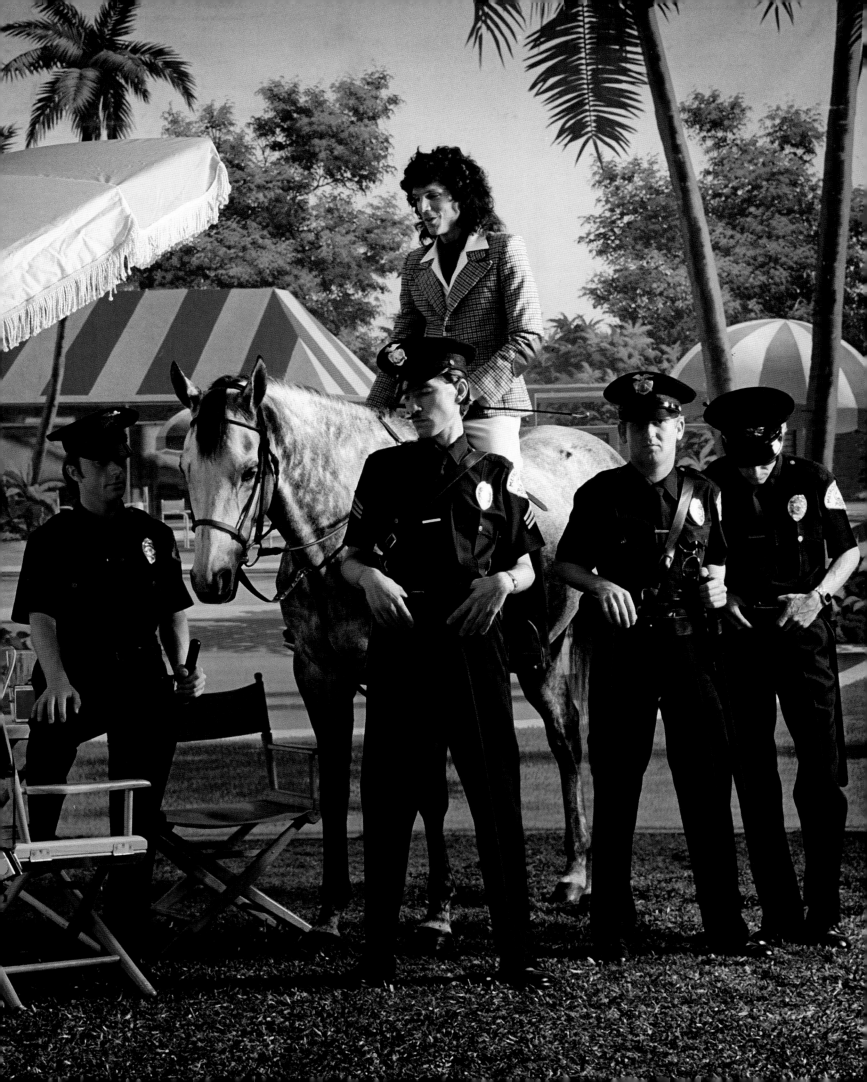

THE PEDDLERS 1966

Drummer Trevor Morais, bass player Tab Martin and keyboardist and vocalist Roy Phillips first got together in Manchester in 1964 as the jazz/blues trio the Peddlers. Two years later they had become regulars on London's established club scene and had a debut live album to their credit. On the back of their debut chart single in 1965, their album *Free Wheelers* reached the UK Top 30 and in 1969 they had their one and only Top 20 hit with 'Birth', which came from their Top 20 album *Birthday*. With Paul Johnson replacing Morais in 1972, the Peddlers carried on until 1976.

"The Peddlers were a great band! They played regularly at the Pickwick Club and recorded their first album there. They played a fabulous blend of blues/rock and jazz and built up a fantastic celebrity following throughout the 60s."

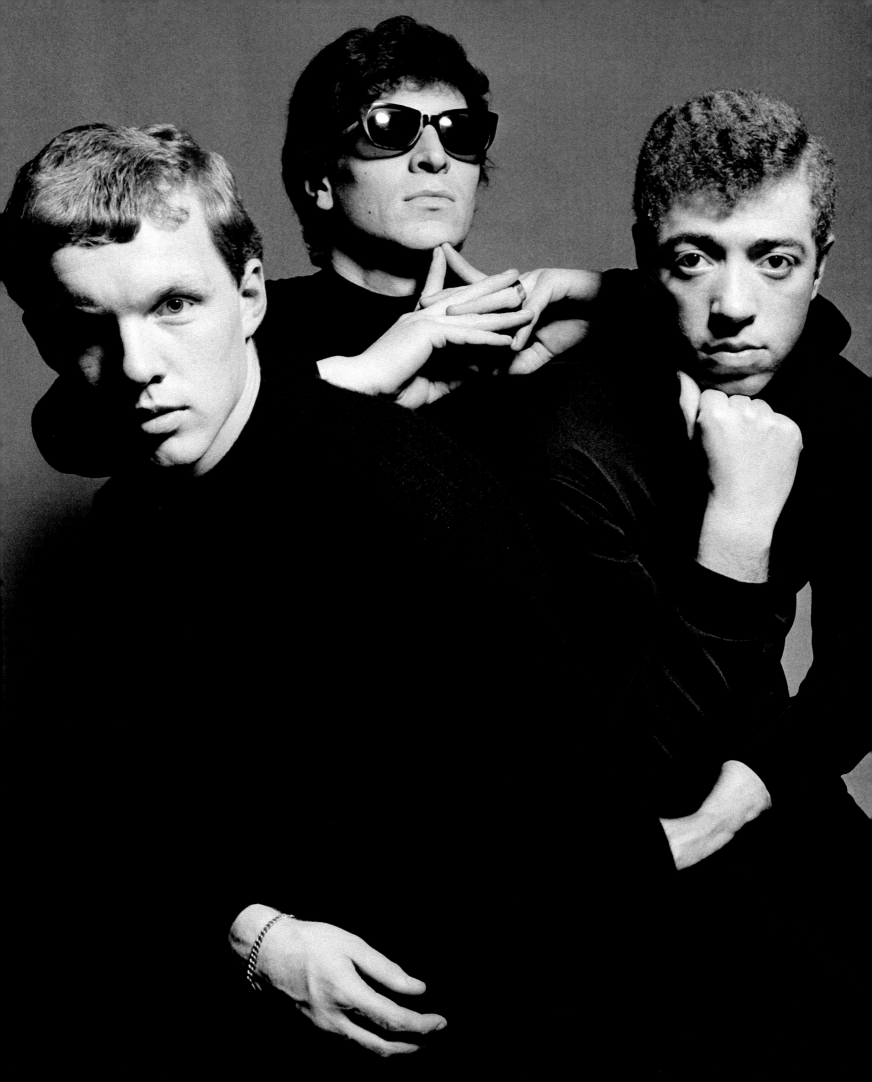

JIMI HENDRIX 1967

Jimi Hendrix arrived in England in September 1966 – accompanied by his manager Chas Chandler, ex-bass player with the Animals – and immediately made an impression on London's Swinging 60s scene with a series of club appearances. By early 1967, when Mankowitz shot his two photo sessions, The Jimi Hendrix Experience – including Noel Redding and Mitch Mitchell – had their first Top 10 hit with 'Hey Joe'. Over the next three years Hendrix made headlines with his sensational stage act and a string of hit records with both the Experience and the Band Of Gypsys but less than a month after playing at the Isle of Wight Festival in August 1970, Hendrix was found dead in a London flat.

"Although I briefly met Jimi shortly after he arrived in London at the end of 1966, he didn't come to my studio until February in 1967. He had tremendous power and charisma and took to the fashions of the day like a duck to water! He was charming, modest, quiet and funny and a joy to work with, allowing me that wonderful moment of access which makes a great portrait. The second session a few weeks later was primarily to get fresh shots with the band as they had had their hair permed to give them an 'afro' look . . . !"

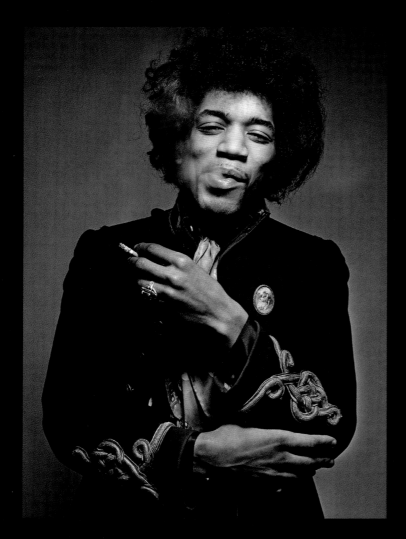

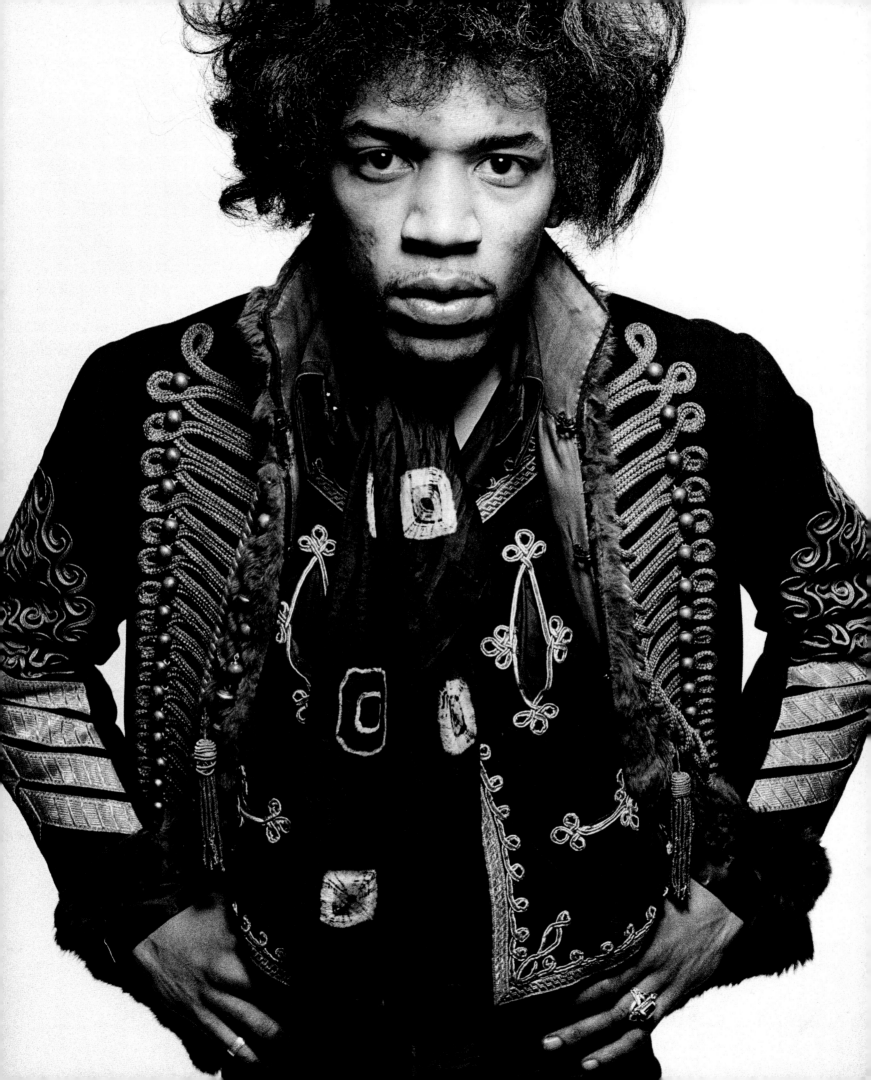

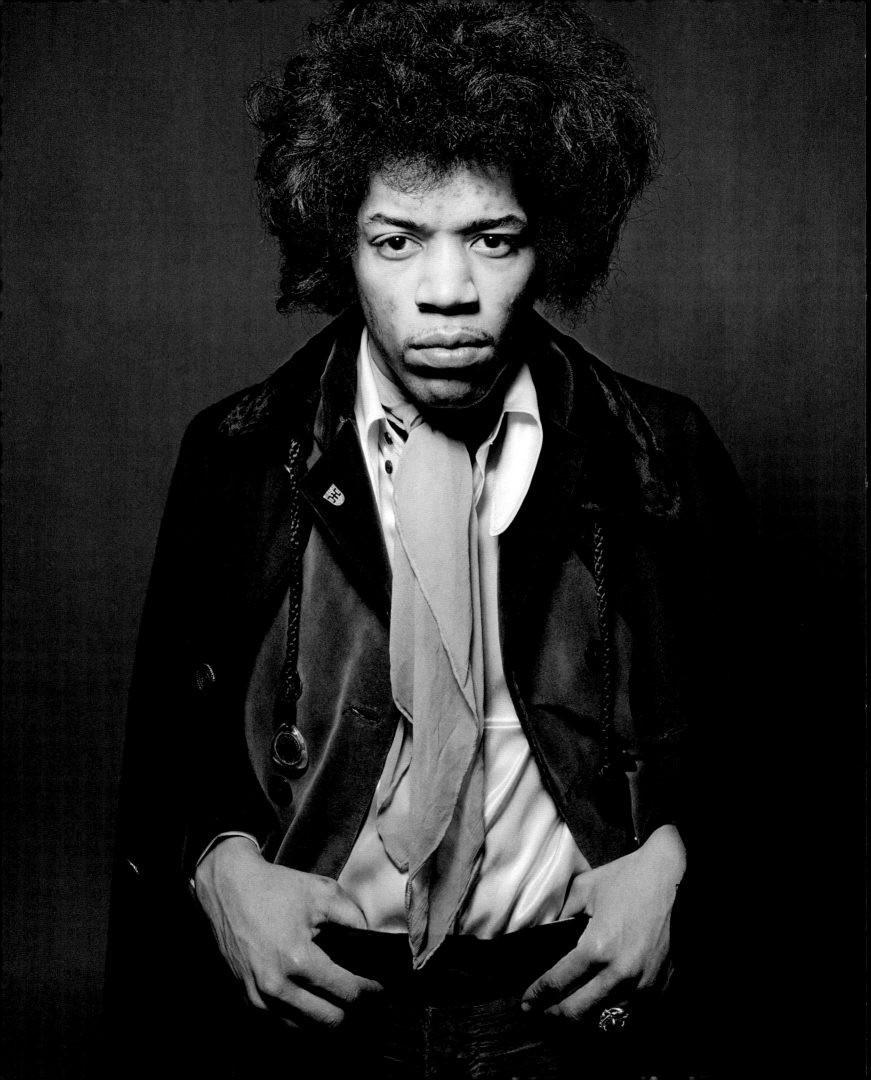

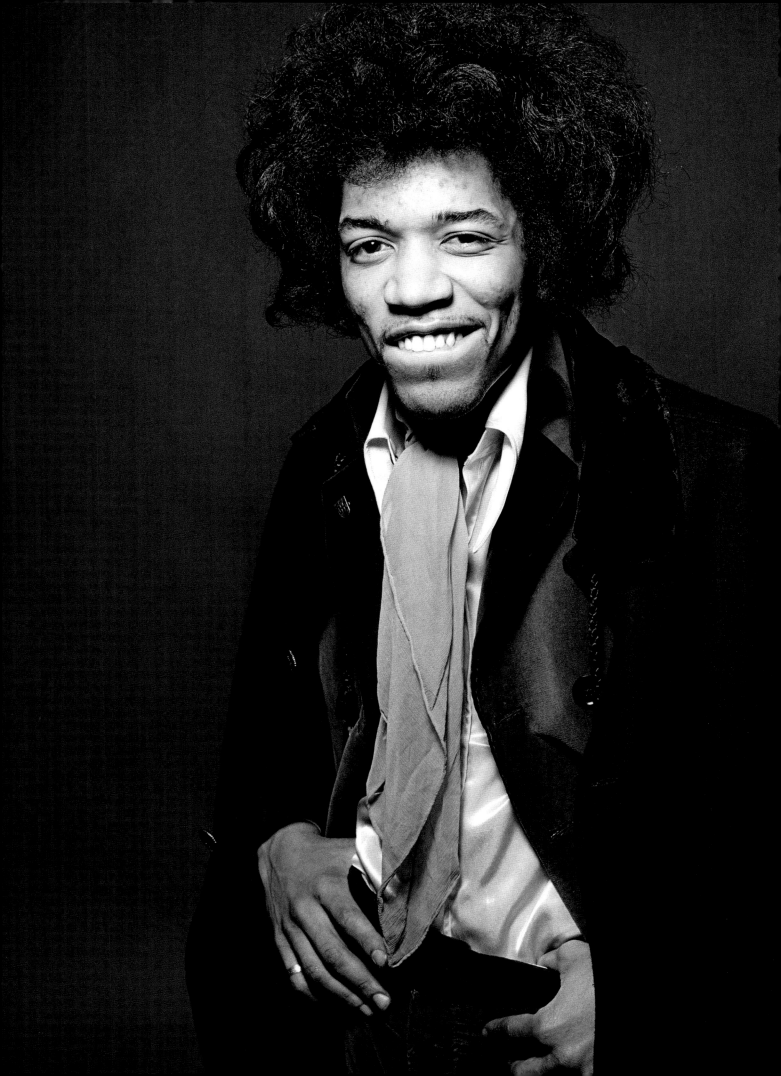

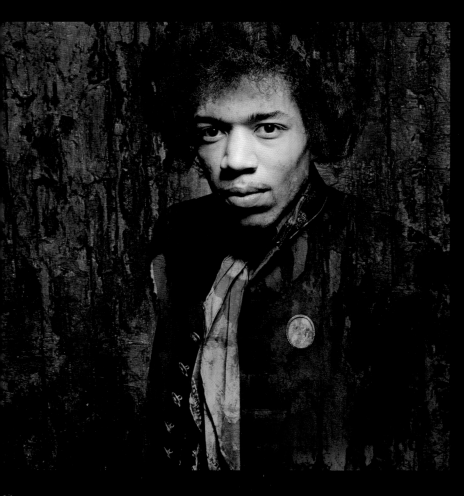

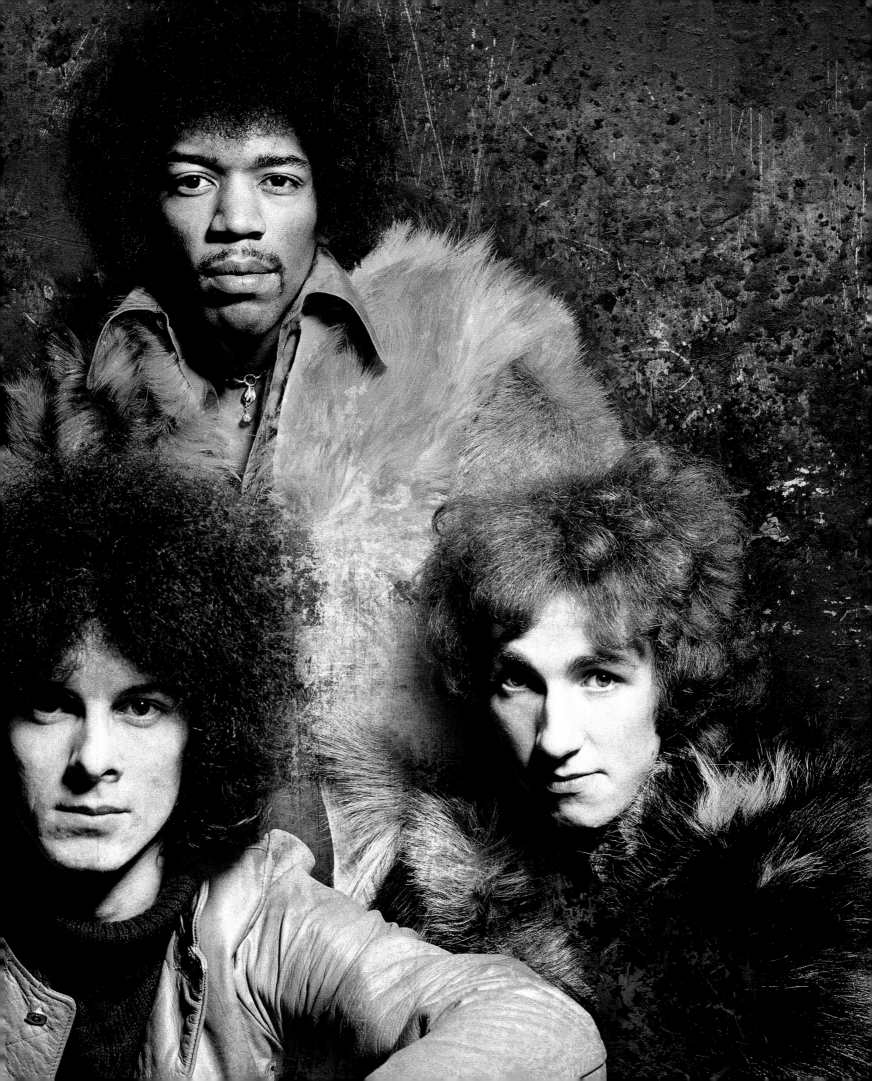

SPOOKY TOOTH 1968

Spooky Tooth was one the most respected but commercially unsuccessful progressive rock bands of the 60s. Formed in 1967 by Gary Wright, when he got together with Mike Harrison, Greg Ridley, Mike Kellie and Luther Grovesnor, who had all played in the VIPs, Spooky Tooth released their debut album – with a cover photographed by Mankowitz – the following year. Their second album *Spooky Two*, which was a minor hit in America, followed in 1969 and, after Wright left, the band continued through to their final album *The Last Puff*, which was released the following year. After reforming in 1972, the band split again in 1974 but reunited once more in 1998.

"Spooky Tooth were one of Island Records' best bands of the 60s but never achieved the commercial success that they deserved. I shot the cover session for their first album *It's All About*, and then a press session on the farm that they all lived in. They lived in delightful, stoned, hippie squalor, which comes across pretty well, I think – very 60s!"

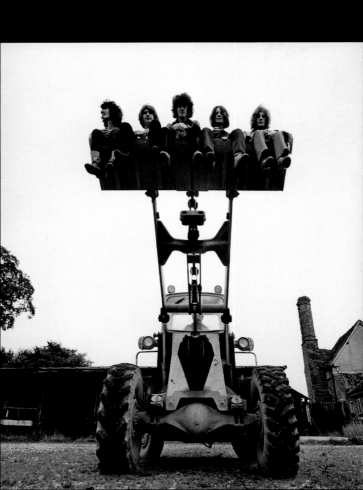

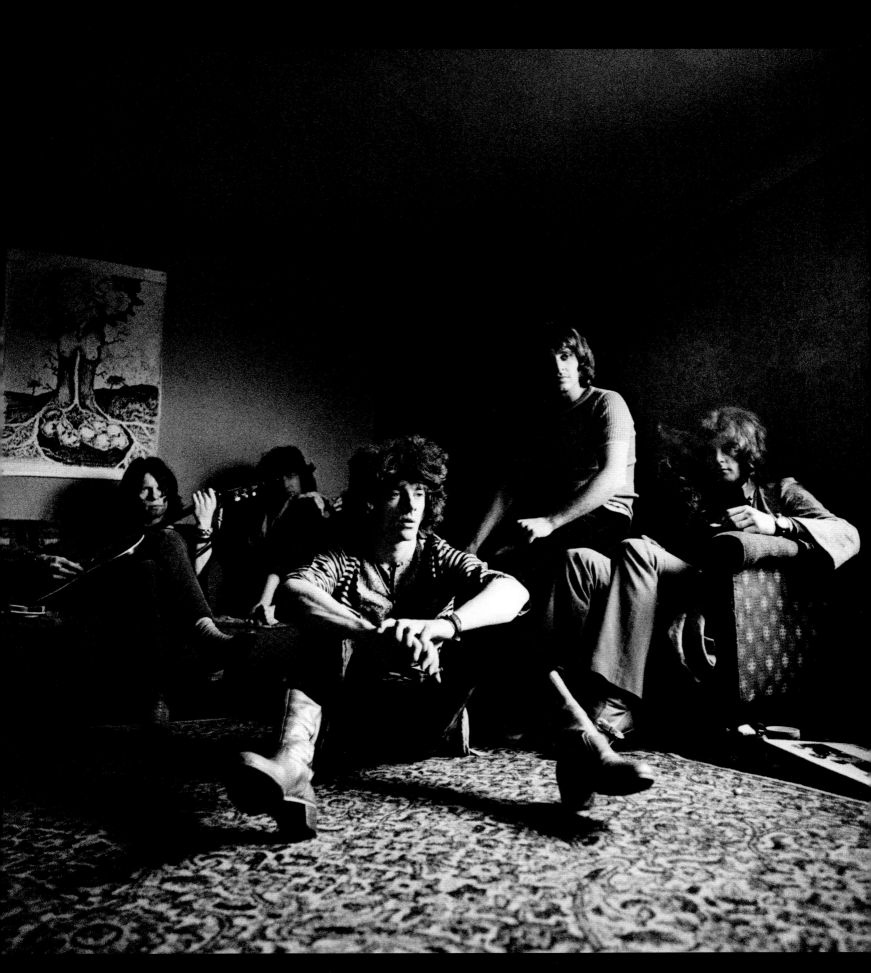

Please
do not
disturb

RANDY NEWMAN 1982

Established as one of the most influential and successful songwriters in popular music, Randy Newman has written for artists such as the O'Jays, Cilla Black, Gene Pitney, Alan Price, Three Dog Night and Nilsson. He issued his debut solo album in 1962, first hit the charts in America in 1974 and three years later reached the Top 10 with both the album *Little Criminals* and the single 'Short People'. He has combined releasing his own collections with writing music for films such as *Three Amigos, Ragtime, Meet the Parents, Cars, Monsters, Inc* and all three *Toy Story* movies and he has been rewarded with two Oscars and seven Grammy awards.

"In the 80s I shot a great deal for the London Sunday *Observer* magazine, and this was one of those great opportunities to photograph someone I had long admired and probably would never have another opportunity to work with. He was locked away in his room at a London hotel, apparently songwriting, and didn't want to spend too much time having his photograph taken!"

CLIFF RICHARD 1969 TO 2000

Cliff Richard began his career in music back in 1957 with appearances at London's main rock and roll venue the 2i's Coffee Bar in Soho. His debut single 'Move It' hit the charts the following year when he also teamed up with the Drifters who became the Shadows in 1959. As Britain's most successful solo singer – with more than 130 hit singles (14 Number 1s) and over 60 hit albums (seven chart-toppers) – Richard has appeared in the UK charts for the past seven decades during which time he has also recorded with the Shadows, Olivia Newton-John, Phil Everly, Elton John and Van Morrison. He was knighted in 1995.

"I had first met Cliff when I was only 13 years old and visited the set where he was starring in his first role in my father's film *Expresso Bongo*. It was a great thrill, as Cliff had made a tremendous impact and was already a big star. Subsequently he has become a national icon and I have worked with him on many occasions shooting covers for several of his albums."

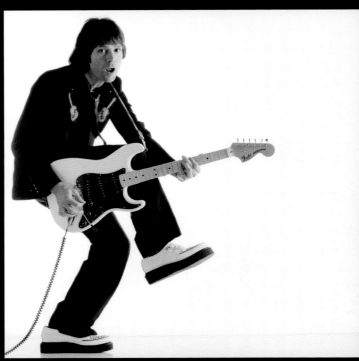
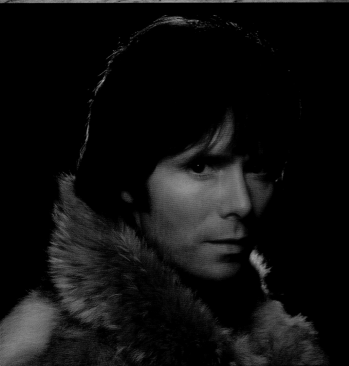
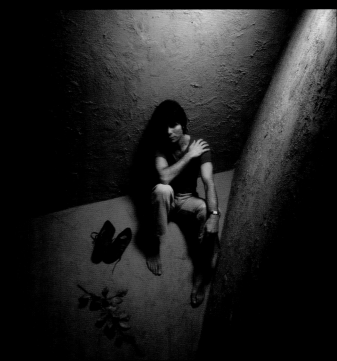

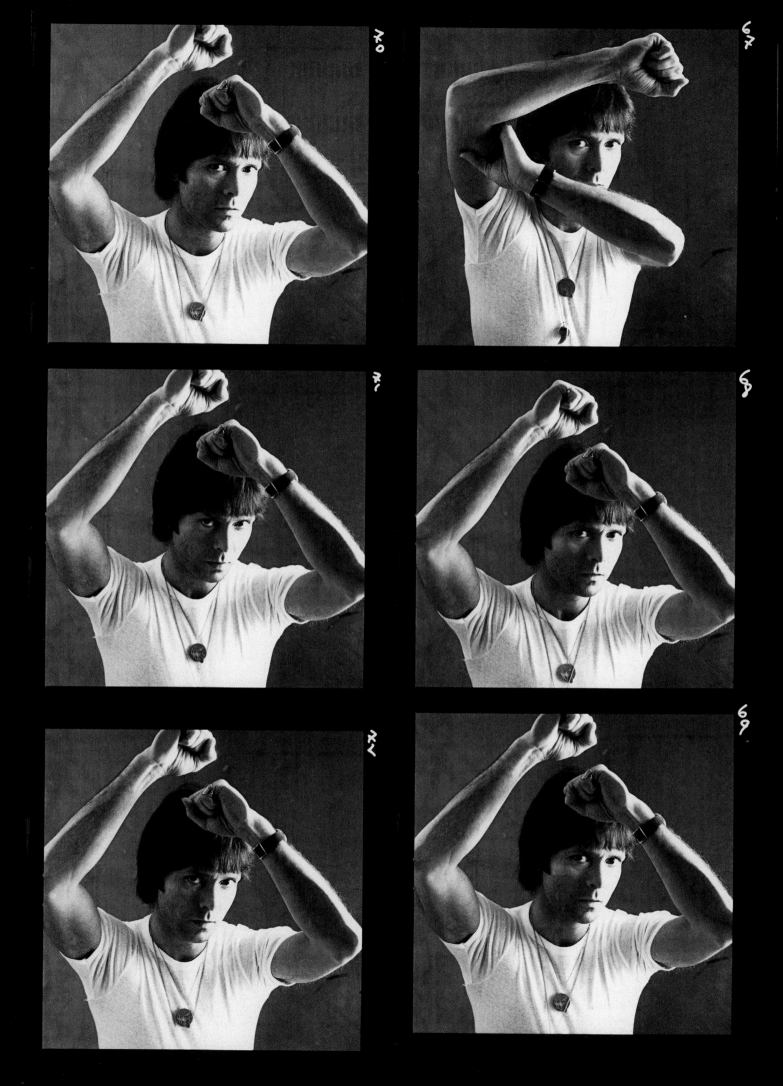

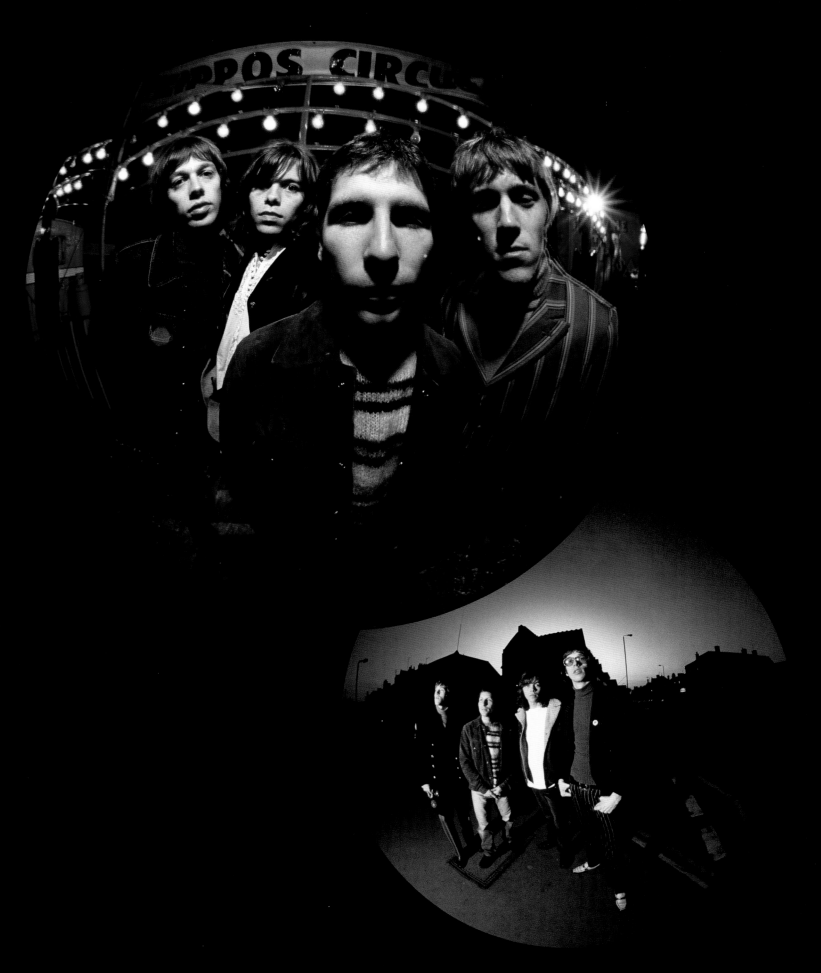

RIDE 1994

In 1988 three Oxford-based art college students Mark Gardener, Andy Bell and Laurence Colbert drafted in Stephan Queralt to create the band Ride, who entered the UK charts with three EPs in 1990. They followed these with the hit albums *Nowhere* (which peaked at Number 11) and *Going Blank Again* (a UK Number 5 hit) before releasing another Top 5 success *Carnival Of Light* in 1994. The band's final album *Tarantula* managed to get to Number 21 in 1996 despite being available for only one week as the band members considered other projects ahead of a final split later the same year.

"This session was for the cover of the band's *Carnival Of Light* album, which is much favoured by their fans. They all loved my Stones *Between The Buttons* cover and the fact that it was done after an all-night recording session, so we decided to stay up all night and shoot until the dawn. It is also the only time that I used a fisheye lens, something I'd avoided for the best part of 30 years!"

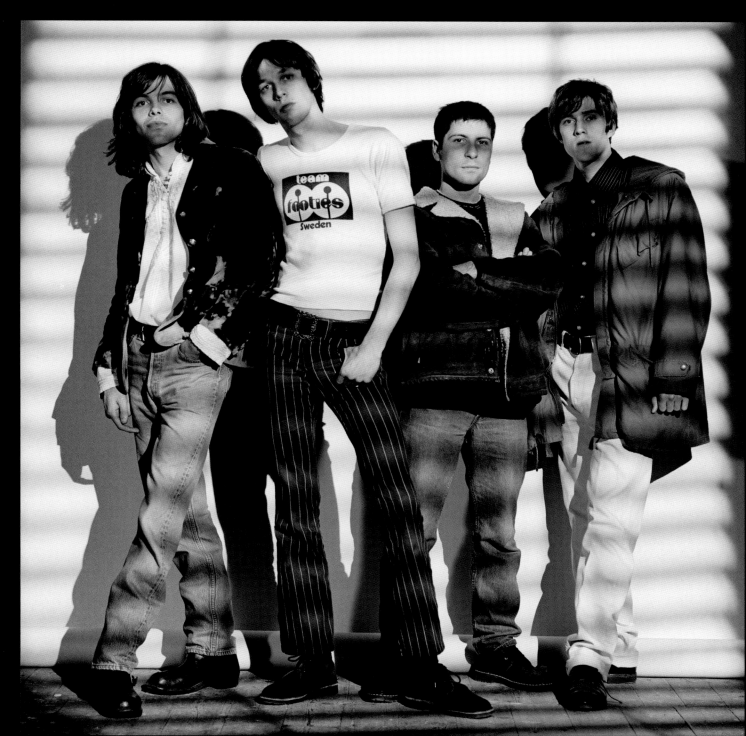

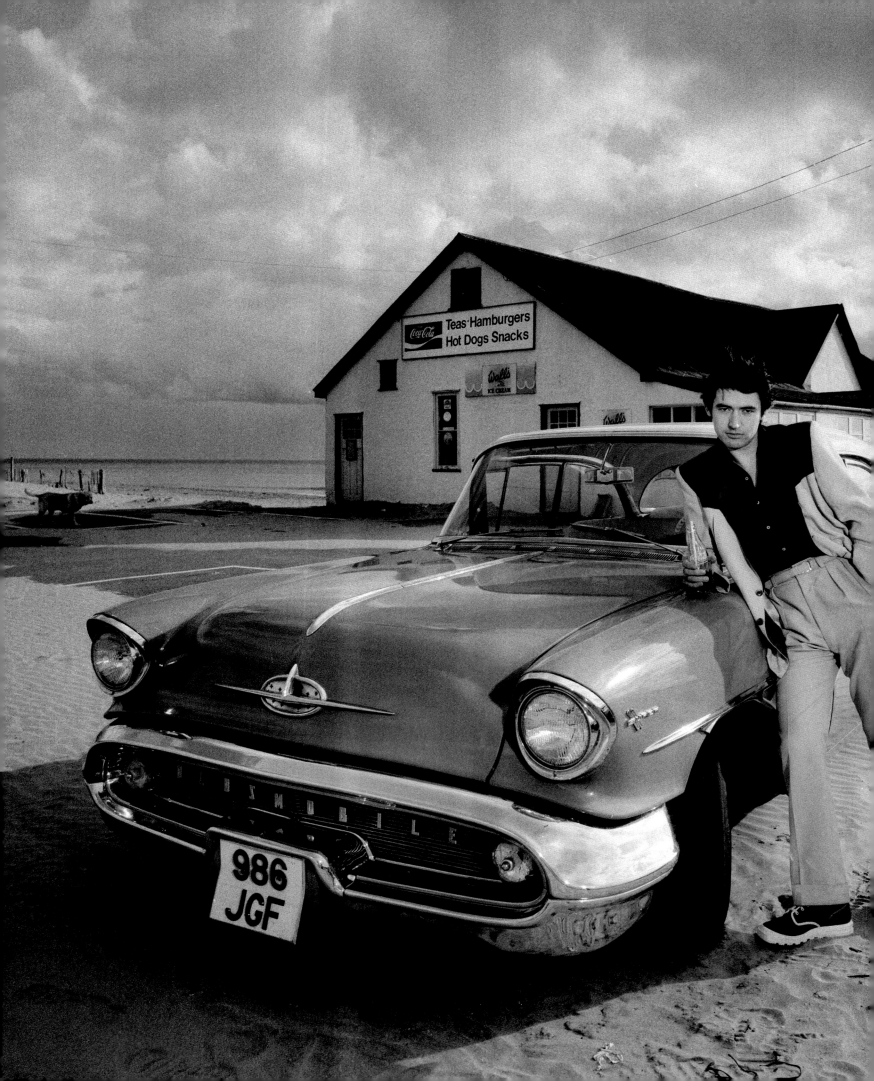

CHRIS SPEDDING 1975 & 2003

Considered to be one of Britain's most accomplished session guitarists, Sheffield-born Chris Spedding has a career that spans over 40 years. During that time he has worked with the likes of Battered Ornaments, Nucleus, Nilsson, Roy Harper, Roxy Music, Brian Eno, Laurie Anderson and on Paul McCartney's album *Give My Regards to Broad Street*. He was also the producer of the first demo recordings made by the Sex Pistols and a member of the hit-making Wombles during the mid-70s. His solo career – which includes 12 studio albums – brought him just one hit when 'Motor Bikin'' from the album *Chris Spedding,* which Mankowitz photographed on Camber Sands, reached the Top 20 in 1975.

"This is from the cover session for Chris's album on RAK records, which was released in 1975. We had such fun on this shoot because we also made my first promo film for his single 'Jump In My Car'. The 1957 Oldsmobile Rocket 88 was mine and Chris got completely immersed in the mood we were trying to create, which was a sort of stylish retro American 50s look, in spite of shooting on a rather windy, cold and very English beach! The portrait below was taken in 2003 as part of a series on great guitarists and their favourite instruments."

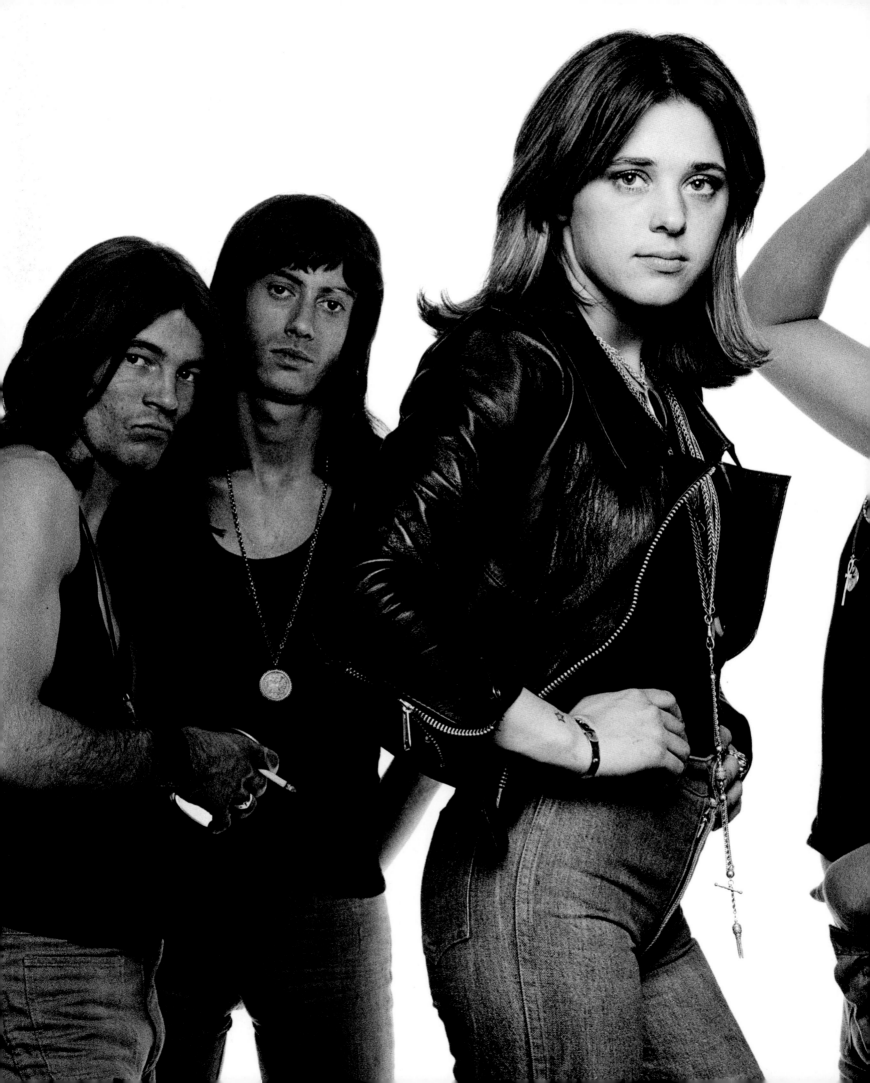

SUZI QUATRO 1973 TO 1978

Born in Detroit in 1950, Suzi Quatro was a member of the rock group Cradle when producer Mickie Most first saw her perform in 1969 and invited her to the UK to record. Working with the writing team of Nicky Chinn and Mike Chapman, Quatro reached Number 1 in 1973 with her debut 'Can The Can', which was released in a singles bag photographed by Mankowitz. With her three-piece backing band, Quatro appeared in the charts through to 1982 with 15 more singles – including four Top 10 hits – before moving into a career in TV and as an actress.

"The great producer Mickie Most discovered Suzi in 1969 but she didn't start having hits until he introduced her to Nicky Chinn and Mike Chapman (Chinnichap) and they came up with 'Can The Can'. I shot the session for that record and came up with the Leader of the Gang look, although I believe it was Mickie's idea to put her into the leather jump suit. She's a genuine talent. I continued to work with her throughout the 70s and have worked with her regularly since then."

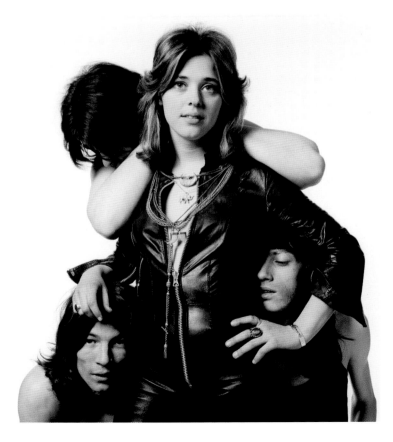

SISTER ROSE 1975

Rosemary Stone was a member of Sly and The Family Stone – alongside her brothers Sly and Freddie – for ten years from 1966 and as Sister Rose appeared on their US number singles 'Everyday People', 'Thank You (Falettinme Be Mice Elg Agin)' and 'Family Affair'. In 1976 she released her solo album *Rose* – which included her R&B hit 'Whole New Thing' – under the name Rose Banks, following her marriage to producer Bubba Banks. She went on to record with Michael Jackson and Ringo Starr before performing as a backing singer on Robbie Williams' hit album *Escapology* in 2002.

"Rose Stone was the sister of Sly Stone and had been one of the singers in the band Sly and The Family Stone. This session was shot at the famous Bradbury Building in downtown Los Angeles and was for the cover of her debut solo album *Rose* on Motown Records, although I'm not sure how it ended up being used!"

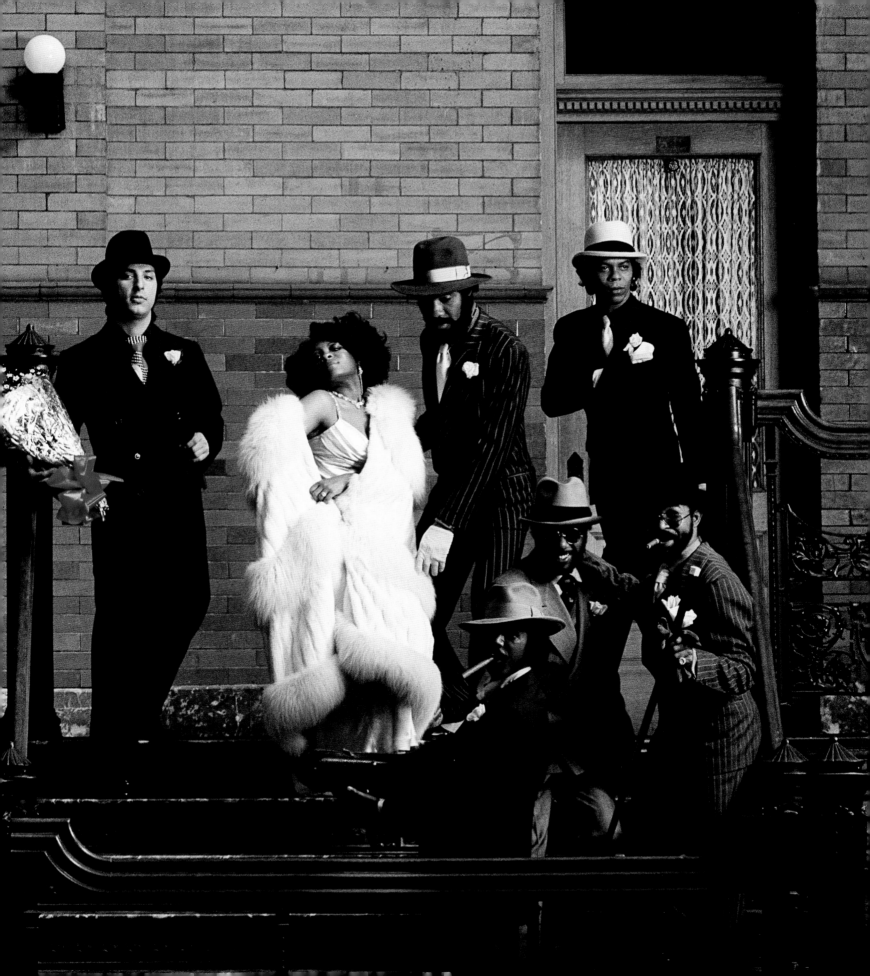

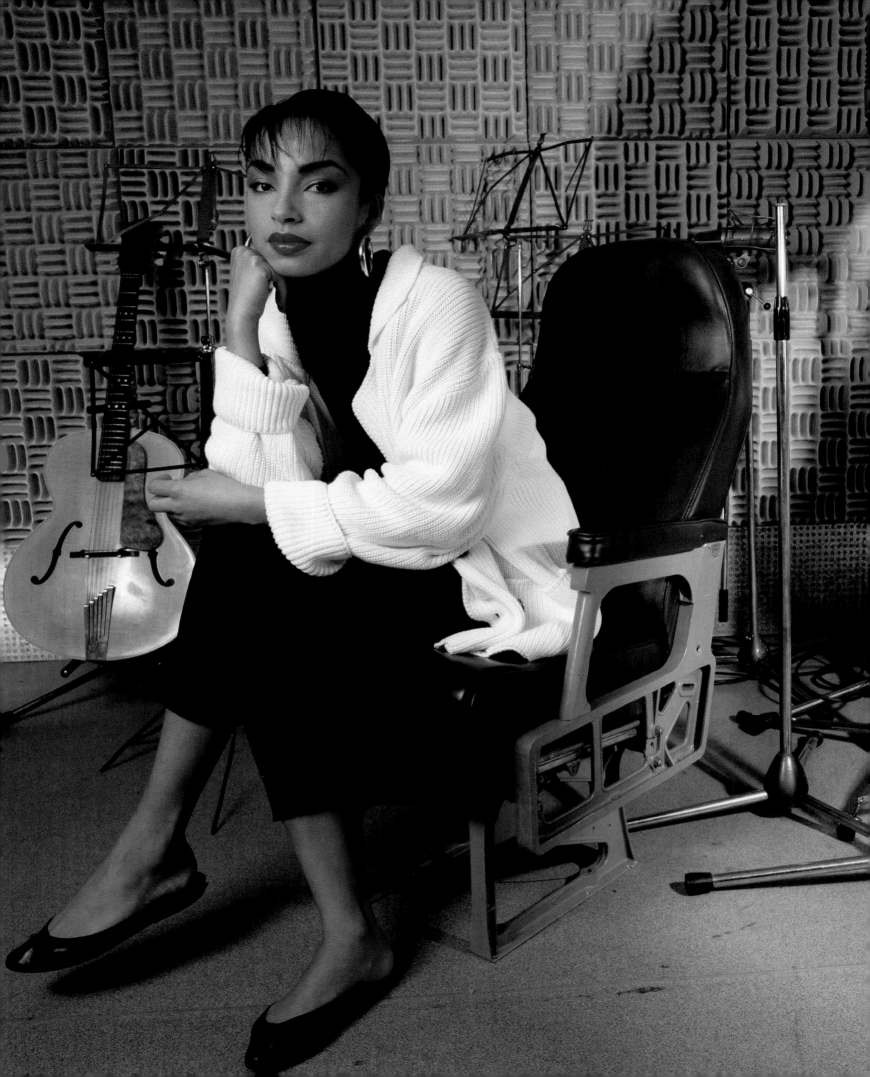

SADE 1985

Born in Nigeria and raised in Essex, Helen Folasade Adu began singing with Arriva and Pride before setting off on her solo career as Sade. Her debut single 'Your Love Is King' hit the UK Top 10 in 1984 and, after Top 5 success in both the UK and the US with the album *Diamond Life*, Sade went to Number 1 on both sides of the Atlantic in 1985 with the album *Promise*. Following the release of her *Best Of* compilation in 1994, Sade remained quiet until 2000, when she returned with her album *Lovers Rock*, which hit the UK Top 20 and reached Number 3 in America.

"The beautiful and stylish Sade was causing quite a stir in the music world by the time a London magazine asked me to take her portrait. I went to a small recording studio she used and set my shot up in a corner. Her earlier experience as a model meant that the session went very smoothly …"

THE THREE DEGREES 1978

Originating from Philadelphia, the Three Degrees' first line-up featured Fayette Pinkney along with Linda Turner and Shirley Porter until Sheila Ferguson and Valerie Holiday replaced Turner and Porter in 1965. The new line-up signed with Philadelphia International and in 1974 hit the UK charts with three singles, including the chart-topping 'When Will I See You Again', which reached Number 2 in America. Dubbed by the media as "Prince Charles' favourites" – they sang at his 30th birthday party – the Three Degrees were regulars in the UK charts through to 1985 and made a return to the Top 60 in 1998.

"This session was for the album called *New Dimensions*, which was produced by Giorgio Moroder. They were great women, beautiful, very professional and full of enthusiasm and a terrific attitude."

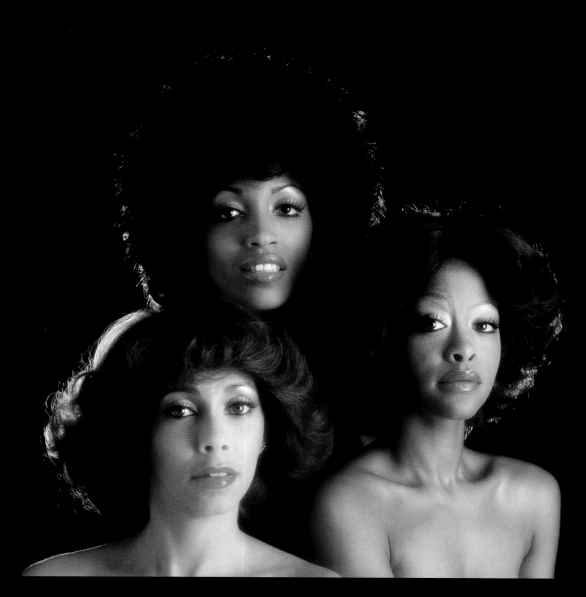

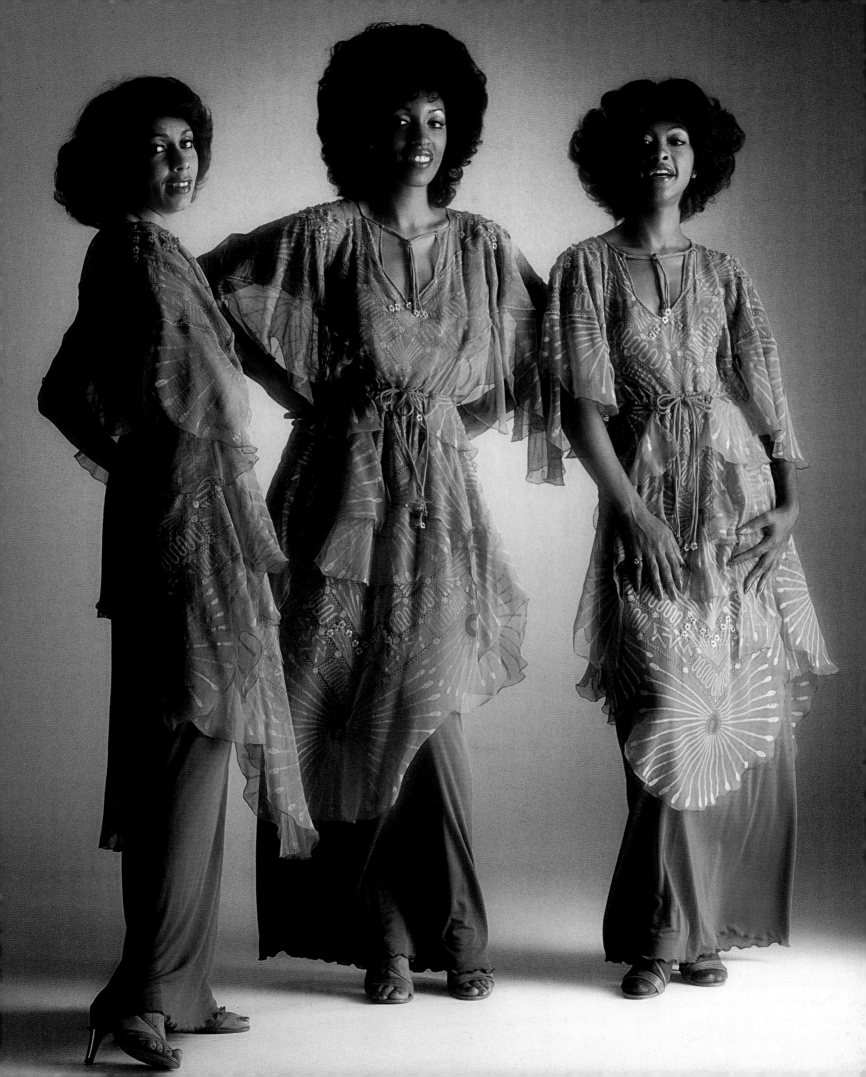

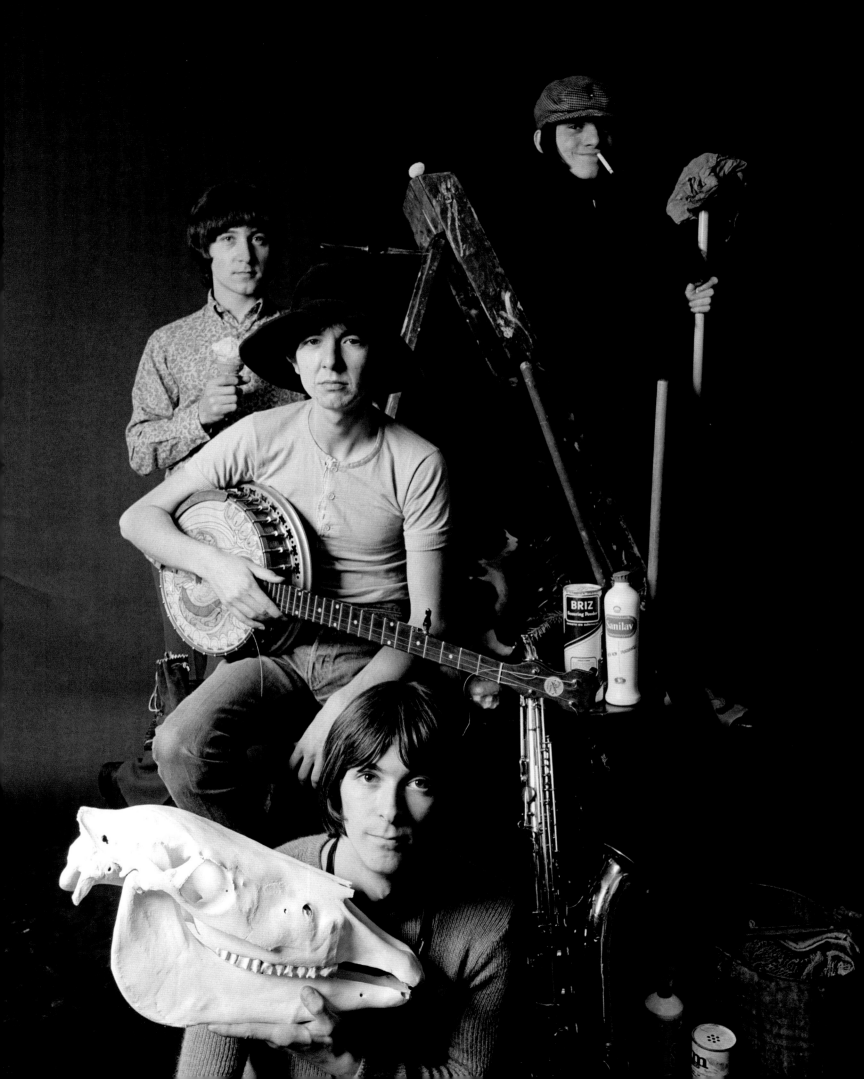

SMALL FACES 1967

In November 1965 the most familiar Small Faces line-up was settled when Ian McLagan replaced original organist Jimmy Winston to join Steve Marriott, Ronnie Lane and Kenny Jones. They first hit the Top 10 with 'Sha La La La Lee' in early 1966 and went to Number 1 with 'All Or Nothing'. 'Itchycoo Park' was a UK Number 2 and a Top 20 hit in the US before their 1968 album *Ogden's Nut Gone Flake* – in its revolutionary round cover and with inner sleeve shots by Mankowitz – reached Number 1. A year later Marriott left to create Humble Pie while the remaining members joined forces with singer Rod Stewart to form the Faces.

"I first photographed the Small Faces back in 1965 when Jimmy Winston was in the band, for their manager, the notorious Don Arden. However, the most exciting period for them was at Immediate records and the portraits here were all shot for the infamous *Ogden's Nut Gone Flake* album. I did several sessions with the band until they broke up and Steve Marriot formed Humble Pie. The Small Faces were a great band and Steve was, without doubt, one of the greatest British soul singers of all time!"

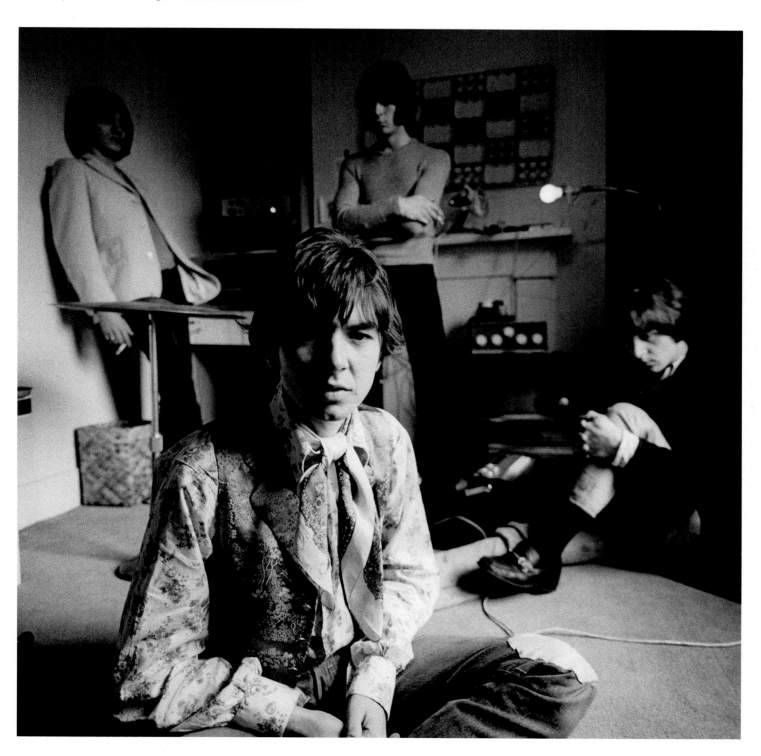

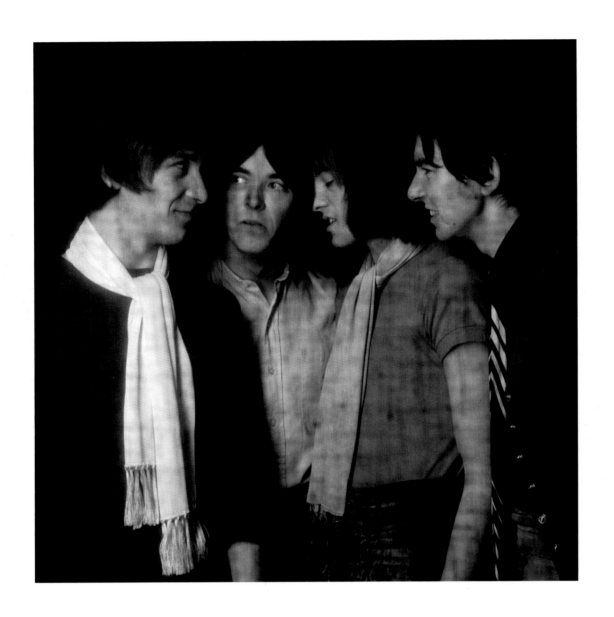

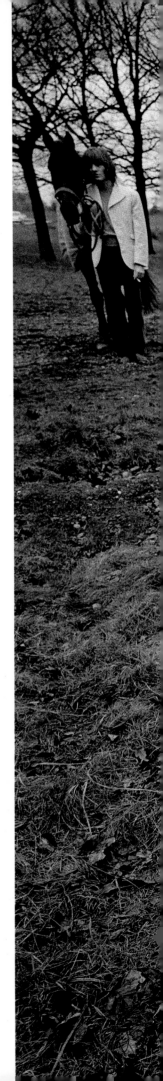

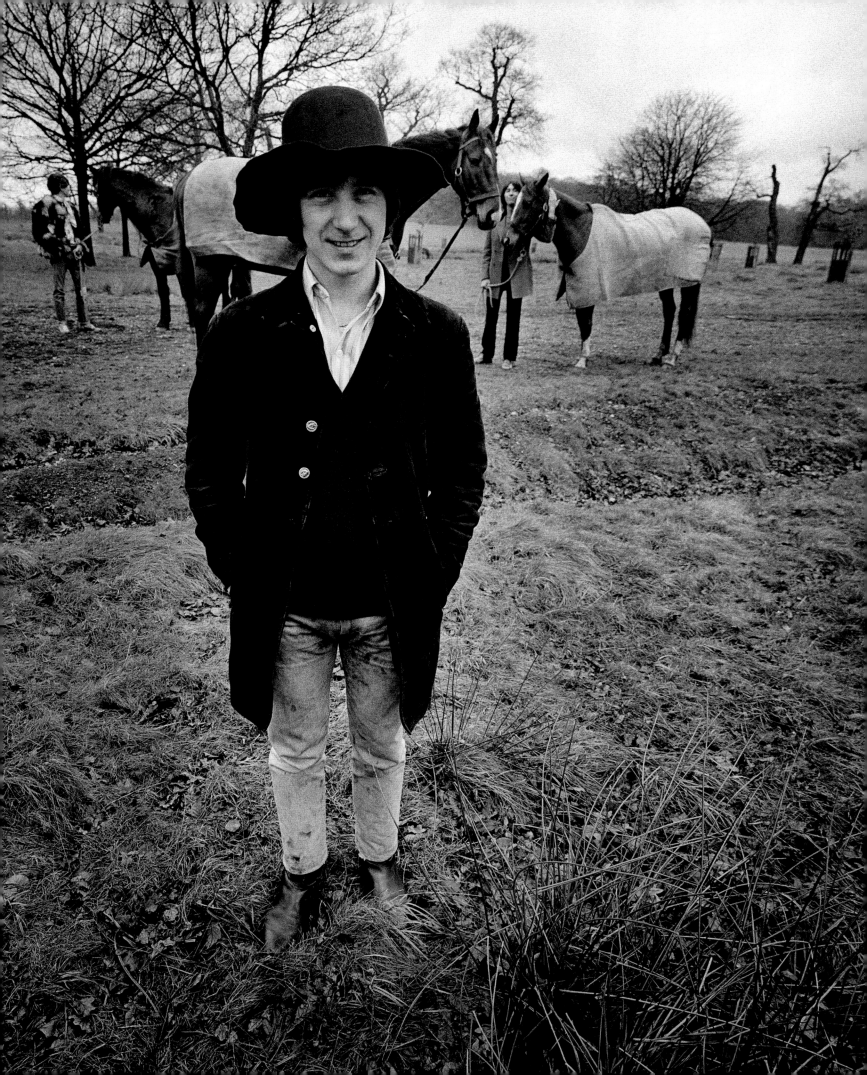

SUEDE 1993

Singer Brett Anderson pulled the band Suede together in 1992 when he recruited Bernard Butler, Matt Osman and Simon Gilbert and their first four singles all charted alongside their debut Number 1 album *Suede,* which also brought them the 1993 Mercury Music Prize. When Butler left in 1994, Richard Oakes joined the group and the new line-up racked up the Number 1 albums *Coming Up* and *Head Music* plus a further twelve Top 20 singles. In 2005 Anderson and Butler reunited as The Tears and in 2013 Anderson, after issuing four solo albums, returned to the band to record their seventh album *Bloodsports.*

"*MOJO* magazine asked me to work with Suede, who had just made a fantastic impact with their first album and an amazing performance at the 93 BRIT awards. They were one of the happening bands of the year and looked great. They responded well to my simple idea and Bernard Butler, their brilliant guitarist, really made the shot special with his performance at the back of the group!"

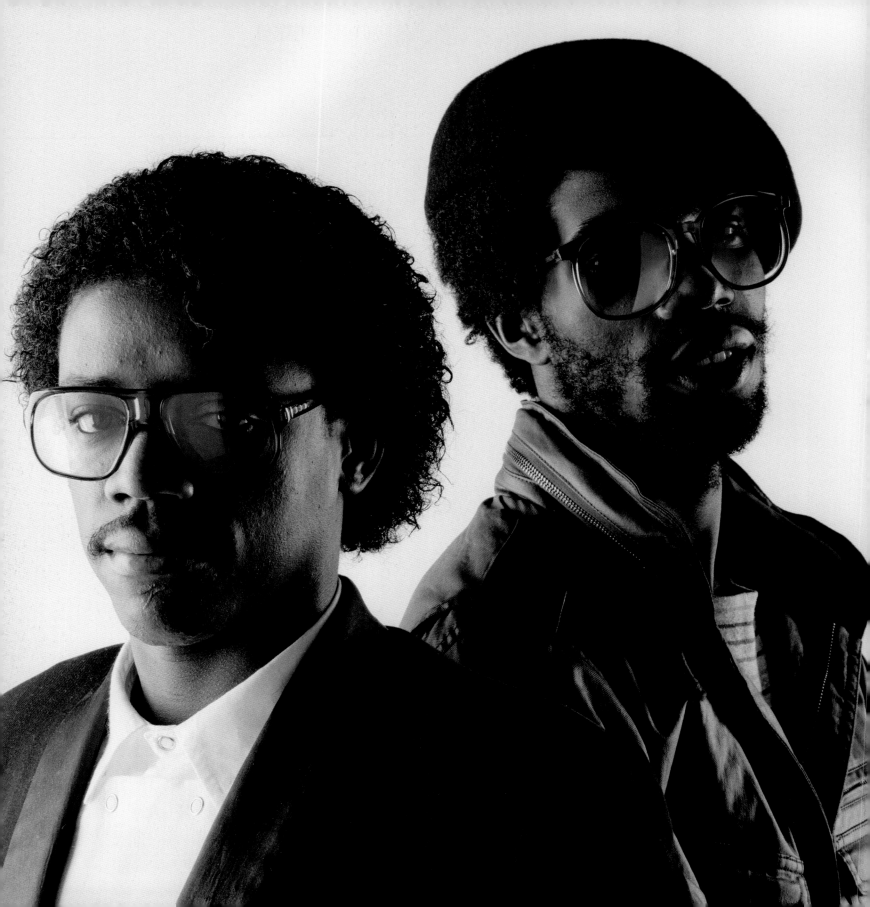

LINX 1980

British soul funk band Linx formed as a five-piece with David Grant, Peter "Sketch" Martin, Bob Carter, Andy Duncan and Canute Edwards and they debuted in the UK Top 20 in 1980. After that vocalist Grant and bass player Martin continued as as a two-piece and reached Number 8 in 1981 with their debut album *Intuition* while the title track single peaked at Number 7. The duo folded in 1982 and Grant went on to release eight more hit singles – including a Top 5 duet with Jaki Graham – before becoming the voice coach on TV's *Fame Academy*.

"David Grant and Peter 'Sketch' Martin caused a minor sensation when they first hit the UK soul/funk scene, and I shot this session for their first album, called *Intuition* after one of their biggest hits. Their future seemed set with a second album and hits both here and in the US, but they chose to disband in 1982 with David pursuing a solo career and then evolving into one of the UK's leading vocal coaches."

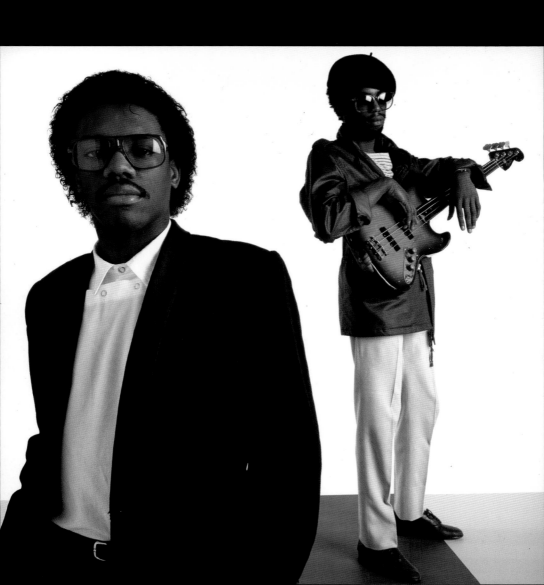

SMOKIE 1974 TO 1979

In an effort to avoid confusion with Smokey Robinson, the legendary Motown singer, Chris Norman, Alan Silson, Peter Spencer and Terry Uttley opted to call themselves Smokie when they got together after a period as Kindness. Signed to Mickie Most's RAK label and linked with songwriters Nicky Chinn and Mike Chapman, the group hit the UK Top 10 twice in 1975. Hugely successful in Europe, Smokie also hit the US Top 30 with their 1976 UK Top 5 hit 'Living Next Door To Alice' and released seven more chart singles before finally breaking up in 1980.

"Nicky Chinn and Mike Chapman (Chinnichap) were major clients of mine throughout the 70s and I worked with all their artists, including Smokie. We did 15 sessions together throughout their peak success, including all their album covers. They were a great pop band and were lovely lads to work with – we had a lot of fun and got some great shots!"

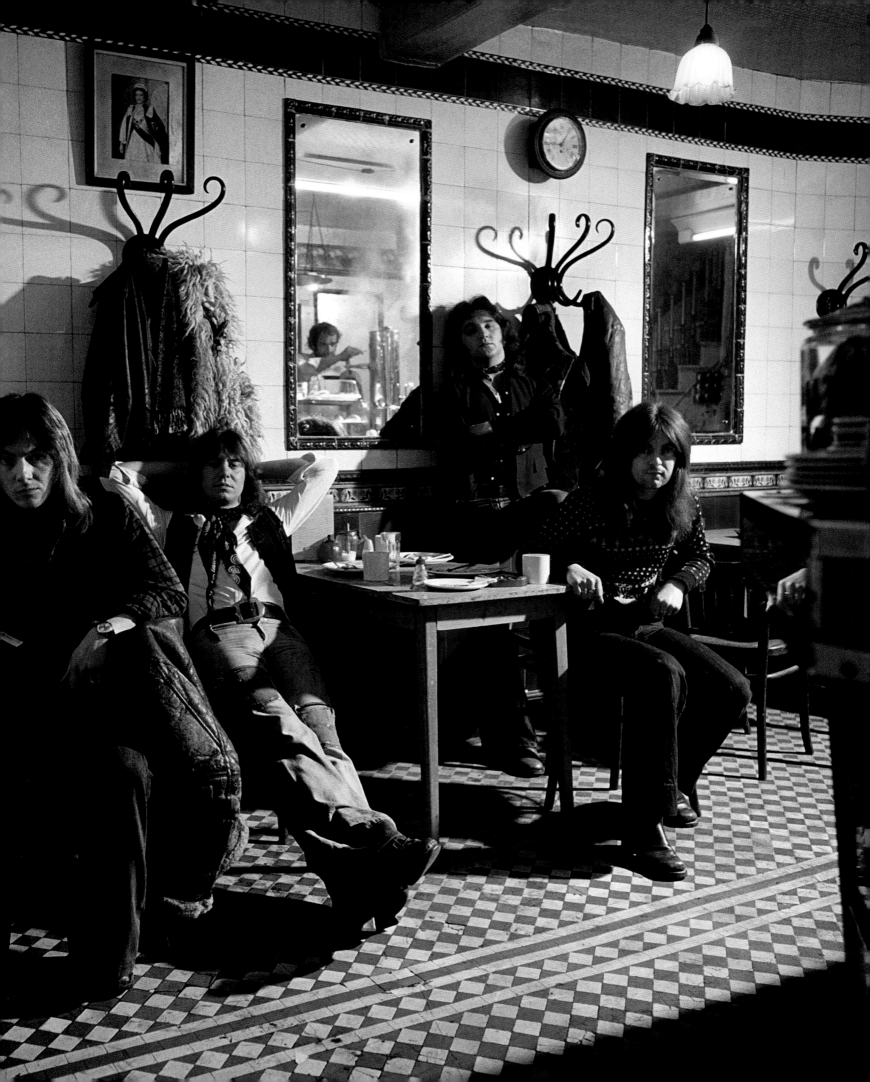

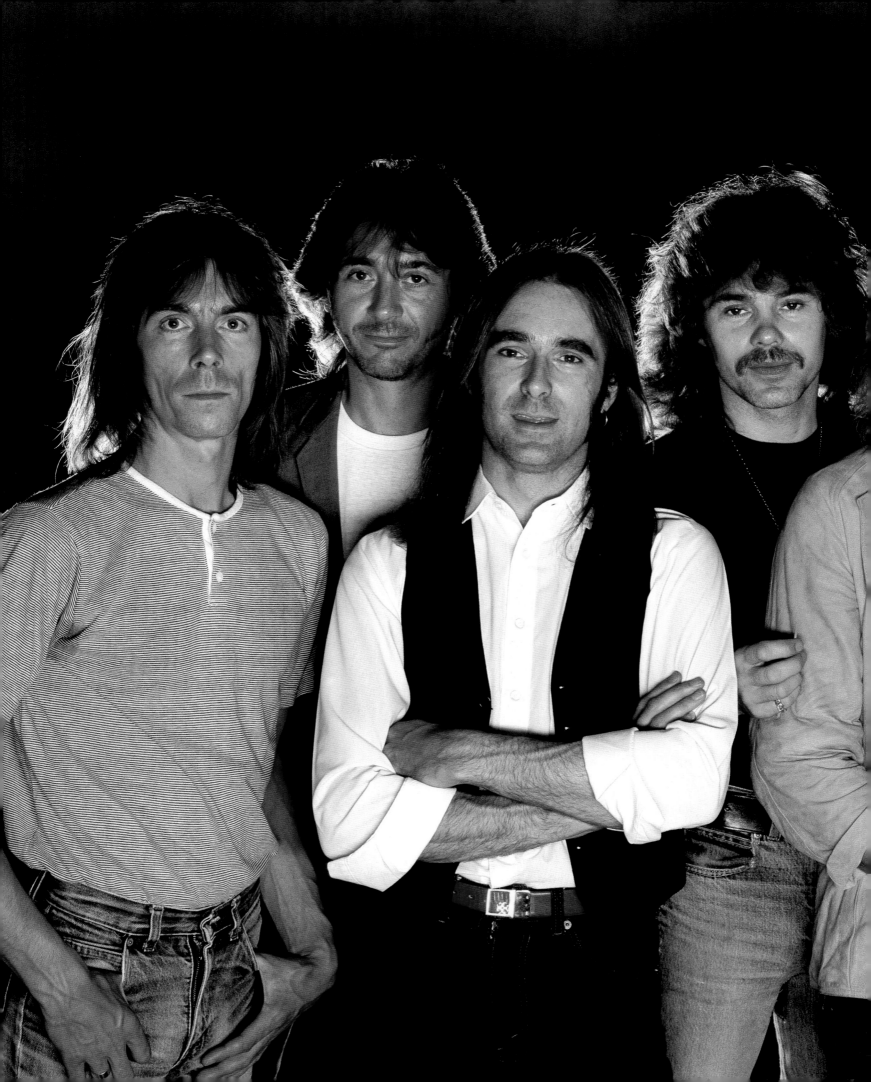

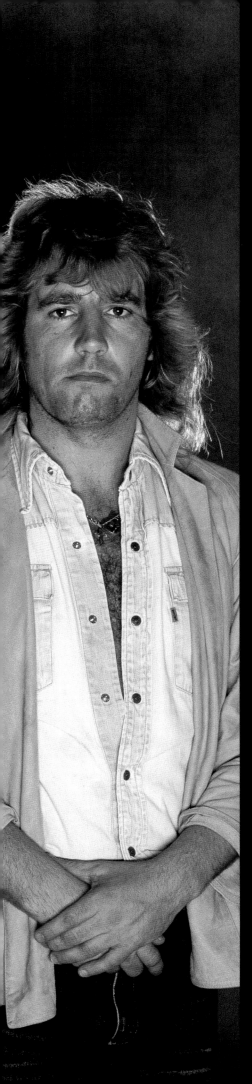

STATUS QUO 1982

It was in 1967 when Status Quo first hit the charts in both the UK and the US with 'Pictures Of Matchstick Men'. The line-up of Francis Rossi, Roy Lynes, Alan Lancaster, John Coghlan and Rick Parfitt stayed together until 1970 when Lynes left and the four-piece – plus part-time pianist Andy Bown – remained together until Lancaster's departure in 1983. With over 60 hit singles – including the Number 1 'Down Down' – to their credit, Quo's tally of Top 20 albums puts them behind only the Beatles and the Rolling Stones. Remembered as the opening act at London's Live Aid concert in 1985, Quo – featuring Rossi and Parfitt – are still together after over 45 years.

"Status Quo are legends, and as such I was delighted to have had the chance to work with them. As it turned out they were, probably, the most stoned band I have ever worked with! Each of them had their own personal roadie who arrived in advance, carrying a box containing the band member's personal needs, which covered the entire gamut of rock and roll excess!"

DEL SHANNON 1967

Born in Michigan in 1934, Del Shannon topped the US and UK charts in 1961 with his debut single 'Runaway' and by the end of 1963 he had racked up a further nine UK hits and also charted in America with his version of 'From Me to You' making it the first Lennon–McCartney song to register in the US hit parade. His session with Andrew Loog Oldham took place at Olympia studios in London, but the recordings weren't released until 1978. In 1990 – two years after touring the UK with American singers Bobby Vee and Brian Hyland – Shannon was found dead at his home in California.

"Andrew Oldham was producing an album with Del, who was in the UK touring at the time. I was a big fan and was delighted to have the chance to sit in on the sessions, which were packed with all the great session musicians of the day as well as a posse of Immediate artists and even the odd Stone!"

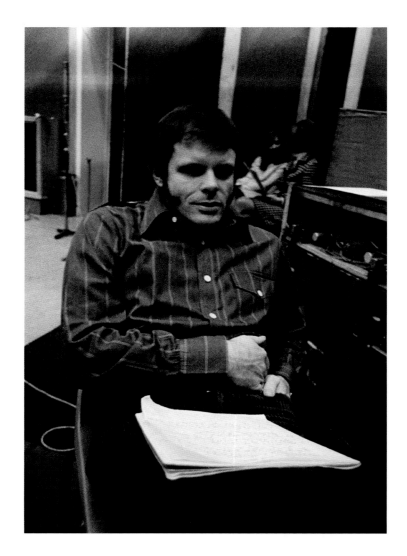

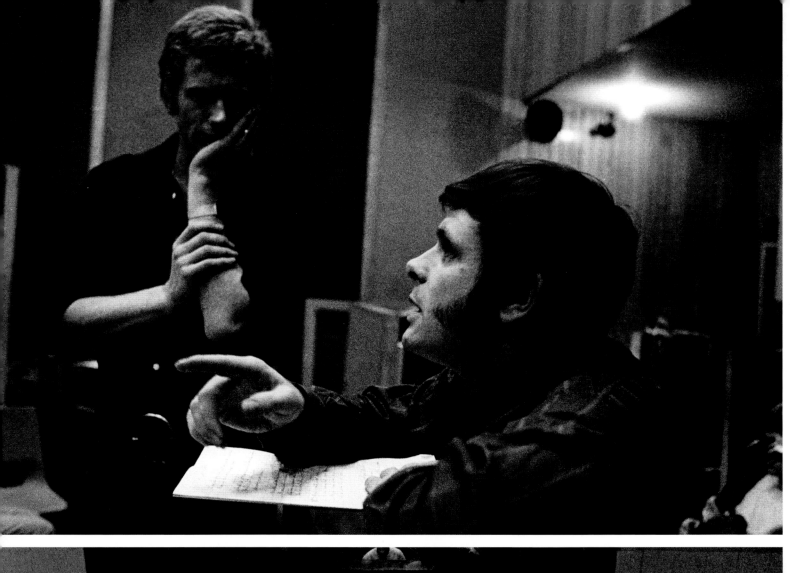
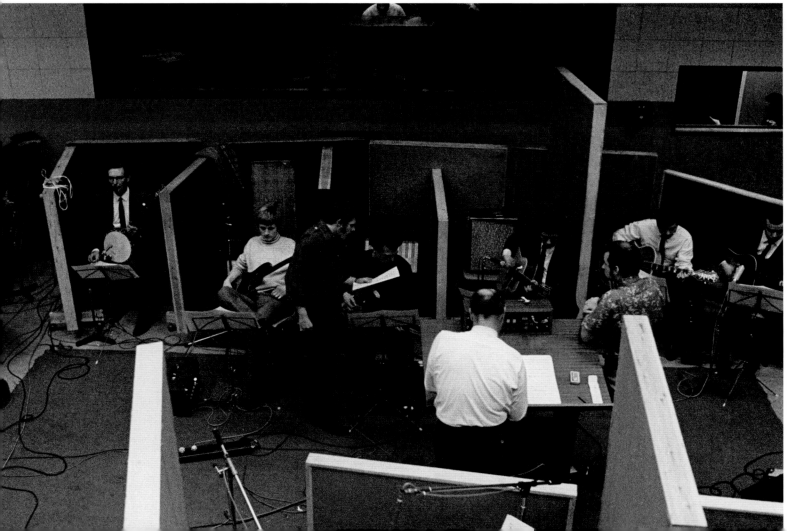

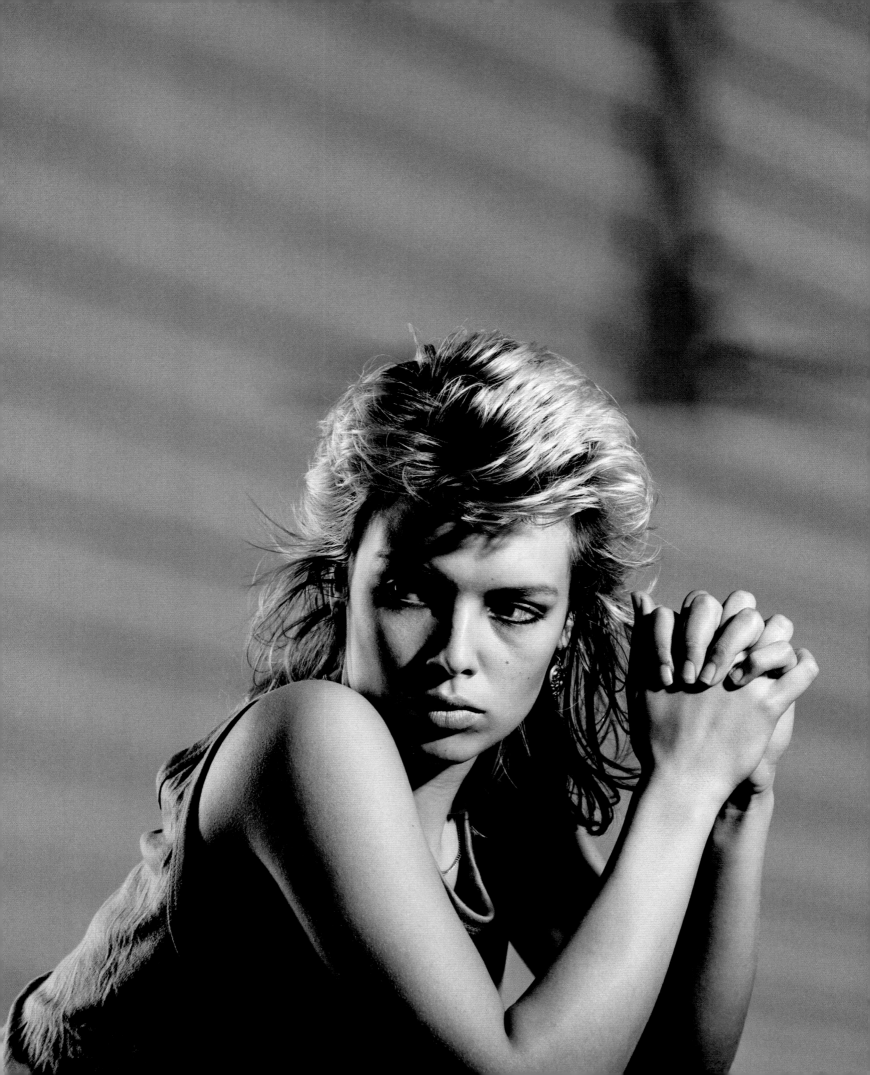

KIM WILDE 1982

Aged 20 Kim Wilde, the daughter of 1950s British rock star Marty Wilde, signed her first record deal with producer Mickie Most in 1980 and a year later peaked at Number 2 with her debut single 'Kids In America'. Her first two albums *Kim Wilde* and *Select* – both photographed by Mankowitz – were major UK hits and her 1986 version of 'You Keep Me Hangin' On', which reached Number 2 in the UK, went to the top of the US charts making Wilde only the fifth British female artist to hit Number 1 in America. In recent years she has combined music with her passion for gardening and horticulture.

"I loved photographing Kim, she was so bright and photogenic, and the daughter of one of my all time heroes, the great Marty Wilde! I shot her first two albums for Mickie Most at RAK records and several other sessions during her brief initial success."

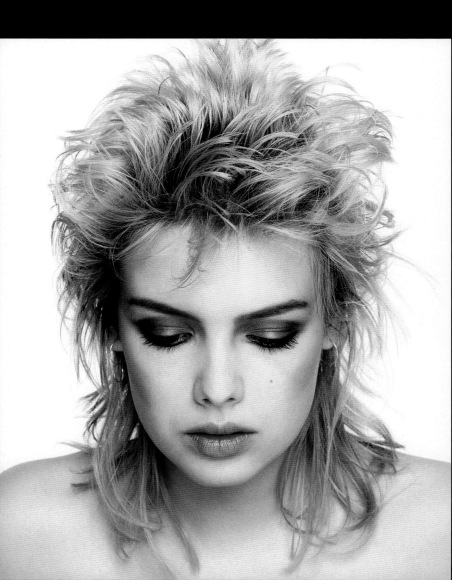

arts featured four
Fender, Rita Ray
he John Dummer
mmy Howell and
nto the charts in
ve Number 2 hits
he was replaced
ght-piece line-up

"Darts were probably the most successful British doo-wop revival band in regard to the UK charts ever and were terrific to work with, being very creative and enthusiastic. The image on the left was shot in a dressing room with the band's original nine-piece line-up and was used as part of an album package. The other shot was taken for publicity a bit later in the band's career when they had shrunk to an eight-piece!"

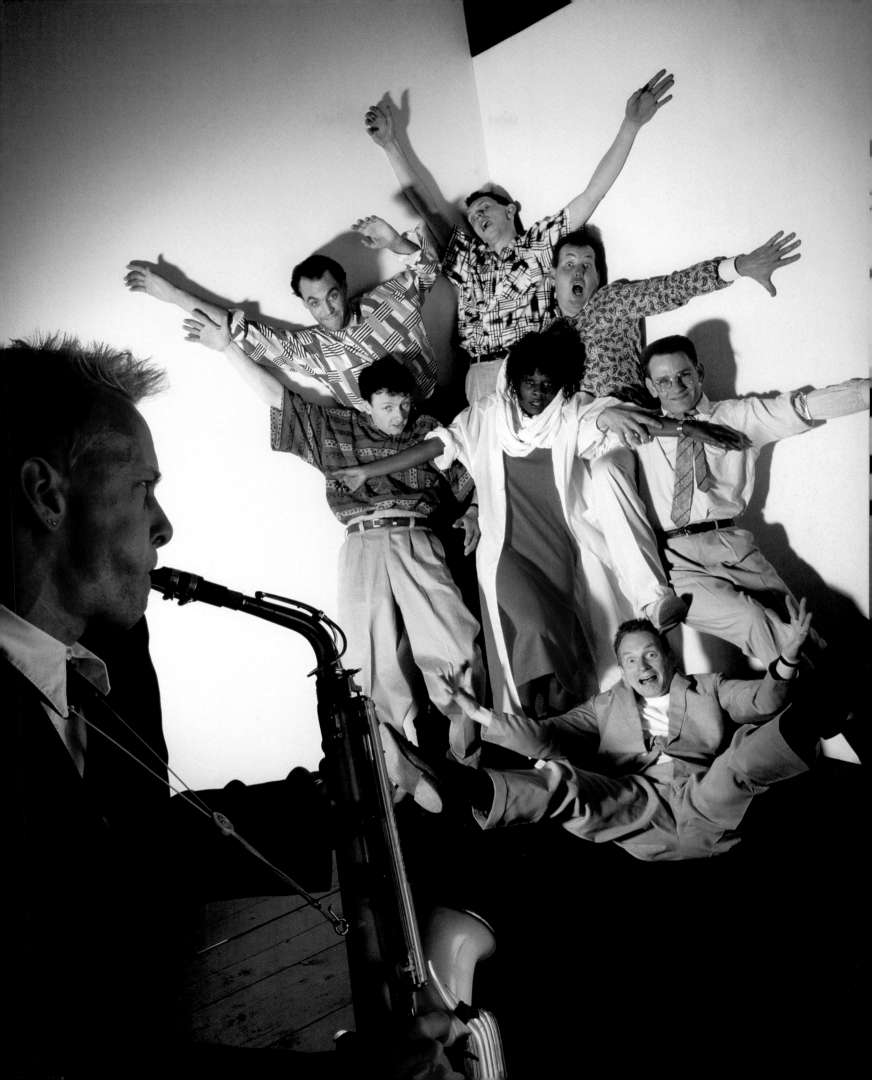

THIEVES 1978

Seven leading American session musicians were assembled by British producers and songwriters Nicky Chinn and Mike Chapman in 1978 to form the 'super group' Thieves. Lead singer Sue Chapman plus Linda Lawley, Andrea Robinson, Rusty Buchanan and Steve Goldstein joined former Fairport Convention member Jerry Donahue and future Fairport player Gerry Conway to record the group's only album *Yucatan*, which was released – with Mankowitz's cover shot – in 1980. Thieves disbanded in 1981 and Lawley, Donahue and Buchanan went on to form the Roommates.

Thieves were the creation of Nicky Chinn and Mike Chapman who auditioned hundreds of musicians in Los Angeles before they settled on the final talented line-up. The sleeve concept was that this was a group of Thieves hiding out in the Yucatan jungle of Mexico, each of them taking on a different theatrical persona. It was the last of the great extravaganzas as we trooped into the jungle with trunks of props and costumes and a make-up artist, and it cost a fortune, but was great fun and a terrific adventure. Unfortunately the album was a commercial failure in spite of containing several catchy pop/rock numbers!

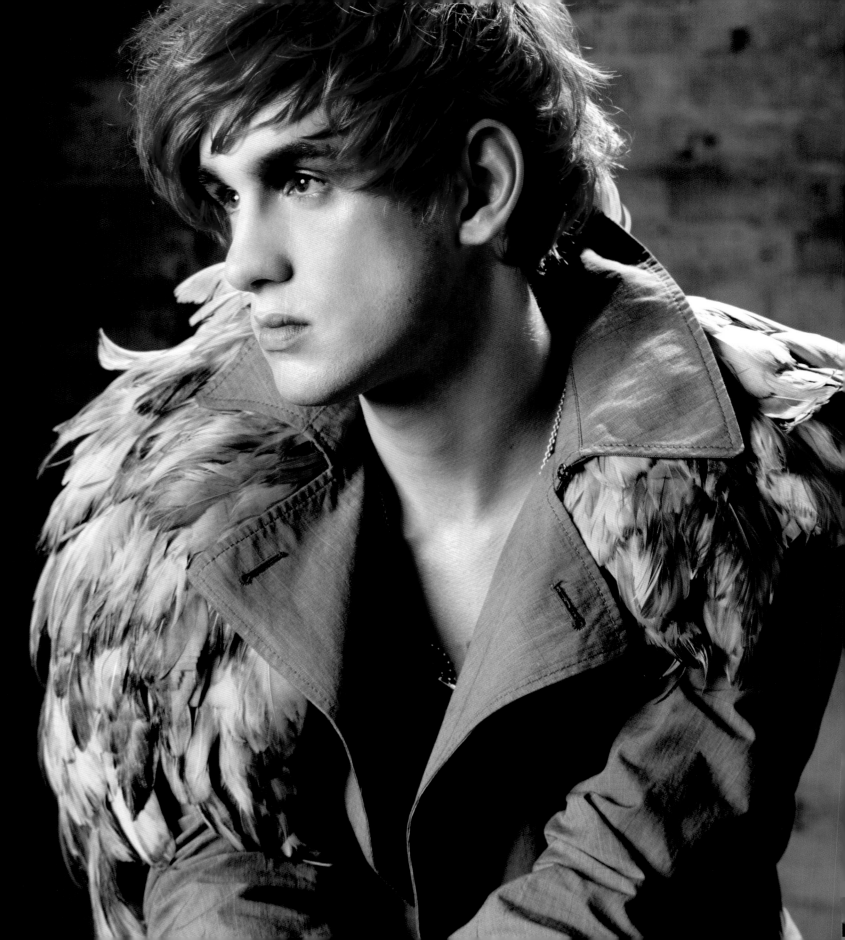

PATRICK WOLF 2007

London-born vocalist and multi-instrumentalist Patrick Wolf built his reputation by combining romantic folk music with techno pop. After joining his first band Minty at the age of 14, Wolf turned to busking and released his debut album *Lycanthropy* in 2003. His third album *The Magic Position* was issued in 2007 and featured Wolf's collaborations with singer Marianne Faithfull. In addition to touring the US, Japan and Europe, Wolf released three further albums between 2009 and 2012 while also working as a male model.

"I really enjoyed working with Patrick because he is the sort of creative powerhouse who pushes you and brings out the best you have to contribute at the time. I really enjoyed his music and his eccentric style and look and was thrilled to shoot the cover for his third album *The Magic Position*."

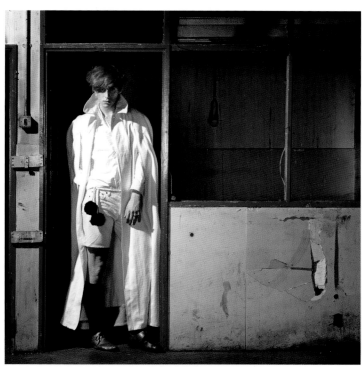

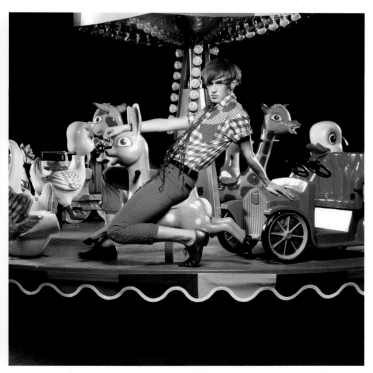

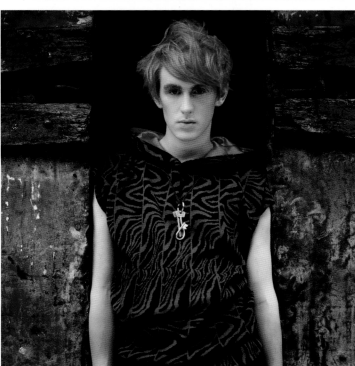

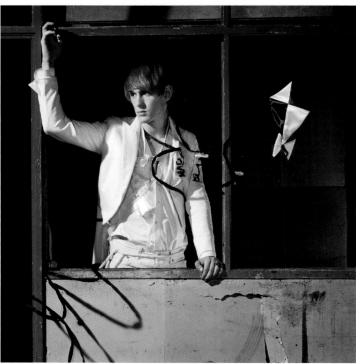

DUKE SPIRIT 2004

Rock group Duke Spirit was established in 2003 when Luke Ford, Toby Butler and singer Liela Moss got together after studying at the same college in Cheltenham. They added Dan Higgins and Olly Betts to the band and debuted on the charts in 2004 and issued three more singles before releasing their Top 50 album *Cuts Across The Land*. After their follow-up album *Neptune* came out in 2008, Higgins left the band and was replaced by Marc Sallis, and the group's 2011 EP 'Kusama' – a tribute to Japanese artists Yayoi Kusama – came out just before their album *Bruiser*.

"A great London band and highly thought of, although only limited commercial success so far, but full of tremendous potential. Hard working and very creative with a most charismatic singer in Liela Moss, they are destined for great things …"

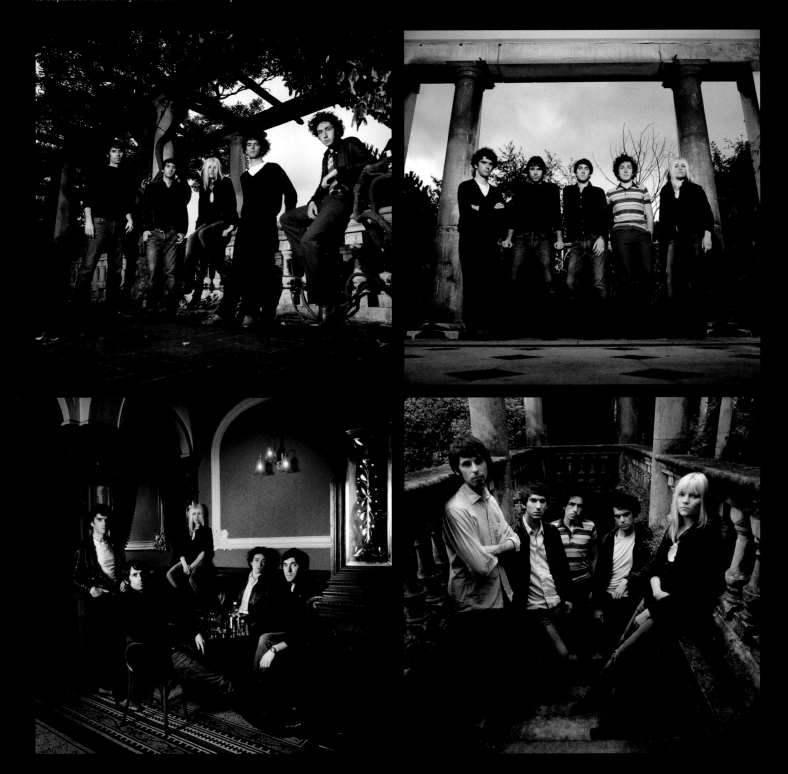

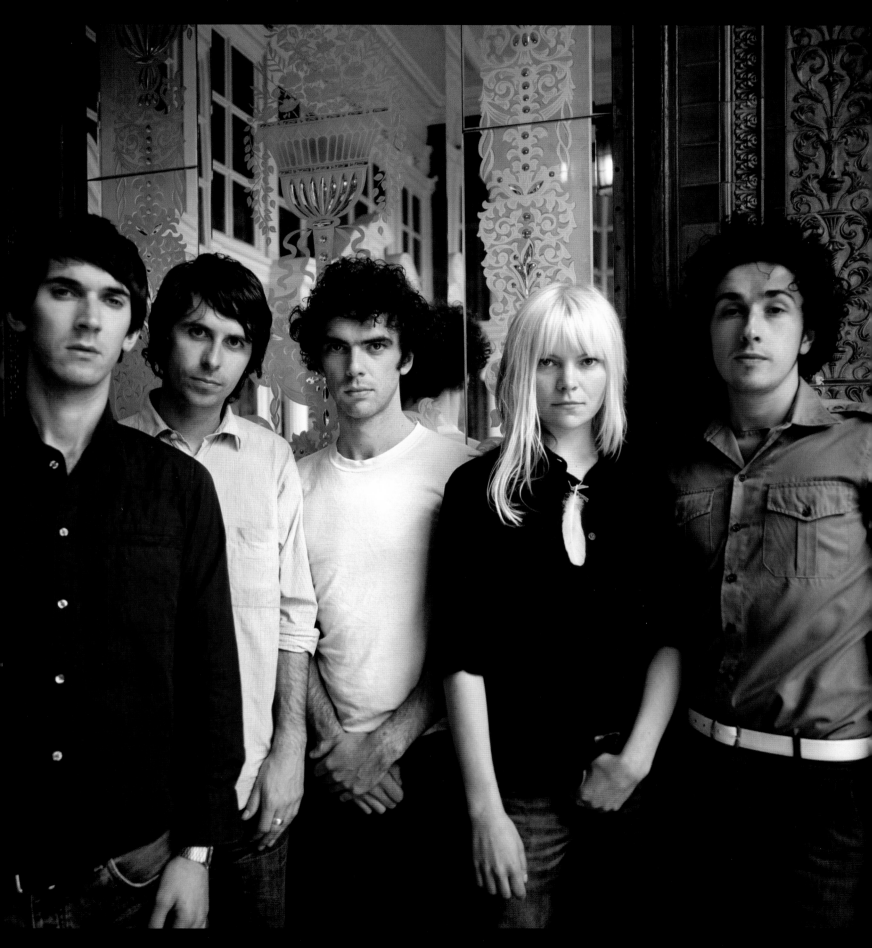

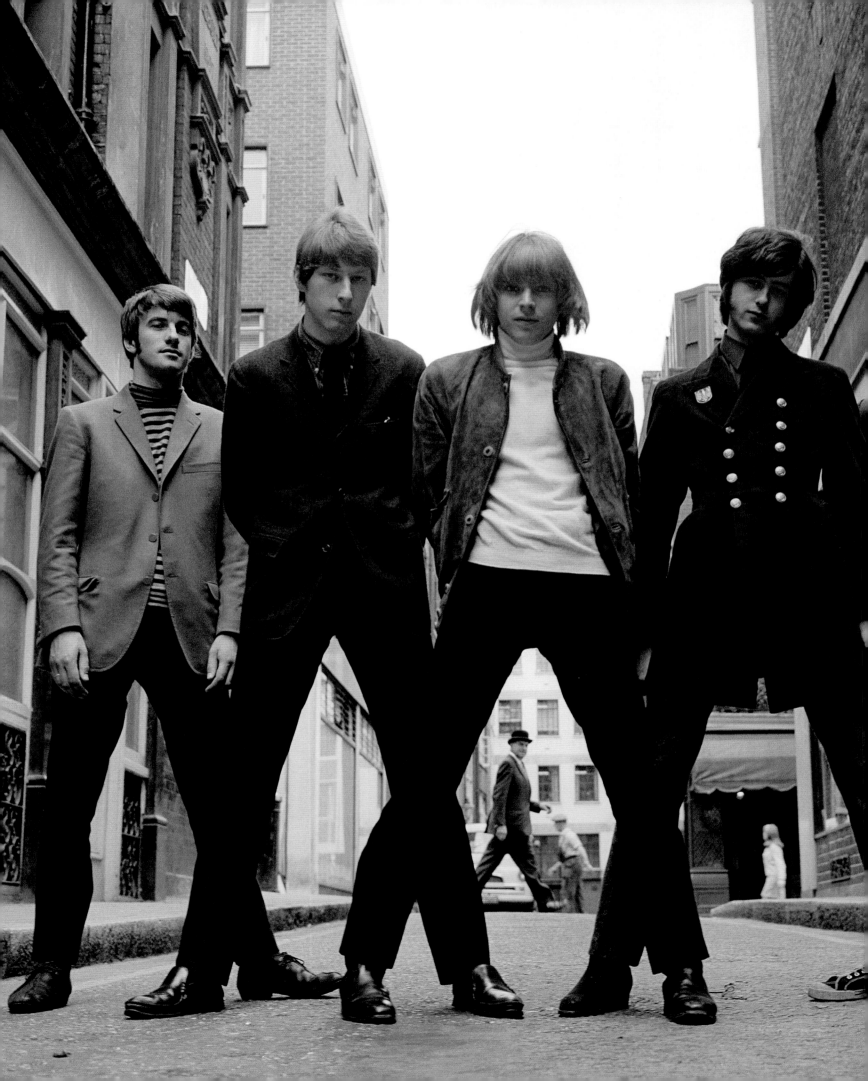

THE YARDBIRDS 1966

The original Yardbirds were founded in 1963 when Keith Relf, Ian Samwell-Smith, Chris Dreja and Jim McCarty teamed up with Eric Clapton and hit the charts in 1965 with 'For Your Love'. Following Clapton's departure, Jeff Beck joined as the group released four more Top 10 singles before Samwell-Smith left in 1966 to be replaced by Jimmy Page. In the same year, the group's debut album *The Yardbirds* reached the UK Top 20 before the band finally disbanded two years later with Page going on to form the New Yardbirds – with John Paul Jones, Robert Plant and John Bonham – as a forerunner of Led Zeppelin.

"This session captures the band with both Jimmy Page and Jeff Beck, who many considered to be the finest British rock guitarists of this time. I shot this just outside my studio and it was pure luck that in the background you can see the symbol of the British establishment striding past wearing his bowler hat, snapped between the legs of singer Keith Relf."

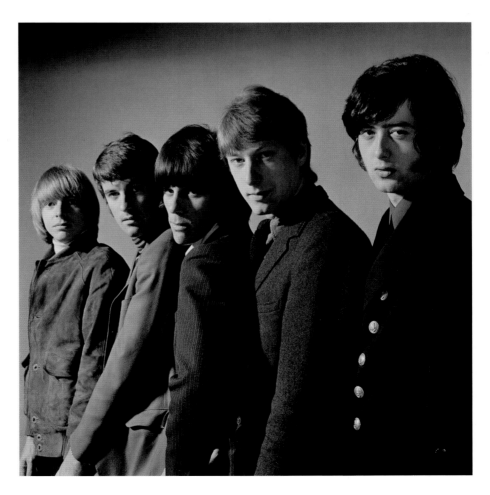

BRETT SMILEY 1974

American Brett Smiley was a child actor before he moved to London to become part of Britain's glam rock scene in the 1970s. Aged just 16 he was discovered by Andrew Loog Oldham and released the single 'Va Va Voom' in 1974 ahead of recording his debut album *Breathlessly* – produced by Oldham and the Small Faces' Steve Marriott and featuring a cover shot by Mankowitz – which remained unreleased until 2004. Moving back to America, Smiley made a number of cameo film appearances before he returned to the studio to start recording again.

"Andrew Oldham discovered Brett, who took the androgynous look of the early 70s to new heights. I was trying to achieve a sort of Marlene Dietrich meets Andy Warhol look! The records were rather good but were just too far-out for the time, although Brett has achieved cult status since!"

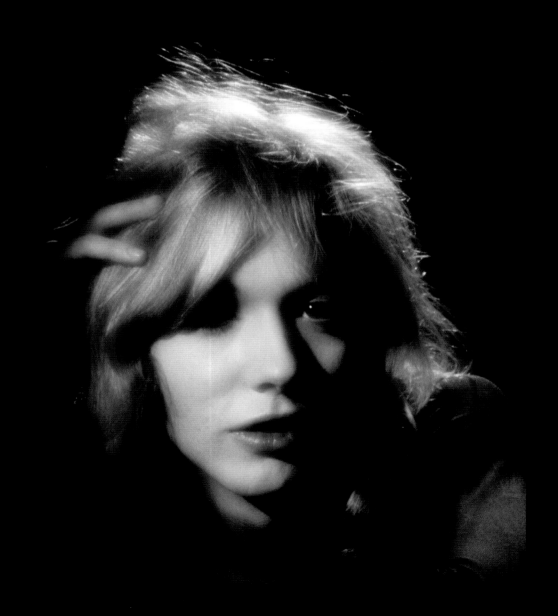

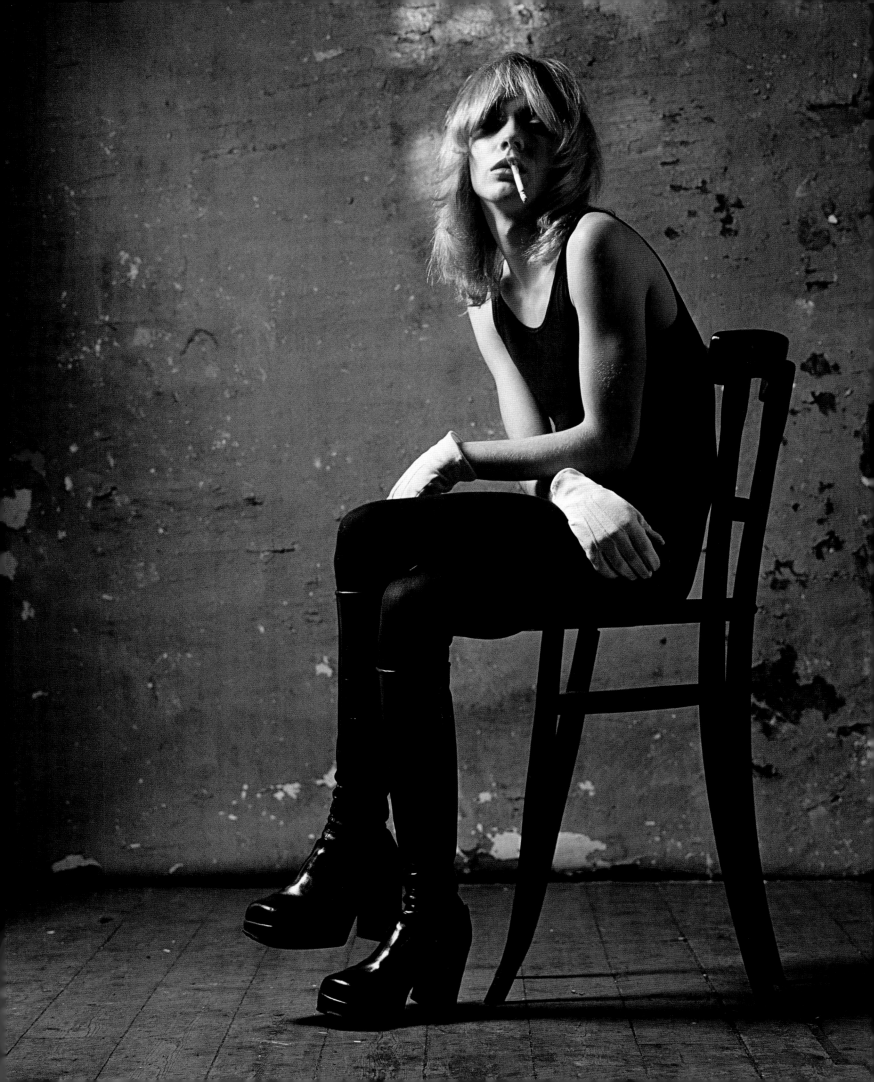

THOMAS RIBEIRO 1997

Singer Thomas Ribeiro was signed to Island Records' subsidiary label 4th & Broadway in the mid-90s when he recorded and released three singles. While the track 'My Love Ain't The Kind' made an impact, it still failed to chart. It was followed by 'Rocket Ship' and 'Lil Darlin'', which featured a photograph by Mankowitz on the singles bag.

"I shot this session for Island Records and thought that Thomas had huge potential and was convinced that he was going to be a great success. He had tremendous charisma, a great voice and seemed to me to be destined to be a star. I have no idea what happened, but ran into him in New York a couple of years later and he seemed to be trying to make it over there …"

HAIRCUT 100 / NICK HEYWARD 1982 & 1985

By the end of 1981 Nick Heyward, Les Nemes and Graham Jones had recruited Blair Cunningham, Phil Smith and Mark Fox to the line-up of the band they named Haircut 100. Their first four singles all made it into the UK Top 10 while their debut 1982 album *Pelican West* – featuring a cover shot by Mankowitz – was a major Number 2 hit in the UK, selling over 300,000 copies in its first week of release. When Heyward left to go solo, Fox, who had quit earlier, returned as lead vocalist but Haircut 100 managed only one more Top 50 hit.

"I did several sessions with Haircut 100, including the cover for their first album *Pelican West.* The idea for the big sweaters and the autumn leaves came from the televised version of *Brideshead Revisited,* which had been a huge hit a couple of years earlier. The band were doing pretty well when Nick decided to leave for a solo career in 1983 and I shot a session with him by himself in 1985."

MOODY BLUES 1983

By the time Mankowitz photographed the Moody Blues in 1983, the cosmic-prog rock band had been together for nearly 20 years, having been formed by Denny Laine, Mike Pinder, Graeme Edge, Ray Thomas and Clint Warwick in 1964 when they hit Number 1 with 'Go Now'. By 1966 Justin Hayward and John Lodge had been recruited to replace Warwick and Laine and in 1978 Patrick Moraz took over from Pinder as the Moody Blues continued to add to their collection of 20 hit albums – including three UK Numbers 1s and two US chart-toppers – and total worldwide record sales of nearly 60 million.

"The Moody Blues were one of the great British bands from the 60s that I didn't have the opportunity of working with back then, so I was delighted to have been able to catch up with them in 1983, when they were established as rock royalty and great survivors from a previous age!"

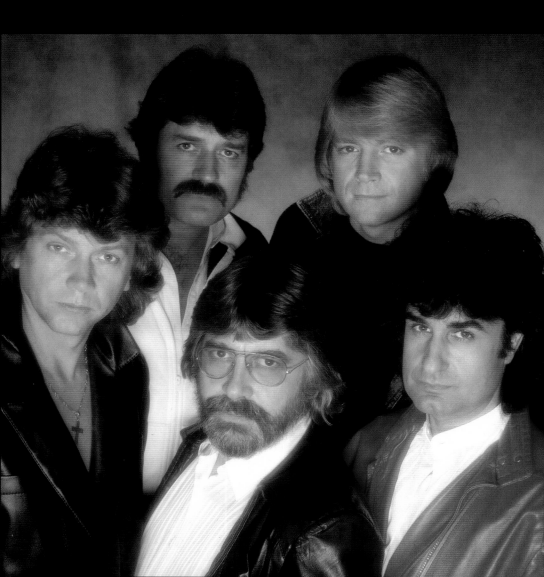

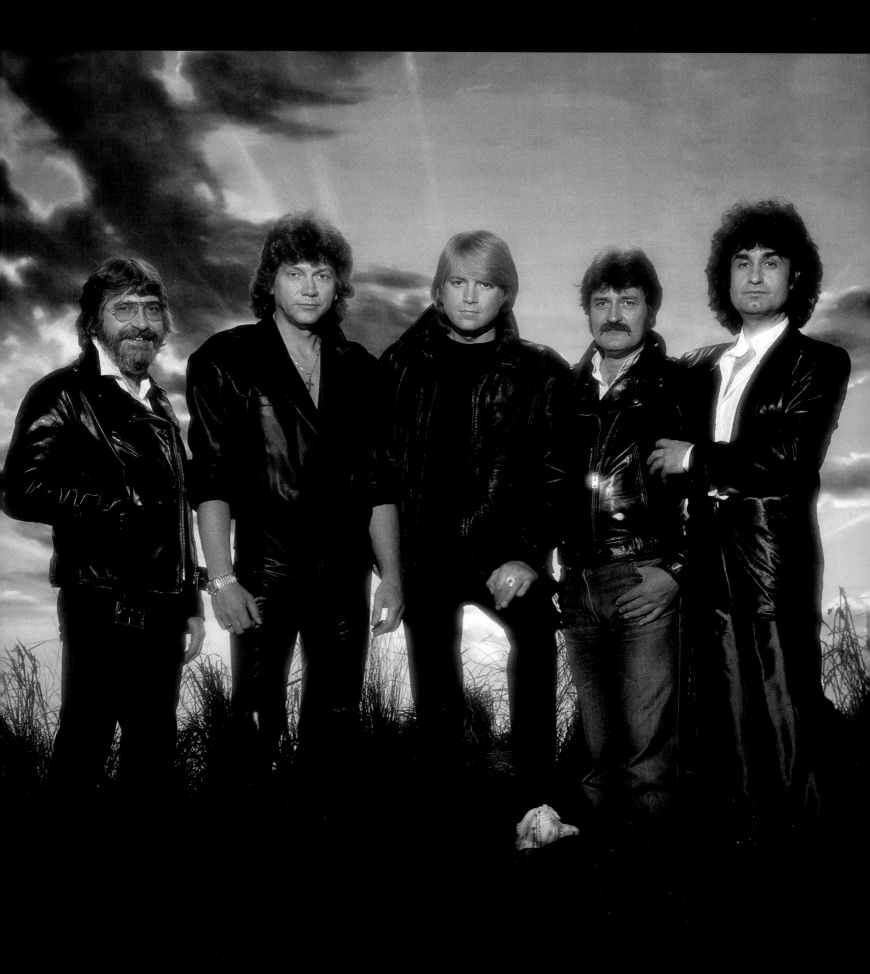

HOLLY AND THE ITALIANS 1982

New wave band Holly and the Italians moved to Britain from Los Angeles in the early 1980s and Holly Beth Vincent, Mark Sidgwick and Steve Young recruited Colin White to the band for their debut single 'Tell That Girl to Shut Up'. Extra musicians – including Mike Osborne as a replacement for Young – were recruited for the band's first album *The Right to Be Italian,* which was issued in 1981 and became a minor US hit. Vincent released her solo album *Holly and the Italians* in 1982, when she also recorded a version of 'I Got You Babe' with Joey Ramone before eventually returning to America.

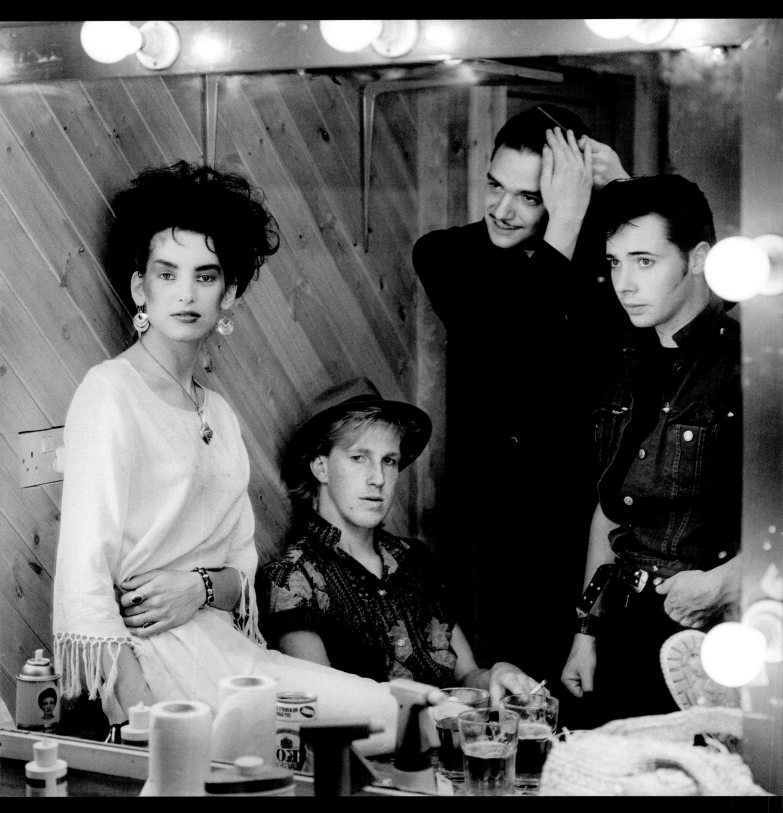

"Holly and the Italians originally came from Los Angeles and moved to London in the early 80s. I photographed them for Virgin records and thought they had a great look but major success evaded them."

WHAM! 1983

After meeting on the first day at school in 1975, George Michael and Andrew Ridgeley formed the five-piece band the Executive in 1979 but later focused on a career as the duo Wham! Their debut chart hit was 'Young Guns (Go For It!)' in 1982 and a year later their album *Fantastic* topped the UK charts. By 1985 Wham! were established as a major international act, topping both the UK and US charts with three singles and the album *Make It Big* before becoming the first Western pop group to perform live in China. In 1986 – after selling more than five million singles – Michael and Ridgeley parted company to pursue new solo careers.

"I shot this for the cover of *Smash Hits* magazine and it proved to be one of their most popular covers. Wham! had just had a hit with 'Club Tropicana' and the session was in mid-summer, hence the beach theme!"

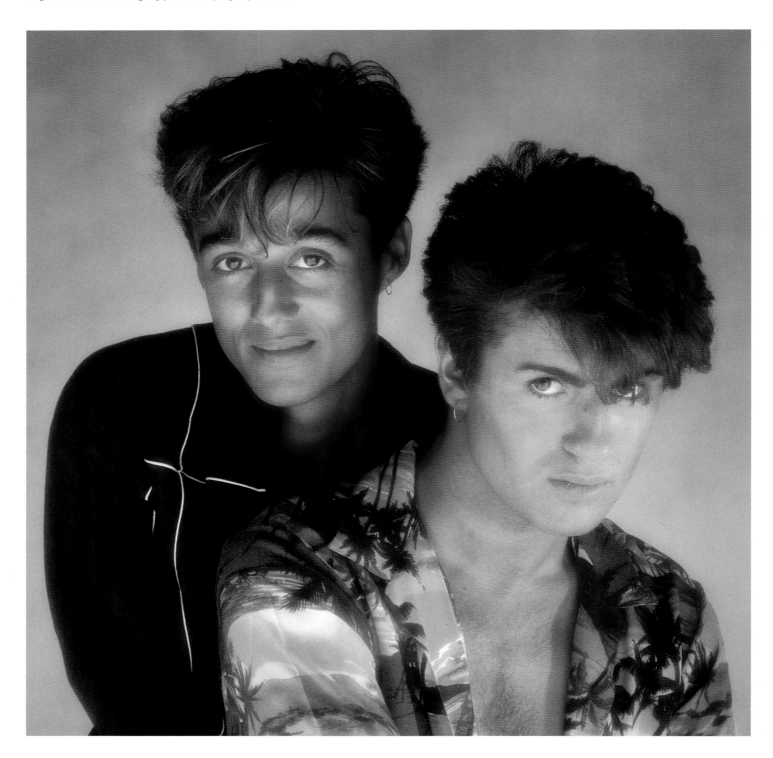

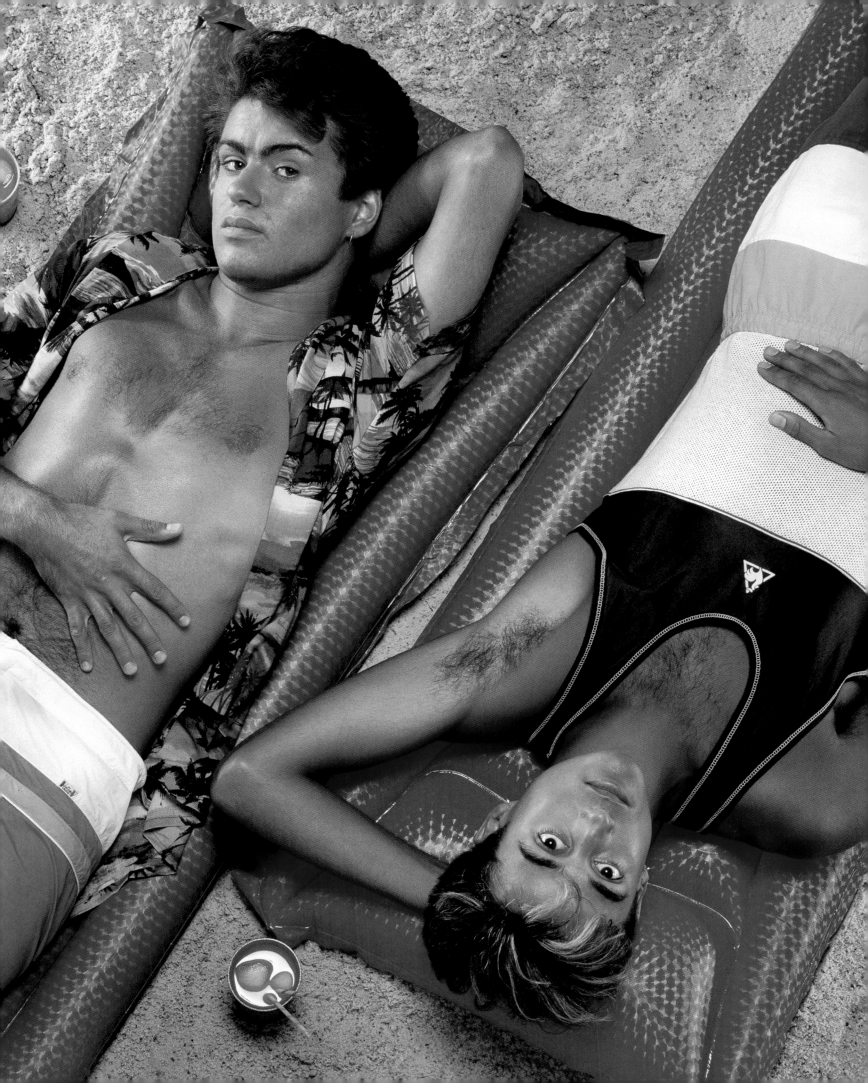

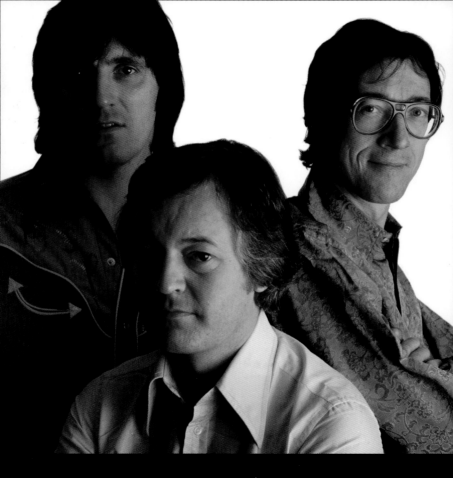

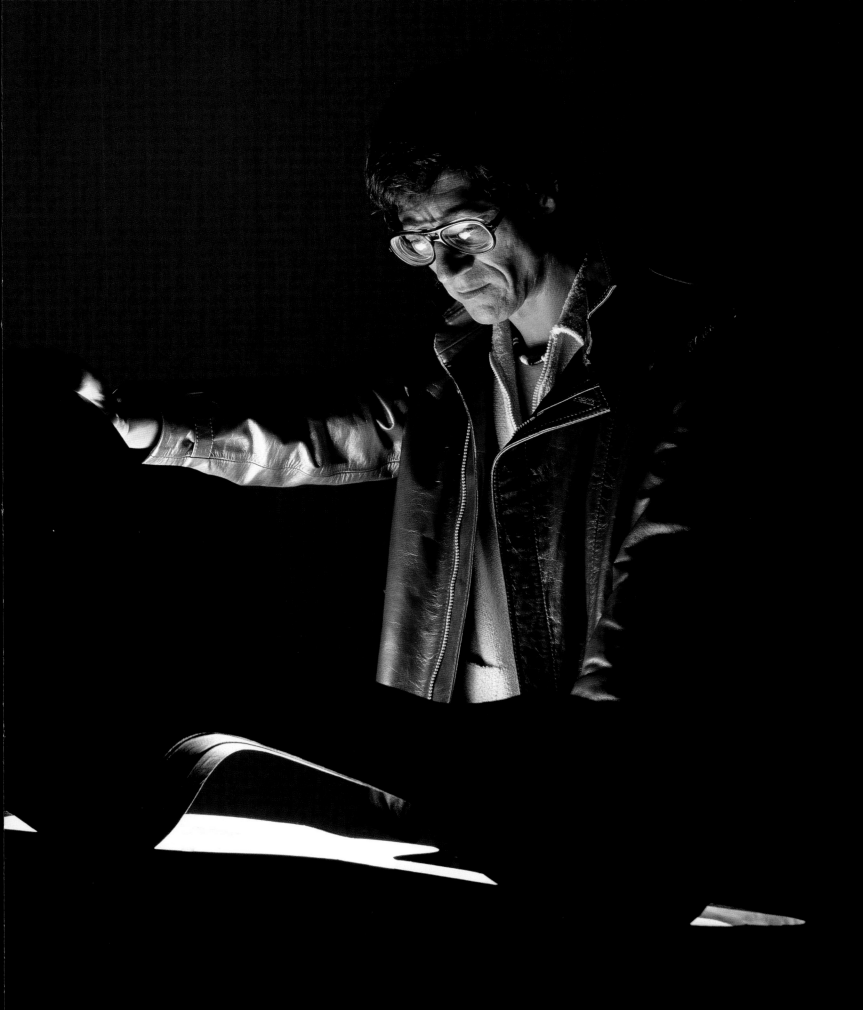

OASIS 1994

Oasis were formed in Manchester in 1992 with brothers Liam and Noel Gallagher being joined by Paul Arthurs, Paul McGuigan and Tony McCarroll. By the end of 1994 they had notched up five hit singles and a UK Number 1 with their debut album *Definitely Maybe*. Despite line-up changes – including recruiting Ringo Starr's son Zak as drummer – Oasis set new records by remaining in the UK charts for 134 weeks in 1996 and, a year later, *Be Here Now* sold over one million copies in just 17 days. The band finally split in 2009 after racking up sales of over 70 million, and Noel set-up The High Flying Birds while Liam formed Beady Eye.

"*MOJO* magazine asked me to photograph Oasis for the cover, and although I was pleased to work with such a 'happening' band, I wasn't really that impressed with their music and thought they were a bit like a Beatles/ Stones tribute band! I suggested that I did a new version of my famous Stones Primrose Hill session and the magazine liked the idea. When the band arrived at the studio they were in a foul mood and Noel stormed in and immediately flung himself on to a couch and fell asleep without a word to anybody. Meanwhile Liam had decided to kick anything he could, including the furniture, doors and walls, before settling down in the kitchen to drink and smoke. Fortunately I knew their tour manager, and after about an hour he was able to get them in front of the camera. Once the guys saw the first Polaroid they were completely on my side and we had a great session, but for a while it was touch and go!"

ABC 1981 TO 1983

Singer Martin Fry joined former Vice Versa members Mark White and Stephen Singleton to create ABC in 1980 before recruiting Mark Lickley and Dave Robinson. Two years later they hit the charts with 'Poison Arrow' and 'The Look Of Love' ahead of their debut album *The Lexicon Of Love* reaching Number 1 in the UK and the US Top 30. After the 1984 line-up changes – David Yarrith replaced Singleton and Eden came in for Lickley – Fry and White opted to continue ABC as a duo from 1987 and charted in Britain and America with 'When Smokey Sings' from the album *Alphabet City*. After issuing the album *Skyscraping* in 1997, ABC returned with *Traffic* in 2008.

"ABC were one of the first bands who really studied image and took the whole photographic process very seriously, involving themselves with every detail. It was always a very rewarding and creative process working with them, and we ended up shooting several sessions together. They were also the first band ever to give me a gold disc, having been quite shocked to find that I didn't have any!"

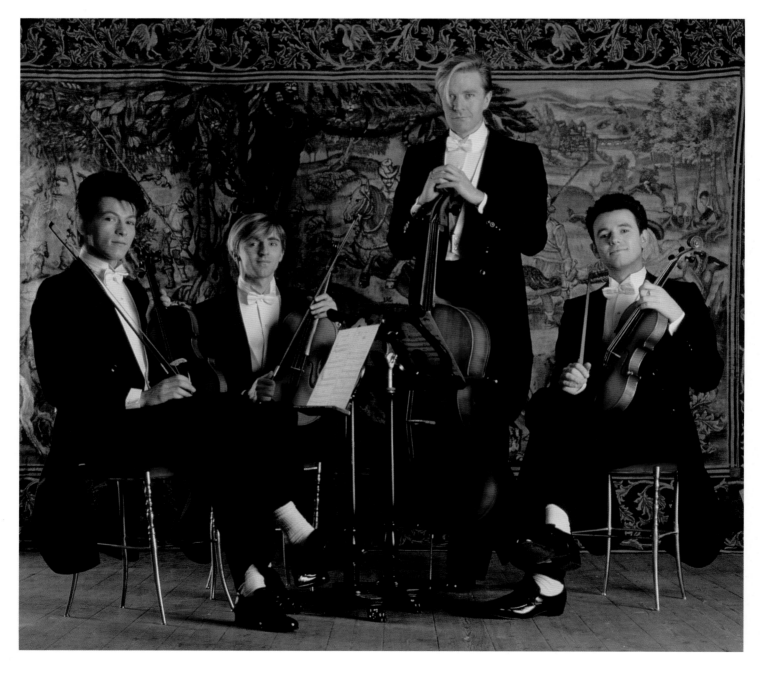

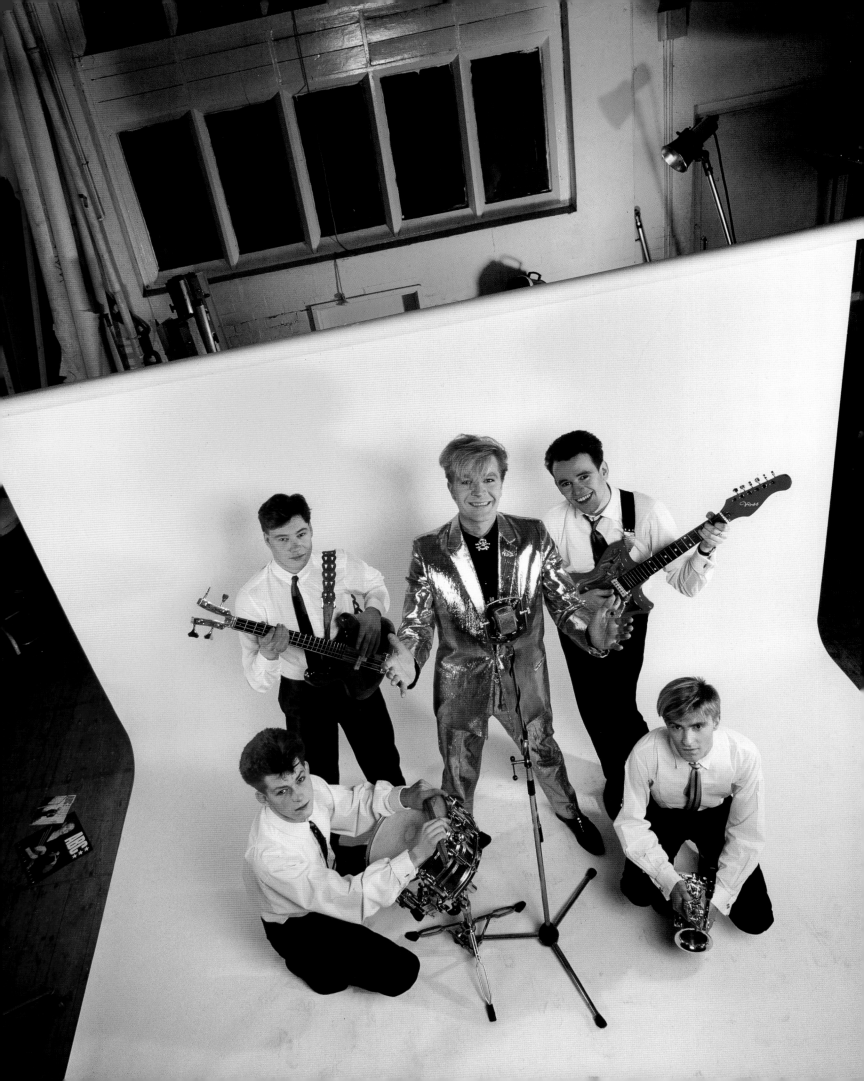

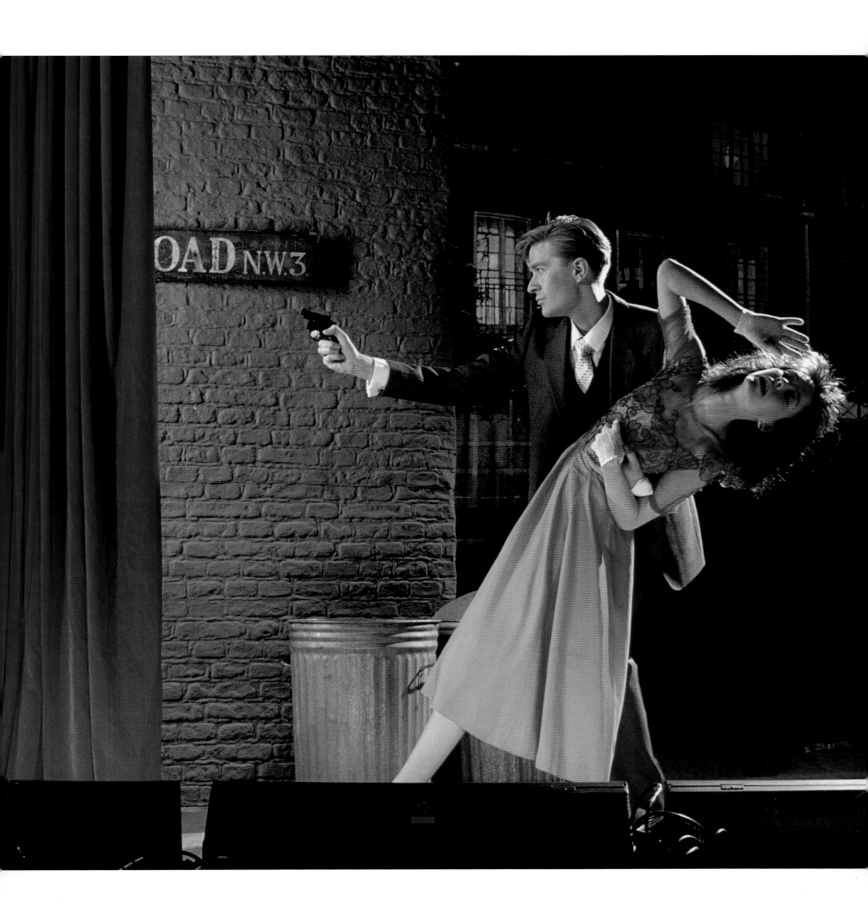

GARY MOORE 1990 TO 2001

Belfast-born Gary Moore founded Skid Row in 1968 before moving to London and recording his first album with the Gary Moore Band in 1973. After spending time with Thin Lizzy and Colosseum II, Moore issued his debut solo album *Back On The Streets* in 1978 and hit the Top 10 with his single 'Parisienne Walkways'. A leading blues guitarist, Moore released the Top 10 albums *Wild Frontier, After Hours* and, in 1993, *Blues Alive*, which featured Mankowitz's cover photography. In 1994 Moore briefly teamed up with Jack Bruce and Ginger Baker to form BBM and in 2008 released his final album *Bad For You Baby*. In 2011 Moore died while on holiday in Spain.

"I worked with Gary on several occasions and even went on the road with him for a few days in Germany back in 1993 for his *Blues Alive* album. He was always very pleasant to be with and I enjoyed working with him but he wasn't an easy person to photograph because of the scars on his face, which he was very conscious of but didn't want to go out of his way to hide. Every session was a bit of a tricky balancing act."

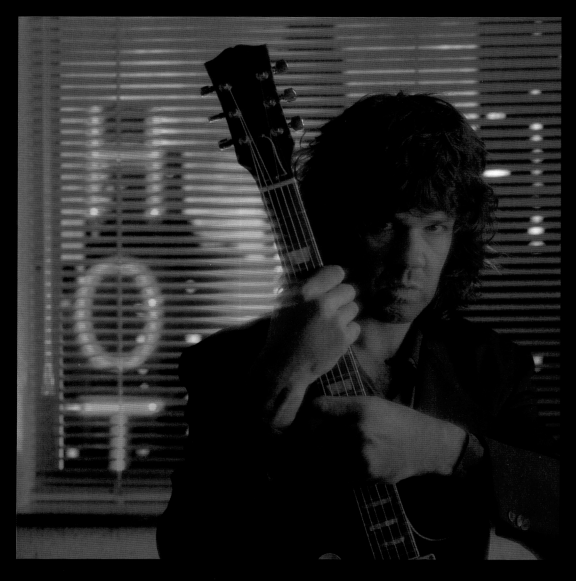

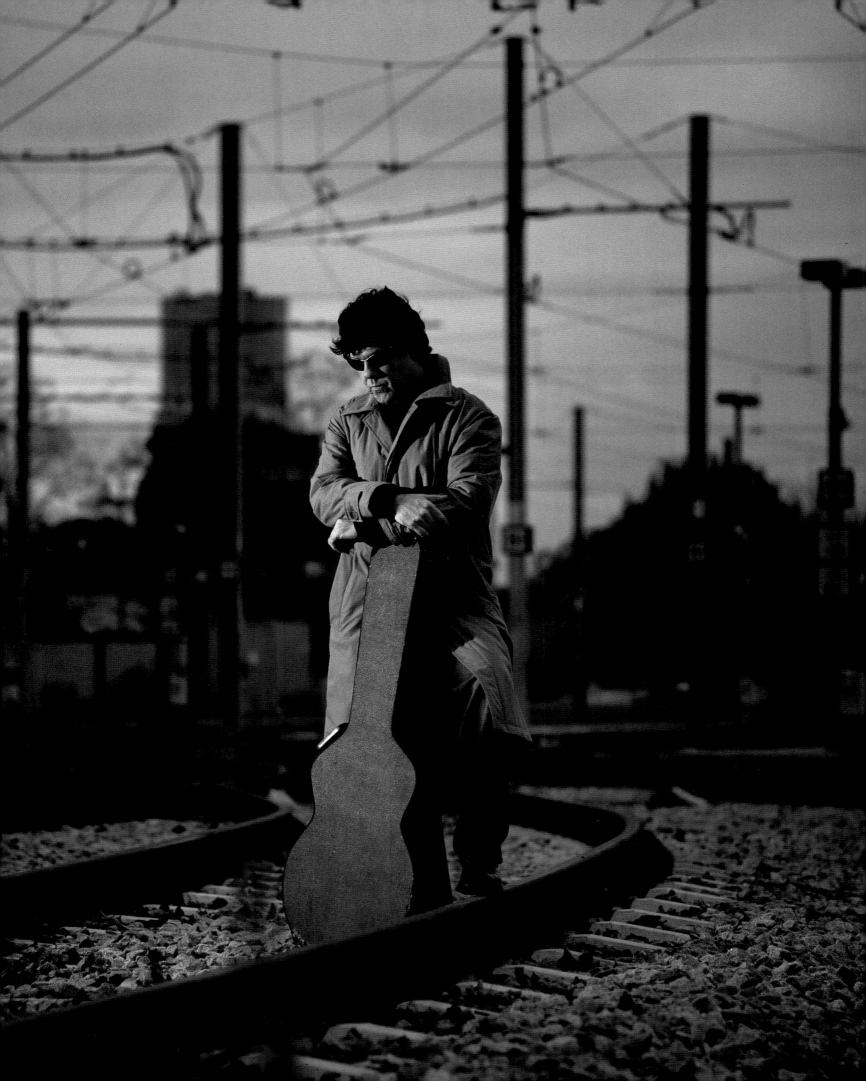

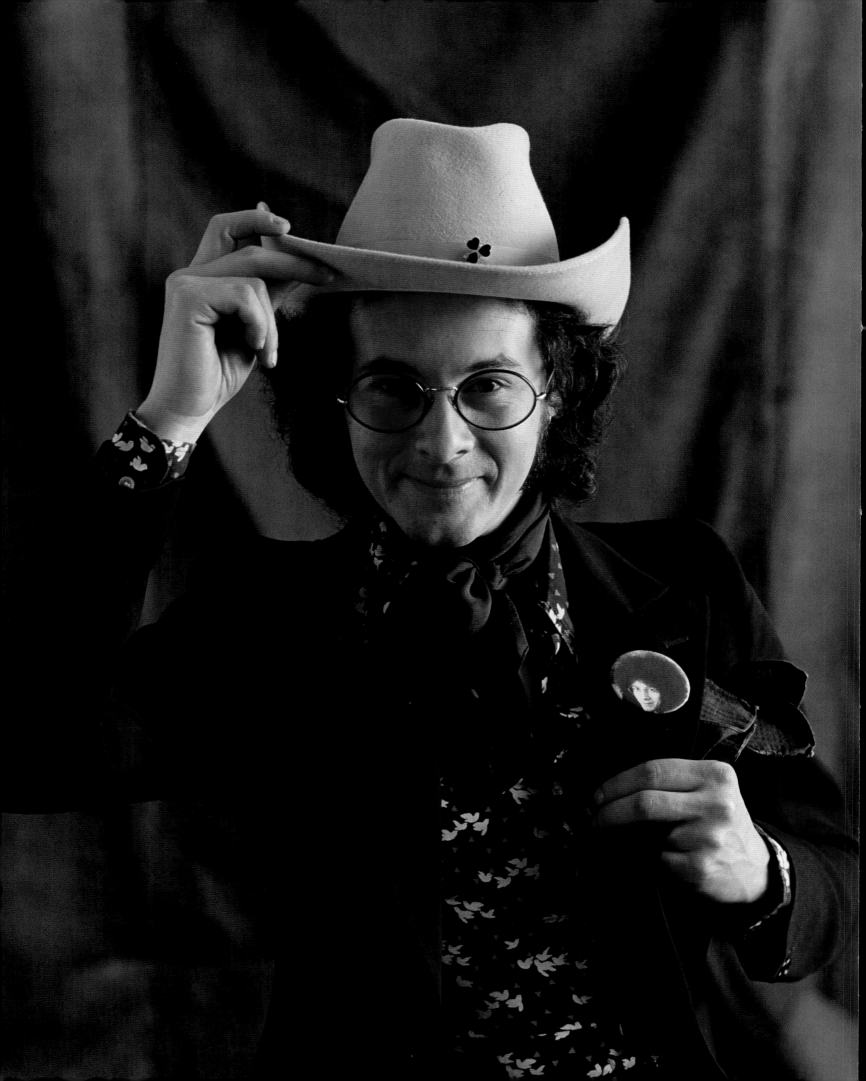

NOEL REDDING 1969 TO 1975

Following his three-year stint as a member of the successful Jimi Hendrix Experience, Noel Redding left in 1969 and teamed up with Neil Landon, Jim Leverton and Eric Dillon to form Fat Mattress, who released two albums. Redding then left for America, where he formed the trio Road. He moved to Ireland in 1972 and established the Noel Redding Band – also known as the Clonakilty Cowboys – with Eric Bell, Dave Clarke, Les Sampson and Robbie Walsh, but they disbanded after issuing two albums. Redding continued to play and record with various musicians until he died in Clonakilty in 2003 at the age of 57.

"I had maintained a degree of contact with Noel after he left The Jimi Hendrix Experience and had worked with his previous band Fat Mattress, shooting their first album in 1969. In 1972 he moved his home to Clonakilty in County Cork, Ireland and formed the Clonakilty Cowboys, and we shot the session for the sleeve in 1975. Noel was in high spirits throughout the session and seemed both happy and optimistic with the band."

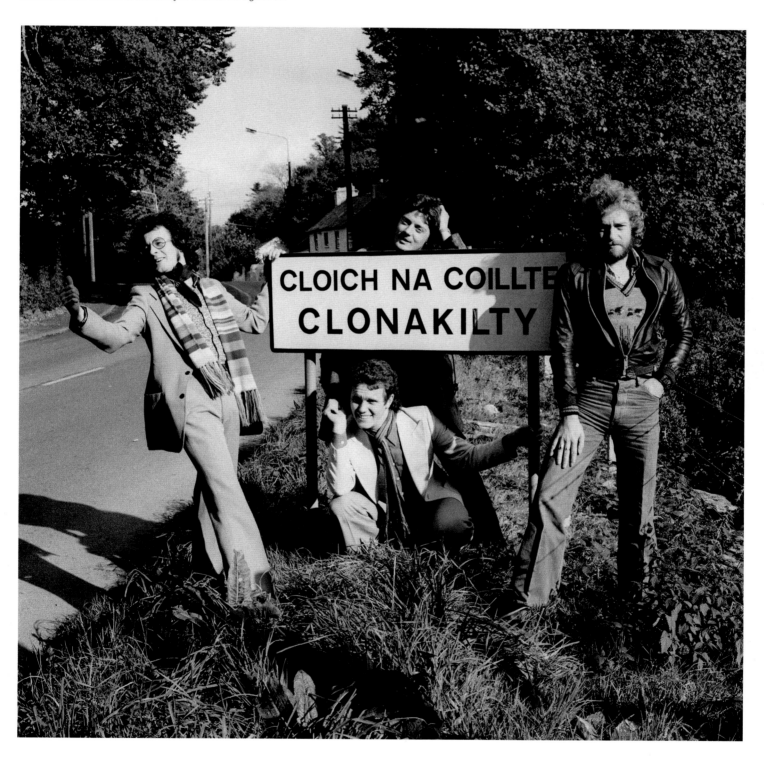

Brian Connolly, Mick Tucker and Steve Priest recruited Andy Scott to their band Sweetshop before shortening the name to The Sweet and releasing their first three hit singles in 1971. Working with writers Nicky Chinn and Mike Chapman, The Sweet followed the Number 1 'Blockbuster' with three successive Number 2 hits including 'Ballroom Blitz' – with a cover shot by Mankowitz – in 1973. After 17 chart singles, including four US Top 10 hits, Connolly left the Sweet in 1979. The band split up in 1984 but was reformed in the 80s and 90s by Tucker and Scott while Connolly died of heart failure in 1997.

"The Sweet had been around in one form or another for several years before the brilliant Nicky Chinn and Mike Chapman got hold of them and they started having hits. Although I always struggled with their image, we regularly came up with some interesting sessions and the shoot for 'Ballroom Blitz' was particularly weird and interesting. The colour portrait was for *Bravo* magazine in Germany and caught the ghastly decadence of glam rock!"

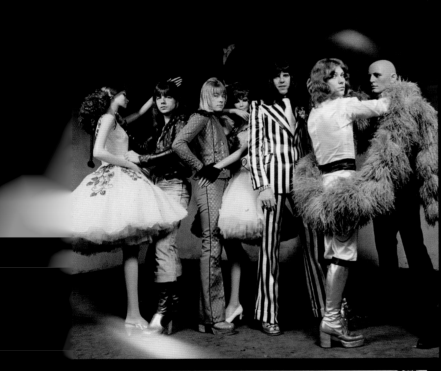

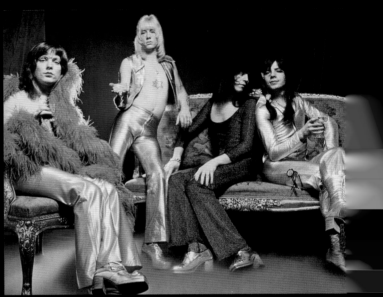

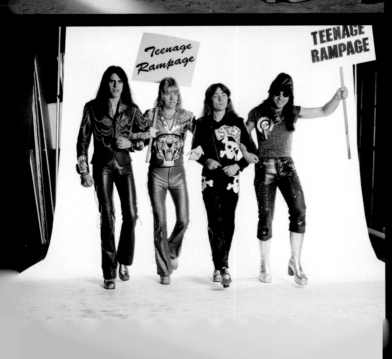

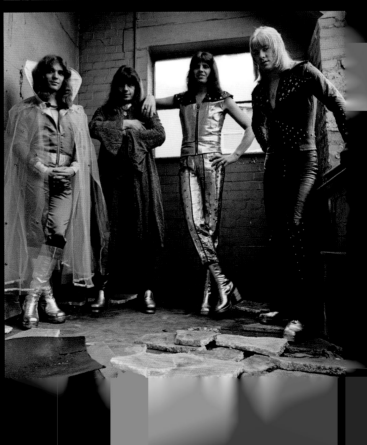

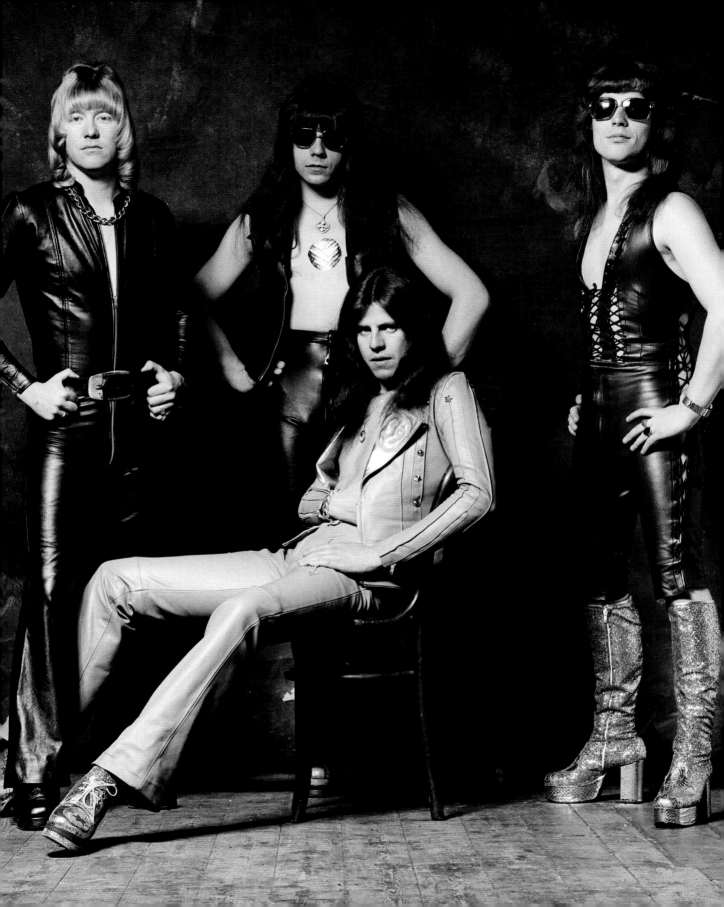

Paul McCartney and John Lennon wrote 'With a Little Help from My Friend's for their ground-breaking 1967 album *Sgt. Pepper's Lonely Hearts Club Band.* It was one of over 250 songs they created – together and alone – for the Beatles during the band's recording campaign from 1962 until 1969, which resulted in total sales of over one billion records. After the Beatles split, McCartney embarked on a career that included recordings with his wife Linda, with the band Wings plus duets with Michael Jackson and Stevie Wonder. His song 'Yesterday' remains the most recorded composition of all time while the 1977 release 'Mull Of Kintyre' was the UK's best-selling single (over 2.5 million) for 20 years.

"I never worked with the Beatles but knew Paul a bit socially and these portraits were taken during a recording session when Mick Jagger produced a few tracks with Marianne Faithfull and Paul dropped by to help when she tried singing 'With a Little Help from My Friends'."

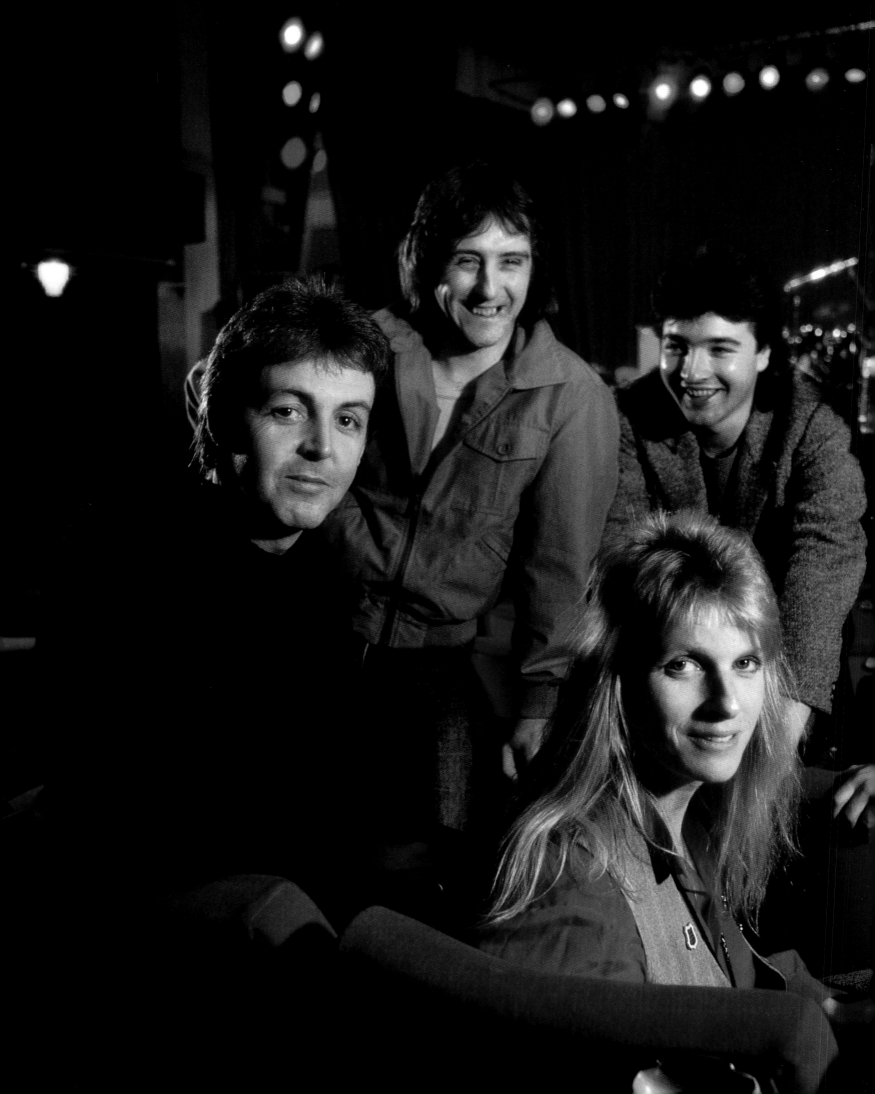

WINGS 1979

The Wings line-up featuring Laurence Juber on guitar and Steve Holly on drums, alongside Paul and Linda McCartney and Denny Laine, came together in July 1978 – six months after the record breaking single 'Mull Of Kintyre' was released. Their 1979 album *Back To The Egg* was a Top 10 hit in both the UK and the US and was also the final album credited to Wings before McCartney went solo. After playing an 18-date tour of the UK in November and December 1979, Wings flew to Japan in January 1980 where McCartney was arrested and jailed for ten days for marijuana possession. Laine, Juber and Holley all left Wings in 1981 as McCartney continued to record as a solo artist

"I was very flattered when Paul wanted me to shoot while the band were rehearsing for the Wings Over Japan tour. Everybody was very happy with the shots, but the tour was abandoned because Paul was busted at Tokyo airport!"

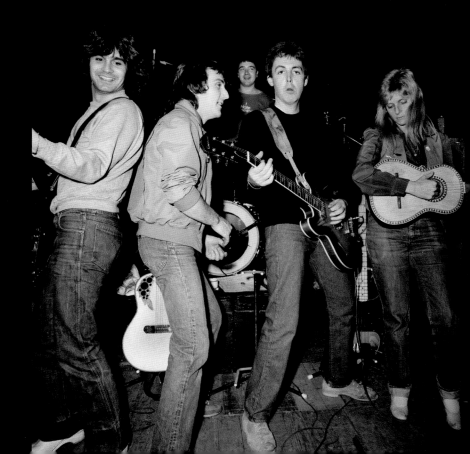

...ard player Georgie Fame moved on from backing rock acts such as Gene ...nt and Billy Fury to lead his own band the Blue Flames in the early 60s before ...g his first Number 1 single 'Yeh Yeh' in 1965. The following year he returned ...mber 1 with 'Get Away' and in 1968 hit the top spot for a third time with 'The ...Of Bonnie And Clyde', which was also a US Top 10 hit. After a partnership with ...imal Alan Price in 1971 – which resulted in the Top 20 hit 'Rosetta' – Fame ...ined recording and composing with working alongside Van Morrison.

"Georgie Fame was one of the leading R&B musicians in the UK having started his career at age 16 with manager Larry Parnes, who gave him his name, and put him together with another of his great artists – Billy Fury. Georgie had many hits through the 60s and 70s with his band the Blue Flames and more recently has been working with Bill Wyman and Van Morrison."

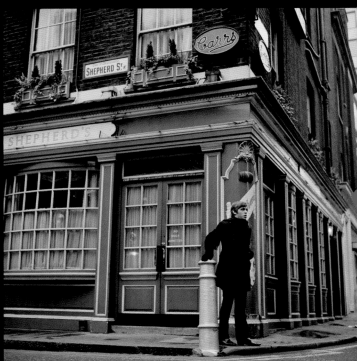

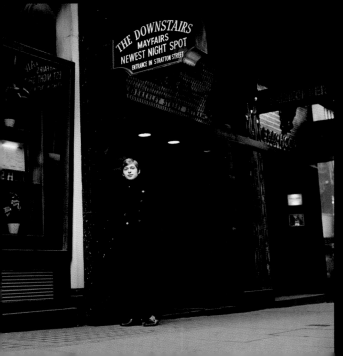

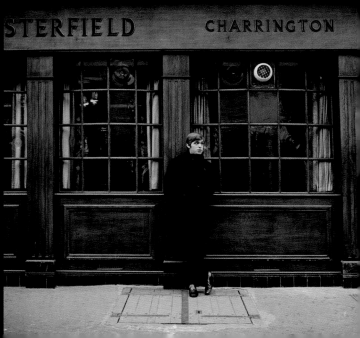

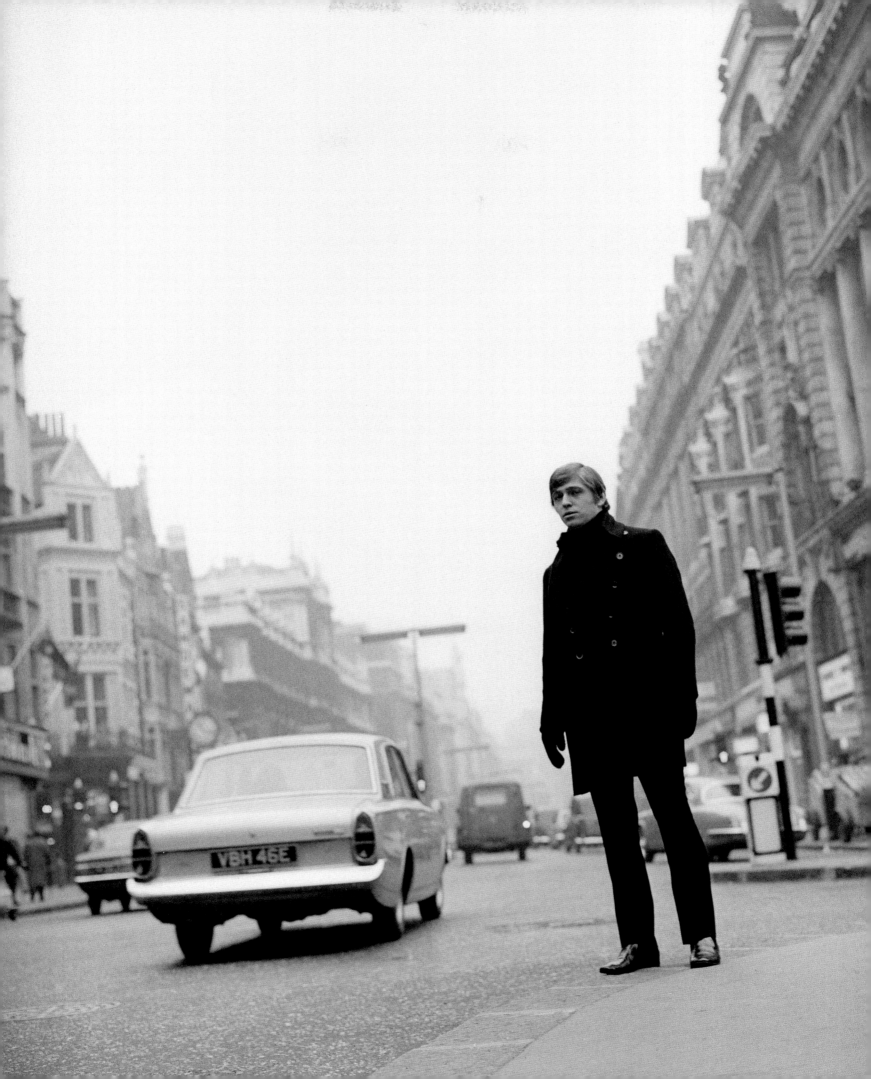

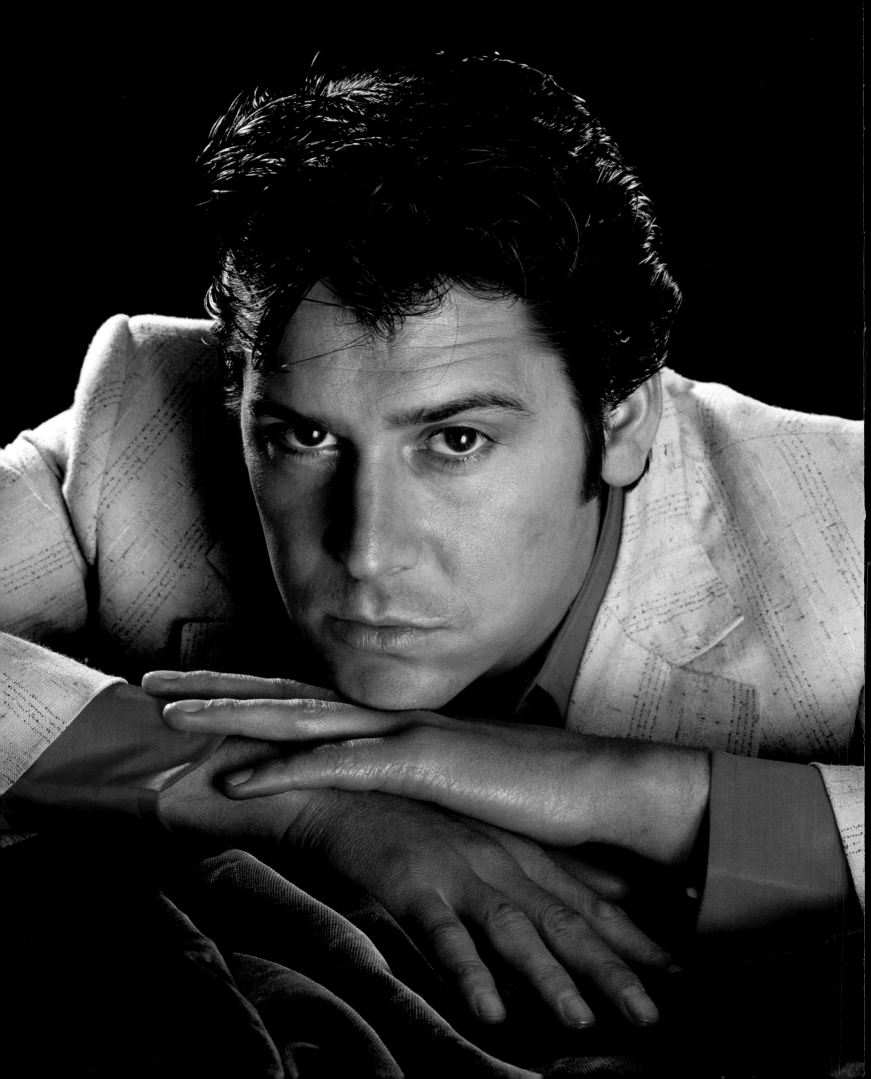

SHAKIN' STEVENS 1977

After starting out with the rock and roll revival band the Sunsets, Shakin' Stevens appeared as Elvis Presley in the 1977 stage musical *Elvis* and released his debut single three years later. In 1981 his version of 'This Ole House' reached Number 1 and was followed to the top by 'Green Door' as the Welsh-born singer went on to become the most successful singles chart act of the 80s. Following his 1992 hit 'Radio', which featured Queen drummer Roger Taylor, Stevens continued to tour until he won the TV show *Hit Me, Baby, One More Time* in 2005, which saw him return to the charts with 'Trouble'.

"Shakin' Stevens had just finished playing Elvis in the hit musical on stage in London's West End, and this session was for his forthcoming eponymous album. I wanted to exploit the Elvis connection and created the 'shadow of Elvis' shot and the pastiche of the classic chocolate box portrait."

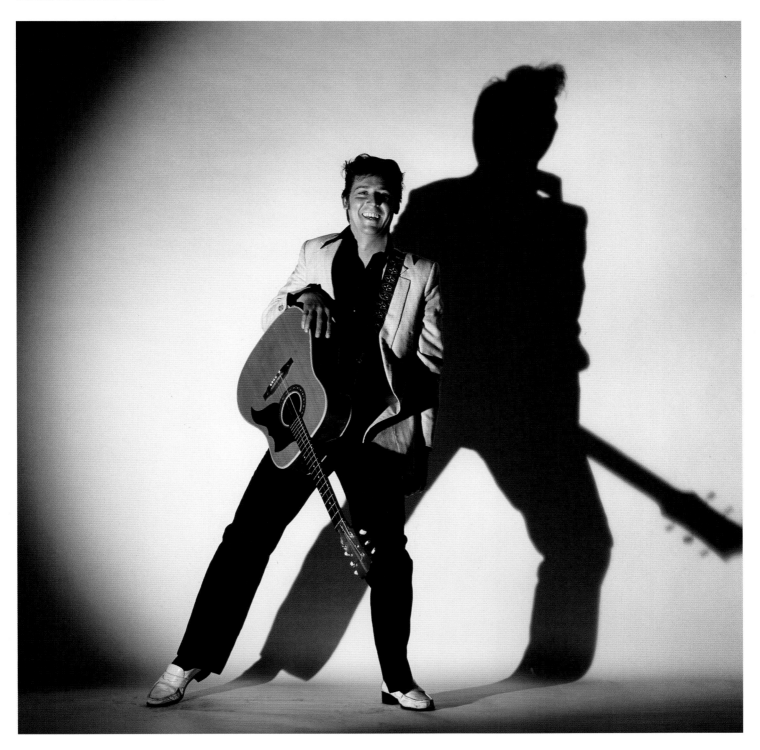

WAH! 1982

Pete Wylie was part of the Liverpool trio the Crucial Three with Ian McCulloch and Julian Cope – followed by the Spitfire Boys and the Opium Eaters – before he created Wah! Heat and released 'Seven Minutes to Midnight 'in 1980. Next came Wah! with Wylie and Carl "Oddball" Washington and in 1982 they went to Number 3 in the charts with 'The Story Of the Blues', which featured a singles bag cover shot by Mankowitz. In 1984 Wylie and the Mighty Wah! were back in the charts with the single 'Come Back' while the album *A Word To The Wise Guy* reached the Top 30.

"Wah! were on the verge of having their biggest UK hit – 'The Story Of The Blues (part 1)' – when they came to my studio for this session. We had decided on a very stylish, gangsterish, 1940s look and I had found the old-fashioned torches on a trip to America the year before."

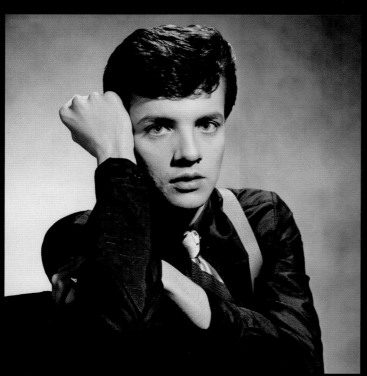
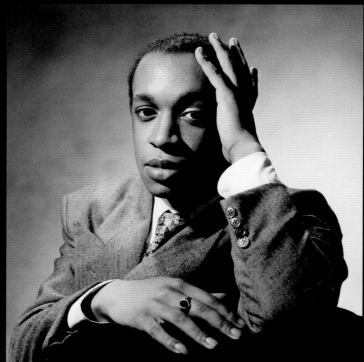

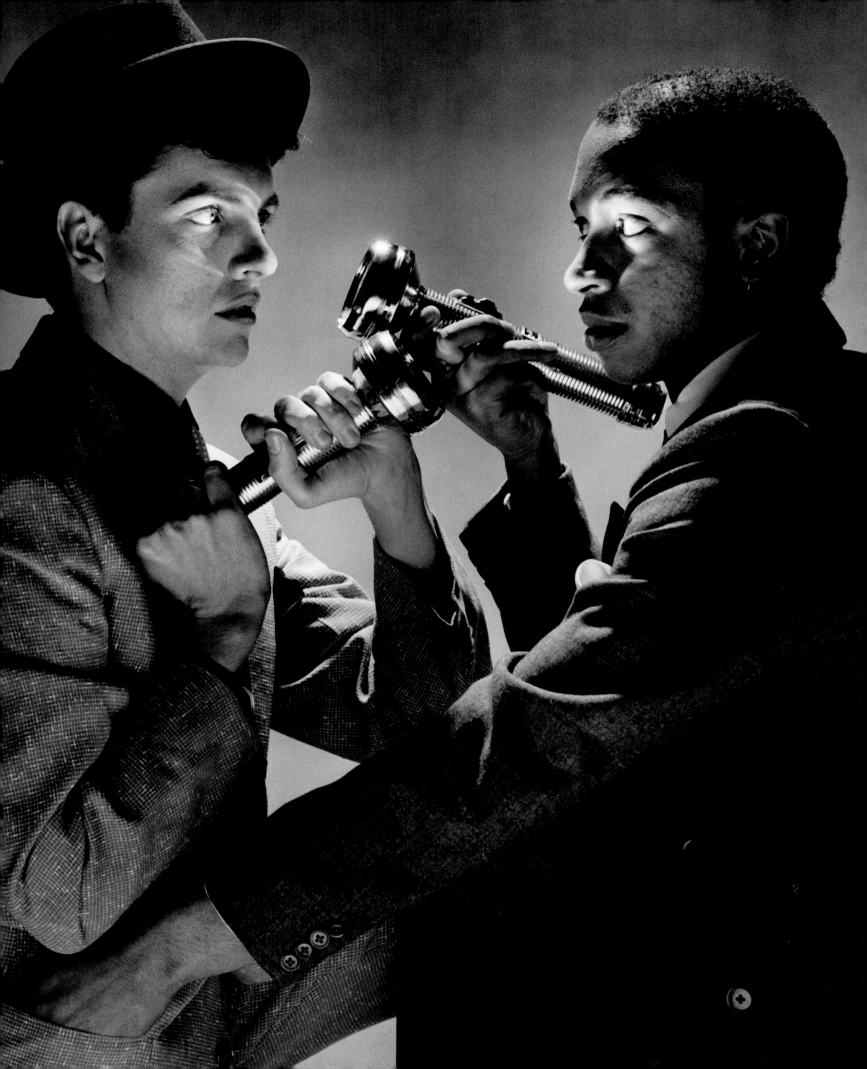

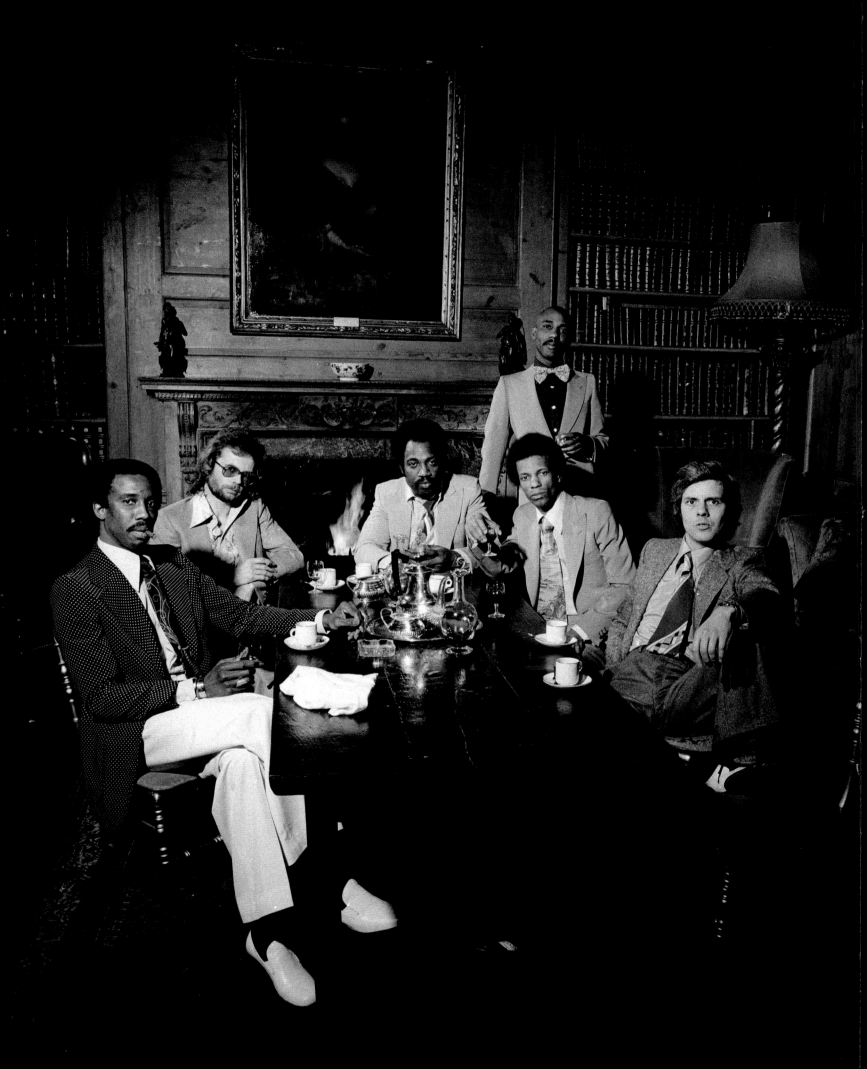

HOT CHOCOLATE 1973 TO 1982

Following a brief period on the Beatles' Apple label, Hot Chocolate re-located to RAK Records in 1970 when they hit the Top 10 with 'Love Is Life'. Formed by West Indians Errol Brown and Tony Wilson – who initially recruited Patrick Olive, Larry Ferguson, Ian King and Franklyn De Allie – the band released 13 hit singles before they hit Number 1 with 'So You Win Again' in 1977. By that time De Allie and King had been replaced by Harvey Hinsley and Tony Connor while Tony Wilson's departure in 1975 reduced the band to a five-piece, but Hot Chocolate continued having hits through to 1987 when singer Brown went solo and the group disbanded.

"Hot Chocolate with their charismatic singer Errol Brown were always in the UK charts throughout the 70s and were one of the mainstay acts of Mickie Most's RAK stable. I worked with them throughout this period and they were a lovely bunch of highly professional musicians and always good fun to hang out with."

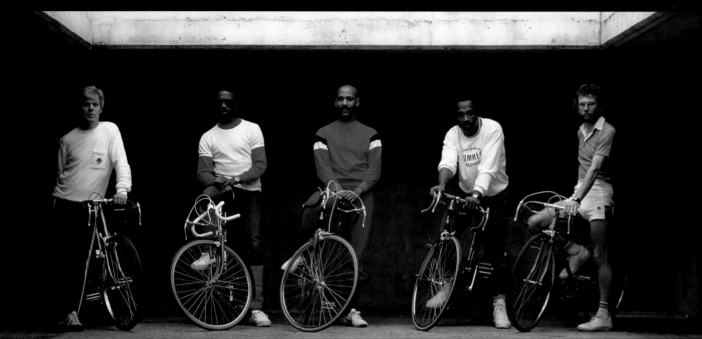

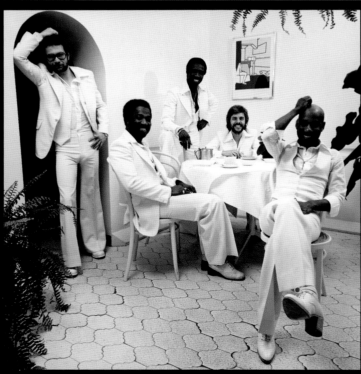

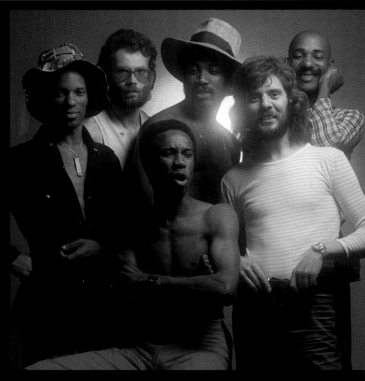

RICHARD & LINDA THOMPSON 1979 & 1981

Richard Thompson quit leading folk band Fairport Convention in 1972 to issue his first solo album before teaming up with Linda Peters – whom he married in 1974 – and releasing seven albums as Richard & Linda Thompson, including *Sunnyvista* in 1979 and *Shoot Out The Lights* three years later, both of which featured artwork photography by Mankowitz. In 1983 Thompson went solo and had his first chart success two years later with the album *Across a Crowded Room.* Working with an assortment of leading musicians, Thompson released a further nine chart albums – including the Top 30 hit *Mirror Blue* – between 1986 and 2005.

"Richard & Linda were well established by the time I shot the cover for their 1979 album *Sunnyvista,* which was a more cynical collection of songs than previous work and we wanted to reflect that in the cover by shooting it on a rather disturbing housing estate in northwest London. The second session was for the *Shoot Out The Lights* album and Linda was heavily pregnant at the time and decided that she didn't want to be shot full length for the cover, so we shot a new portrait and hung it on the wall of the studio set!"

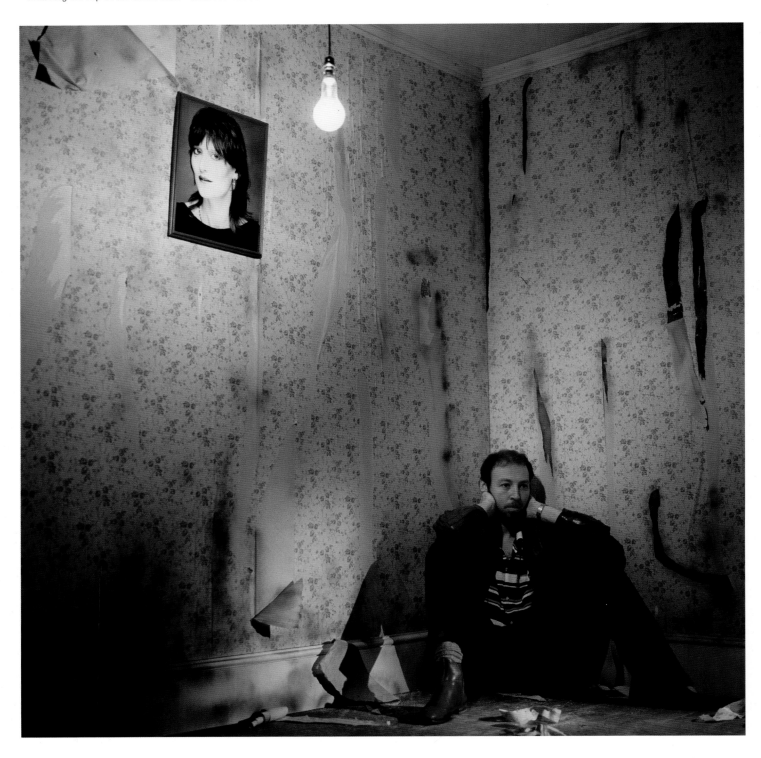

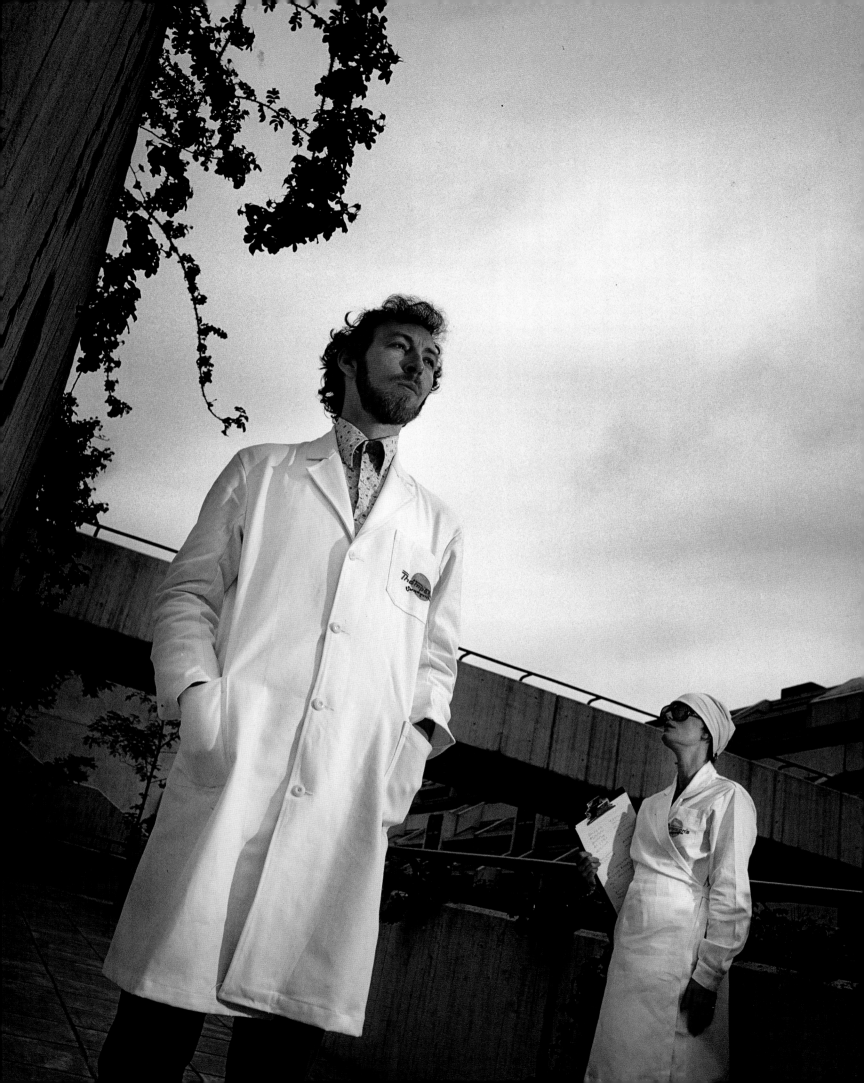

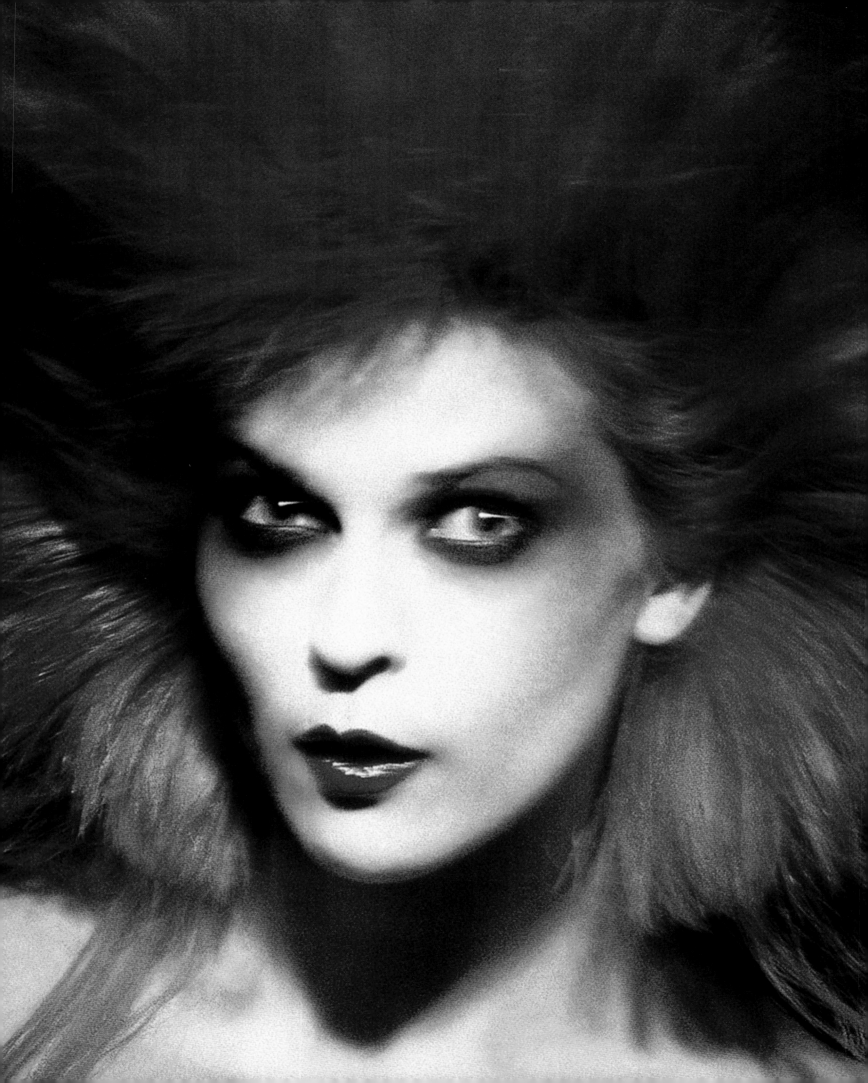

After appearing in the films *Jubilee* in 1977 and *Quadrophenia* two years later, Toyah began her musical career and she hit the Top 10 in 1981 with the EP 'Four From Toyah', which featured the track 'It's A Mystery'. Two more Top 10 singles followed in the same year alongside her Number 2 hit album *Anthem* as the Birmingham-born performer continued to combine her singing and acting careers. In addition to teaming up with her husband Robert Fripp – founder of King Crimson – she also notched up a further seven hit albums while starring in productions of *Trafford Tanzi* and *Cabaret*.

"I loved Toyah's weird theatricality and always enjoyed working with her. She worked very hard to get the image as she wanted, and together with art director Bill Smith I thought we made a great team."

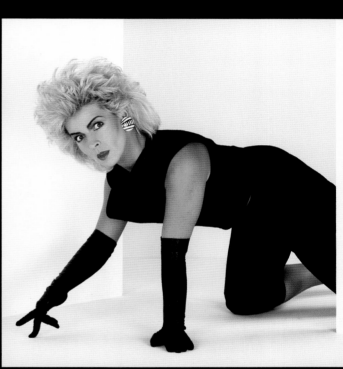

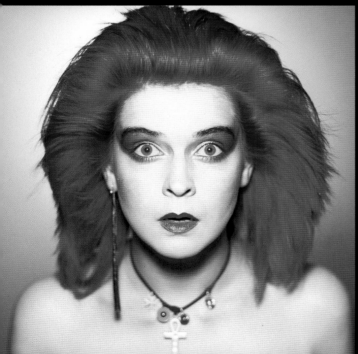

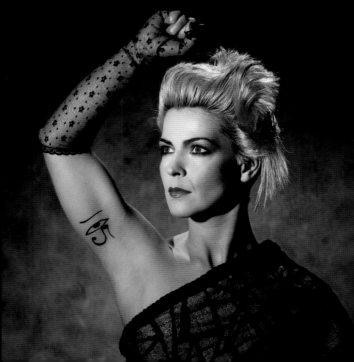

Chrissie Hynde first arrived in London in 1973 and, after a brief return to America in 1975, formed the Pretenders in Britain in 1978. The following year they hit number 1 in the UK with 'Brass In Pocket' and the album *Pretenders* and went on to release a further 18 chart singles. Throughout the years – and despite line-up changes – Hynde has continued to use the group name for various projects, including her 2008 album *Break Up the Concrete* while also recording the Number 1 hits 'I Got You Babe', with UB40, and 'Love Can Build a Bridge', with Cher, Neneh Cherry and Eric Clapton.

"I had met Chrissie a few times socially but had never worked with her or the Pretenders. So when the opportunity came up to shoot a portrait for a book project about great guitarists and their favourite instruments I was delighted that she agreed to pose. I can't remember how we ended up making the portrait in her bath, but it was certainly different and unexpected!"

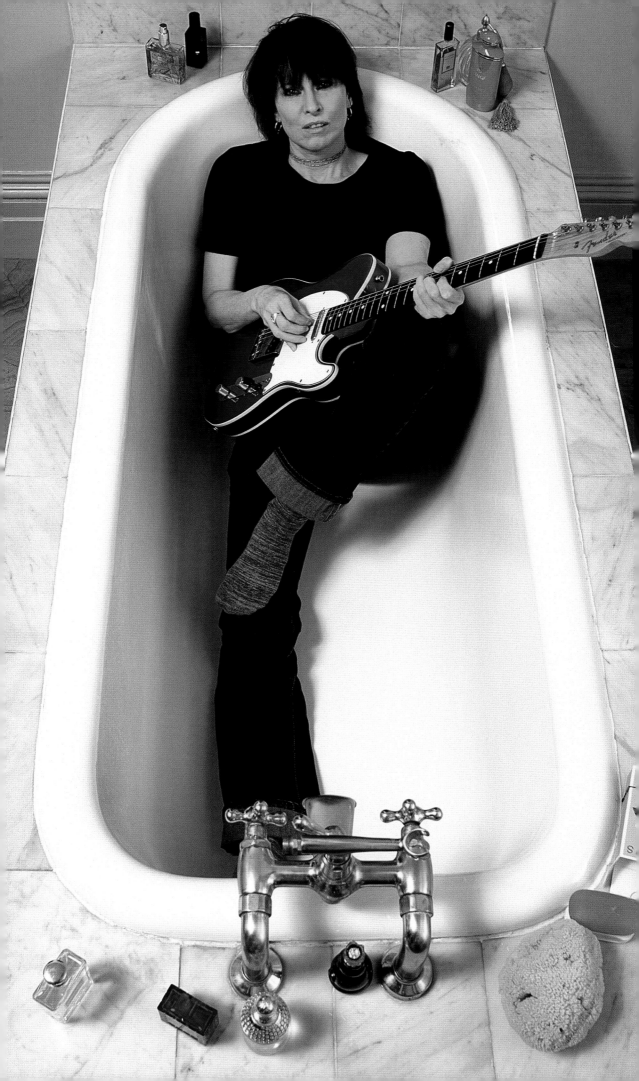

RAY RUSSELL 1963 & 2006

Ray Russell's career as a guitarist took him from the John Barry Seven to Georgie Fame's Blue Flames and on to rock bands such as the Rock Workshop, Stackridge, Chopyn and his own Ray Russell Band. Combining playing with producing and composing music for TV series such as *A Touch Of Frost, Bergerac, A Bit Of a Do* and *Rock Follies,* Russell, who joined John Barry's group in 1963, has also released a total of 14 albums since 1968, including the 2006 title *Goodbye Svengali,* when he once again teamed up with photographer Mankowitz.

"Having become re-acquainted with Ray after a gap of over 40 years, he asked me to shoot the cover for his *Goodbye Svengali* album. We decided to re-create the portrait that I had done of him back in 1963, when he was in the John Barry Seven."

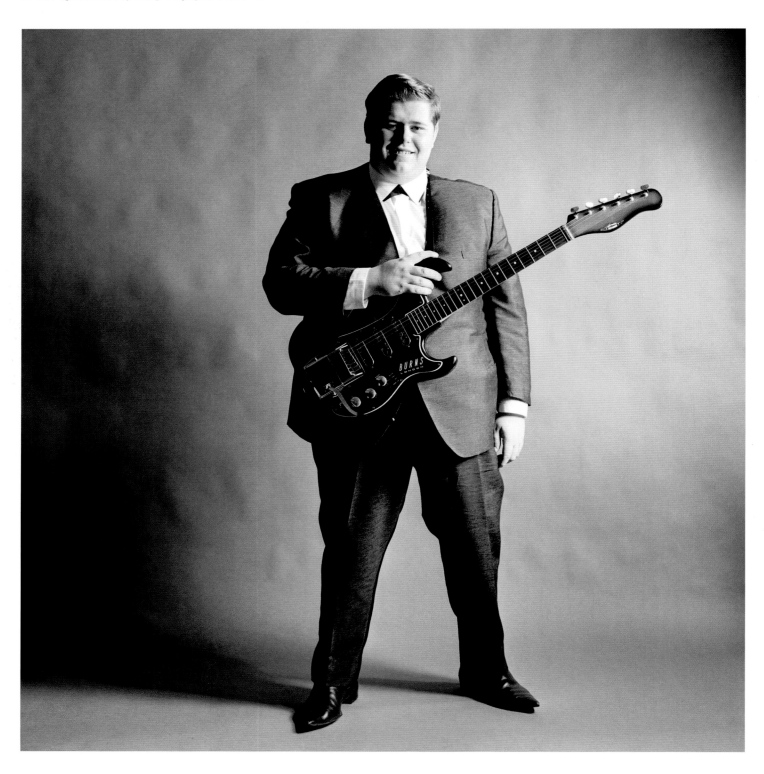

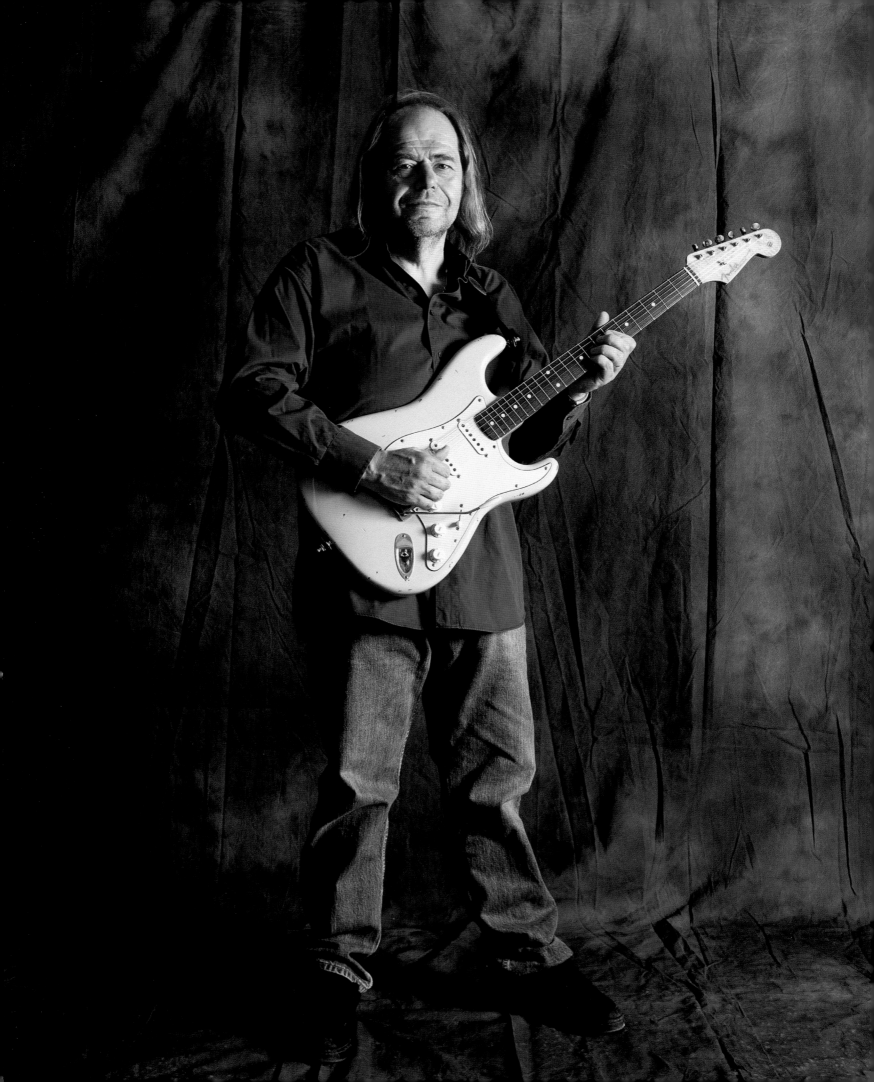

MALCOLM McLAREN 1982

From managing the New York Dolls in 1974, Malcolm McLaren moved on to create the Sex Pistols and launch the UK's punk revolution. After ending his association with the Pistols, Londoner McLaren delivered the group Bow Wow Wow before making his debut as a performer with the 1982 hit single 'Buffalo Gals' – which was credited to McLaren & the World's Famous Supreme Team – and the album *Duck Rock*. His efforts – including partnerships with a host of artists and producers – earned McLaren ten chart hit singles and five hit albums before his death in 2010 at the age of 64.

"This was the only occasion I had the pleasure of meeting McLaren and he was a complete maniac! As usual he was completely ahead of the curve and was about to launch his solo musical project *Duck Rock*, the album that brought country lyrics together with New York hip-hop music and the amazing single 'Buffalo Girls'. Completely mad but good fun!"

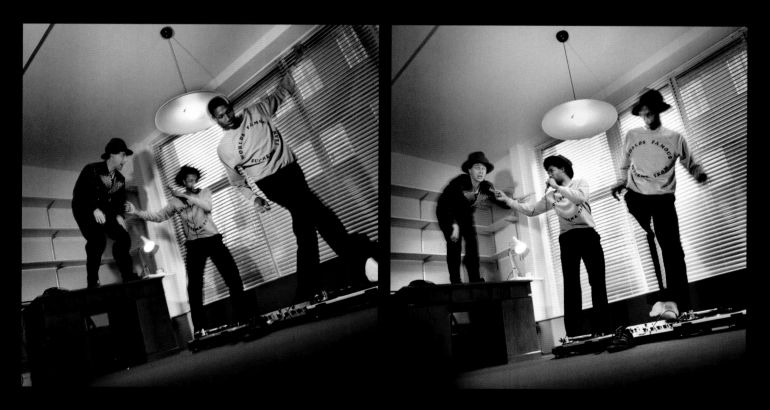

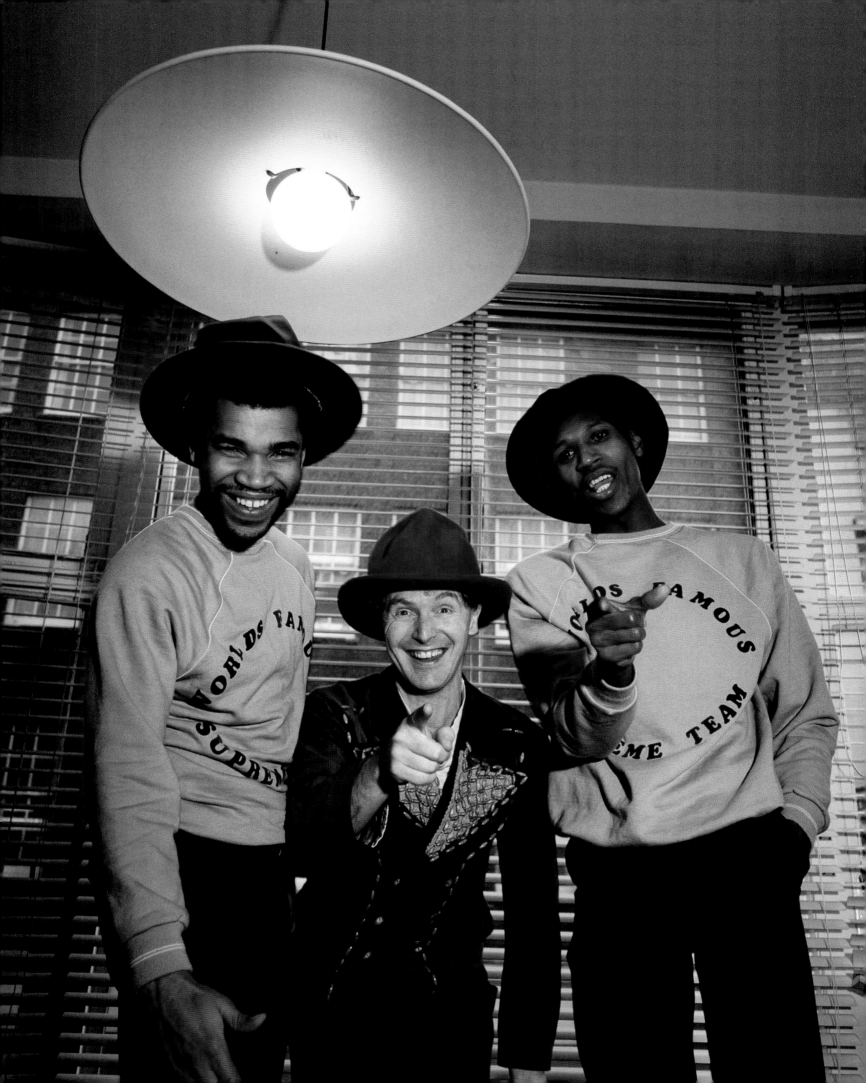

MICKIE MOST 1988

Following a string of hit records in South Africa and one UK chart entry, Mickie Most switched from singing to concentrate on discovering and producing artists and he achieved major success with acts such as the Animals, Herman's Hermits, Donovan, Brenda Lee and Lulu. Setting up RAK Records in 1969, Most signed Julie Felix, CCS, Suzi Quatro, Smokie, Hot Chocolate, Mud and Kim Wilde before he sold out to EMI in 1983. He died in 2003, aged 64.

"Mickie Most was one of the most prolific record producers and hit makers of all time, working with an endless list of great artists from the 60s until his death in 2003. Our paths crossed many times throughout this time and I shot many different artists for him. This portrait was done in his home, which at the time was the largest and most expensive private home to have been built in the UK since the war."

PHIL SPECTOR 1989

New York-born producer and songwriter Phil Spector first tasted success when his song 'To Know Him Is To Love Him' became a US Number 1 for his group the Teddy Bears in 1958. He graduated to create his famous 'wall of sound' production style, which he used on major 1960s hits for the Crystals, the Ronettes, the Righteous Brothers and Ike & Tina Turner. He went on to work on the Beatles' album *Let It Be* plus solo efforts by George Harrison and John Lennon alongside albums by Leonard Cohen and the Ramones. In 2009 he was convicted of the murder of a Los Angeles actress and sentenced to 19 years in prison.

"The mythic producer was being managed by Allen Klein, and Andrew Oldham suggested that I should shoot a new session for an album in which they were all involved. It was probably the last of the truly mad and bizarre rock and roll sessions in which I was involved. Phil kept us waiting for days, but finally relented and allowed us in his home to shoot. He was charming and funny and I really enjoyed photographing him. I don't think the album was released and I have no idea if the portraits were ever used!"

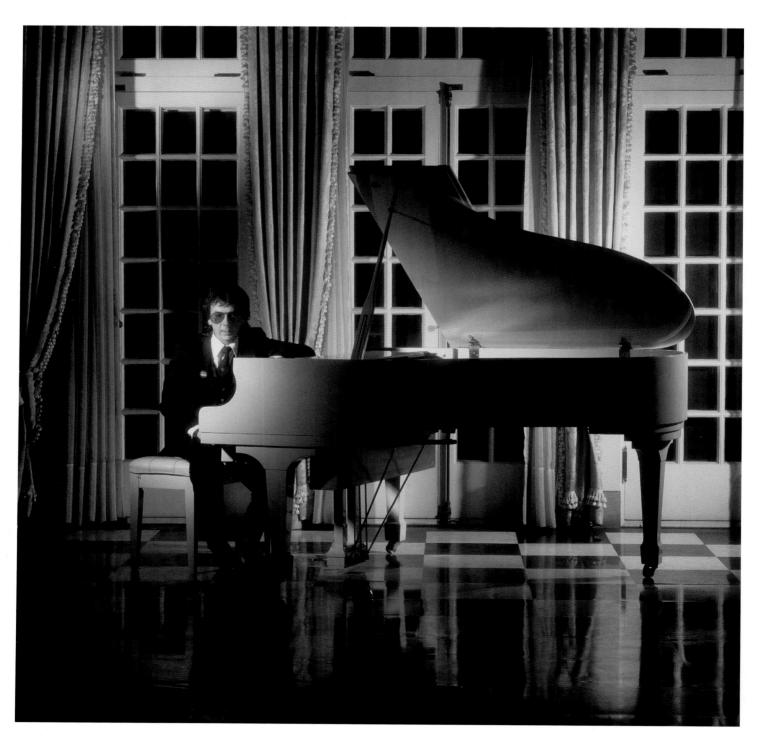

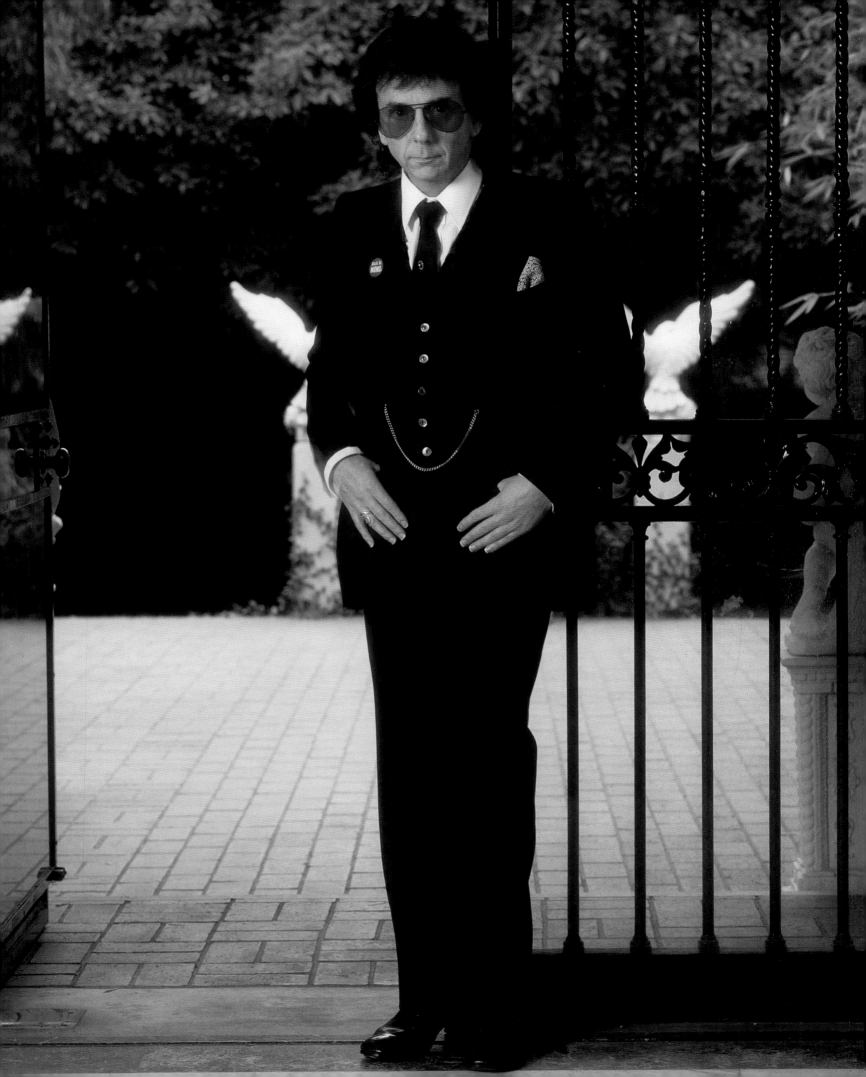

ANDREW LOOG OLDHAM 1965 & 1967

Flamboyant London-born impresario Andrew Loog Oldham began his long career in the music industry as a publicist for producer Joe Meek and singer/songwriter Bob Dylan before he turned to managing and producing the Rolling Stones between 1963 and 1967. He discovered Marianne Faithfull ahead of setting up his own Immediate Records label in 1965 and signing successful artists such as Chris Farlowe, the Small Faces, Rod Stewart, the Nice and Amen Corner. After working in America from 1980, where he produced Donovan, Oldham moved to Colombia and produced three best-selling autobiographies while also hosting a US satellite radio show.

"Of all the extraordinary people I have had the good fortune to work with, Andrew has to be the most important. He was a great visionary and always managed to push my photography further than I thought I could go, inspiring me to think harder and experiment more. My time with the Stones and Immediate Records *were* the 60s for me and without Andrew it wouldn't have been nearly as much fun. He became a dear friend and still is!"

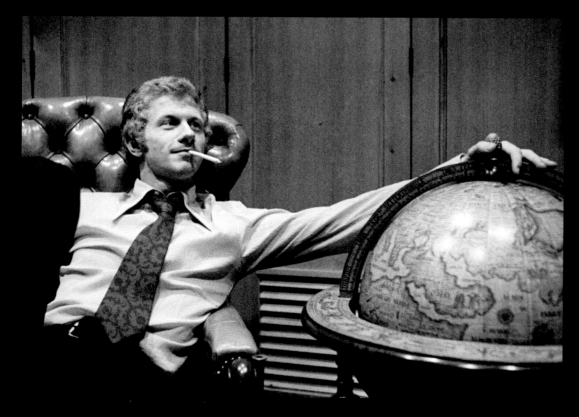

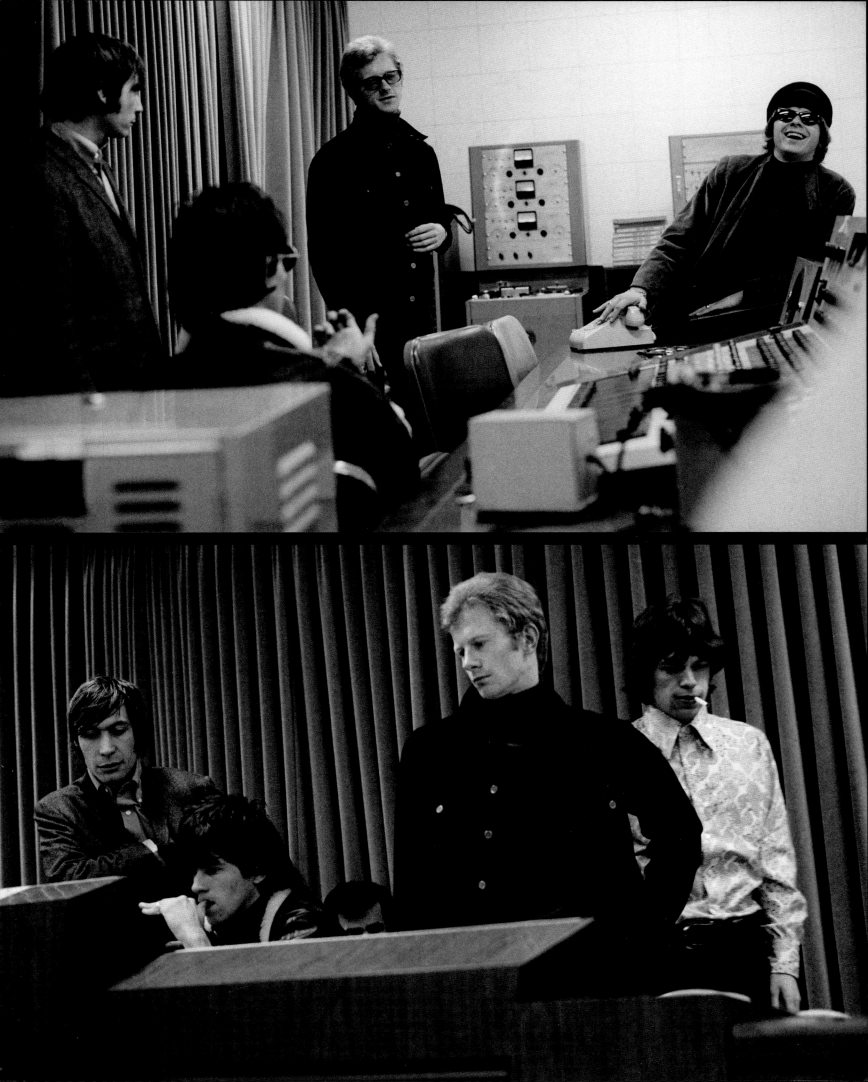

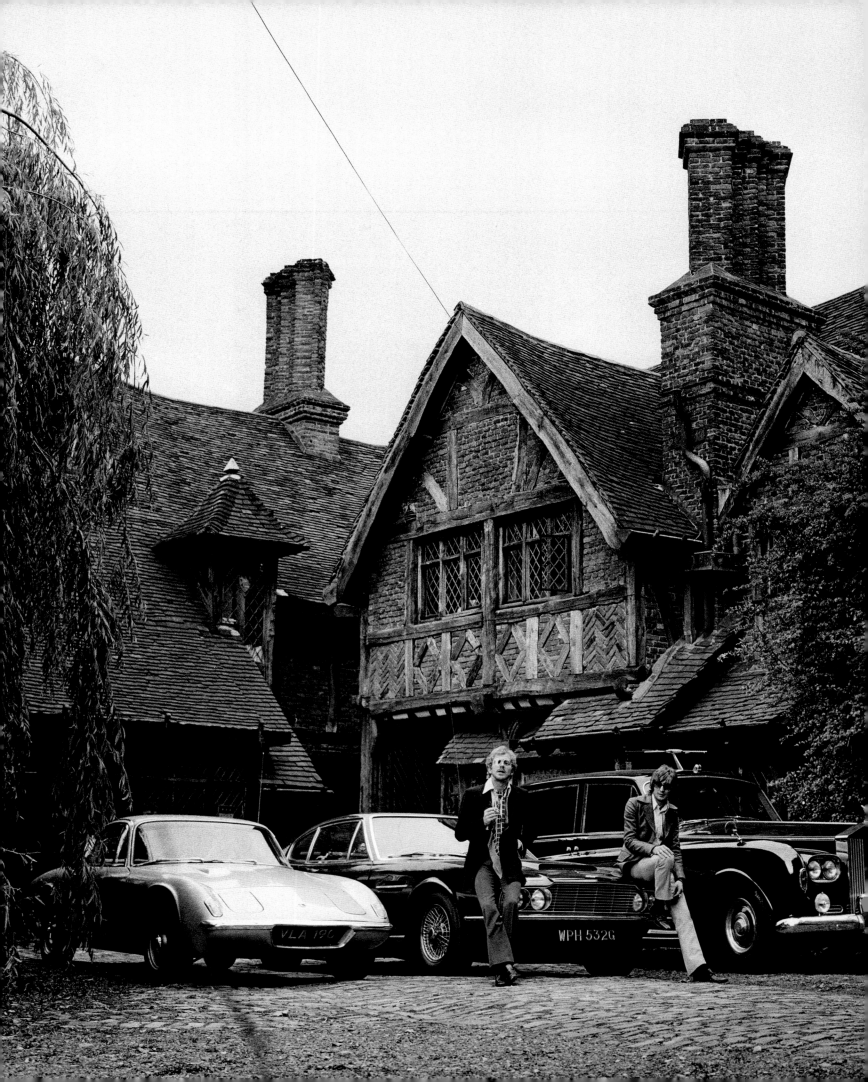

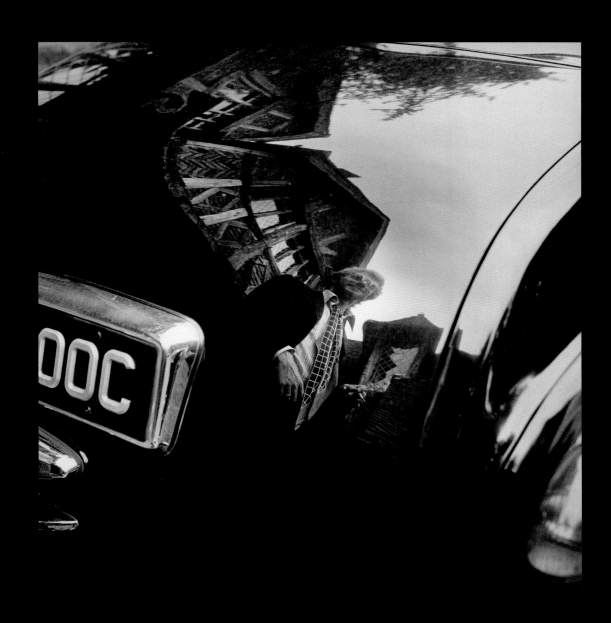

THE ROLLING STONES 1965 TO 1967

The legendary all-conquering Rolling Stones' line-up of Mick Jagger, Keith Richards, Brian Jones, Bill Wyman and Charlie Watts first came together in January 1963, when they debuted at London's Flamingo Jazz Club. They signed with manager Andrew Loog Oldham four months later and, despite Jones leaving in 1969 and Wyman in 1993, the Stones stayed together and have now spent over 50 years touring the world and making hit records, including more than 20 Number 1 albums and singles in the UK and America. Photographer Mankowitz joined them on their fourth tour of America in October 1965 while *Between The Buttons* was a Top 3 album in 1967.

"I was so lucky that Andrew Loog Oldham decided to give me the chance to work with the Stones in 1965. The mid-60s period was the peak of the band's original success and I was there to share a great deal of it with them, including an amazing US tour at the end of 65, and the excitement of the *Between the Buttons* session at the end of 1966. My association with the band consolidated my career and I will be forever grateful!"

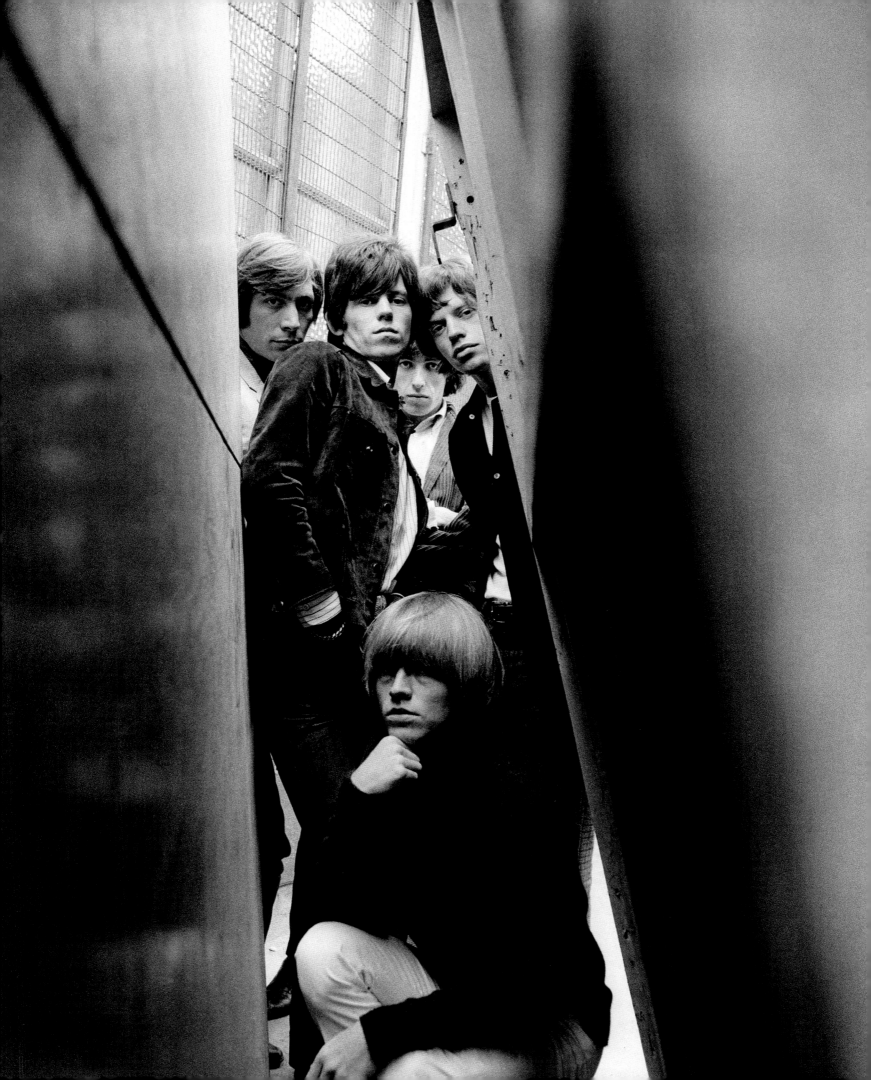

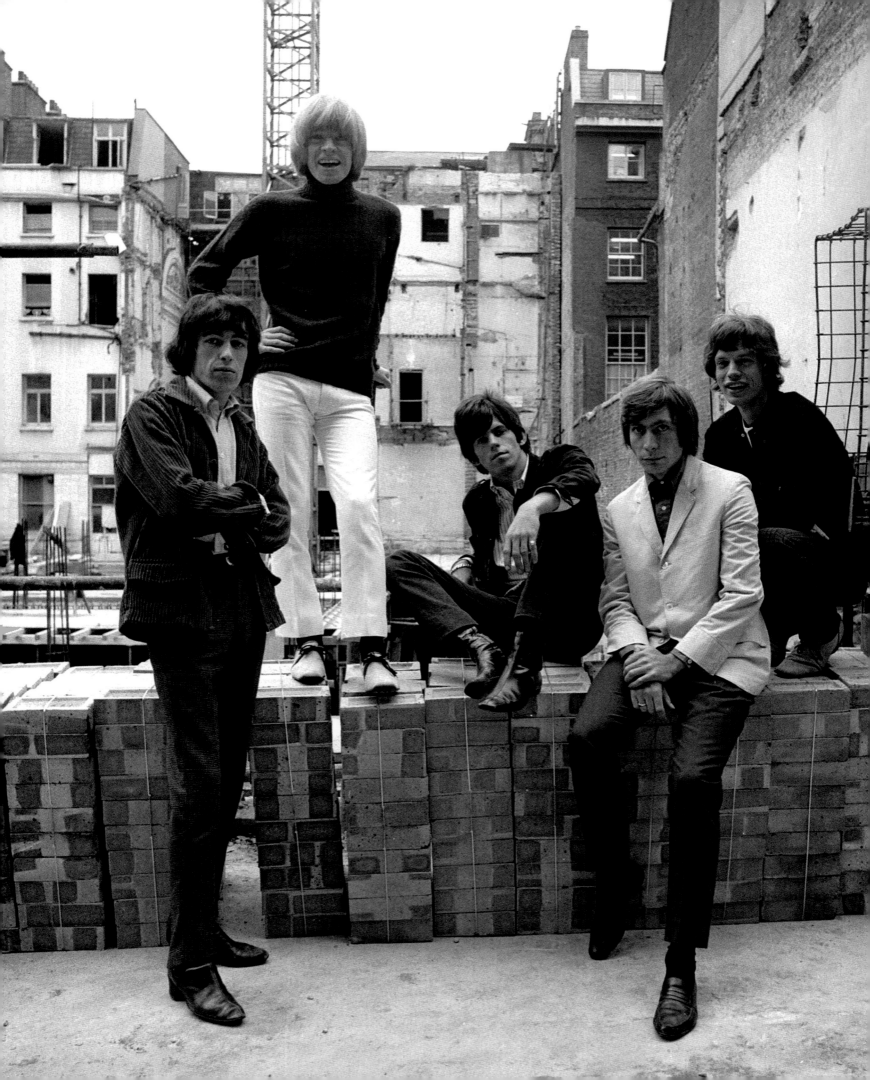

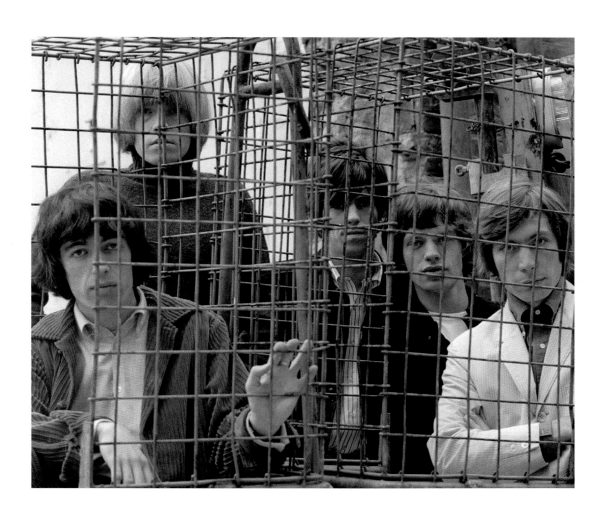

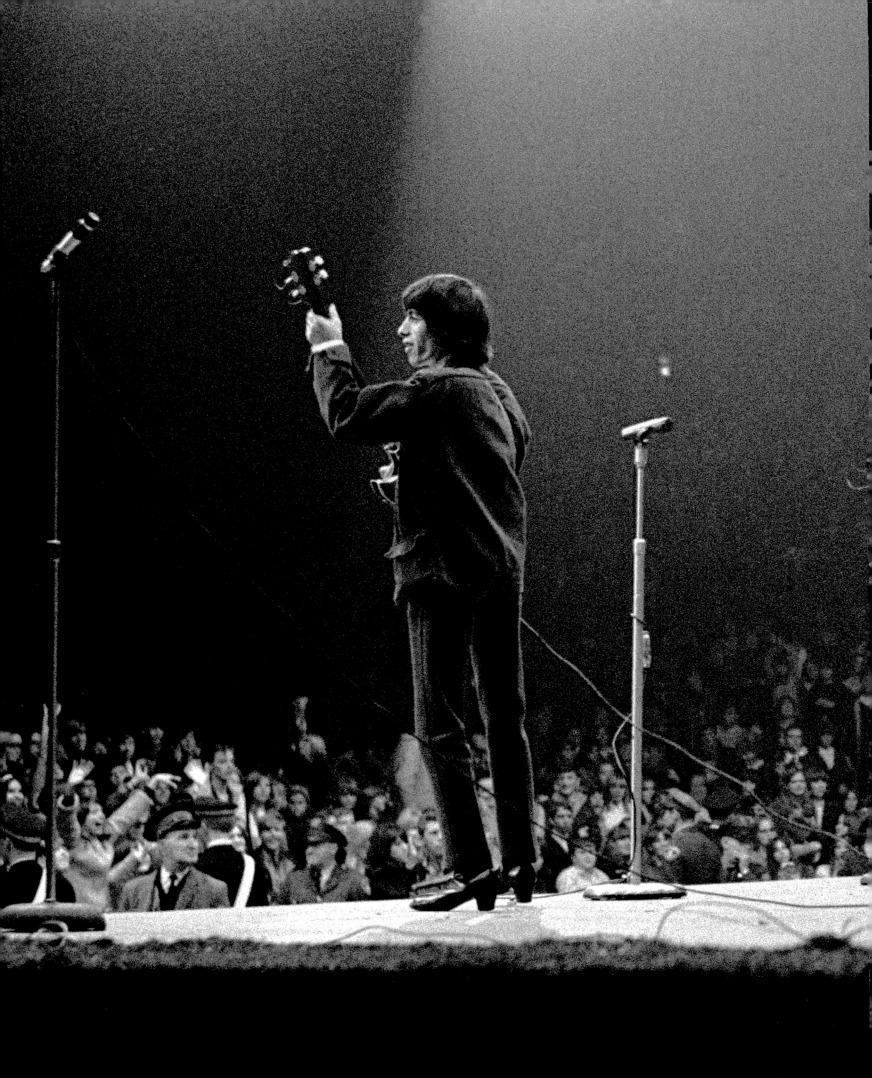

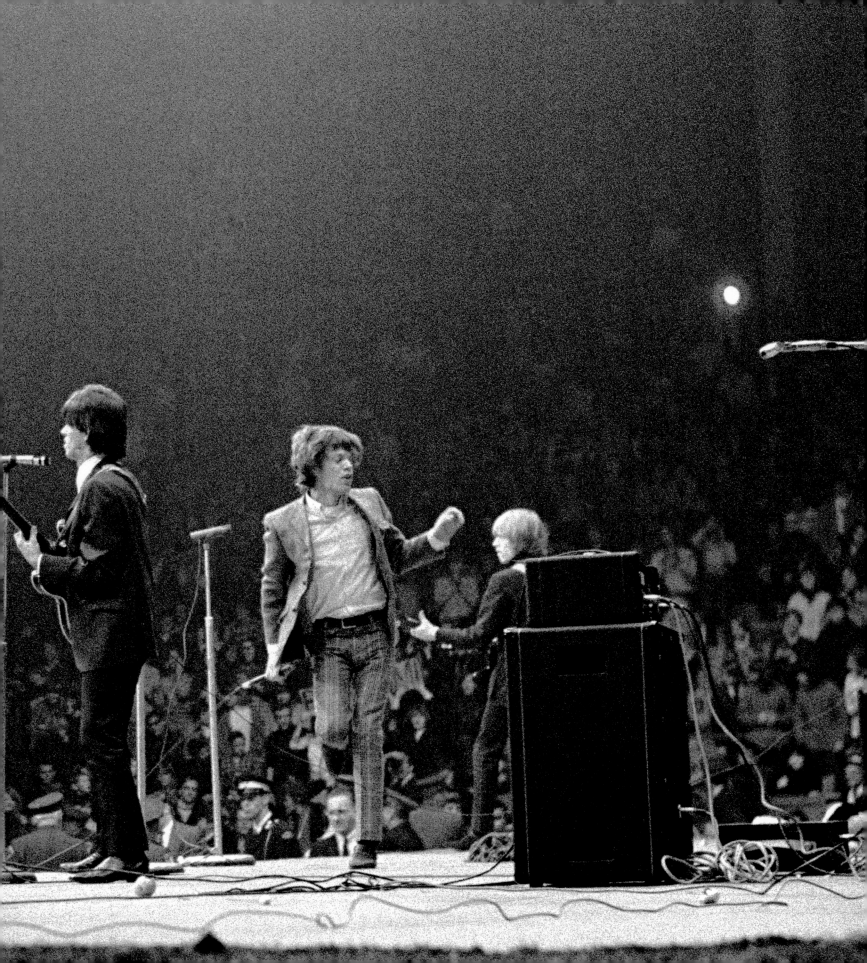

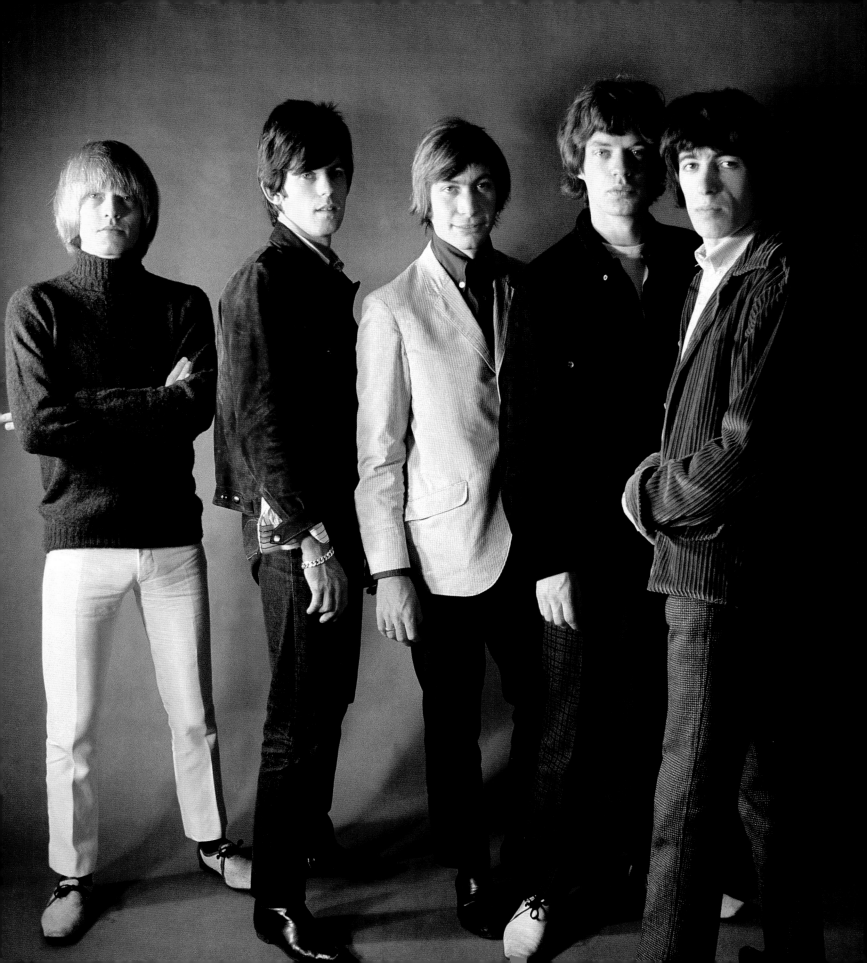

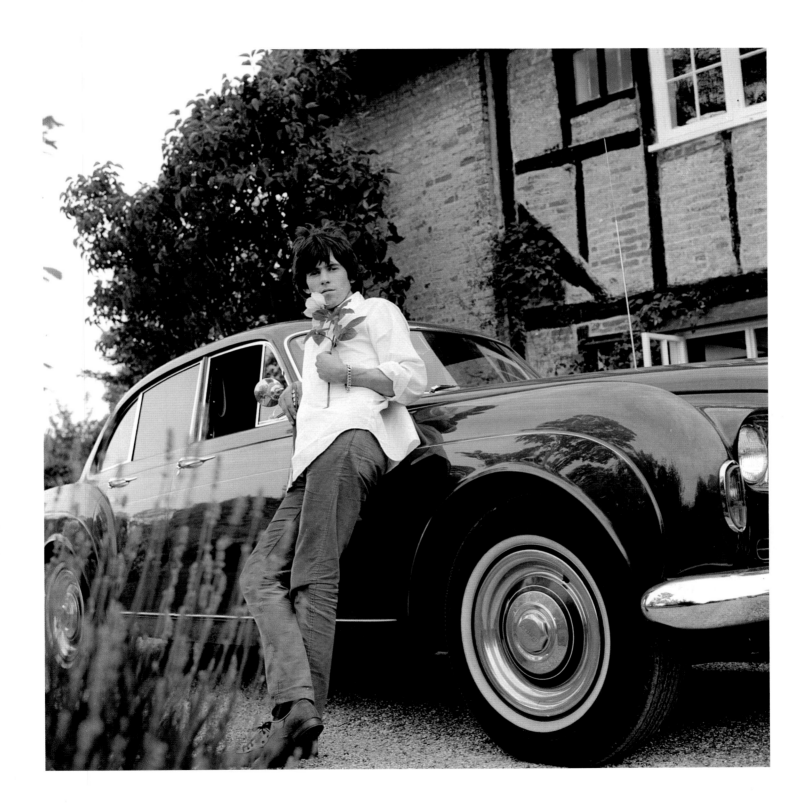

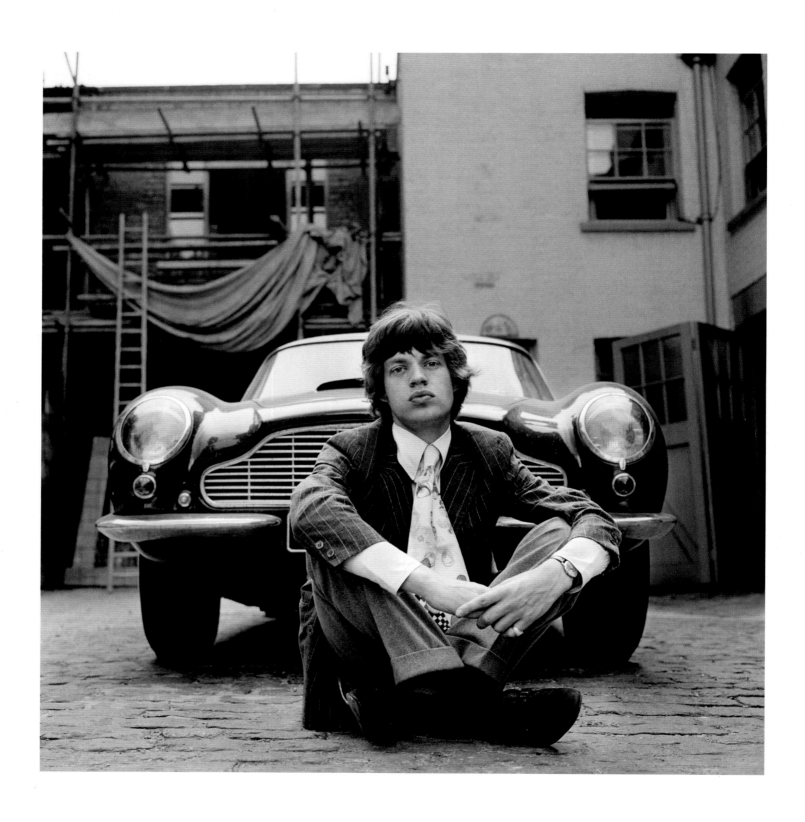

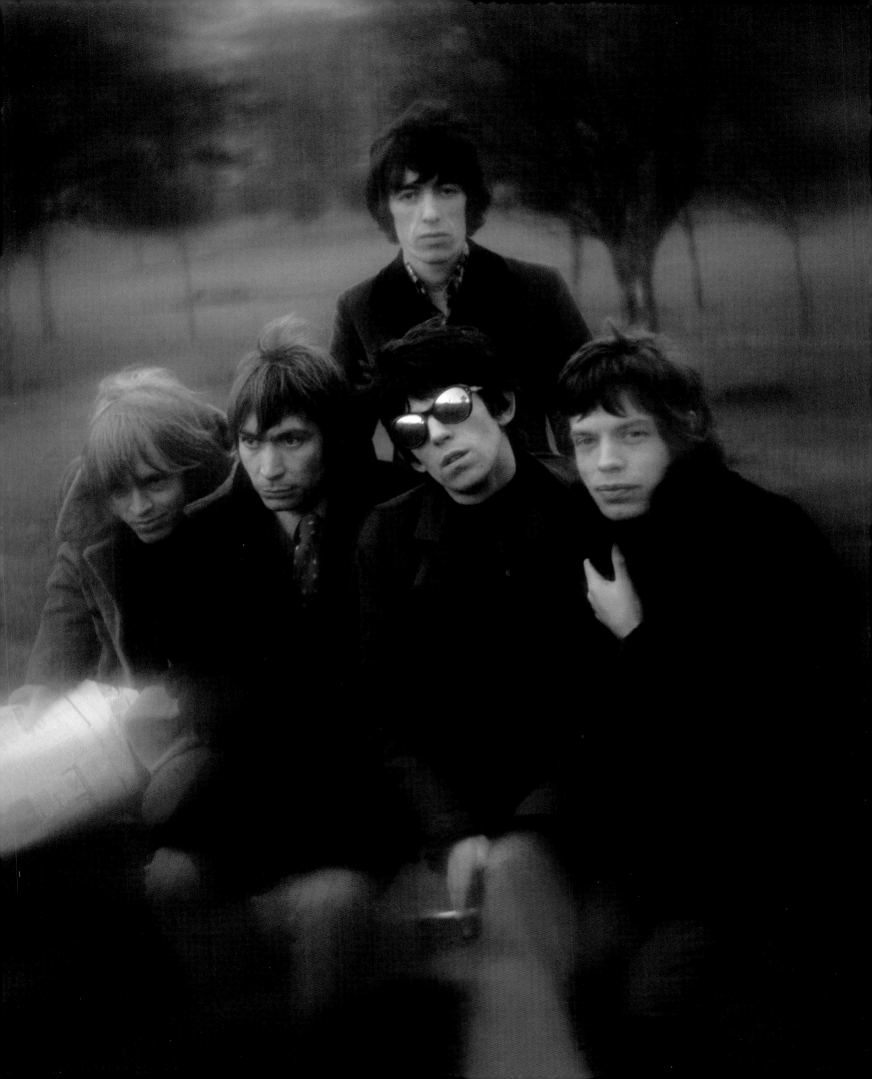

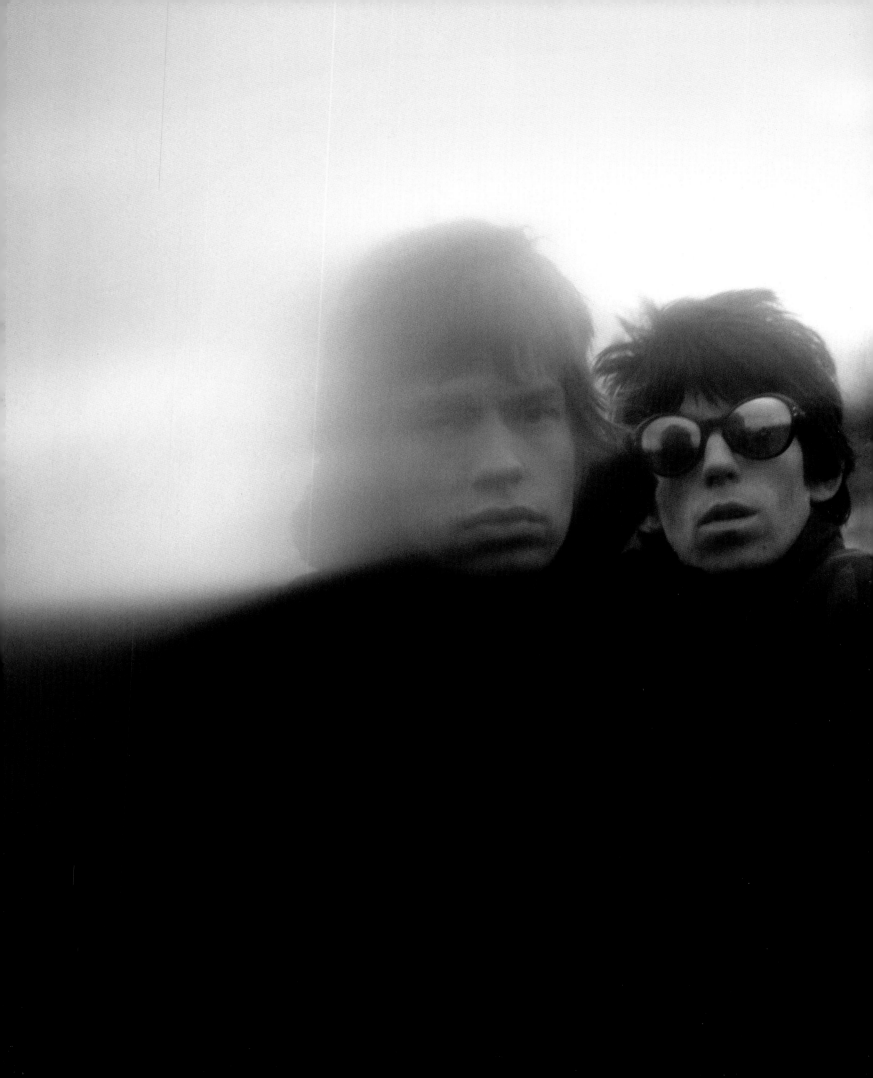

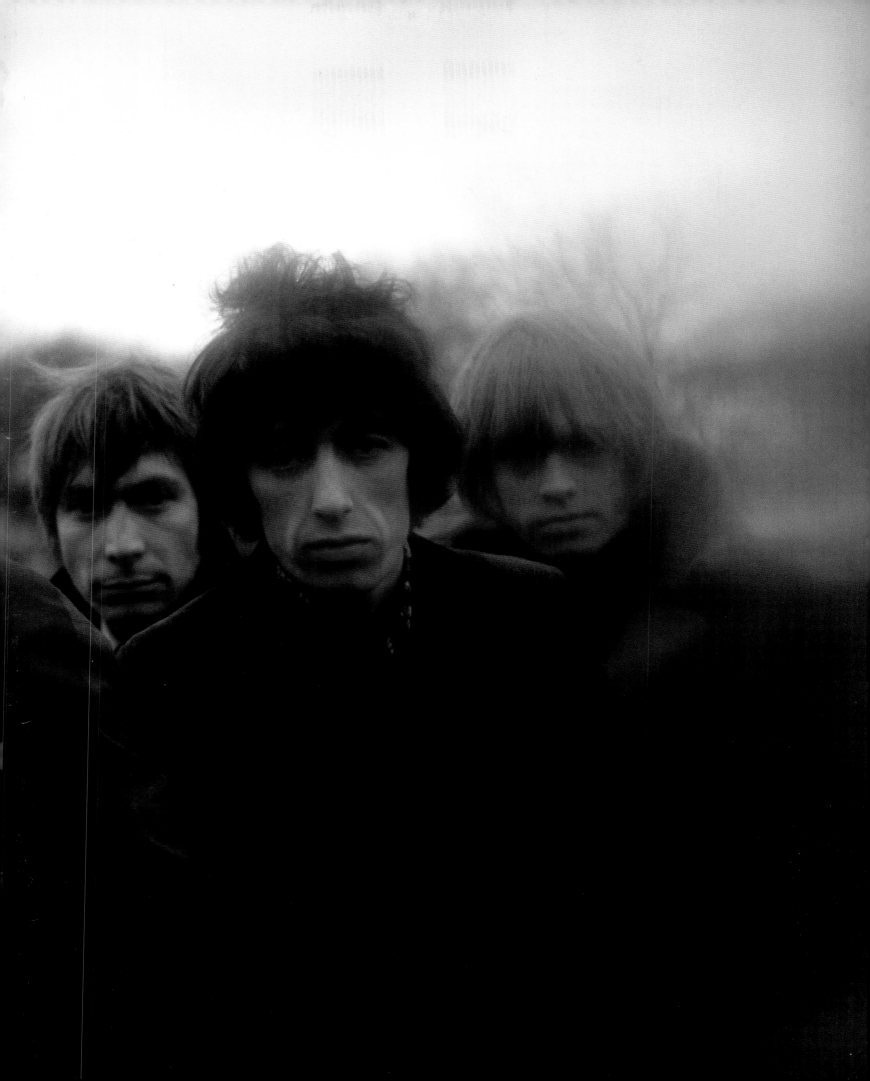

ACKNOWLEDGMENTS

I would like to thank all the subjects who have so generously allowed me to take their portraits and given me a tiny bit of their soul.

All the managers, press officers and record companies who have supported my career over the past 50 years.

All the art directors and designers with whom I have collaborated on so many of the images that I have shot.

All the assistants who have helped me over the years, but most particularly Andrew Whitton, who spent hours helping me prepare the material for this book at the beginning of the project.

To my dear wife Julia, who has been with me for the best part of of those 50 and my daughters Jessica and Rachel and their husbands Alex and Andy.

To Frank Wonneberg for his design integrity and unwavering support in trying to bring this book to fruition.

To Peter York for his insightful and charming introduction.

To Keith, Bill and Annie for their kind forewords.

To all at Carlton Books for bringing the book to life.

Front endpapers: The Jimi Hendrix Experience, 1967
Page 2: Jimi Hendrix, 1967
Page 8: Marianne Faitfull, 1964
Page 9: Rolling Stones, 1966
Page 10: Keith Richards, 1965
Page 12: P.P. Arnold, 2006
Page 13: Andrew Loog Oldham, 1967
Page 14: Annie Lennox, 1979
Page 16: Kate Bush, 1978
Page 17: Small Faces, 1967
Page 18: Bill Wyman, 1966
Page 320: Apple Corps headquarters, 1976
Back endpapers: Rolling Stones, 1966
Book cover (front): From King Crimson's album *Red*
Book cover (back): From T. Rex's album *Bolan's Zip Gun*

Published by Goodman
A division of the Carlton Publishing Group
20 Mortimer Street
London W1T 3JW

Text and photograph copyright © 2013 Gered Mankowitz
Design copyright © 2013 Carlton Books

A CIP catalogue for this book is available from the British Library.

ISBN 978-1-84796-065-8

Printed in China